epica book 11

The Epica organisers wish to thank the Epica Jury and all those who contributed to the success of the 11th annual Epica Awards.

Edgard Aboulker, Mark Anthierens, Jure Apih, Alexandra Archetti-Stølen, Pascal Baetens, George Barberopoulos, Kiki Barbouni, Stefan Barholm, Norman Barry, Ruth Barry, Michel Barseghian, Christian Blachas, Lewis Blackwell, Mark de Block, Katherina Bomba, Igor Borzenkov, Anne Le Boulett, Madela Canepa, Jan Carlzon, Jean-Pierre Chaminade, Nathalie Champagne, Audrey Chaouat, Vjacheslav Chernjackhovsky, Pierre-Edmond de Cordon, Isabelle Cousteil, Michel Cros, Nathalie Darcourt, Olivier Darmon, Jack Demaison, Meta Dobnikar, Caryn Doran, Christophe Drault, Perrine Duval, Ana Isabel Egido, Lotta Enberg, Jean-Noël Escoffier, Elvira Esparza, Bertrand Fugagnoli Noëlle Gauthier, Karin van Gilst, Alice Goh, Michelle Goldstein, David Gourdy, Yannis Goutis, Pavel Hapak, Bo Hedin, Johan Helmertz, Angelica Hiltmann, Bruno Hug, Stein Arild Iglebaek, Michaela Jandova, Anne Jimmy, Jack Johnstone, Joakim Jonason, John Kao, Tülin Kara, Marja Liisa Kinturi, Andreas Knaut, Jurij Korenc, Gérard Lalande, James Lanham, Angus Lawrie, Bernard Lefèvre, Alla Leikina, Åke Lindberg, Alex Lukacs, Mia Luthje, Willy MacGillivray, Eva Manhardt, Olli Manninen, Romaine Marti, Vincent Michelet, Dominique Millot, Brian Morris, Gianni Muccini, Christian Mucha, Isabelle Musnik, Claude Nicolas, Tuula Nummela, Renée Nyberg, Attila Ögüd, Gürül Ögüd, Malou Örner, Svend-Erik Pedersen, Morten Peetz-Schou, Olivier Perrenchio, Oliver Prange, Astrid Prummel, Benoît Quides, Jean Quiles, Kehrt Reyher, Marzenna Reyher, Tommaso Ridolfi, Isabella Ripota, Bo Rönnberg, Nancy Ross, Stefan Ruzas, Salvatore Sagone, Anne-Rose Schlutbohm, Kristina Sipek, Natalya Smirnova, Stuart Smith, Jean-Michel Stichelbaut, Hans Sydow, Mohamed Tabi, Daniel Tilles, Carlos Villegas, Sophie Vitry, Ia Wadendahl, Peter Wallgren, Kim Weckstrom, Alain Weill, Michael Weinzettl, Bernhard Wenger, Richard White, Ulf Wickbom, Peter van Woensel Kooy, Diane Young, Gordon Young and many others.

EPICA
EUROPE'S PREMIER
CREATIVE AWARDS

contents

EPICA WINNERS 1997

Epica d'Or	Pirella Göttsche Lowe (Milan) and BRW & Partners (Milan)	Superga, "The Challenge"
Pro Prize (Photography)	J. K. Potter (USA) and Garbergs International (Amsterdam)	Two Dogs, " Dog Face"

PRINT WINNERS

Food	Saatchi & Saatchi (Madrid)	Campbell's Soups
Confectionery & Snacks	LDV/Partners (Antwerp)	Fisherman's Friend
Dairy Products	Paltemaa Huttunen Santala TBWA (Helsinki)	Valio Classic Ice Cream
Alcoholic Drinks (A)	Young & Rubicam (Madrid)	J & B Scotch Whisky
Alcoholic Drinks (B)	Ogilvy & Mather (London)	Guinness Beer
Non-Alcoholic Drinks	Euro RSCG Babinet Erra Tong Cuong (Paris)	Evian Mineral Water
Retail Services	BDDP GGT (London)	French Connection UK
Financial Services	Nordin & Co (Stockholm)	Nordnet Share Transactions
Public Interest	Young & Rubicam (Frankfurt)	Aids Awareness
Transport & Communication	Ogilvy & Mather (Brussels)	Westrail/Thalys Railway
Homes, Furnishings & Appliances	DSDS (Amsterdam)	Int'l Flower Bulb Centre
Audiovisual Equipment & Accessories	S Team Bates Saatchi & Saatchi Balkans (Belgrade)	Sony Walkman
Toiletries	Not Just Film (Amsterdam)	Odol Mouth Freshener
Beauty Products	Pickl Advertising (Munich)	Diesel Plus Plus Fragrances
Pharmacy & OTC (Prescription)	RG Wiesmeier (Munich)	Lovelle Birth Control Pills
Pharmacy & OTC (Non-Prescription)	Ray, Leach, EMO (London)	Mates Condoms
Automobiles	Publicis (Brussels)	Renault Clio Oasis
Automotive & Accessories	Tandem Campmany Guasch DDB (Barcelona)	Volkswagen Spare Parts
Office Equipment	Ogilvy & Mather (Paris)	IBM Network Stations
Business Services	JvM (Hamburg)	JvM Self-Promotion
Industrial & Agricultural Equipment	Intevi Werbeagentur (Cologne)	Spies Hecker Car Paints
Clothing & Fabrics	CLM/BBDO (Paris)	Kookaï Women's Fashion
(2 winners)	Paradiset DDB (Stockholm)	Diesel Jeans & Workwear
Footwear & Personal Accessories	Cowan Kemsley Taylor (London)	Gargoyle Sunglasses
Tobacco & Accessories	McCann-Erickson (London)	Camel Cigarettes
Media & Entertainment	Forsman & Bodenfors (Gothenburg)	Gothenburg Post Classified
Recreation & Tourism	Bates Dorland (London)	Banham Zoo
Interactive	McCann Interactif (Paris)	Dauphin Poster Simulator CD ROM
New Media	BDDP GGT (London)	The Big Issue Postcards
Direct Marketing	Milenio (Lisbon)	Norteshopping
Publications	Grupo Barro-Testa (Madrid)	Polygram Films Press Book
Packaging Design	Futura (Ljubljana)	Slowind CD Cover
Illustration & Graphics	KesselsKramer (Amsterdam)	Nike Tour de France Sponsorship

FILM WINNERS

Food	JBR McCann (Oslo)	Ideal Wasa Crisp Bread
Confectionery & Snacks	Tony Kaye & Partners (London)	
	(for J. Walter Thompson, Paris)	Nestle Lion Bar
Dairy Products	Hasan & Partners (Helsinki)	Keiju Margarine
Alcoholic Drinks (A)	Lowe & Partners (Copenhagen)	Gammel Danish Bitter
Alcoholic Drinks (B)	BDDP GGT (London)	John Smith's Beer
Non-Alcoholic Drinks	Eclipse Productions (London)	
	(for HHCL & Partners, London)	Blackcurrant Tango
Retail Services	Casadevall Pedreño & PRG (Barcelona)	Fotoprix Photo Enlargements
Financial Services	Weber, Hodel, Schmid (Zürich)	Schweizerischer Bankverein
Public Interest	FCB/TAPSA (Madrid)	Once Recruitment of Disabled
Transport & Communication	JvM (Hamburg)	German Railways
Homes, Furnishings & Appliances	New Deal DDB (Oslo)	Ikea Furniture
Household Maintenance	TBWA (Paris)	Mappa Rubber Gloves
Audiovisual Equipment & Accessories	Honegger/von Matt (Zürich)	Panasonic Radios
Toiletries	Umwelt Advertising (Copenhagen)	Panasonic Shavers
Beauty Products	Ogilvy & Mather (London)	Impulse Cologne
Pharmacy & OTC (Non-Prescription)	Ogilvy & Mather (Brussels)	Proflora Intestinal Pills
Automobiles	Gerard de Thame Films (London)	
	(for Lowe & Partners, New York)	Mercedes-Benz
Automotive & Accessories	PPGH/JWT (Amsterdam)	Shell Petrol
Office Equipment	DDB Advertising (Paris)	Epson Stylus Colour Printer
Business Services	Garbergs (Stockholm)	Telenordia Internet
Clothing & Fabrics	Paradiset DDB (Stockholm)	Diesel Jeans & Workwear
Footwear & Personal Accessories	Pirella Göttsche Lowe (Milan) and BRW & Partners (Milan)	Superga Shoes
(2 winners)	Barbella Gagliardi Saffirio DMB&B (Milan)	Swatch Watches
Tobacco & Accessories	Kolle Rebbe Werbeagentur (Hamburg)	Gauloises Blondes
Media & Entertainment	Delvico Bates (Barcelona)	Planeta Encyclopaedia
(2 winners)	Mother (London)	Channel 5: Jack Docherty Show
Recreation & Tourism	Result DDB (Amstelveen) and Cellusion Films (Amsterdam)	Toto Select Football Lottery
New Media	BDH Communications (Manchester)	Tizer Soft Drink

introduction

by joakim jonason

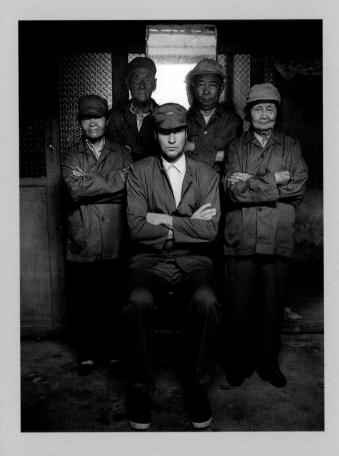

Some days I wonder if advertising has a future.

These are the days when I notice that people are sick of bad advertising. Sick of how advertising lacks the very elements that people desire from it – such as any signs of civilised thinking, or a generous spirit, or any relationship to the real world, or an inspiring message that connects to the consumer at a personal level.

It is odd how advertising can so often end up polluting people's minds instead of enriching them. It should be at the front of any advertisers' objectives to endeavour to build a relationship with the consumer based on trust and inspiration. But this is rare.

Instead, the advertising industry prefers to settle for the same old flirtation with the consumer, seemingly blind to the signs of people's irritation at receiving beautifully packaged lies. The advertising industry so often shows that it has lost all contact with real creativity as it pushes out advertising based on the same old basic "rules" for selling to people. We too often rely on tired formulas and only recognise "good advertising" by matching up the new work against historical precedents.

So what would happen if we left the old attitudes and old lies behind and closed in on the real world? For one thing there would be more work. We would integrate our marketing and advertising thinking. Initially, our work would be harder as we sought to understand the much more complex situation that exists (a complexity the tired old model of advertising fails to recognise). But out of this hard work would be born a new understanding.

Marketing and advertising, like war, rely on strategic analysis. In the battle, the ones who dare to attack first from an unexpected direction will be ahead of the others, and are most likely to succeed. So for all the work and risk, the rewards are substantial. For those who redesign the map of advertising, the possibilities of its new routes will be the greatest.

Sometimes creativity is pictured as something that is about tearing down structures, breaking down doors. Well, it can be – but it can also be seen another way. At this point in our advertising evolution, I think it could be about opening doors and creating new rooms in which to live, in which to relate to consumers.

If we want to have a meaningful dialogue with our fellow inhabitants on planet Earth, and if we want to have this within advertising, then we have to be aware that constant change is an unavoidable part of that. Society is always developing.

Bill Bernbach, the advertising guru whose wisdom has often been misconstrued into those "rules", once said that those of us who shape the mass-media have an immense responsibility in helping shape society. We can vulgarize that society, we can brutalize it. Or we can help lift it onto a higher level.

Decide on the latter and you should sleep easier at night – and probably earn a fortune. Two good things for the price of one. Now that's an offer no consumer can resist. Can you?

Joakim Jonason is creative director of Paradiset DDB, Stockholm.

the jury

The Epica Awards jury is made up of representatives from Europe's leading advertising magazines.

AUSTRIA
Extra Dienst

BELGIUM
Pub

CZECH REPUBLIC
Strategie

DENMARK
Markedsføring

FINLAND
Markkinointi & Mainonta

FRANCE
CB News

GERMANY
Lürzer's International Archive
Werben und Verkaufen

GREAT BRITAIN
Creative Review
Marketing Week
The Drum

GREECE
Advertising Today

IRELAND
IMJ

ITALY
Pubblicitá Italia
Pubblico
Strategia

NETHERLANDS
Adformatie
Nieuws Tribune

NORWAY
Kampanje

POLAND
Media Polska

PORTUGAL
Prisma

RUSSIA
Reklama
Reklamny Mir

SLOVAKIA
Stratégie

SLOVENIA
Marketing Magazine

SPAIN
Campaña

SWEDEN
Resumé

SWITZERLAND
Persönlich

TURKEY
Marketing Türkiye

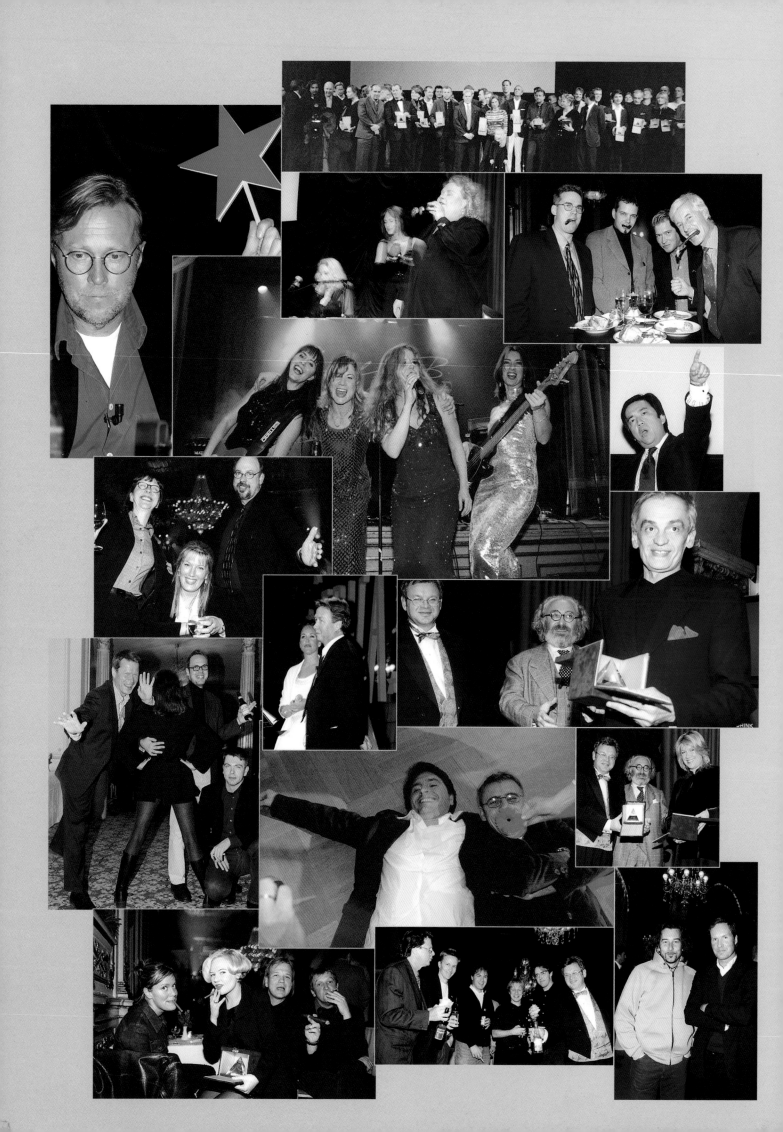

annual
report

RESULTS
Epica's second decade started with a record level of participation:
4,481 entries from 666 advertising agencies, studios and production companies.

A total of 62 winners were announced in 1997, two more than the previous
year. In five cases the jury decided that standards did not justify a category
winner and in three other instances a pair of joint-winners were named
in the same category. There were 28 film winners and 34 print winners,
print categories being more numerous.

Work from 35 countries was entered in the 1997 awards. The winners came
from 15 countries and ten other countries were represented on the list of
finalists. Great Britain was the most successful, followed by Sweden, France,
Germany, Holland and Spain.

BDDP GGT, London, was the most successful entrant with three winners.
DDB was the most successful network, for the second consecutive year,
with seven winners from six countries, followed by Ogilvy & Mather with five
winners from three countries.

EPICA D'OR
The 11th annual Epica d'Or was won by Pirella Göttsche Lowe, Milan,
and their production company, BRW & Partners, for the Superga commercial,
"The Challenge," directed by Tarsem. BRW and Tarsem finished second
in 1994 with Mulino Bianco, and Superga was the runner-up in 1996, so the
1997 result was a well-deserved success for all concerned.

Epica jury member Lewis Blackwell, editor of Creative Review, reports on
the 1997 Superga commercial on page 12.

PRO PRIZE
The 1997 Pro Prize, for advertising photography, went to the American
photographer J. K. Potter and Garbergs International for Two Dogs.
Their winning ad for this alcoholic lemon drink is called "Dog Face"
and features a creature that's half man and half dog (see page 16).

AWARDS CEREMONY
The awards ceremony took place at the famous Grand Hotel, Stockholm
in January, 1998, at the same time that the city embarked on its tenure
as European Cultural Capital of the Year.

The full-day's event was hosted by Resumé, the leading Swedish advertising
magazine. It included a seminar involving top Swedish creative personalities
like Joakim Jonason of Paradiset DDB and Bo Rönnberg of Rönnberg
McCann, as well as presentations on creativity in business by experts such as
Jan Carlzon, former President of SAS, and John Kao of the Harvard Business
School. The ceremony was followed, of course, by a party...

Photos: Michael Engström

finding the generation gap

by lewis blackwell

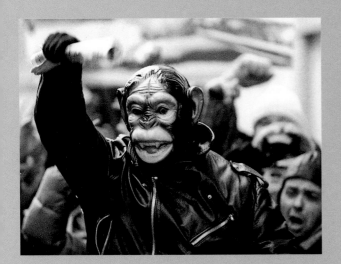

There's a riot going on. Police facing off angry protesters. One man wearing an animal mask, a loincloth and little else, taunts the authorities. Suddenly the tension explodes when a protester pushes over an oil drum bonfire. Violence rips through the scene as the police set dogs on the demonstrators and open fire with gas and incendiary bombs. One boy, engulfed in flame by the spilt fire, is hastily dowsed by a fireman. A police horse is pushed over, captured in slow motion. Suddenly a combat helicopter drops into view as tear-gas sends the rioters running. Do we need all this... to sell a traditional white canvas shoe?

When media studies professors in, say, 2098 come to view "The Challenge" – the film that won this year's Epica d'Or – they will indeed find a challenging and perhaps baffling comment on the 1990s. For one thing, they may find difficulty in understanding the talismanic significance of the hero of the piece, the shoe. Another problem might be in simply assembling any storyline from the fast-paced, jump-cut edit. And perhaps trickiest of all will be finding the connection between the drama and violence of the film and the knowledge that this is advertising.

But such challenges are why The Challenge is a great contemporary commercial. Viewed close up to its audience it has the sound and fury and visual appeal to stand out in a tough marketplace (the sports shoe) where high style is commonplace. But there is more than sheer energy and style to be taken out of a viewing. This film is a remarkably tightly plotted tale, with a complex set of values to explore.

In its subject and its execution it is a small gem of condensed social observation. It is precisely a child of its time. From the music – Prodigy's ferocious "Firestarter", which went on to top the charts after its use in the spot – to the choice of an animal rights demonstration as the key part of the action, to the placing of a young woman as the central character, this is a film that connects at several fashionable levels.

"The Challenge projects a simultaneous contrast between good and evil, or freedom and repression, and between who wears Superga and who doesn't," explains Pino Rozzi, copywriter and joint creative director at Milan agency Pirella Göttsche Lowe, which holds the Superga account. He originated the commercial with his co-creative director and art director Roberto Pizzigoni. But there was a vital third component to this creative team – the director Tarsem.

"The original idea, presented to the client in a ten-line script, was to depict a political demonstration in front of a factory, watched by the company's boss from inside his limousine," recalls Rozzi. "The demonstrators were to be clad in balaclavas but the director, Tarsem, thought this might suggest they were terrorists and he introduced the idea of making them animal rights protesters disguised with animal masks. Tarsem pushed our idea to the maximum."

As with all the great directors, nothing but the maximum vision is acceptable. Tarsem clearly eats and sleeps film, and shoots a tremendous amount of the time – which makes for difficulty in tracking him down for an interview. Talk of a telephone interview to Tenerife (or was it Tunisia?) where he is shooting, changes to a plan to meet in London before finally I get the message to call him *now* at his Los Angeles apartment, catching him prior to his heading out for a meeting. After the talk I enter in the diary *in pencil* a proposed date to meet again in London.

Even on this link around the world, his energy and commitment to a project that is now deep history in his fast-moving life still comes through. "I told them I would do the job if they would buy the song, Firestarter. I have been a fan of Prodigy for years, and told the agency that if they had this song they would have me."

He saw in the song a precise tool for his transformation of the script. Its aggression now seems at one with the charge of the film scenes and the edit, but this approach was not obviously there in the original idea. "They didn't want a riot, it was just a demonstration outside a factory. And they wanted something politically safe – like anti-nuclear – as the reason for it," recalls

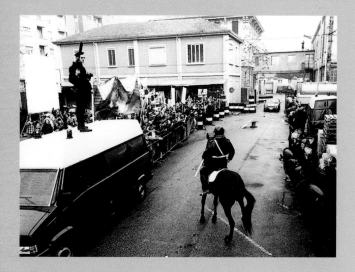

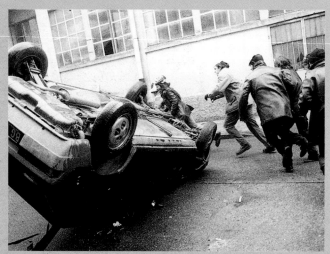

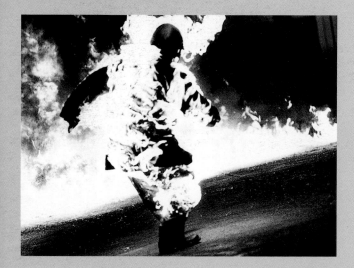

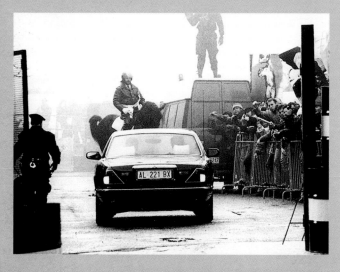

Tarsem. This embryonic plot element was just the beginning for him, something to take apart and rearrange with more drama, more opportunity for driving a plot.

Tarsem suggested animal rights as the subject of the protest. "I wanted something topical, which both sides could feel strongly about." Ironically, while the heroine of the piece is on the side of the anti-animal testing protesters, Tarsem asserts "I agree with animal testing". Just what he means by this is never quite explained, as he moves on quickly in conversation to explain the rich visual area opened up by his switches in the script. The protesters' distorted animal masks not only give an exotic charge to the opening scenes – scary, violent and somehow sexual in that there is also semi-nudity and rude gestures – but are essential to the plot. In that the heroine wears a mask she is not recognised by her businessman father when she lands on his car and then runs away. In this is the crucial shift in the story. This not only provides for his later surprise at realising she was in the protest, but also for our surprise as viewers – we discover the connection at the same time as he does.

This clever plot hinges around an archetypal moment, the one where the product becomes hero. In her dropping of a shoe at the scene of the conflict, which becomes the clue for the father to recognise her presence there later, we even find a reference to the Cinderella story. The dropped shoe allows for a lingering look at the brand carrier, while also providing a neat moment to switch the direction of the action. Then we are in the businessman's home at dinner: as he sits down at the formal dining table he accidentally knocks his newspaper on the floor, and when he bends down to pick it up he notices his daughter is wearing only one Superga. Cut to super: "Si odia o si ama", love them or hate them. At this point the film is not just about good and evil, young and old, freedom and repression, but has also overlaid family values onto the argument.

Tarsem was in two minds about the ending initially, disliking the neatness of the sign off. But then he explored the ambiguity. The dining scene is cut to with no clear expectations as to what might happen, but is dressed in such a way to further project the repression of the rich business life, setting it against the freedom of youth. The demonstrators' masks mean that we have no foreknowledge of the role of the girl, or for that matter whether the son at the dining-table might not be the rioter (we have been conditioned to think the protesters are young men).

"I wanted to end just at the point where you know what the commercial is about," says Tarsem. "It is the point of highest tension, everything builds to that moment, and then it ends."

It sounds almost obvious – after all, many commercials build to a pay off copyline – but the achievement with The Challenge is that the complex multi-scene cut is all explained in that final moment, with the eye contact between father and daughter representing political opposition, good and bad, youth and age. The remarkable worried stare of the beautiful Yugoslavian model who stars is the haunting final image before the super.

The film was shot in black and white, giving it an almost documentary feel, on the streets of Milan (where not only the agency but also the production company BRW & Partners are based, and where at times Tarsem has lived). Its monochrome visual style makes it link in the campaign with the predecessor "Procession" (which nearly won the Epica d'Or last year) and the latest, "Infatuation", shot in Sri Lanka, which is striking for its sex scene and its deliberate attack on over-branded shoes.

"Fashion rather than performance is the inspiration for these commercials," says Rozzi, explaining how Superga has positioned itself well away from the likes of Nike and Reebok. "The spots aim to appeal not just to the youth market but to audiences aged from 15 to over 50, all of whom wear Superga. Thus the first commercial, shot in Sicily, conveyed a sense of Italian history and was shot in black and white in a manner reminiscent of Italy's neo-realist film movement."

Rozzi admits that the violence in The Challenge provoked lots of complaints. Indeed, the film could never be shown as advertising in many countries, and was re-cut in Italy to a shorter, less aggressive version after the first few showings had prompted outrage. Needless to say, Tarsem feels the original version is the only one which works: "I hate the watered-down version – I think Italians must wonder what that is about. As the line suggests 'you love it or hate it'. That is how it should be."

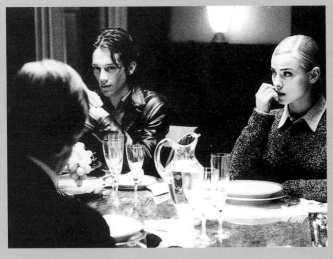

As I write this, the business pages are full of stories about the meltdown in the training shoe market, where sales have dipped and there are signs that the market is seeking fashion not so overly attached to sport. Superga, Pirella Göttsche Lowe and Tarsem might just have made a very cool call in their advertising.

And whatever the pundits might make of The Challenge in the future, it looks likely to be helping shape our tastes now.

Lewis Blackwell is editor and publisher of Creative Review, the London-based international magazine on excellence in advertising and design.

Photos: Nico Marziali

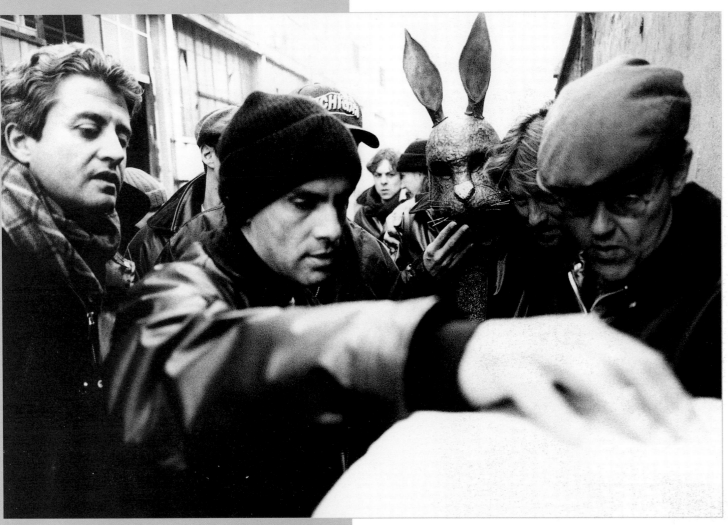

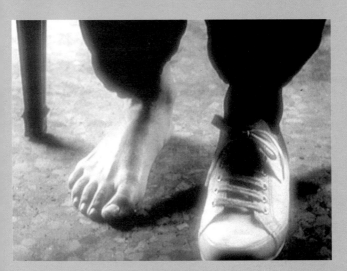

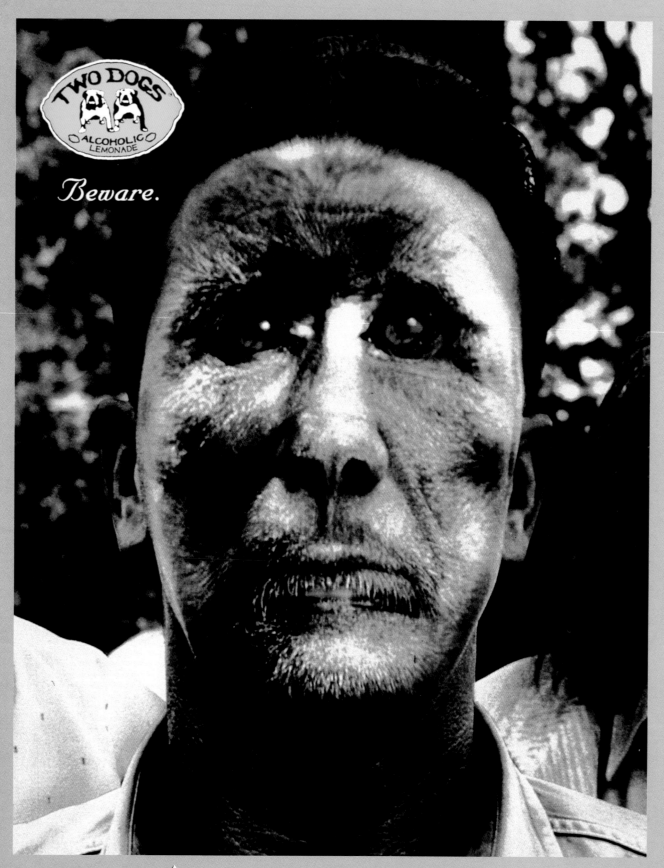

Photographer:	J.K. Potter
Creative Director:	Paul Falla
Art Directors:	Remco Bos
	Mark Aink
Agency:	Garbergs
	International,
	Amsterdam
Client:	Two Dogs
	Alcoholic Lemonade

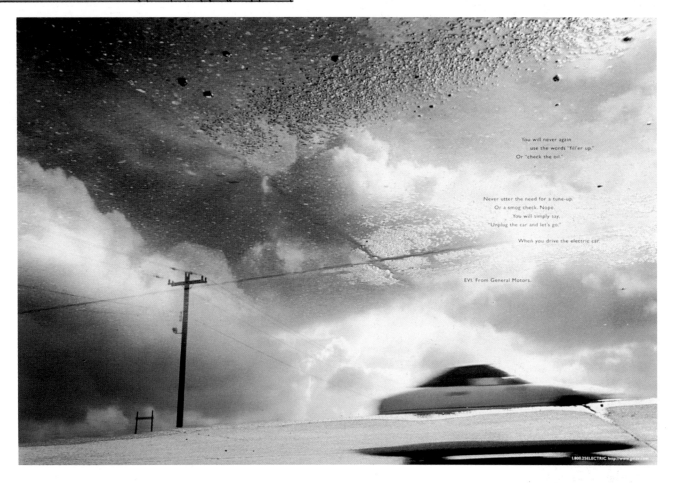

Pro Prize: Advertising Photography 17

Photographer:	Nadav Kander
Art Director:	John Doyle
Agency:	Hal Riney & Partners, San Francisco
Client:	Saturn

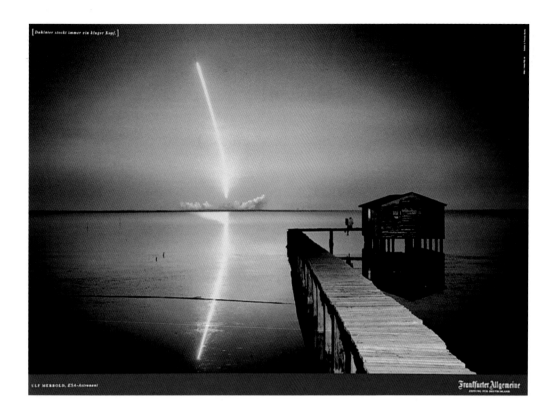

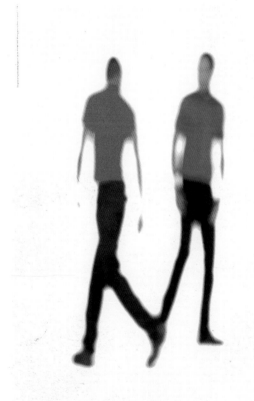

Remember the last time you had unprotected sex? What if the guy had HIV? Would you assume you might now be HIV positive, because you assumed he was HIV negative? **ASSUME NOTHING.**

Unprotected? Worried about getting HIV? Ever thought you might be passing it on? **ASSUME NOTHING.**

18 **Pro Prize: Advertising Photography**

Photographer:	Alfred Seiland	Photographer:	Peter Dazeley
Creative Director:	Sebastian Turner	Art Directors:	Shaun Whelan
Art Director:	Petra Reichenbach		Juliet Barclay
Agency:	Scholz & Friends, Berlin	Agency:	Spencer Landor, London
Client:	Frankfurter Allgemeine Zeitung	Client:	The Terrence Higgins Trust

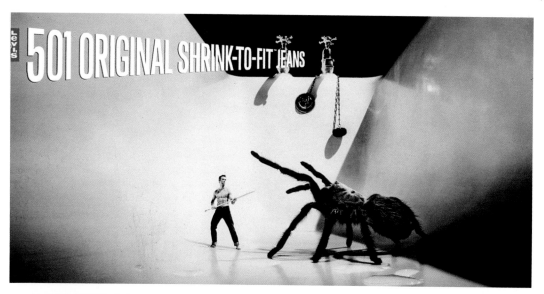

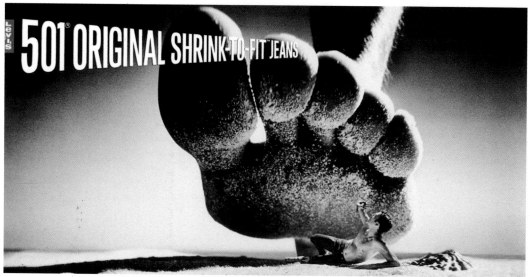

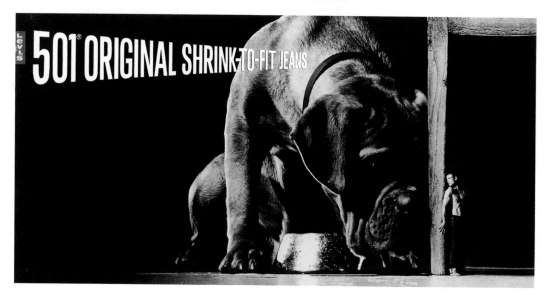

Photographer:	Nadav Kander
Art Director:	Rosie Arnold
Agency:	Bartle Bogle Hegarty, London
Client:	Levi Strauss

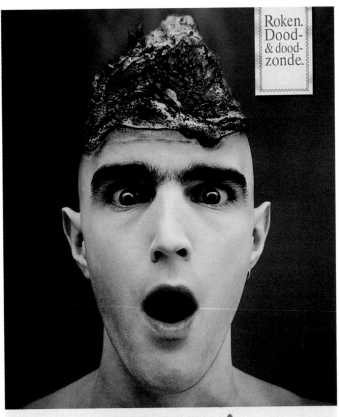

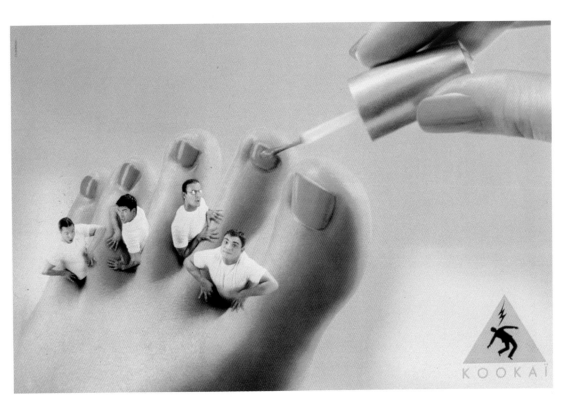

20 Pro Prize: Advertising Photography

Photographer:	Gerdjan van der Lugt	Photographers:	Les Guzman	
Art Director:	Ron Gessel	Creative Director:	Anne De Maupeou	
Agency:	BvH, Rotterdam	Art Director:	Nicolas Chauvin	
Client:	Stivoro	Agency:	CLM/BBDO, Paris	
		Client:	Kookaï	

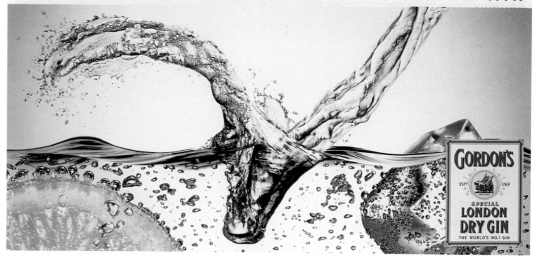

GORDON'S AND TONIC ❋ EXPERIENCE THE MIX

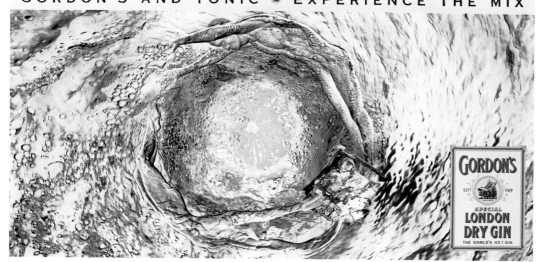

GORDON'S AND TONIC ❋ EXPERIENCE THE MIX

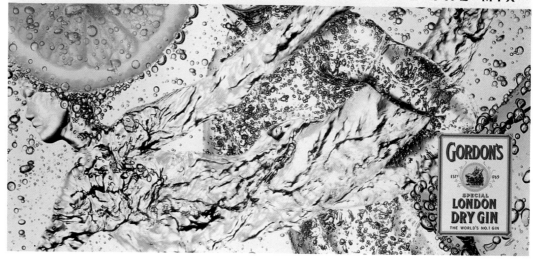

GORDON'S AND TONIC ❋ EXPERIENCE THE MIX

Photographer:	Ray Massey
Art Directors:	Stuart Newman
	Julian Burrough
Agency:	Leo Burnett, London
Client:	Gordon's Gin

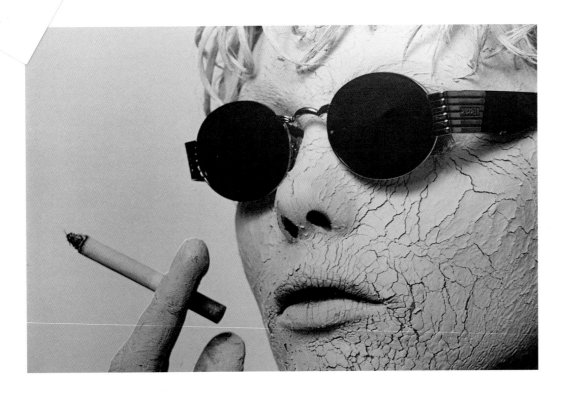

Pro Prize: Advertising Photography

Photographers:	Ruslan Semichev		Photographer:	Peter Gehrke
	Vladimir Kornelyk		Creative Director:	Joakim Jonason
Creative Director:	Vyacheslav Pypenko		Art Director:	Joakim Jonason
Art Director:	Pavel Koshenko		Agency:	Paradiset DDB,
Agency:	B&W Style, Donetsk			Stockholm
Client:	B&W Style		Client:	Diesel Jeans
				& Workwear

Pro Prize: Advertising Photography **23**

Photographer: Dietmar Henneka
Art Director: Urs Schwerzmann
Client: Daimler-Benz

SUCCESS.
IT'S A
MIND
GAME.

Zum Glück nähern wir uns einer
Epoche, **in der die Farbe Ihres Anzugs**
wichtiger ist als die Ihrer Haut.

strellson
menswear

24 **Pro Prize: Advertising Photography**

Photographer:	Nadav Kander	Photographer:	Matthias Ziegler
Art Director:	Eric Holden	Creative Directors:	Carlos Obers
Agency:	BDDP, Paris		Claudia Jäh
Client:	Tag Heuer	Art Director:	Claudia Jäh
		Agency:	RG Wiesmeier, Munich
		Client:	Strellson Menswear

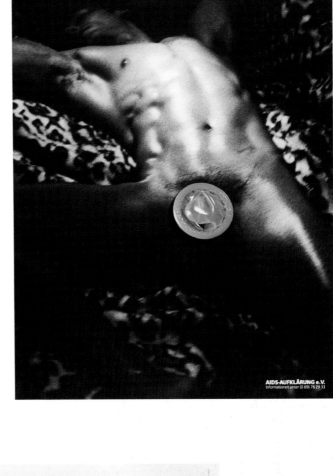

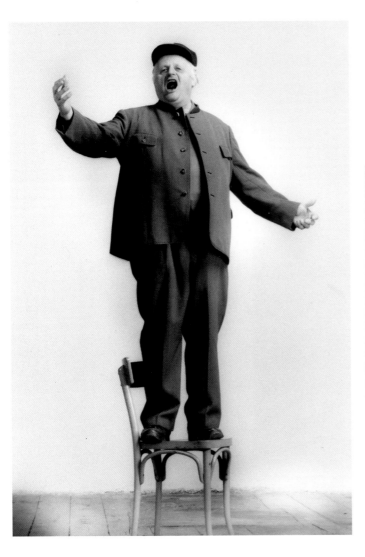

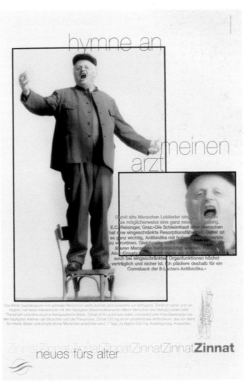

Photographer:	Markus Nikot	Photographer:	Herta Hurnaüs
Creative Directors:	Juergen Braun	Creative Director:	Angelica Freyler
	Reiner Dewenter	Agency:	Werkstudio,
	Laszlo Körössy		Rom & Freyler,
Art Director:	Sven Klohk		Vienna
Agency:	Young & Rubicam,	Client:	Zinnat
	Frankfurt		
Client:	Aids-Aufklärung		

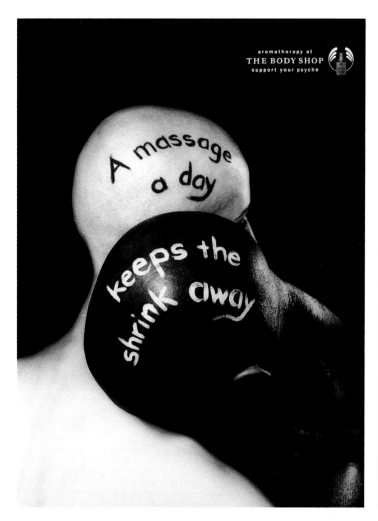

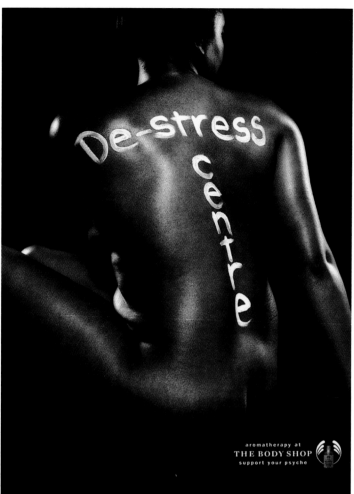

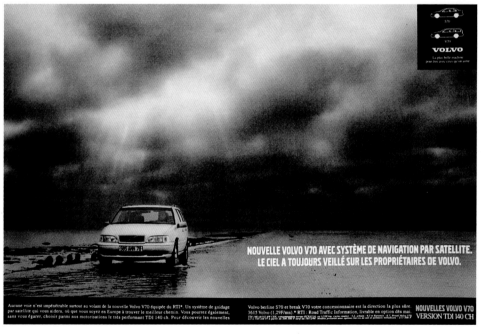

Pro Prize: Advertising Photography

Photographer:	Nadav Kander	**Photographer:**	Marc Gouby
Creative Director:	Graeme Norways	**Art Director:**	Yves Loffredo
Art Directors:	Jeff Ford	**Agency:**	Australie, Paris
	Graeme Norways	**Client:**	Volvo
	Gary Sollof		
Agency:	Bean Andrews		
	Norways Cramphorn,		
	London		
Client:	The Body Shop		

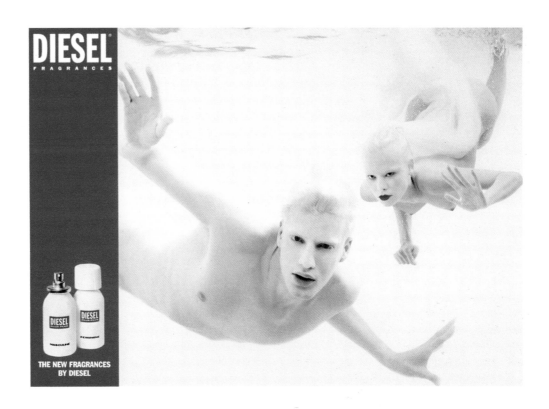

Louis Vuitton. Writing.

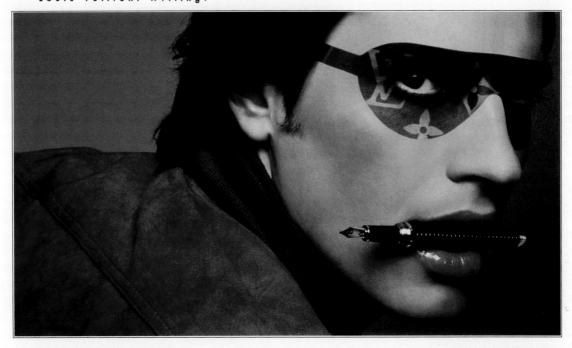

Louis Vuitton luggage and accessories are available only in exclusive Louis Vuitton shops.
Paris · Monaco · Tokyo · New York · Los Angeles · Hong Kong ·
Beijing · London · Rome · Milan · Munich · Düsseldorf · Geneva · Zurich · Sydney.

LOUIS VUITTON

Photographer:	Karina Taira	**Photographers:**	Inez van Lamsweerdere
Creative Director:	Alexander Pickl		Vinoodh Matadin
Art Director:	Alexander Pickl	**Creative Directors:**	Pascal Gregoire
Agency:	Pickl Advertising		Maurice Betite
	Agency, Munich	**Art Director:**	Maurice Betite
Client:	Diesel Plus Plus	**Agency:**	Euro RSCG Gregoire
	Fragrances		Blachere Huard
			Roussel, Paris
		Client:	Louis Vuitton

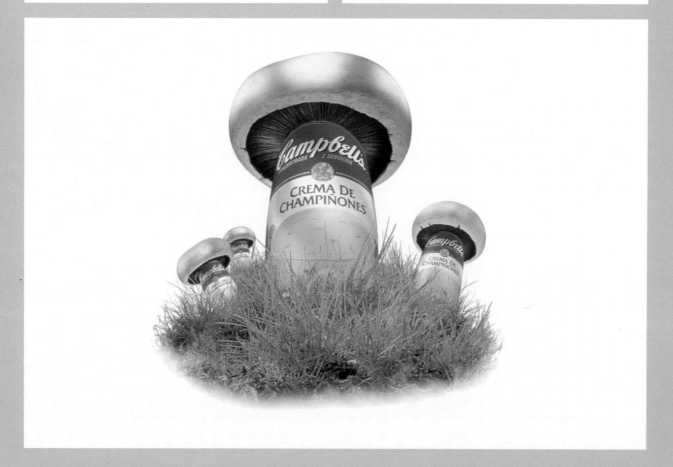

Agency:	Saatchi & Saatchi Advertising, Madrid
Creative Directors:	Antonio Lopez
	Tito Lopez
Art Director:	Soni de Vega
Photographer:	Joseph Martinez
Client:	Campbell's Soups

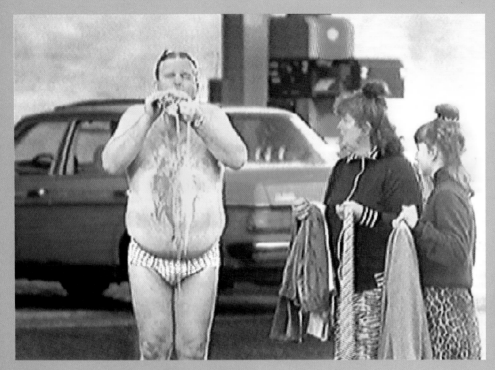

Problemer?

Burger-Wasa

wasa.
Lett å leve med

 Food 29

Agency:	JBR McCann, Oslo
Creative Director:	Kjetil Try
Copywriter:	Kjetil Try
Art Director:	Einar Fjoesne
Production:	JBR Film
Director:	Erik Poppe
Producer:	Torleif Hauge
Client:	Ideal Wasa Crispbread, "Burger Wasa"

A fast food customer witnesses, with trepidation, the special techniques that others adopt to protect themselves from the generous helpings of ketchup and mustard that pour out of their hamburgers. A Wasa Crispbread burger would solve these problems.

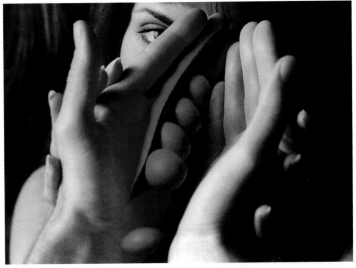

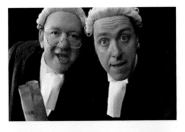

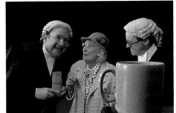

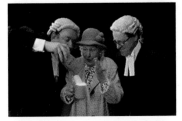

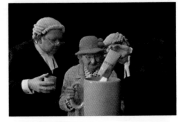

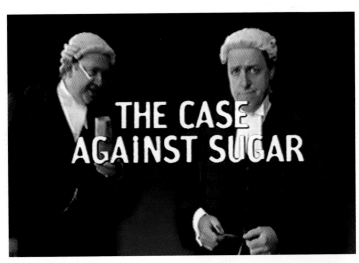

Agency:	Tamir Cohen (Jacobsohn), Tel Aviv
Creative Director:	Rony Cohen
Copywriters:	Orit Ringel
	Anita Rave
Art Director:	Jaacov Turgeman
Production:	Roll Communication
Director:	Yariv Gaver
Producers:	Israel Ringel
	Ido Zukerman
	Anat Oz
Client:	Tivall Frozen Vegetables, "The Way to Eat"

Images of Tivall vegetables are superimposed over scenes of everyday life. They blend into the actors' bodies to make the point that Tivall is second nature for people who care about fitness, health and emotional well-being.

Agency:	Ammirati Puris Lintas, Copenhagen
Creative Director:	Carsten Kaag
Copywriter:	Carsten Kaag
Art Director:	Carsten Kaag
Production:	Talk Back Productions
Director:	Griff Rhys Jones
Producers:	Anita Staines
	Frank Thomsen
Client:	Danisco Sugar

Mel Smith and Griff Rhys Jones argue the case against sugar. Smith calls an old lady as a witness and kindly offers her a cup of tea, he then proceeds to empty an entire bag of sugar into it to make his point. Not to be outdone, Jones, for the defense, pours the same amount of sugar into an oversized mug, arguing that everything is a matter of proportion. The witness is delighted and Smith, realising that he's been outsmarted, demands a retrial.

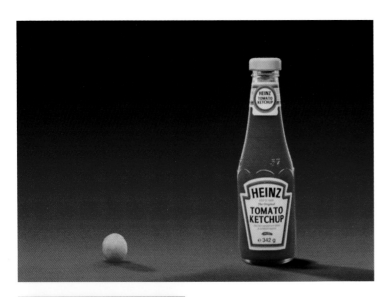

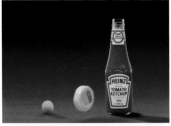

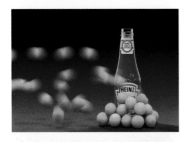

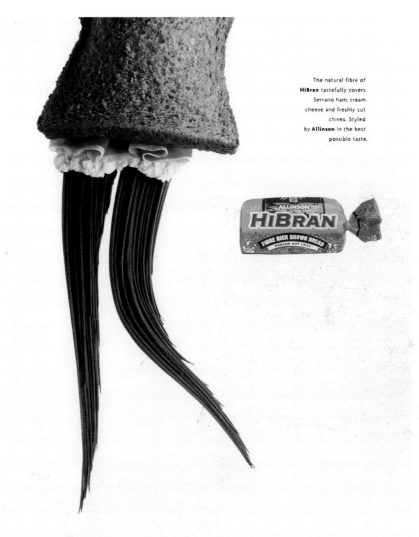

The natural fibre of
HiBran tastefully covers
Serrano ham, cream
cheese and freshly cut
chives. Styled
by **Allinson** in the best
possible taste.

Agency:	Mark/BBDO, Prague	One of three commercials that marked	**Agency:**	Publicis, London
Creative Director:	Martin Holub	the return of Heinz ketchup to the Czech	**Creative Director:**	Gerry Moira
Copywriters:	David Brada	market. Potatoes and other foods are so	**Copywriter:**	Tago Byers
	Martin Holub	eager for Heinz that they are drawn to the	**Art Director:**	Fernando Sobrón
Art Directors:	Vladimira Feyrerová	product as if by magnetic attraction. "Can	**Photographer:**	Graham Ford
	Jiri Kubík	your ketchup do this?" asks the advertiser.	**Client:**	Hi-Bran Bread
Production:	Art & Mo			
Director:	Jirí Tyller			
Producers:	Katerina Slampová			
	Ondrej Hanicinec			
Client:	Heinz Ketchup,			
	"Scout"			

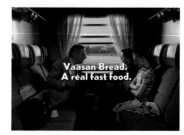

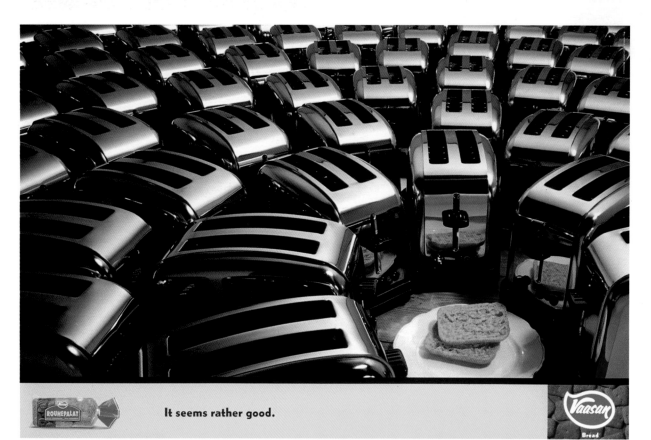

It seems rather good.

Agency:	Paltemaa Huttunen Santala TBWA, Helsinki	A man prepares to eat two slices of Vaasan bread while a pair of boys, sharing the
Copywriter:	Markku Rönkkö	same compartment, look on with envy.
Art Director:	Unto Paltemaa	Their train passes through a dark tunnel
Production:	Oh-la-la Filmproduktion, Stockholm	with a predictable result: the bread disappears. The two boys maintain an air of innocence, munching surreptitiously
Director:	Olavi Häkkinen	whenever the opportunity arises, while
Producers:	Niclas Peyron Marja Vattulainen	the confused gentleman searches high and low for his lunch. "Vaasan bread,
Client:	Vaasan Bread, "The Tunnel"	a real fast food."

Agency:	Paltemaa Huttunen Santala TBWA, Helsinki
Copywriter:	Markku Rönkkö
Art Director:	Jyrki Reinikka
Client:	Vaasan Bread

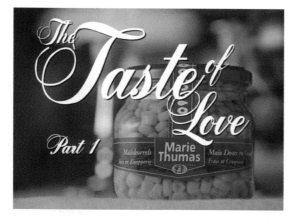

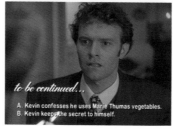

to be continued…

A. Kevin confesses he uses Marie Thumas vegetables.
B. Kevin keeps the secret to himself.

Call us.

0900/00250

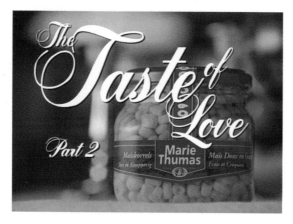

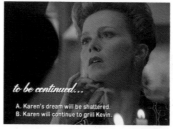

to be continued…

A. Karen's dream will be shattered.
B. Karen will continue to grill Kevin.

Call us.

0900/00250

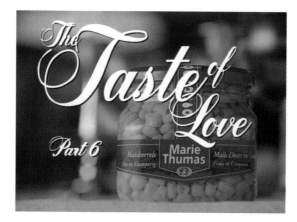

Marie Thumas

The End

Agency: Saatchi & Saatchi
 Belgium, Zaventem
Creative Director: Danny Pauwels
Copywriter: Grégory Ginterdaele
Art Director: Marie Laure
 Cliqeunnois
Production: Cin & Art, Brussels
Director: Derek Coutts
Producers: Gerda Coppens
 Brenda Keirsebilck
Client: Marie Thumas
 Vegetables,
 "A Taste of Love"

Karen desperately tries to discover the secret of Kevin's sweetcorn soufflé in a soap opera with six episodes. Viewers are given two options at the end of each commercial and their votes determine the following week's sequel. In the last episode Kevin finally admits that Marie Thumas is his secret, and the couple are united with a declaration of undying love.

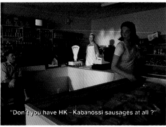
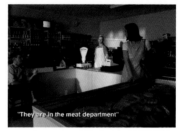

"Don't you have HK – Kabanossi sausages at all ?"

"They are in the meat department"

Best seller.

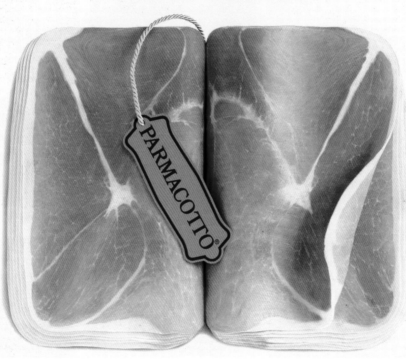

Prefazione:
quando si parla di
prosciutto cotto si parla
di Parmacotto.
Perche' ogni fetta
ha una storia
da raccontare.

Capitolo 1:
Parmacotto ricerca
le migliori materie
prime e la carne
di maiale selezionata.

Capitolo 2:
Parmacotto ha qualcosa
in piu' proprio perche'
non ha i polifosfati
e le proteine della soia.

Capitolo 3:
Parmacotto ti conquista
non solo per il gusto,
ma anche per il prezzo.

Capitolo 4:
Parmacotto rispetta
le nuove esigenze
di una cucina attenta
tanto al gusto quanto
alla leggerezza.

Epilogo:
non rinunciare mai
alla qualita'
e alla genuinita'
del prodotto.
Chiedi Parmacotto.

Agency:	Paltemaa Huttunen Santala TBWA, Helsinki
Copywriter:	Petri Uusitalo
Art Director:	Jyrki Reinikka
Production:	Elohopea-filmi, Helsinki
Director:	Olli Rönkä
Producers:	Ville Varesvuo, Leena Silfverbeg
Client:	HK Sausages, "Meat Department"

A shopper looks unsuccessfully for her favourite brand in a large freezer full of sausages. Eventually she asks the disinterested sales staff if they really have no HK sausages, only to be told that they're over in the meat department.

Agency:	Armando Testa, Turin
Photographer:	Nino Mascardi
Client:	Parmacotto Ham

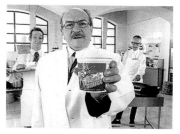

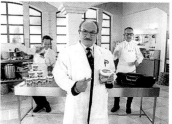

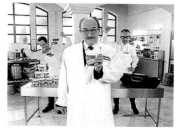
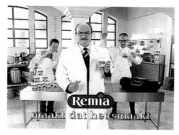

Food 35

Agency:	Lowe Kuiper & Schouten, Amsterdam	**Agency:**	Månson Reklambyrå, Stockholm
Creative Directors:	Aad Kuijper Pieter van Velsen	**Creative Director:**	Johan Månson
Copywriter:	Aad Kuijper	**Copywriter:**	Johan Månson
Art Director:	Pieter van Velsen	**Art Director:**	Jon Swahn
Production:	Ocean View	**Production:**	Jarowskij
Director:	Hans van Rijs	**Director:**	Magnus Wikman
Producers:	Clarisse Venekamp Peter Burger	**Producers:**	Dan Renneús Peter Bergendahl
Client:	Remia Freak Sauce	**Client:**	Dafgård, "Gorby's Pirogue"

A Remia spokesman proudly announces Freak Sauce, specially developed for American-style food. And because the product is mainly for young people, he continues, they've found some modern music to go with it. His assistants start dancing to the disco hit "Freak Out," by Le Chic, while the spokesman insists that the song even has the same name as the new product. Every time the refrain, "freak out," is heard he proudly points to the Freak Sauce label, delighted by this apparent coincidence.

A woman waits impatiently in a smart restaurant while her date is still at home trying on different outfits and checking his appearance in the mirror. Eventually she phones him to complain but, undeterred, he continues to preen himself and is just as happy to fix a Gorby's Pirogue in the microwave while admiring his reflection in a stainless steel toaster. "When you don't have time to eat dinner," recommends Dafgård.

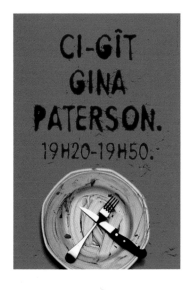

CI-GÎT
GINA
PATERSON.
19H20-19H50.

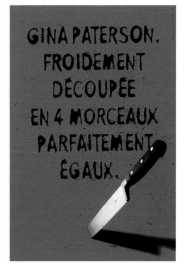

GINA PATERSON.
FROIDEMENT
DÉCOUPÉE
EN 4 MORCEAUX
PARFAITEMENT
ÉGAUX.

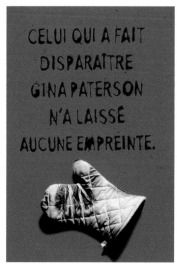

CELUI QUI A FAIT
DISPARAÎTRE
GINA PATERSON
N'A LAISSÉ
AUCUNE EMPREINTE.

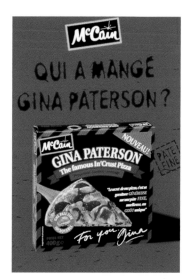

McCain

QUI A MANGÉ
GINA PATERSON ?

GINA PATERSON
The famous in'Crust Pizza

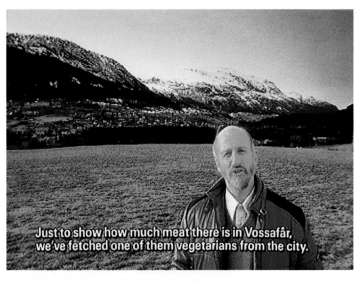

Just to show how much meat there is in Vossafår, we've fetched one of them vegetarians from the city.

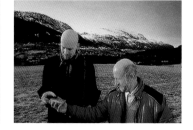

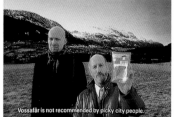

Vossafår is not recommended by picky city people.

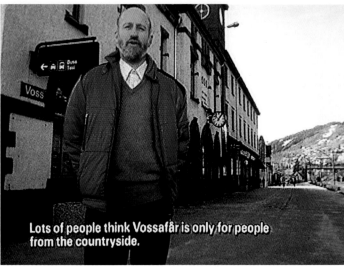

Lots of people think Vossafår is only for people from the countryside.

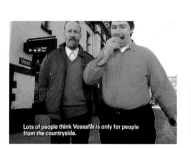

Lots of people think Vossafår is only for people from the countryside.

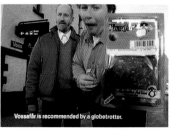

Vossafår is recommended by a globetrotter.

Agency:	BDDP, Paris	RIP Gina Paterson. 7:20 - 7:50 pm.	**Agency:**	Bates Camp, Oslo	Two commercials for Vossafår sausages
Creative Director:	Jean-Claude Jouis				
Copywriter:	Eric Helias	Gina Paterson: sliced into four perfectly			
Art Director:	Jeorges Carreno	equal parts in cold blood.			
Client:	McCain,				

Agency: BDDP, Paris
Creative Director: Jean-Claude Jouis
Copywriter: Eric Helias
Art Director: Jeorges Carreno
Client: McCain, Gina Paterson Frozen Pizza

RIP Gina Paterson. 7:20 - 7:50 pm.

Gina Paterson: sliced into four perfectly equal parts in cold blood.

Whoever put Gina Paterson away left no fingerprints.

Who ate Gina Paterson?

Agency: Bates Camp, Oslo
Copywriter: Bendik Romstad
Art Director: Anne Gravingen
Production: Kraftwerk Productions, Oslo
Director: Morten Tyldum
Producer: Knut Jensen
Client: Vossafår Meats, "Vegetarian" & "Globe-Trotter"

Two commercials for Vossafår sausages both playing on their rural origins and making fun of people from the city.
In the first spot the product is predictably rejected by an urban vegetarian. This is presented in a positive light, "Vossafår is not recommended by picky city people."
In the second film, the product is heartily endorsed by Ole, a local resident who has twice visited the city. Vossafår is therefore, "Recommended by a globe-trotter."

 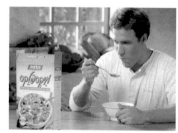

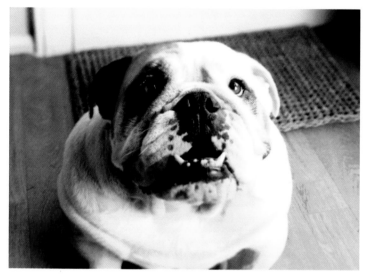 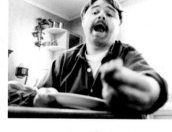

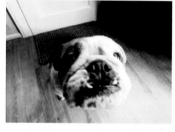 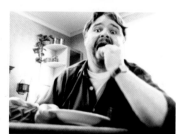

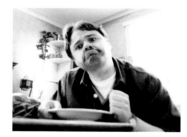 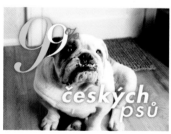

Agency:	Bates Bauman Ber Rivnay, Tel Aviv	A shower of breakfast cereal rains down into a bowl of milk to the accompaniment of the Beach Boys' song, "I get around." The dried fruit and flakes dance and bob in the milk as if choreographed by Busby Berkeley in a "celebration of taste and health."	
Creative Directors:	Shony Rivnay Micky Ber		
Copywriter:	Shuly Glanz		
Art Director:	Shony Rivnay		
Production:	Kaitz Productions		
Director:	Gabi Biblyovitz		
Producers:	Shlomo Orbach Dorit Rabinovitz		
Client:	Tami Mixflakes		

Agency:	Leo Burnett, Prague	A salivating bulldog waits in hope while his master mops up the last of his soup with a piece of bread. The man tempts the dog briefly before finishing off his meal, thereby underlining the fact that "99% of Czech dogs will never enjoy the taste of Vitana soups."	
Creative Director:	Cal Bruns		
Copywriter:	Martin Charvát		
Art Directors:	Cal Bruns Tony Oleksewycz		
Production:	Production Int'l		
Director:	Jorn Hagen		
Producers:	Lucien Tyssendier Karel Paulovsky Lubomír Procházka Vilém Rubés		
Client:	Vitana Standard Soups, "Dog"		

WILL YOU SWALLOW JUST ABOUT ANYTHING ?

With sugar, you get the real thing.

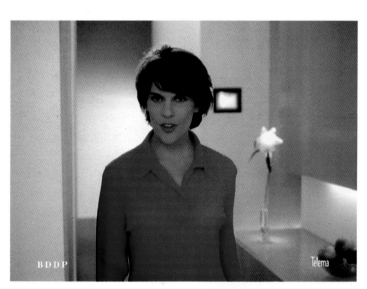

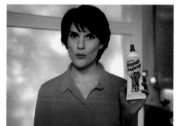

WILL YOU SWALLOW JUST ABOUT ANYTHING ?

With sugar, you get the real thing.

Agency:	BDDP, Paris	Two spoof commercials for imaginary
Creative Director:	Jean-Claude Jouis	products: Fast Oysters and Rapid
Copywriter:	Rémi Noel	Asparagus. Both give perfect results
Art Director:	Eric Holden	in minutes. "Will you swallow just about
Production:	Telema	anything?" asks the advertiser.
Director:	Etienne Chatilliez	"With sugar you get the real thing."
Producers:	Farid Chaouche	
	Evelyne Luverdis	
Client:	Cedus Sugar,	
	"Oysters" &	
	"Asparagus"	

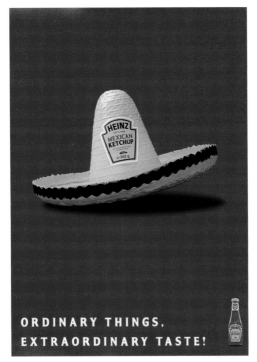

ORDINARY THINGS,
EXTRAORDINARY TASTE!

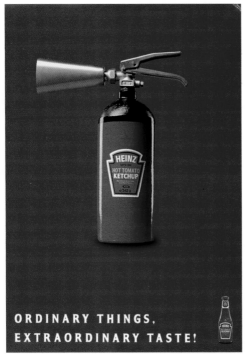

ORDINARY THINGS,
EXTRAORDINARY TASTE!

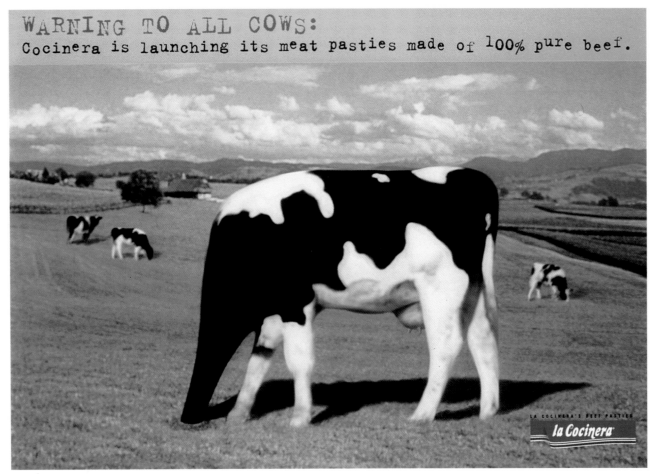

WARNING TO ALL COWS:
Cocinera is launching its meat pasties made of 100% pure beef.

la Cocinera

Agency:	Mark/BBDO, Prague	Agency:	Contrapunto, Madrid
Creative Director:	Martin Holub	Creative Director:	Antonio Montero
Copywriter:	David Brada	Copywriter:	Rosa Garcia
Art Directors:	Vladimira Feyrerová	Art Director:	Antonio Montero
	Jiri Kubík	Client:	La Cocinera Meat
Photographer:	Emil Bratrsovsky		Pasties
Client:	Heinz Ketchup		

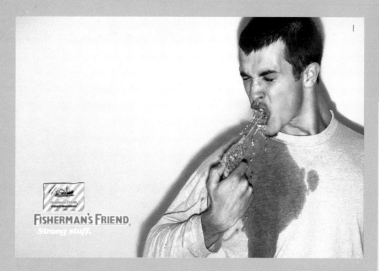

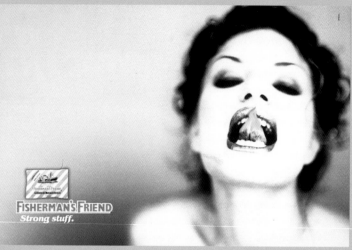

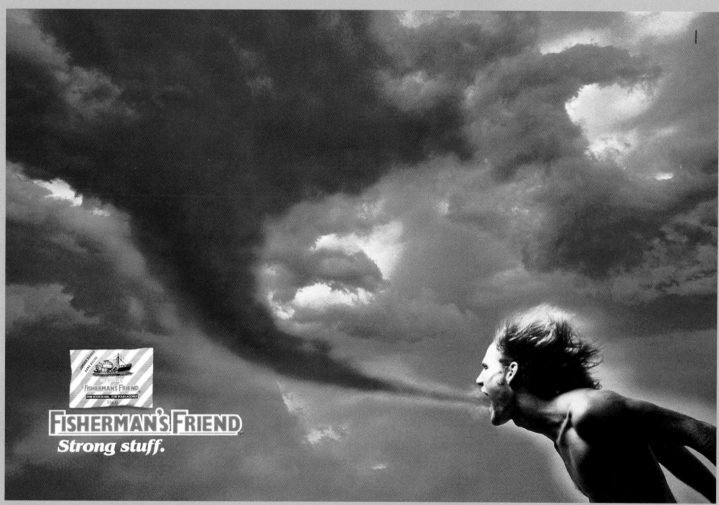

Agency:	LDV/Partners, Antwerp
Creative Director:	Werner Van Reck
Copywriters:	Werner Van Reck
	Paul Popelier
Art Directors:	Werner Van Reck
	Paul Popelier
Photographers:	Christian D'Hoir
	Jurgen Rogiers
Client:	Fisherman's Friend

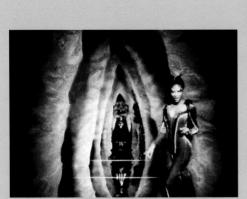

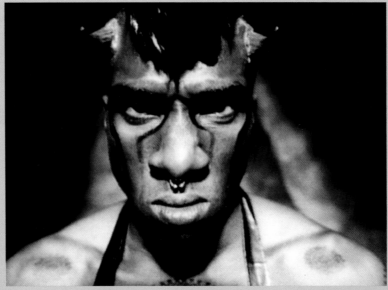

 Confectionery & Snacks 41

Agency:	J. Walter Thompson, Paris	A night club is full of animal people, each one representing the creature that best matches their own physical appearance and personality: monkeys, giraffes, rhinoceroses and exotic birds. The party is in full swing when the Lion man arrives. His roar silences the revellers and leaves a pretty panther trembling with anticipation.
Creative Director:	Francois Biehler	
Copywriter:	Raphael Hehn	
Art Director:	Patrick Jumeau	
Production:	Tony Kaye & Partners, London Wanda, Paris	
Director:	Erick Ifergan	
Producers:	Vanessa Vallette Patrick Barbier	
Client:	Lion Bar, "The Night Club"	

"Tell me you love me!"

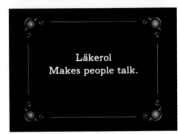

"............"

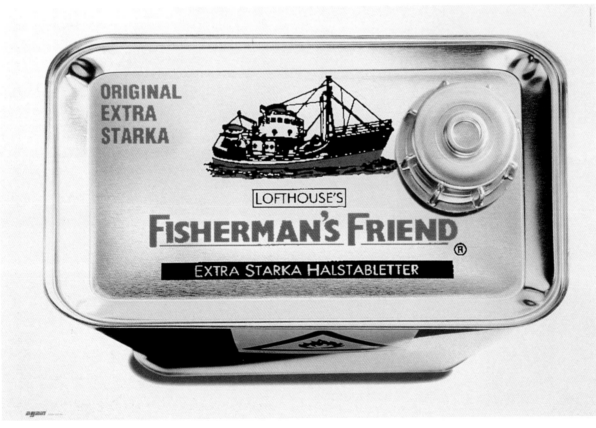

Läkerol
Makes people talk.

Agency:	Lowe Brindfors, Stockholm	The hero of a silent movie has returned from battle. His paramour wants to know if he still loves her but the unfortunate man has lost his voice. A Läkerol pastille solves the problem and the silent movie miraculously becomes a talkie. Fascinated by the sound of his own voice, our hero goes from strength to strength with his proclamations of love, giving support to the claim that, "Läkerol makes people talk."	**Agency:**	Jerlov & Company, Gothenburg
Copywriter:	Mikael Hjärtsjö		**Creative Director:**	Fredrik Jerlov
Art Director:	Mark Baughen		**Copywriter:**	Fredrik Jerlov
Production:	Moland Film		**Art Director:**	Madelene Wallström
Director:	Erik Gustavsson		**Photographer:**	Magnus Pajnert
Producers:	Carl Christian Hvoslef Mark Baughen		**Client:**	Fisherman's Friend
Client:	Läkerol Throat Lozenges, "Silent Movie"			

L'OBELISCO.

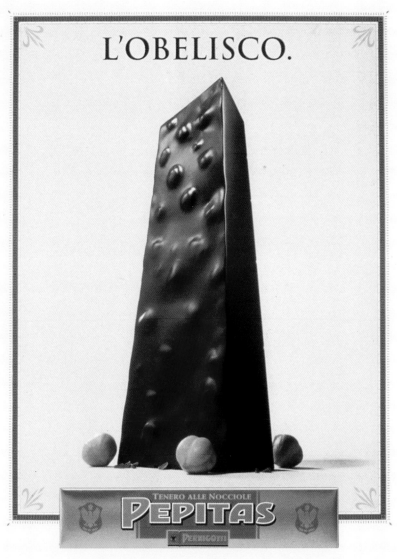

PEPITAS PERNIGOTTI A ROMA È UN CLASSICO.

IL CUPOLONE.

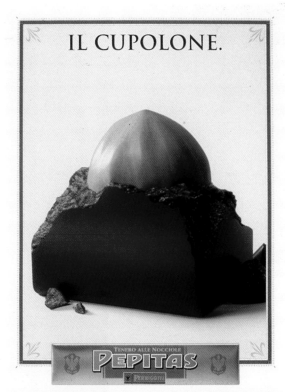

PEPITAS PERNIGOTTI A ROMA È UN CLASSICO.

L'ARCO DI TRIONFO.

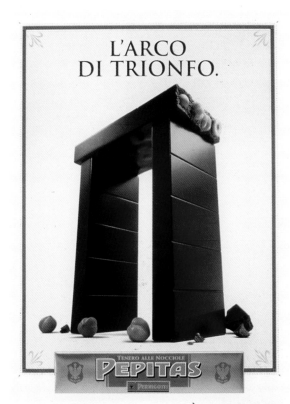

PEPITAS PERNIGOTTI A ROMA È UN CLASSICO.

Confectionery & Snacks **43**

Agency:	Saatchi & Saatchi Advertising, Milan
Creative Directors:	Guido Cornara
	Agostino Toscana
Copywriter:	Vincenzo Celli
Art Director:	Stefano Ginestroni
Photographer:	Raffaello Bra
Client:	Pepitas Pernigotti Chocolate Bars

Pepitas Pernigotti is a classic in Rome (the posters show well-known Roman monuments).

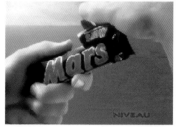

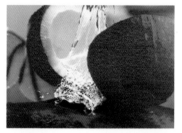
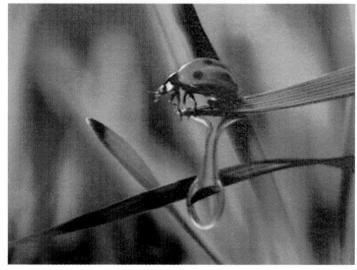
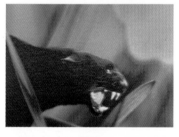

44 **Confectionery & Snacks**

Agency:	DMB&B, Paris	A man is playing a virtual reality game that
Creative Director:	Gerard Monot	consists of catching a beautiful woman.
Copywriter:	Hervé Bourdon	Upset by always losing her, he pauses
Art Director:	Christian Picard	by a virtual vending machine to purchase
Production:	Planète Spots	a virtual Mars bar. This reminds him of the
Director:	Barry Myers	authentic Mars taste, so he stops the game
Producer:	Guy Pechard	to enjoy real life, much to the disgust of
Client:	Mars Bar, "Cyber"	the woman he was pursuing.

Agency:	CLM/BBDO, Paris	A young girl relaxes in a city park and
Creative Director:	Anne de Maupeou	becomes fascinated by a ladybird and
Copywriter:	France Bizot	a droplet of water hanging from a blade
Art Director:	Capucine Chotard	of grass. She bites into a Bounty and
Production:	Première Heure	is carried away to a world of exotic
Director:	Tran Anh Hung	sensations: the bead of water is
Producers:	Pascale Petit	transformed into a coconut and the grass
	Erinn Lothe	becomes a jungle, rich with wildlife.
Client:	Bounty,	"You've just had a Bounty, you've tasted
	"The Bounty World"	the exotic."

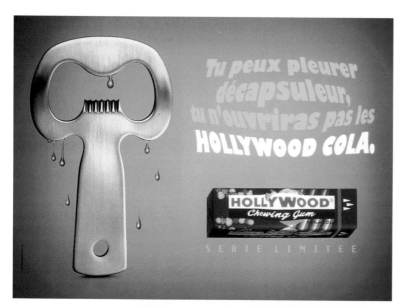

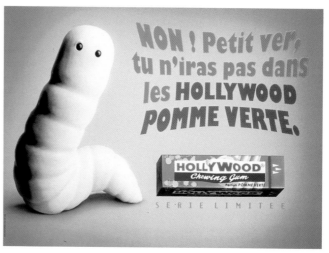

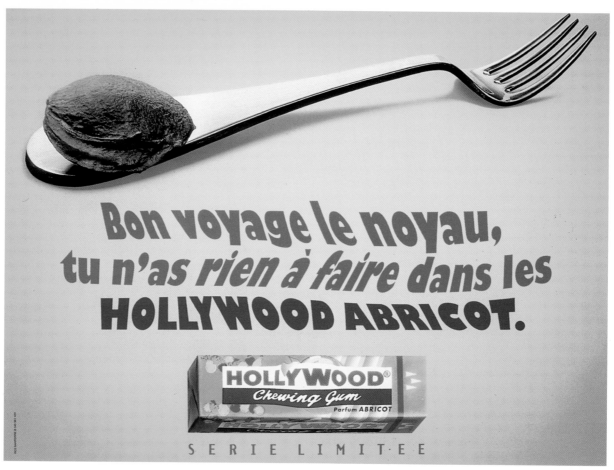

Agency:	Euro RSCG Babinet Erra Tong Cuong, Paris	No, little worm, you won't get into the Hollywood Green Apple.
Creative Director:	Rémi Babinet	
Copywriter:	Didier Barcelo	Cry as much as you want, bottle opener, you won't open the Hollywood Cola.
Art Director:	Jean-Christophe Saurel	
Photographer:	Blaise Arnold	Have a good trip, apricot stone, you have no reason to be in the Hollywood Apricots.
Client:	Hollywood Chewing Gum	

46 **Confectionery & Snacks**

Agency:	Euro RSCG Babinet Erra Tong Cuong, Paris	Three short commercials each consisting of five bizarre vignettes without sound: a hand comes out of the bottom of a man's trouser leg to scratch his ankle, a head emerges from a bowl of goulash soup, a caterpillar crawls up a man's face while he slaps the other cheek, another man rips off his beard with adhesive tape and so on. Each film closes on a male presenter holding up the product and shaking his head vigorously while we hear the distinctive rattle of the sweets in their small tin can. "Cachou Lajaunie. It's not strong, it's worse."
Creative Director:	Rémi Babinet	
Copywriter:	Valérie Chidlovski	
Art Director:	Agnès Cavard	
Production:	Les Télécréateurs	
Director:	Brian Baderman	
Producers:	Arnaud Moria Valérie Judek	
Client:	Cachou Lajaunie	

Croky à l'ancienne.
Alors forcément,
elle est un peu fripée.

Croky à l'ancienne.
Ça fait combien
en nouveaux francs?

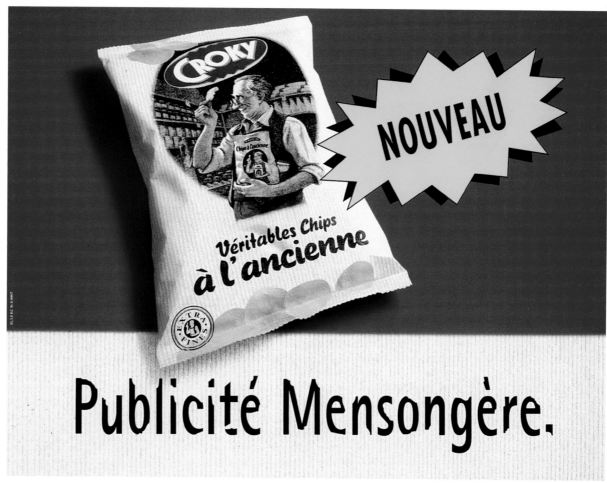

NOUVEAU

Publicité Mensongère.

Agency: BL/LB, Paris
Creative Director: Bruno Lacoste
Copywriter: Thierry Le Bec
Art Director: Bénédicte Potel
Photographer: Kay Mucke
Client: Old-Style Croky
 Potato Crisps
 (Croky à l'Ancienne)

Old-Style Croky. How much is that in
new francs?

Old-Style Croky. So, inevitably, it's a bit
wrinkled.

New. Real old style crisps. Misleading
advertising.

Add a touch of luxury to your everyday.

Add a touch of luxury to your everyday.

48 **Dairy Products**

Agency:	Paltemaa Huttunen Santala TBWA, Helsinki
Copywriter:	Markku Rönkkö
Art Director:	Anu Igoni
Photographer:	Jörgen Ahlström
Client:	Valio Classic Ice Cream

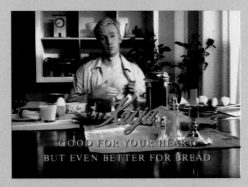

GOOD FOR YOUR HEART
BUT EVEN BETTER FOR BREAD

Agency:	Hasan & Partners, Helsinki	A man prepares breakfast for his girl-friend while she gets ready for the day. She does her hair and gets dressed while he squeezes fresh orange juice, boils eggs, and warms the rolls. His timing is perfect but the woman is running late and just blows him a kiss as she hurries out of the door. Feeling sorry for himself, the poor man dips his fingers into the margarine and gently massages his chest. "Good for your heart," claims Keiju, "but even better on bread."
Copywriter:	Timo Everi	
Art Director:	Esko Moilanen	
Production:	Oh-la-la Filmproduktion, Stockholm	
Director:	Pehr Seth	
Producer:	Niclas Peyron	
Client:	Keiju Margarine, "Breakfast for Two"	

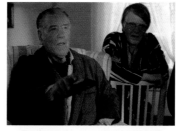

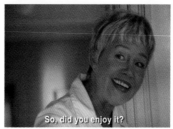

So, did you enjoy it?

Sun ice
Sun Ice-cream
- genuinely moving moments from Pietarsaari.

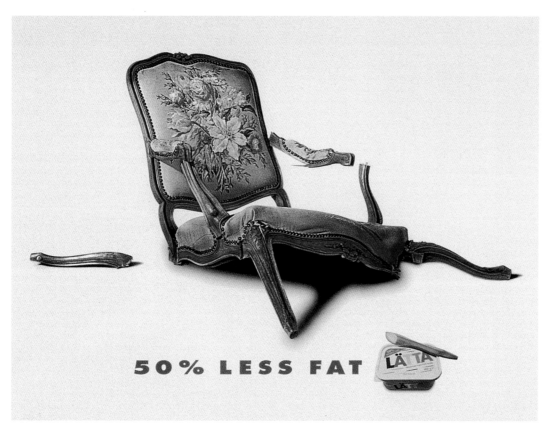

50% LESS FAT LÄTTA

Agency:	Kaisaniemen Dynamo, Helsinki	
Copywriters:	Johannes Savolainen	
	Helge Tallqvist	
	Vesa Kujala	
Art Director:	Johannes Savolainen	
Production:	Crea Filmi	
Directors:	Johannes Savolainen	
	Nick Lowelock	
Client:	Sun Ice Cream, "Old Boys"	

A group of old-age pensioners are secretly watching an X-rated film on TV. They quickly switch back to a sports programme when their nurse enters the room to offer them ice cream. But the old boys get distracted by its taste and are slow to change channels again when their nurse returns. "So, did you enjoy it?" she asks. "Yes, yes," they reply, unsure if she's referring to the ice cream or the movie.

Agency:	McCann-Erickson, Copenhagen
Creative Director:	Mads Rørstrøm
Copywriter:	Mads Rørstrøm
Art Director:	Soren Bitsh
Photographer:	Sten Larsen
Client:	Lätta Margarine

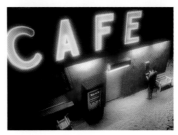
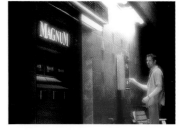

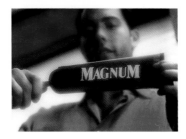

[a bad morning]

Agency:	Ammirati Puris Lintas, Milan	**Agency:**	Bates Backer, Oslo
Creative Directors:	Luca Maroni	**Copywriter:**	Aris Theophilakis
	Anna Montefusco	**Art Director:**	Thorbjørn Naug
Copywriters:	Marco Calaprice	**Photographer:**	Glenn Røkeberg
	Paolo Maccarini	**Client:**	Go' Morgen Yoghurt
Art Directors:	Antonio Cirenza		
	Michael Engelbrecht		
Production:	BRW & Partners		
Director:	Zack Snyder		
Producers:	Daniela Cattaneo		
	Dawn Yarbrough		
Client:	Magnum Ice Cream		

A couple are about to make love on the beach so the young man hurries off to a nearby condom dispenser. He's about to put his last coin in the slot when he notices a Magnum vending machine. Without thinking he chooses the ice cream bar, but quickly realises his mistake. Furious with himself, he hits his head against the condom machine and, miraculously, one pops out. "Life is all about priorities," concludes Magnum.

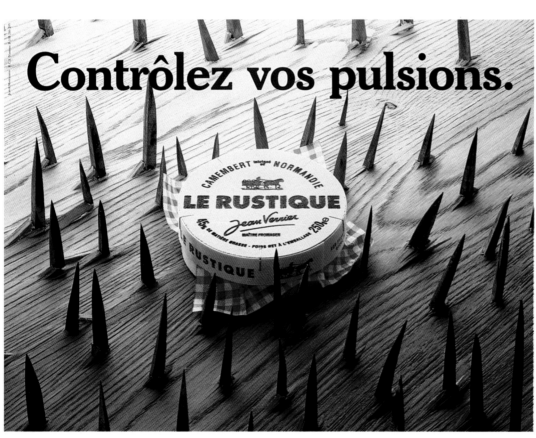

Contrôlez vos pulsions.

Agency:	Hasan & Partners, Helsinki	The tight-fisted old dairy farmer and his wife, continuing characters in the Arla campaign, have won a free vacation.
Copywriter:	Petri Pesonen	But it's not entirely free, he reminds her,
Art Director:	Jon Granström	because they had to pay for a lottery ticket
Production:	Studio 247, Stockholm	in the first place. He only accepts breakfast because it's included and
Director:	Roy Andersson	wangles a raspberry yoghurt from the
Producer:	Johan Carlson	hostess, pocketing the unwanted flavour,
Client:	Arla Yoghurt, "Charter Trip"	"for the cat." "Tastes for all kinds," is the theme of the spot.

Agency:	Jean & Montmarin, Paris	Control your impulses.
Creative Director:	Gérard Jean	
Copywriter:	Sidonie Jean	
Art Director:	Gérard Jean	
Photographer:	Jean Hoffner	
Client:	Le Rustique Camembert	

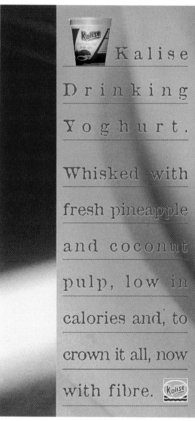

Kalise Drinking Yoghurt.

Whisked with fresh pineapple and coconut pulp, low in calories and, to crown it all, now with fibre.

Agency:	Forsman & Bodenfors, Gothenburg	A young girl auditions for a part and is delighted to be chosen for the role.	Agency:	Grupo Barro-Testa, Madrid
Copywriter:	Fredrik Jansson	She leaves her home in the country and	Creative Directors:	Urs Frick
Art Director:	Johan Eghammer	embarks on a hectic training programme		Uschi Henkes
Production:	Mod : Film, Stockholm	in the city. When the big day comes we		Manolo Moreno Marquez
Director:	Jhoan Camitz	discover her role: a dancing yoghurt pot	Copywriter:	Manolo Moreno Marquez
Producers:	Maria Tamander	in an Arla commercial.	Art Director:	Uschi Henkes
	Maria Bergkvist		Photographer:	Alfonso Zubiaga
Client:	Arla Yoggi		Client:	Kalise Liquid Yogurt,
	Delikatess Yoghurt,			"Suicide Spoon"
	"A Star is Born"			

Disguise yourself.

Another Scottish legend.

The Fountain of Youth.

Till sunrise.

With water.

Cheers.

Agency: Young & Rubicam, Madrid
Creative Director: Miguel Angel Laborda
Copywriter: Anselmo Ramos
Art Director: Cassio Moron
Photographer: Iñaki Preisler
Client: J & B Scotch Whisky

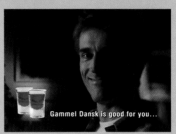

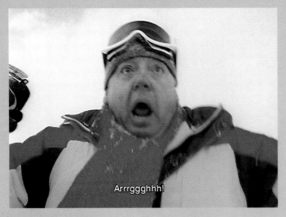

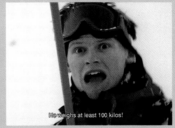

Agency:	Lowe & Partners, Copenhagen	
Creative Director:	Hans-Henrik Langevad	
Copy Writer:	Hans-Henrik Langevad	
Art Director:	Hans-Henrik Langevad	
Production:	Lowe & Partners Production	
Director:	Aake Sandgren	
Producer:	Gitte Sørensen	
Client:	Gammel Dansk Bitter, "Late at Night" & "On the Ski Slope"	

The Gammel Dansk Language School teaches viewers what Danes really mean by way of a voice-off that interprets a seemingly innocent domestic conversation. The man who tells his partner that he's going to bed is really inviting her to join him, while her interest in reading is interpreted as a polite refusal. Only when he pours himself a Gammel Dansk nightcap does the proposition become more attractive and the woman decides that, in fact, she's tired too.

A second lesson from the Gammel Dansk Language School takes place on the ski slope. An inept skier deliberately crashes into another as a pretext to drink Gammel Dansk. They then target an attractive woman for the same treatment.

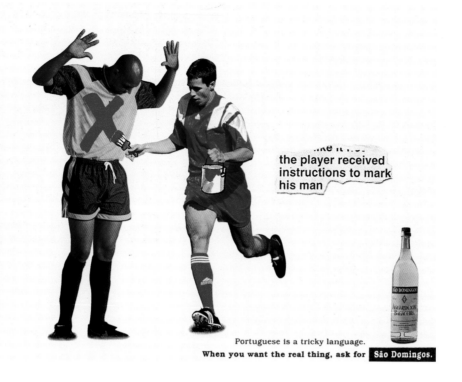

the player received
instructions to mark
his man

Portuguese is a tricky language.
When you want the real thing, ask for São Domingos.

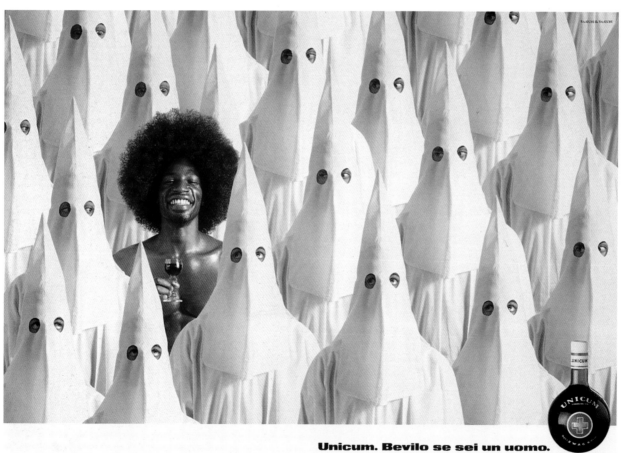

Unicum. Bevilo se sei un uomo.

Agency:	BBDO Portugal, Lisbon	Unicum. You've got to be a man to drink it.
Creative Director:	Jorge Teixeira	
Copywriter:	Vasco Condessa	
Art Director:	Marco Dias	
Client:	São Domingos	

Agency:	Saatchi & Saatchi Advertising, Milan
Creative Directors:	Guido Cornara
	Agostino Toscana
Copywriter:	Stefano Campora
Art Director:	Agostino Toscana
Photographer:	Antonio Capa
Client:	Unicum Liqueur

Agency:	Delvico Bates, Madrid
Creative Directors:	Pedro Soler
	Enrique Astuy
Copywriter:	Nacho Santos
Art Director:	Angel Villalba
Photographer:	Luis Dominguez
Client:	Cutty Sark Scotch Whisky

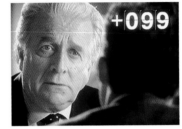

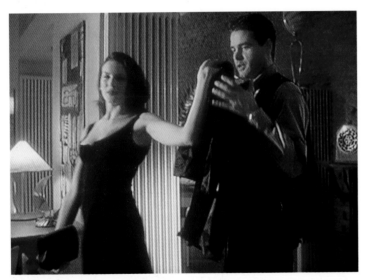

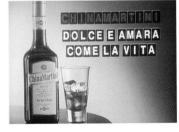

58　　**Alcoholic Drinks A**

Agency:	Armando Testa, Turin
Creative Director:	Mauro Mortaroli
Copywriter:	Nicola Morello
Art Director:	Claudio Antonaci
Production:	Filmgo, Milan
Director:	Simon Delaney
Producer:	Adriana Tosti
Client:	China Martini, "Restaurant" & "Apartment"

A young man and his employer meet by chance in a restaurant. "On a scale from 0 to 100, what chance does this man have of impressing his boss?" asks the voice-off. The young man's points clock-up on the screen like in a TV quiz show and his suggestion of a China Martini aperitif quickly brings his score up to 99. Unfortunately, the boss's attractive young wife then joins the two men and is mistaken for his daughter by the over-confident employee. This gaffe sends his score crashing down to -700.

A second commercial on the same theme takes place in a young man's apartment. This time seduction is the objective and the man's choice of music and his China Martini again quickly brings his score up to 99 points. But all is lost when the woman notices his short white socks. "Bitter and sweet, just like life," that's China Martini.

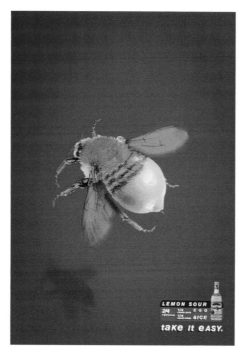

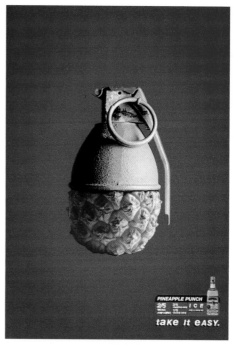

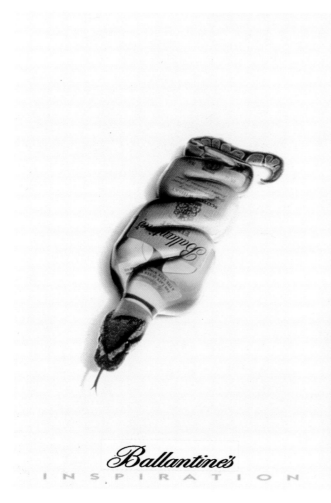

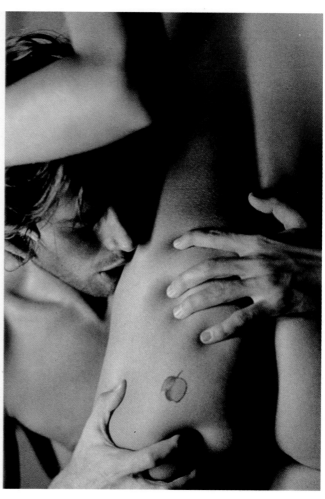

Agency:	Vinizius/Young & Rubicam, Barcelona	**Agency:**	Publicis, Madrid
Creative Directors:	Xavi Moreno Rafa Blasco	**Creative Directors:**	Paco Segovia David R. Vega
Copywriter:	Joan Finger	**Copywriter:**	Nines Montero
Art Directors:	Jordi Almuni Quim Ribes	**Art Directors:**	David R. Vega Carmelo Solar
Photographer:	David Levin	**Client:**	Ballantine's Scotch Whisky
Client:	Jose Cuervo Tequila		

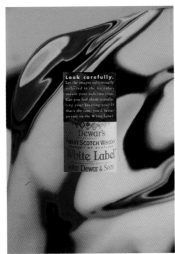

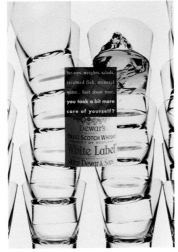

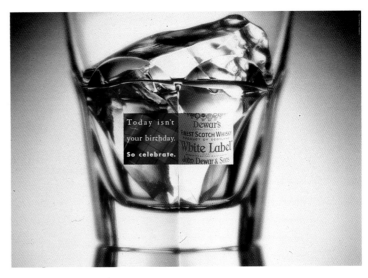

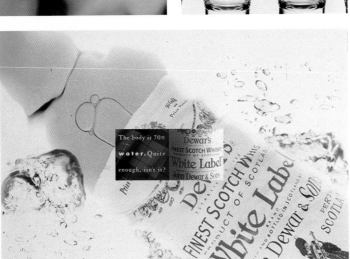

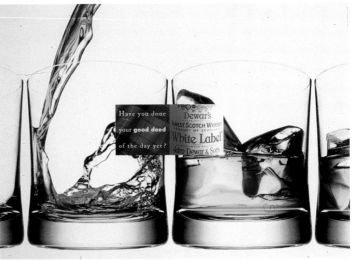

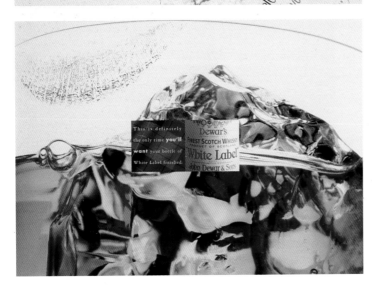

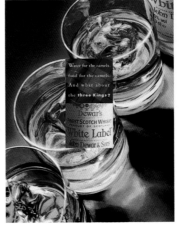

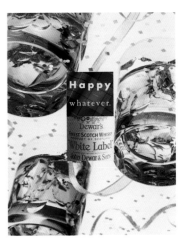

Agency:	Casadevall Pedreño & PRG, Barcelona	Copywriters:	Jose Maria Piera Carlos Holemans
Creative Directors:	Jose Maria Piera		Pablo Rey
	Carlos Holemans		Pepino García
	Pablo Rey		G. Hernandez
	Pepino García	Photographers:	Shu Akashi
Art Directors:	Pepino García		Rafael Jover
	Fernando Planelles	Client:	Dewar's Whisky

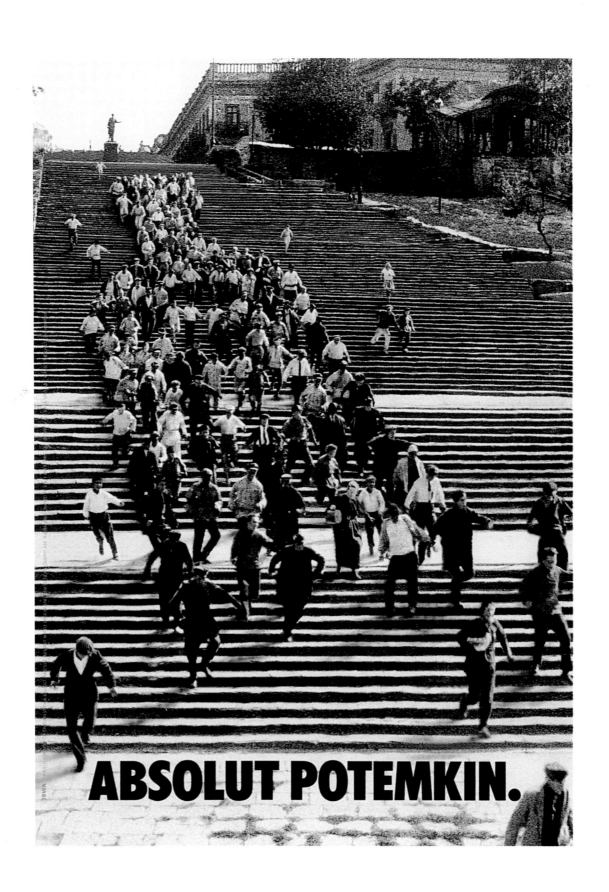

ABSOLUT POTEMKIN.

Agency:	TBWA, Paris
Creative Directors:	Christophe Coffre
	Nicolas Taubes
Copywriter:	Axel Orliac
Art Director:	Laurent Dravet
Client:	Absolut Vodka

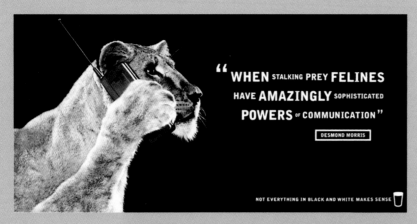

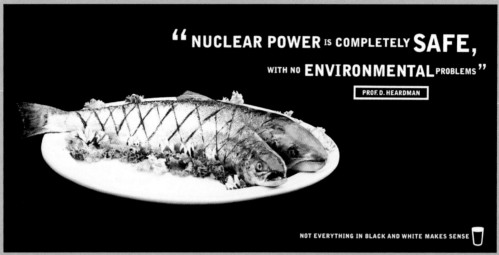

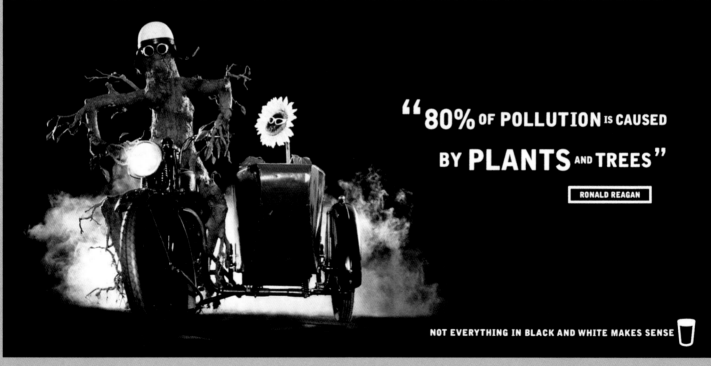

62 Alcoholic Drinks B

Agency:	Ogilvy & Mather, London
Creative Directors:	Clive Yaxley
	Jerry Gallaher
Copywriter:	Adam Denton
Art Director:	Andy Fairless
Photographer:	Andy Green
Client:	Guinness Stout

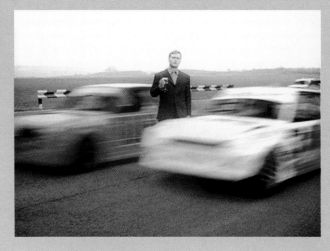

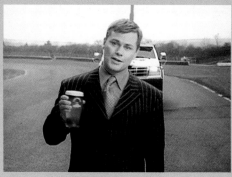

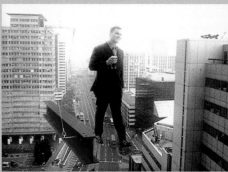

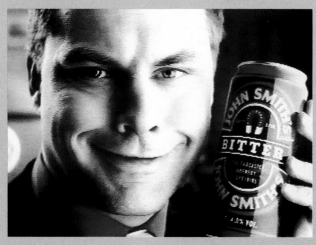

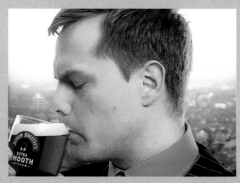

Agency:	BDDP GGT, London
Creative Director:	Trevor Beattie
Copywriters:	Robert Saville
	Alan Moseley
Art Directors:	Jay Pond-Jones
	Graham Cappi
Production:	Limelight
Director:	Daniel Kleinman
Producer:	Diane Croll
Client:	John Smith's Beer,
	"Jeopardy" & "Smile"

Jack Dee, the well-known spokesman for John Smith's, describes his ongoing battle with admen for a simple, no gimmicks, creative approach for the brand with just him, and the beer, in a pub. This time he believes he's got his way, but he's unaware of the death-defying special effects that have been added after the shoot that leave him on a metal girder high above London. At the end of the film Jack steps off into thin air, content in the knowledge that the pub will be added in post-production.

In a second John Smith's commercial Jack Dee explains how admen keep telling him that a smile always sells, but the one he produces is unlikely to have the desired effect.

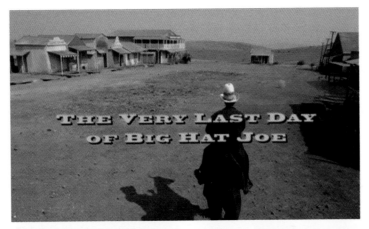

THE VERY LAST DAY OF BIG HAT JOE

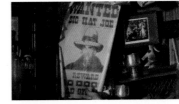

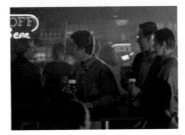

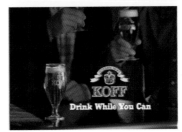

KOFF
Drink While You Can

64 Alcoholic Drinks B

Agency:	Hasan & Partners, Helsinki
Copywriter:	Timo Everi
Art Director:	Esko Moilanen
Production:	Oh-la-la Filmproduktion, Stockholm
Director:	Olavi Häkkinen
Producer:	Niclas Peyron
Client:	Koff Beer, "Big Hat Joe" & "Home Sweet Home"

Big Hat Joe comes to town and patrons of the local saloon quickly evacuate the premises. Joe tosses his famous hat onto a peg and orders a beer. Meanwhile, a last remaining customer comes out of the toilet, unaware of what's going on, and inadvertently takes Joe's big hat instead of his own. As soon as the poor man steps out onto the street he's mown down by the local townsfolk. Joe continues to enjoy his beer while Koff advises viewers to, "Drink while you can."

A young father gets up in the middle of the night to take care of his children and thinks back nostalgically to his bachelor days: drinking beer with his friends and chasing women. "Drink while you can," is again the message.

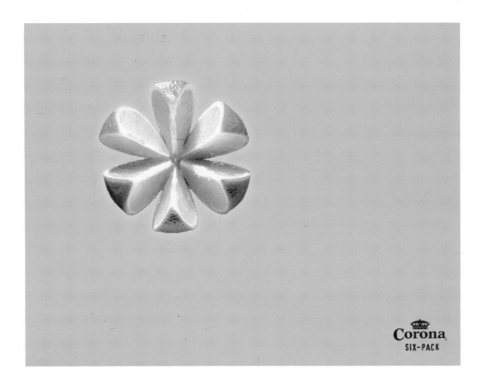

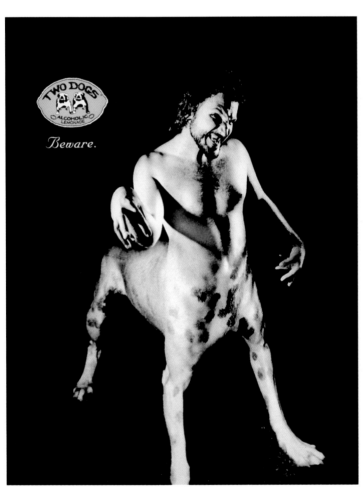

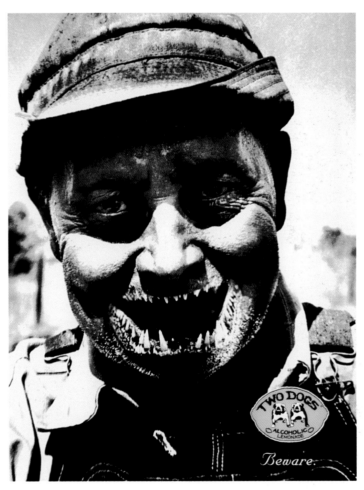

Agency:	B.S.U.R., Amsterdam	**Agency:**	Garbergs International, Amsterdam
Creative Directors:	Hjarald Agnes Joost Perik	**Creative Director:**	Paul Falla
Copywriter:	Huub Lensvelt	**Copywriters:**	Dennis Zijlstra Paul Falla
Art Director:	Bas Moreu	**Art Directors:**	Remco Bos Mark Aink
Photographer:	Hans Pieterse	**Photographer:**	J.K. Potter
Client:	Corona Beer	**Client:**	Two Dogs Alcoholic Lemonade

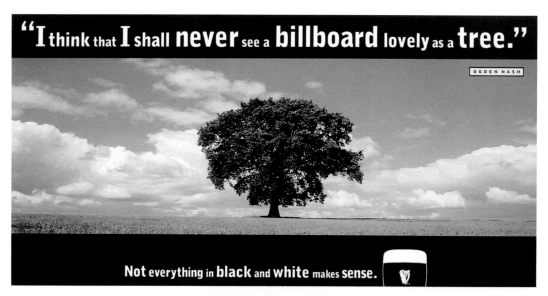

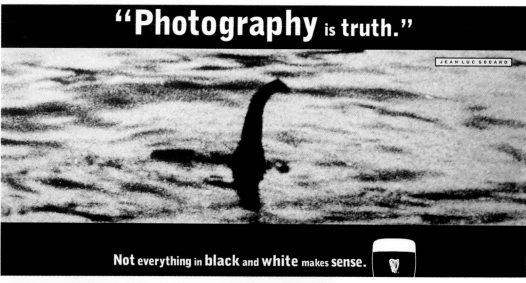

66 Alcoholic Drinks B

Agency:	Bell Advertising, Dublin
Creative Directors:	Martin Wright
	Christan Monge
Copywriters:	Michael Powell
	Justin Hooper
Art Directors:	Martin Wright
	Christian Cotterall
Photographer:	Dave Campbell
Client:	Guinness Stout

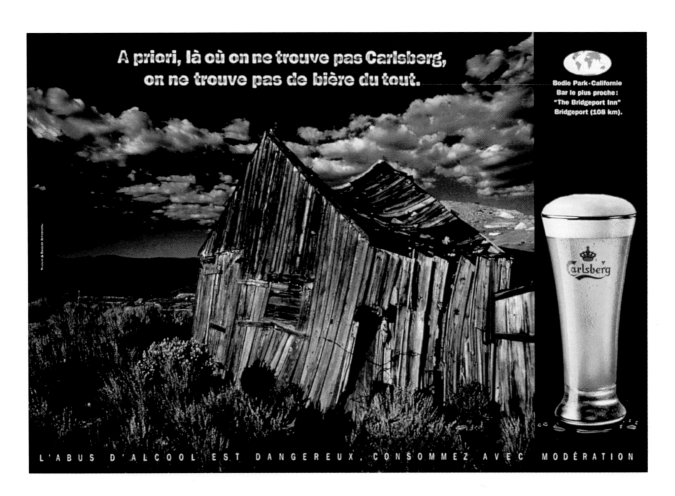

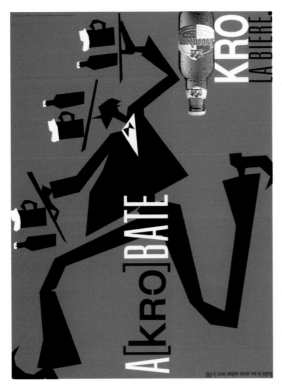 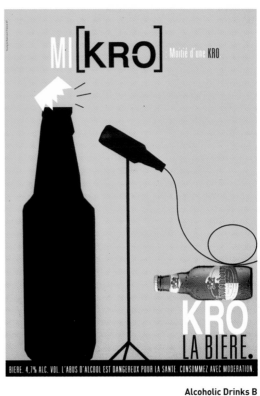

Agency:	Saatchi & Saatchi Advertising, Paris	Where Carlsberg can't be found, no beer can be found. Boddle Park, California. Nearest bar, Bridgeport Inn (100 kms).	**Agency:**	Young & Rubicam, Paris
Creative Director:	Gilles Soulier		**Creative Director:**	Bruno Le Moult
Copywriter:	Edgard Montjean		**Copywriter:**	Carole Greep
Art Director:	Bertrand Pallatin		**Art Director:**	Christelle Raynal
Photographers:	Russel Porcas Chris Frazer Smith		**Illustrator:**	Thierry Aubert
Client:	Carlsberg Beer		**Client:**	Kronenbourg Kro Beer

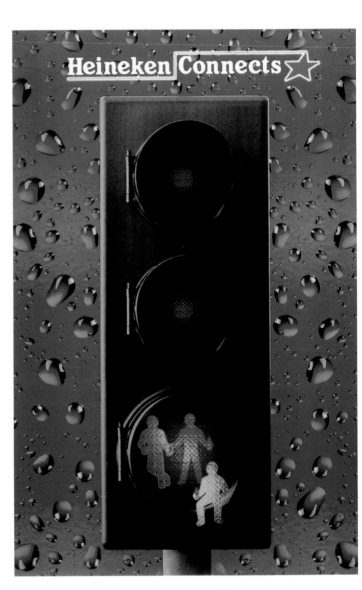

Agency:	Publicis, London	
Creative Director:	Gerry Moira	
Copywriter:	Paul Quarry	
Art Director:	Jamie Colonna	
Production:	Cowboy Films	
Director:	Mark Storey	
Producers:	Georgina Lowe	
	Caroline Black	
Client:	Harp Beer, "Jig"	

Patrons in an English pub enjoy the new Harp beer from Ireland. Its 4.3% alcohol effect is immediate: everybody starts doing an Irish jig from the waist down, while the upper parts of their bodies continue with their normal pub activities. This gives added meaning to the question one man poses to his friend, "So, what's your other half doing tonight?"

Agency:	DDFH&B Advertising, Dublin
Creative Director:	Ronnie Trouton
Copywriter:	John Philips
Art Director:	Michael Creagh
Client:	Heineken Lager

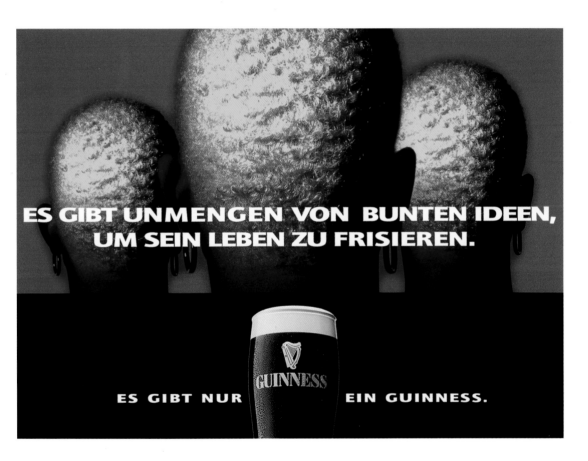

ES GIBT UNMENGEN VON BUNTEN IDEEN, UM SEIN LEBEN ZU FRISIEREN.

ES GIBT NUR GUINNESS EIN GUINNESS.

Agency:	Rönnberg McCann, Stockholm	
Copywriter:	Bo Rönnberg	
Art Director:	Dan Fredriksson	
Production:	Jarowskij	
Director:	Johan Rheborg	
Producer:	Mary Lee Copeland	
Client:	Spendrups Beer, "Sauna"	

The occupants of a sauna are desperate for a beer, served preferably by an attractive barmaid, but all they have is fruit juice. They imagine a beer-laden boat approaching their island and, miraculously, this turns out to be true. Unfortunately, the mean-spirited skipper has no intention of sharing his cargo until the boat runs aground and the thirsty gentlemen rush naked into the water. The morale of the tale is, "Never, never forget Spendrups".

Agency:	Fröhling Werbeagentur, Düsseldorf
Creative Director:	Andreas Beckmann
Copywriter:	Lennart Niermann
Art Directors:	Andreas Beckmann Frank Weichelt
Photographer:	Christopher Thomas
Client:	Guinness Stout

There are many colourful ways to tune up one's life.

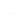

 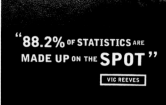

 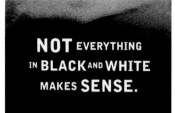

 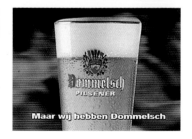

Agency:	Ogilvy & Mather, London	
Creative Directors:	Clive Yaxley	
	Jerry Gallaher	
Copywriter:	Jerry Gallaher	
Art Director:	Clive Yaxley	
Production:	Gorgeous	
Director:	Chris Palmer	
Producers:	Tim Marshall	
	John Montgomery	
Client:	Guinness Stout, "Statistics"	

The commercial presents a series of obscure, but believable, statistics about strippers, cows passing wind, Manchester United supporters, clowns and men thinking about sex (every 6 seconds). The truth of these statements is then questioned by a Vic Reeves quote, "88.2% of statistics are made up on the spot," thereby making the point that not everything in black & white makes sense. Or does it, we wonder, as an image of a half-naked woman flashes subliminally on the screen 6 seconds into the pack-shot.

Agency:	Lowe Kuiper & Schouten, Amsterdam
Creative Directors:	Aad Kuijper
	Pieter van Velsen
Copywriter:	Aad Kuijper
Art Director:	Pieter van Velsen
Production:	Czar Films
Director:	Matthijs van Heijningen Jr.
Producers:	Esther Hielkert
	Peter Burger
Client:	Dommelsch Beer

A hypnotist demonstrates his talents on six subjects in a crowded auditorium. Under his spell they lick their lips as they imagine eating a juicy pear and wince when told its become a sour lemon. Finally, he lets his subjects drink an imaginary beer before bringing them out of their trance with a snap of his fingers. Unfortunately, two male participants, dreaming of Dommelsch, continue to enjoy their beers and are oblivious to the hypnotist's frantic attempts to wake them up.

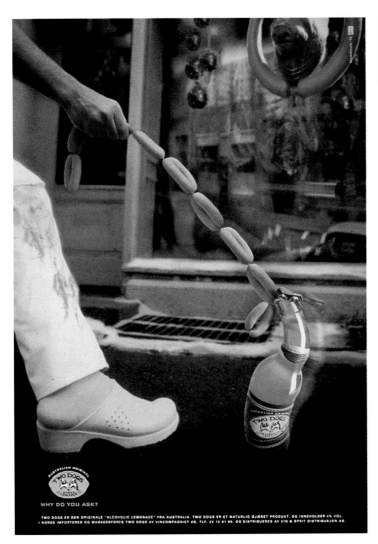

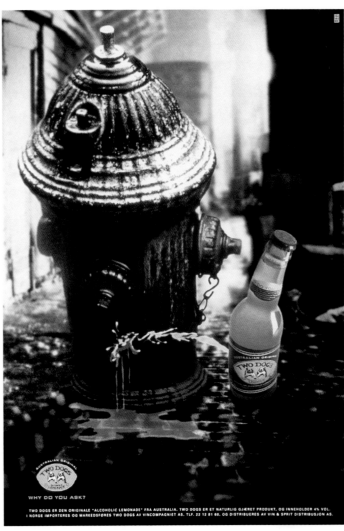

Agency:	BDDP, Paris	More than words can say.	**Agency:**	Kontoret, Oslo
Creative Director:	Jean-Pierre Barbou		**Copywriter:**	Pål Sparre-Enger
Copywriter:	Benoit Leroux		**Art Director:**	Knut Roethe
Art Director:	Philippe Tarroux		**Illustrator:**	Autografene
Photographer:	Guido Mocafico		**Client:**	Two Dogs Alcoholic
Client:	Kronenbourg			Lemonade
	1664 Beer			

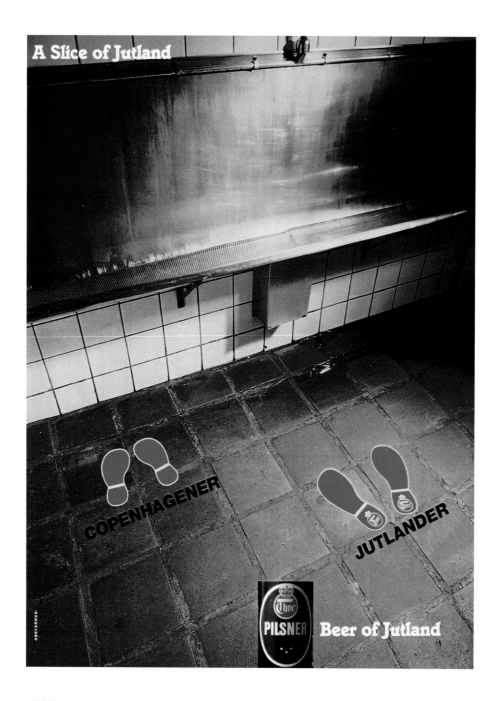

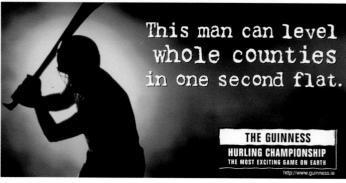

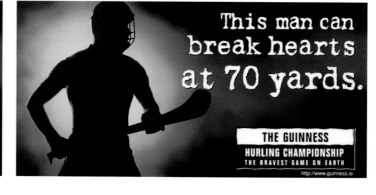

Agency:	Grey, Aarhus	Agency:	Arks Advertising, Dublin
Creative Director:	Henry Rasmussen		
Copywriter:	Henry Rasmussen	**Creative Director:**	Killian O'Donnell
Art Director:	Gaba Jensen	**Copywriter:**	Killian O'Donnell
Photographer:	Michael Berg	**Art Director:**	Carol Lambert
Client:	Thor Pilsner Beer	**Photographer:**	Dave Campbell
		Client:	Guinness Ireland, Hurling Championship

☆SPORTHEROES☆
Working out with Peter and Per

Nice shot Peter, but why are we doing this when no one (GIRL) is watching ??? We will only get TRAININGPAIN!

Per! Because this workout will make our young bodies look very nice. And we can also drink a lot of Tuborg lightbeer. I think your biceps has improved, by the way.

TUBORG KLASS I

The smooth and rich lightbeer for inhabitants who really, really care about their looks.

Or the smooth and rich lightbeer for inhabitants who think the body is the mirror of the soul.

Or the smooth and rich lightbeer for inhabitants who dont know we make strongbeer too.

◎DEEP TALK◎
By Peter and Per (in fact mostly by Peter)

Per, I really like Arnold Schwarzenegger a lot. He communicates with me in an almost scary way. I think it's because he is a bit like me. On the outside he seems hard like steel. But inside that tough body there is a very sensitive guy. A guy who cares about feelings. A guy who love the smell of flowers. And children. Arnold is not only my BIG HERO. He is also someone I can identify myself with in both actions, thoughts and lifestyle.

Peter, I think you should drink a couple of Tuborg lightbeers and shut up.

TUBORG KLASS I

The smooth and rich lightbeer for humans who like to explore their inner selfs.

Or the smooth and rich lightbeer for humans who believe there are signs everywhere (if you only connect your eyes with your heart.

Or the smooth and rich lightbeer for humans who dont know we make strongbeer too.

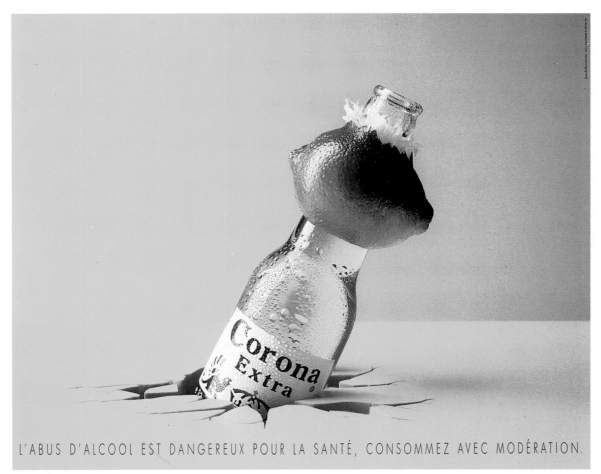

L'ABUS D'ALCOOL EST DANGEREUX POUR LA SANTÉ, CONSOMMEZ AVEC MODÉRATION.

Agency:	Hollingworth/ Mehrotra, Stockholm	**Agency:**	Jean & Montmarin, Paris
Creative Director:	Frank Hollingworth	**Creative Director:**	Gérard Jean
Copywriter:	Peter Fjäll	**Copywriter:**	Loïc Froger
Art Director:	Pelle Sjönell	**Art Director:**	Thierry Fèvre
Client:	Tuborg Beer	**Photographer:**	Paul Goirand
		Client:	Corona Beer

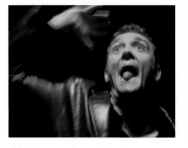
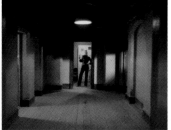
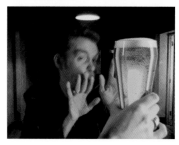
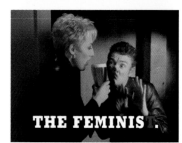

THE FEMINIS.

Many things feel better
soft and smooth.

Sandels – soft and smooth flavour.

Agency:	The Leith Agency, Edinburgh	An attractive woman pours a glass of Tennents for her man and announces that "tea's ready" (in Scotland the letter T is synonymous with Tennents). The eager gentleman rushes towards her down a long corridor, only to crash into a glass partition that separates him from the woman and his beloved brew. As he slides to the floor she raises the glass to toast him with the words, "Down boy."
Creative Director:	Gerry Farrell	
Copywriter:	Dougal Wilson	
Art Director:	Gareth Howell	
Production:	Gerard de Thame Films, London	
Director:	Gerard de Thame	
Producers:	Fabyan Daw Les Watt	
Client:	Tennents Beer, "Feminist"	

Agency:	Paltemaa Huttunen Santala TBWA, Helsinki
Copywriter:	Antti Einiö
Art Director:	Marko Muona
Photographer:	Marjo Tokkari
Client:	Sandels Beer

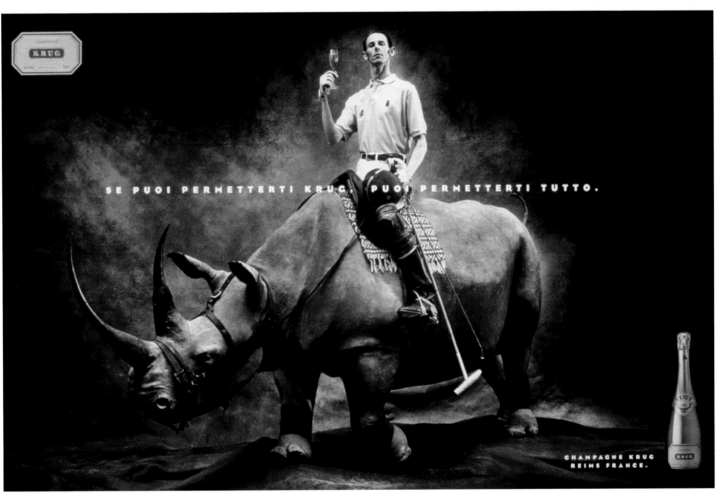

Agency:	Lowe RZR, Madrid	Agency:	Saatchi & Saatchi	If you can afford Krug, you can afford
Creative Director:	Ernesto Rilova		Advertising, Milan	anything.
Copywriter:	Maribel Muñoz	Creative Directors:	Guido Cornara	
Art Director:	Melchor Palacios		Agostino Toscana	
Photographer:	Antonio Bueno	Copywriter:	Stefano Campora	
Client:	Mediterraneo	Art Director:	Roberto Battaglia	
	Sparkling Wine	Photographer:	Christian Coigny	
		Client:	Krug Champagne	

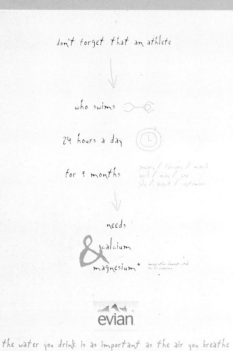

don't forget that an athlete

who swims

24 hours a day

for 9 months

needs
& calcium
magnesium*

evian

the water you drink is as important as the air you breathe

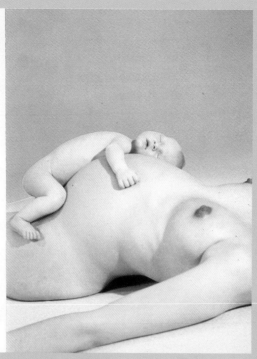

le lait aide à grandir

mais

le calcium d'évian

evian

aidez-le

en lui donnant
une eau pure et légère
en minéraux

evian

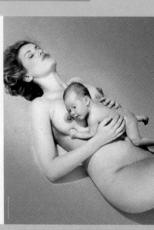

les activités physiques bonnes pour le cœur

marcher

nager

&
lever le coude
pour boire de l'eau d'évian
équilibrée en calcium
et en magnésium

evian

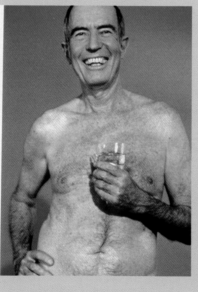

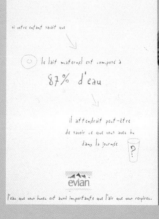

le lait maternel est composé à
87% d'eau

il attendrait peut-être
de savoir ce que vous avez bu
dans la journée

evian

Agency:	Euro RSCG Babinet Erra Tong Cuong, Paris	
Creative Director:	Rémi Babinet	
Copywriter:	Valérie Chidlovski	
Art Director:	Agnès Cavard	
Photographer:	Bettina Rheims	
Client:	Evian Mineral Water	

Everybody knows that milk helps you grow, but not everybody knows that the calcium in Evian is just as good as the calcium in milk.

Physical activities that are good for the heart: walking, swimming and lifting up your arm to drink Evian water, balanced in calcium and magnesium.

Even if he's very proud of being able to eliminate water all on his own, help him by giving him pure water, low in minerals.

If your child knew that his mother's milk is 87% water, maybe he would like to know what you have drunk today. Evian, the water you drink is as important as the air you breathe.

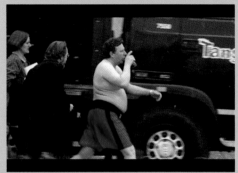
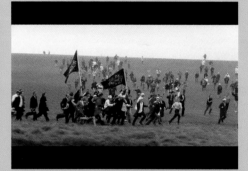

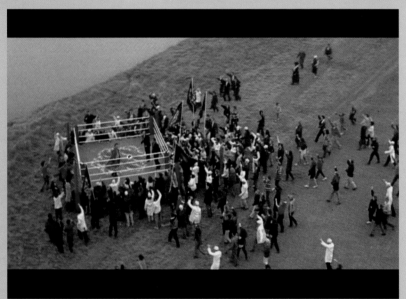

Agency:	Howell Henry Chaldecott Lury, London	Ray Gardiner, spokesperson for Tango, is mildly indignant that, after three years in development, a French exchange student has the gall to write that he does not like new Blackcurrant Tango as much as the other Tango flavours. Stripping down to his shorts, Ray becomes more and more belligerent as he questions the credentials of any foreigner to pass judgement on his new drink. He leaves the office and heads towards a boxing ring, perched high on the White Cliffs of Dover, where, accompanied by hordes of xenophobic Brits and the RAF, he shouts out his challenge to the world.
Copywriter:	Chas Bayfield	
Art Director:	Jim Bolton	
Production:	Eclipse Productions	
Director:	Colin Gregg	
Producers:	Anthony Taylor	
	Harry Rankin	
	Peter Muggleston	
Client:	Blackcurrant Tango, "St. George"	

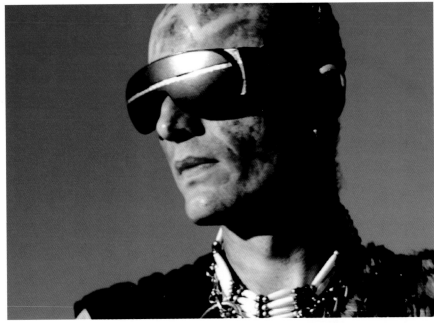

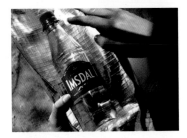

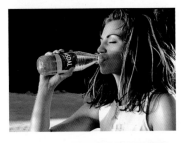

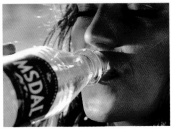

MRS. DEE HYDRATED

T. HIRSTY

MR. & MRS. WITHERING

DR. DAMN-COOL

A. RID

MR. I.B. PARCHED

EVA PORATED

Agency:	Strand & Lund, Oslo
Creative Director:	Harald Schielderup-Lund
Copywriter:	Ole Petter Tharaldsen
Art Director:	John Kåre Raake
Production:	Kraftwerk Productions
Director:	Anders Skog
Producers:	Knut Jensen
	Tom Jordsjø
Client:	Imsdal Mineral Water

Futuristic villains are in a dry desert without water. With high-tech glasses they spot a young woman with a bottle of clean water in the distance and then the chase is on. The woman runs for her life and eventually escapes her pursuers by leaping over a deep ravine. Safe on the other side, she refreshes herself with pure, natural Norwegian water.

Agency:	Des O'Meara & Partners, Dublin
Creative Director:	Pearse McCaughey
Copywriter:	Alan Kelly
Art Director:	Ciara Winkelmann
Client:	Coca-Cola

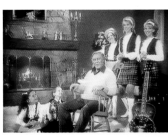
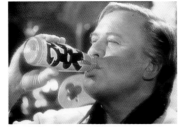
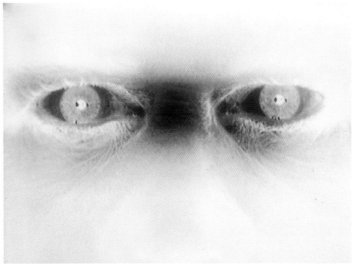

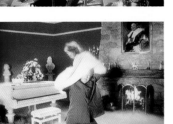
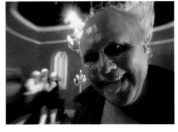

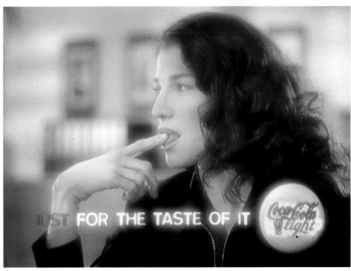

Agency:	Ogilvy & Mather, London	A friendly man, who appears to be the host of a children's programme, greets his audience and proposes a new song about the love between a little boy and his puppy. He then drinks from a bottle of Lucozade NRG and is transformed into a drug-crazed rock star. To loud techno music he rips off his shirt, gyrates amid billowing stage-smoke and proceeds to demolish the whole room. His age eventually catches up with him and he hobbles off the set, clutching his back.
Creative Directors:	Nicola Gill Sally Bargman	
Copywriter:	Nicola Gill	
Art Director:	Sally Bargman	
Production:	Gorgeous	
Director:	Chris Palmer	
Producers:	Tim Marshall Kim Parrett	
Client:	Lucozade NRG, "Crooner"	

Agency:	Leo Burnett Italia, Milan	The sexual temperature rises while female office workers prepare themselves for the imminent arrival of someone special. It's the handsome young Coca-Cola delivery man who's come to fill their dispenser with Coke Light.
Creative Directors:	Franco Moretti Fabrizio Russo	
Copywriter:	Luca Grelli	
Art Director:	Lorenzo Bassano	
Production:	BRW & Partners	
Director:	Jeremiah Chechik	
Producers:	Stefano Quaglia Antonello Filosa	
Client:	Coca-Cola Light, "Dispenser"	

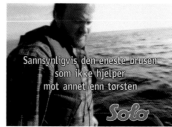

Sannsynligvis den eneste brusen
som ikke hjelper
mot annet enn tørsten

Solo

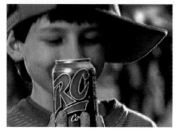

התחגולה שהמפה לאמר יחק את הראש

RC
Cola

80 **Non-Alcoholic Drinks**

Agency:	JBR Parkveien, Oslo
Copywriter:	Frode Karlberg
Art Director:	Bjørn Smørholm
Production:	Reel Image
Directors:	Espen Sandberg
	Joachim Rønning
Producer:	Steinar Jøraandstad
Client:	Solo Soft Drink

A father and son are out fishing. The boy is beginning to feel sea-sick and the father cannot get the outboard motor to start. The exasperated man snatches a bottle of Solo from his son and drinks it before returning to the engine. This time it starts immediately, only to fall off its mountings and sink into the water. Proof that Solo is "Probably the only soft drink that cures nothing but thirst."

Agency:	Reuveni Pridan - Leo Burnett, Tel Aviv
Creative Director:	Ehud Pridan
Copywriters:	Offer Yaar
	Michel Kremerman
Art Director:	Gal Zakay
Production:	Rabel Production
Director:	Nirit Yaron
Producers:	Shula Shpigel
	Amit Deckel
	Carmit Yochpaz
Client:	RC Cola, "The Kid"

A tall vending machine poses something of a challenge for this small boy who must buy a cola for his demanding young date, but ingenuity wins the day. He first chooses a Pepsi and after that a Coke. Then, standing on the two cans, he's able to reach up to the RC Cola button, the brand his girl wants.

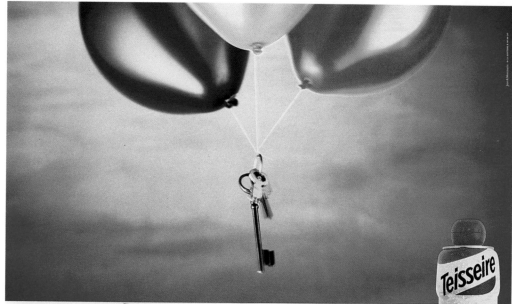

Agency:	Cronert & Company, Helsingborg	Everyday activities like thinking, sleeping and making love are illustrated by chess players, parents-to-be, and the Sleeping Beauty. The hourly liquid depletion rates associated with each of these activities, in decilitres, is superimposed on the screen to promote the pure, natural power of Ramlösa mineral water.	
Copywriter:	Christian Hultberg		
Art Director:	Per Ekros		
Production:	Mekano Film & Television		
Director:	Jesper Ericstam		
Producers:	Elisabeth Somp Peter Hallin		
Client:	Ramlösa Mineral Water, "Chess"		

Agency:	Jean & Montmarin, Paris	You shouldn't have deprived them of Teisseire.	
Creative Director:	Gérard Jean		
Copywriter:	Olivier Couradjut		
Art Director:	Rémy Tricot		
Photographer:	Nicolas Descottes		
Client:	Teisseire Soft Drink Concentrate		

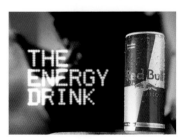

82 **Non-Alcoholic Drinks**

Agency:	Wieden & Kennedy, Portland	The commercial brings alive all the joy of the circus to pass on a special wish to viewers: "May all your days be circus days - red, bright and Coca-Cola."
Production:	Tony Kaye & Partners, London	
Director:	Walter Kehr	
Client:	Coca-Cola, "Circus"	

Production:	Tony Kaye & Partners, London	A male porn star talks frankly about the ins and outs of his profession. He acknowledges that he'll never win an Oscar and stresses the need for fitness and stamina. Meanwhile we see the actor hard at work, his performances culminating in total exhaustion and temporary impotence. But he knows the solution: Red Bull, the energy drink.
Director:	Darren Statman	
Producer:	Benji Howell	
Client:	Red Bull, "Porn Star"	

BIFFA BOLT-ON. BLEI BONK.

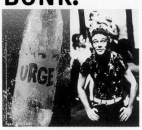

DEATH COOKIE. ENDO. DIGER FACE PLANT.

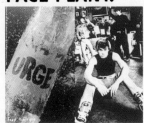

CREDCHIP, DEAD PRESIDENTS, KAMIKAZE. FULL ALPHA CHIMP!

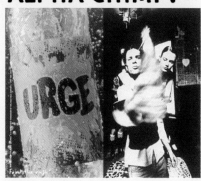

LE CAFÉ QUI EN A REFROIDI PLUS D'UN

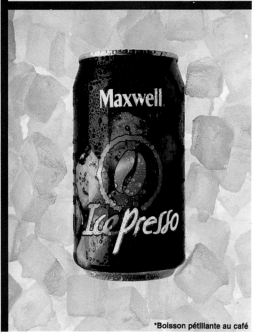

*Boisson pétillante au café

Agency:	Leo Burnett, Oslo	Ads use the new Urge street language consisting of slang from around the world:
Copywriter:	Erik Heisholt	
Art Director:	Paal Wehus	
Photographer:	Victor Boullet	-Crashed into a woman with silicone breasts and was knocked out.
Client:	Urge Soft Drink, "Street Language"	

-Big rock on the road, dived over bike, hit face hard on the ground.

-Credit card, money, taxi. Full control.

Agency:	Young & Rubicam, Paris	Ready for the chill.
Creative Director:	Bruno Le Moult	
Copywriter:	Guillaume Gamain	
Art Director:	Christophe Renard	
Photographer:	Mike Parsons	
Client:	Maxwell Icepresso, Carbonated Coffee Drink	

84 **Non-Alcoholic Drinks**

Agency:	Reuveni Pridan - Leo Burnett, Tel Aviv	Ein Gedi is presented as a mythical water from the desert that refreshes and quenches the thirst of people from all nations.
Creative Director:	Ehud Pridan	
Copywriters:	Michel Kremerman Vered Shani	
Art Director:	Hava Margol	
Production:	P.O.V.	
Director:	Yariv Gaver	
Producers:	Aviv Giladi Carmit Yochpaz	
Client:	Ein Gedi Mineral Water, "The Mythical Water"	

Agency:	BBDO Portugal, Lisbon
Creative Director:	Jorge Teixeira
Copywriter:	Luísa Carvalho
Art Director:	Teresa Costa
Photographer:	Francisco Aragão
Client:	Pepsi-Cola

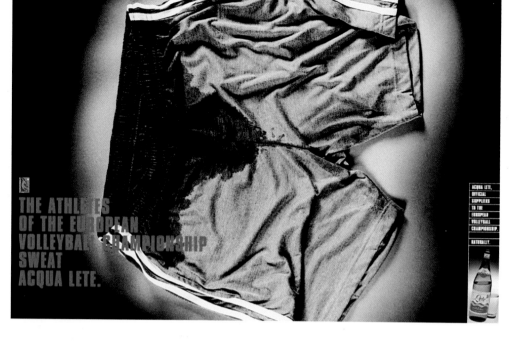

THE ATHLETES
OF THE EUROPEAN
VOLLEYBALL CHAMPIONSHIP
SWEAT
ACQUA LETE.

ACQUA LETE,
OFFICIAL
SUPPLIER
TO THE
EUROPEAN
VOLLEYBALL
CHAMPIONSHIP.
NATURALLY.

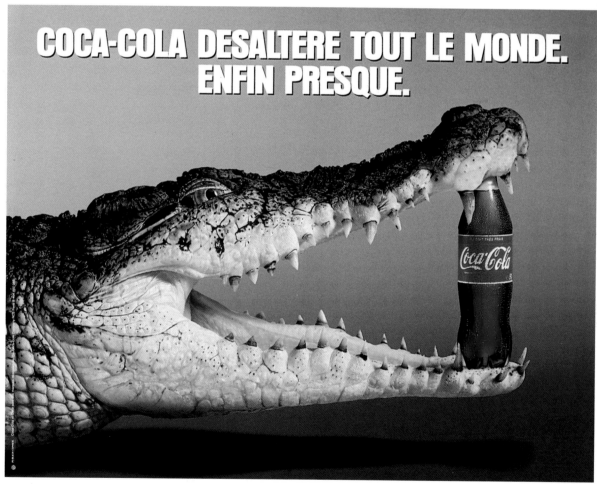

COCA-COLA DESALTERE TOUT LE MONDE. ENFIN PRESQUE.

Agency:	All Partners, Rome	**Agency:**	Publicis Conseil, Paris	Coca-Cola refreshes everybody.
Creative Director:	Leonardo Stabile	**Creative Director:**	Eric Galmard	Well, almost.
Copywriter:	Cristina Costa	**Copywriter:**	Georges Picaud	
Art Director:	Riccardo Ruini	**Art Director:**	Isabelle Sastre	
Photographer:	Steve Bisgrove	**Photographer:**	Mike Parsons	
Client:	Acqua Lete	**Client:**	Coca-Cola	
	Mineral Water			

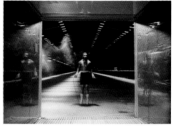

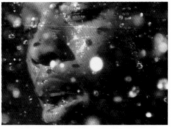

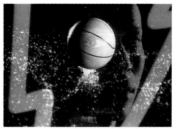

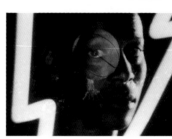

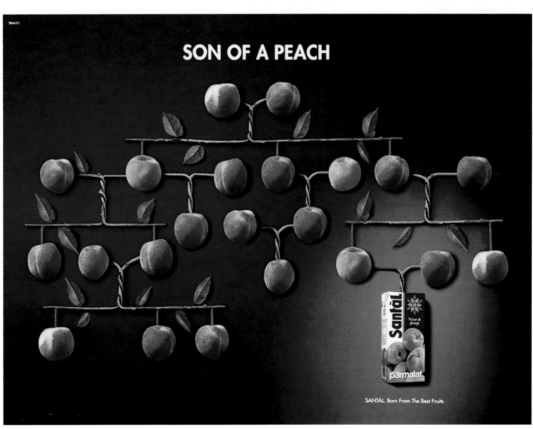

Agency:	FCB, Chicago	Different sportsmen, basketball players,	Agency:	TBWA EPG, Lisbon
Production:	Tony Kaye & Partners, London	a lone runner and a boxer, build up their thirst to a fast techno beat. Gatorade Frost	Creative Director:	Pedro Bidarra
Director:	Rupert Sanders	is their drink.	Copywriter:	Pedro Bidarra
Client:	Gatorade, "Frost"		Art Director:	Jose Heitor
			Photographer:	Sais de Prata
			Client:	Santal Fruit Juices

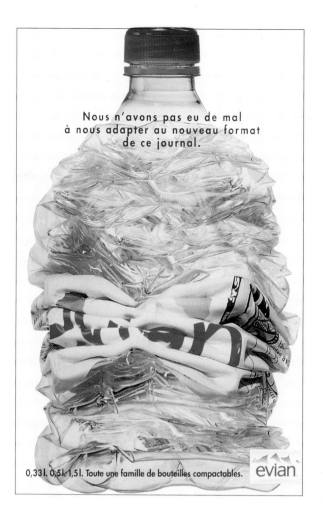

Nous n'avons pas eu de mal à nous adapter au nouveau format de ce journal.

0,33 l. 0,5 l. 1,5 l. Toute une famille de bouteilles compactables. evian

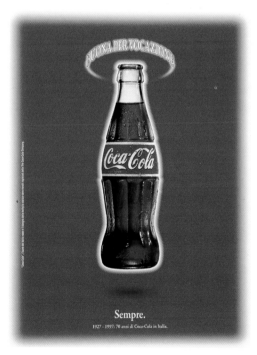

Sempre.

1927 - 1997: 70 anni di Coca-Cola in Italia.

(Parola di otto lettere)

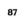

Agency:	Euro RSCG United, Brussels	We didn't have any difficulty adapting to the new format of this newspaper (the ad was designed for a special tabloid-size edition of La Dernière Heure).
Creative Director:	Veronique Hermans	
Copywriter:	Paul Servaes	
Art Director:	Benoit Hilson	
Client:	Evian Mineral Water, Crushable Bottle	

Agency:	Leo Burnett Italia, Milan	Good by vocation.
Creative Director:	Fabrizio Russo	
Copywriters:	Marina Gracchi	An eight-letter word.
	Maria Paola Di Stefano	
Art Directors:	Sandro Sironi	
	Sandro Olivieri	
Client:	Coca-Cola	

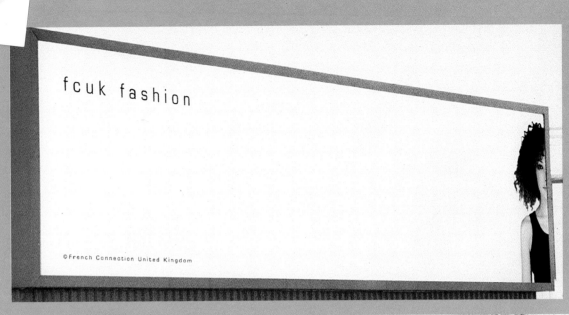

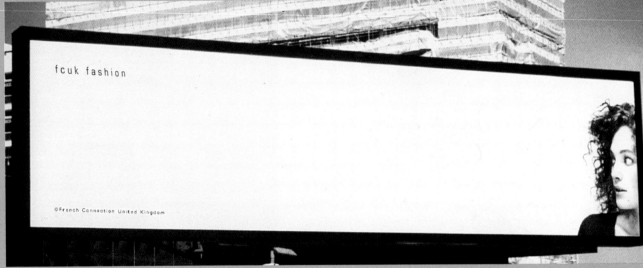

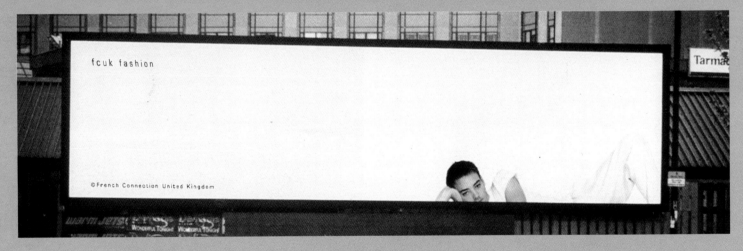

Retail Services

Agency:	BDDP GGT, London
Creative Director:	Trevor Beattie
Copywriter:	Trevor Beattie
Art Director:	Jay Pond-Jones
Photographer:	Neil Davenport
Client:	French Connection UK (Also a Finalist in the Clothing Category)

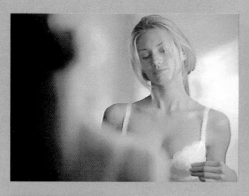 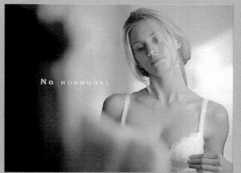 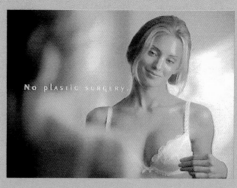

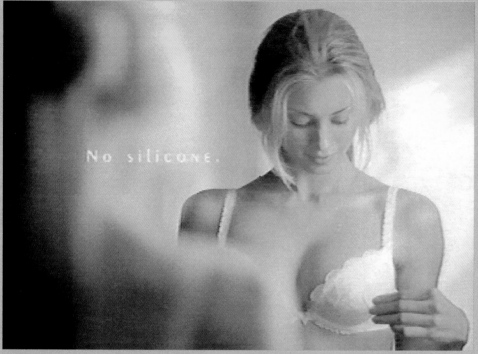 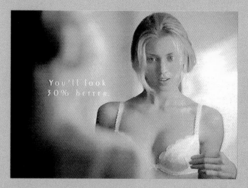

 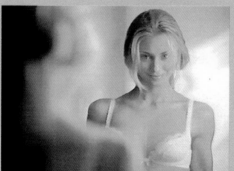

Agency:	Casadevall Pedreño & PRG, Barcelona	A woman admires her breasts in the mirror while successive supers announce:
Creative Director:	José Maria Pujol	no hormones, no plastic surgery, no silicone.
Copywriter:	José Maria Pujol	"To look 30% better, all you need is Fotoprix,
Art Directors:	Ramón Roda	photos that are 30% bigger." With this,
	Josep Marín	we discover that she has been hiding her
Production:	Errecerre	real breasts under a Fotoprix enlargement,
Director:	Xavier Roselló	"The best photos at the best price."
Producers:	Esteve Riera	
	Joaquin Casadevall	
	Pepe Rosas	
Client:	Fotoprix, Photo Shop, "Silicone"	

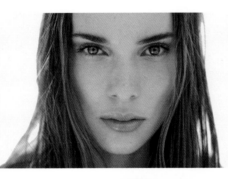

f.c.u.k. advertising

fcuk is a trademark of French Connection UK

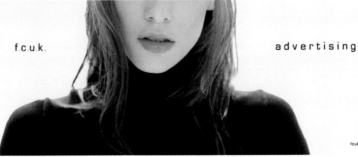

f.c.u.k. advertising

fcuk is a trademark of French Connection UK

f.c.u.k. advertising

fcuk is a trademark of French Connection UK

Agency:	Heye & Partner, Vienna	Agency:	BDDP GGT, London
Creative Directors:	Alexander Bartel Thorsten Meier	Creative Director:	Trevor Beattie
		Copywriter:	Trevor Beattie
Art Director:	Frank Widmann	Art Director:	Bil Bungay
Client:	McDonald's	Photographer:	Neil Davenport
		Client:	French Connection UK (Also a Finalist in the Clothing Category)

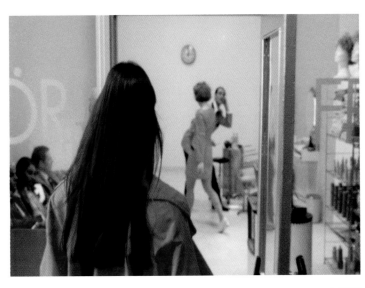
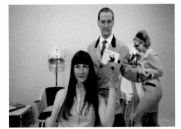
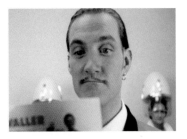
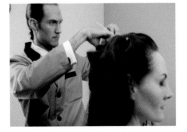
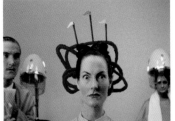

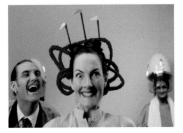

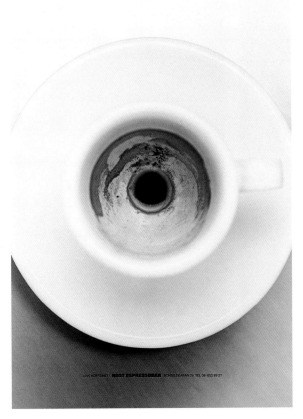
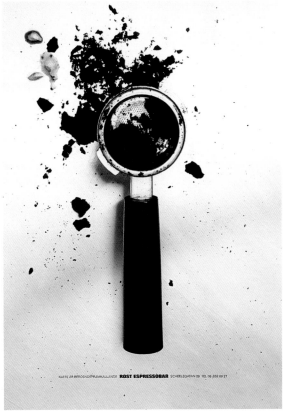

Agency:	WOW Advertising Agency, Stockholm	A self-confident woman enters her salon and shows the maestro a photo of the hair style she wants. He hesitates at first, then goes to work. She's bewildered by the result, and then discovers that the artist has created her chosen style, including the roller-coaster that was in the background of the photograph. She leaves the salon more confident than ever, while the advertiser suggests, "Give your hairdresser a challenge."	**Agency:**	Manne & Co., Stockholm
Copywriter:	Hatto Melin		**Copywriter:**	Martin Stadhammar
Art Director:	Per Ledin		**Art Directors:**	Sten Åkerblom
Production:	Jarowskij			Kalle Haasum
Director:	Magnus Wikman		**Photographer:**	Hans-Erik Nygren
Producers:	Dan Rennéus		**Client:**	Rost Espressobar
	Susann Billberg-Rydholm			
Client:	Swedish Hairdressers' Association, "The Roller-Coaster"			

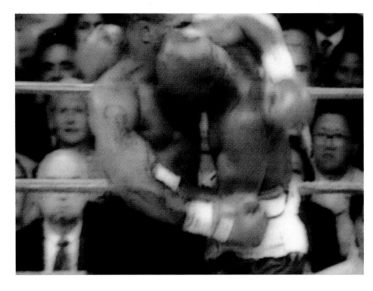
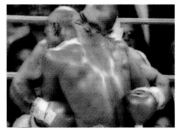

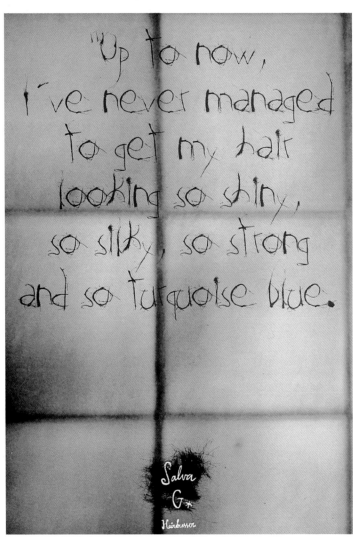

"Up to now,
I've never managed
to get my hair
looking so shiny,
so silky, so strong
and so turquoise blue.

Salva
G*
Hairdresser

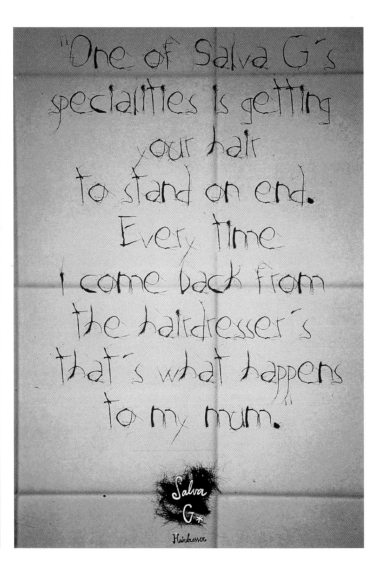

"One of Salva G's
specialities is getting
your hair
to stand on end.
Every time
I come back from
the hairdresser's
that's what happens
to my mum."

Salva
G*
Hairdresser

Agency:	McCann-Erickson, Geneva	A slow-motion, close-up replay of Mike Tyson ferociously biting off a piece of Evander Holyfield's ear and spitting it out, with amplified sound effects. Designed to discourage meat-eating, the spot attracted customers to Zurich's leading vegetarian restaurant.
Creative Director:	Frank Bodin	
Production:	Alberto Venzago, Zurich	
Director:	Alberto Venzago	
Client:	Hiltl Vegetarian Restaurant, "The Bite"	

Agency:	Delvico Bates, Barcelona
Creative Directors:	Julio Wallovits
	Elvio Sanchez
Client:	Salva G, Hairdresser

Drivers prefer McDrive

Agency:	Ammirati Puris Lintas, Warsaw	A man is deeply involved in something but his glasses keep falling off, slipping down	**Agency:**	Corporate Profiles DDB, Warsaw	In a showroom, a man is obsessively interested in a new car's windows:

Agency: Ammirati Puris Lintas, Warsaw
Creative Director: Chris Matyszczyk
Copywriter: Chris Matyszczyk
Art Director: Ray Knox
Production: Opus Film Studio
Director: K. Molotov
Producers: Piotr Dzieciot
Leszek Tarnowski
Client: P. Voigt, Contact Lens Specialist, "Van Gogh"

A man is deeply involved in something but his glasses keep falling off, slipping down the left side of his face. He becomes increasingly angry and eventually removes the glasses and stamps on them. At the same time we discover the man is Vincent van Gogh, with a missing ear. He would have been a good client for P. Voigt's contact lens service.

Agency: Corporate Profiles DDB, Warsaw
Creative Director: Marcin Mroszczak
Copywriter: Marcin Mroszczak
Art Director: Marcin Mroszczak
Production: Shoot, Barcelona
Director: Simon Peters
Producer: Maciej Moczulski
Client: McDonald's, "McDrive"

In a showroom, a man is obsessively interested in a new car's windows: how they work, how big they are, and how fast they open. He sits behind the wheel and practises leaning out of the window. "Drivers prefer McDrive," claims the advertiser and the scene switches to the same man, in his new car, collecting his family meal at a McDrive window.

Agency:	Paltemaa Huttunen Santala TBWA, Helsinki	A child star, wise beyond his age, sings a song with blatently sexual lyrics. The Finnish Bookstore calls on all adults to let their children be children and to give them children's books.	**Agency:**	Clark & Taylor, London
Copywriter:	Kari Eilola		**Creative Director:**	Rodger Williams
Art Director:	Anu Igoni		**Copywriter:**	Peter Evans
Production:	Also Starring		**Art Director:**	Barry Batchelor
Director:	Vellu Valla		**Photographer:**	Gary Bryan
Producers:	Pauliina Valpas Sirkka Norha'		**Client:**	Little Chef Motorway Restaurants
Client:	Finnish Bookstore, "Child Star"			

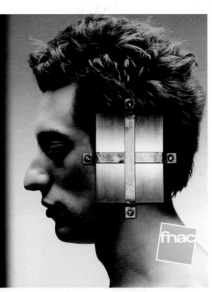

La musique
a ses talents
cachés.
Si bien cachés
qu'on ne les
entend pas.

...sauf à la Fnac.

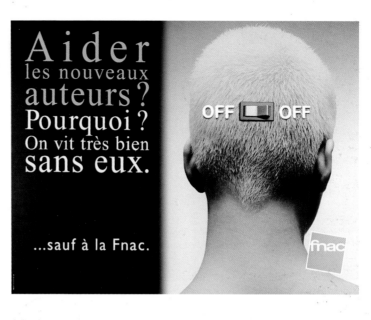

A i d e r
les nouveaux
auteurs?
Pourquoi?
On vit très bien
sans eux.

...sauf à la Fnac.

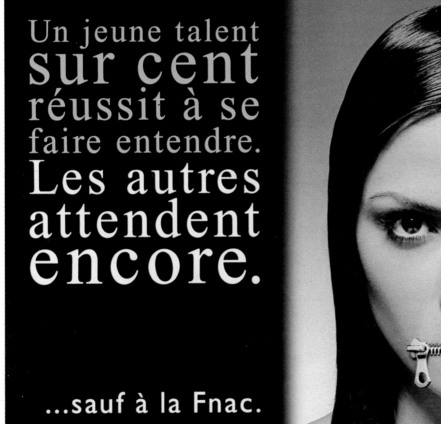

Un jeune talent
sur cent
réussit à se
faire entendre.
Les autres
attendent
encore.

...sauf à la Fnac.

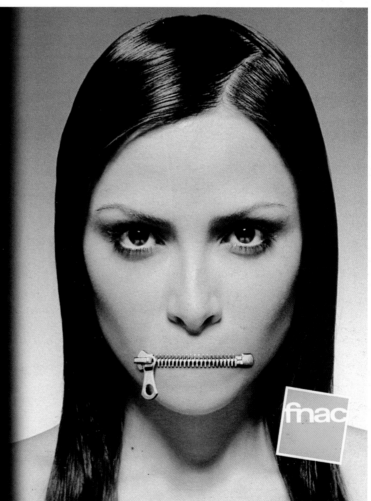

Agency: DDB, Paris
Creative Director: Christian Vince
Copywriter: Manoelle Van der Vaeren
Art Director: Sebastien Vacherot
Photographer: Thierry Le Goues
Client: Fnac, Multi-Media Stores

Help new authors? What for? We can do without...except at the Fnac.

Music is full of hidden talents. So well hidden, you never get to hear them...except at the Fnac.

One talented kid in one hundred succeeds in getting heard. The others are still waiting...except at the Fnac.

You are about to hear
a couple of tunes.
It's up to you
to recognize them.

That proves one thing:

You wouldn't be able
to sell records
at the Fnac store.

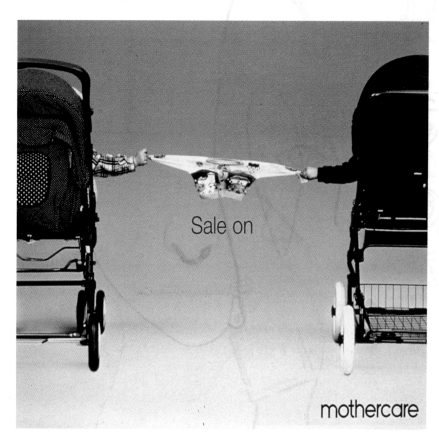

Sale on

mothercare

Agency:	DDB, Paris	A series of customers in a music store	**Agency:**	Valmorisco
Creative Director:	Christian Vince	hum and sing while the viewers are asked		Comunicacion,
Copywriter:	Anne-Cecile	if they can recognize any of the tunes.		Madrid
	Tauleigne	If your score is low, which is likely, that	**Creative Directors:**	Manolo Valmorisco
Art Director:	Thierry Vince	only proves that you would not be able to		Jorge Lopez
Production:	Première Heure	sell records at a Fnac store (250,000 records	**Copywriter:**	Pablo Monzon
Director:	Philippe Pollet Villard	available, 453 salesmen in-the-know).	**Art Director:**	Juan Coronil
Producer:	Sylvaine Mella		**Photographer:**	Carlos Yebra
Client:	Fnac, Multi-Media		**Client:**	Mothercare
	Stores, "The Quiz"			

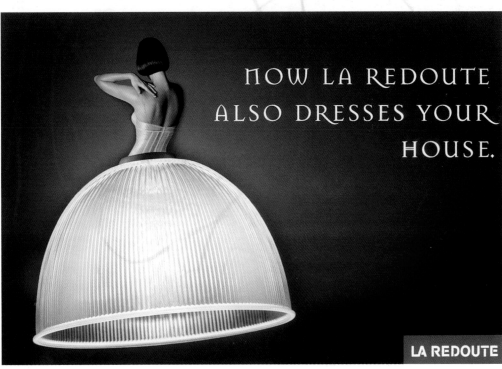

Agency:	BDDP, Paris	At Christmas, you don't have the right
Creative Director:	Jean-Claude Jouis	to make mistakes.
Copywriter:	Rémi Noel	
Art Director:	Eric Holden	
Client:	Toys 'R' Us	

Agency:	TBWA, Brussels
Creative Director:	André Rysman
Copywriter:	Eric Maerschalck
Art Director:	Erik Vervroegen
Photographer:	Maria Dawlat
Client:	La Redoute
	Mail-Order
	Catalogue

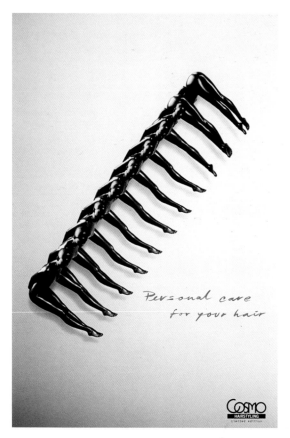

Agency:	Wave Advertising, Rotterdam
Creative Director:	Jan Veth
Copywriter:	Peter van Rij
Art Director:	Obeth Pattipeilohy
Photographer:	Dirk Karsten
Client:	Cosmo Hairdressers

Agency:	BDDP, Paris	Andrée Putmann, Pinin Farina, Xuly
Creative Directors:	Jean-Pierre Barbou	Baet...where do you get your ideas from?
	Jean-Claude Jouis	Designer enriched!
Copywriter:	Rémi Noel	
Art Director:	Eric Holden	
Photographer:	Thierry Desmarquet	
Client:	3 Suisses	
	Mail-Order	
	Catalogue	

VOUS N'AVEZ PAS DE QUOI PAYER LE LAVOMATIC ? PAYEZ-VOUS UNE MACHINE A LAVER.

CRAZY GEORGE'S

Location avec option d'achat sous réserve d'acceptation du dossier par THORN Financement S.A.

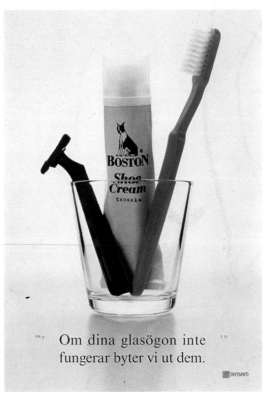

Om dina glasögon inte fungerar byter vi ut dem.

SYNSAM

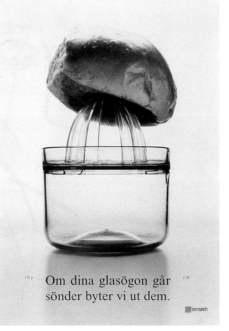

Om dina glasögon går sönder byter vi ut dem.

SYNSAM

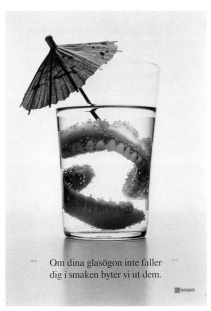

Om dina glasögon inte faller dig i smaken byter vi ut dem.

SYNSAM

100 **Retail Services**

Agency:	BL/LB, Paris	You don't have the means to go to the launderette? Buy yourself a washing machine. (Crazy George offers credit to students and unemployed people who would not normally qualify for a loan).	Agency:	Villmer Advertising, Stockholm	If your glasses don't work, we'll replace them.
Creative Director:	Bruno Lacoste				
Copywriter:	Céline Desmoulins		Copywriter:	Håkan Olofsson	If your glasses break, we'll replace them.
Art Director:	Charles Bire		Art Director:	Stefan Lidström	
Photographers:	Pascal Aulagner		Photographer:	Fredrik Lieberath	If you change your mind about your glasses,
	Pascal Dolmieux		Client:	Synsam Optician	we'll gladly give you a new pair.
Client:	Crazy George's Discount Store				

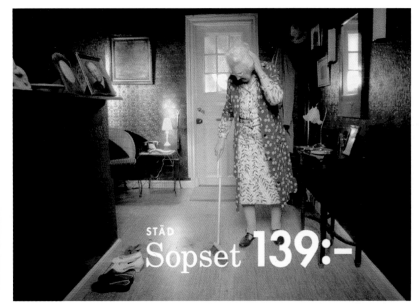

STÄD
Sopset **139:-**

Ordning och reda veckor
13 mars–6 april.

IKEA

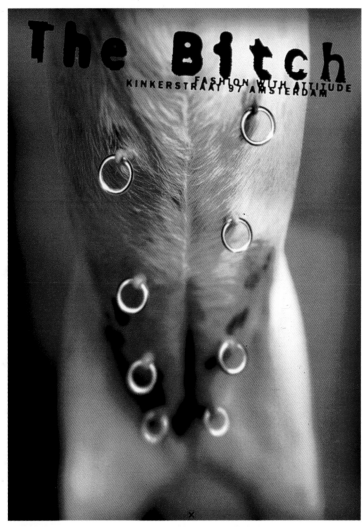

Agency:	Forsman & Bodenfors, Gothenburg	An old woman methodically sweeps her hall, a small rug then comes into view and she brushes the dust under it. Ikea announces a special sale on household furnishings; brooms and rugs are particularly cheap.	**Agency:** Laboratorium, Amsterdam
Copywriters:	Filip Nilsson Fredrik Jansson		**Photographer:** Thirza Schaap
Art Director:	Anders Eklind		**Client:** The Bitch Fashion Store
Production:	Easy Film, Copenhagen		
Director:	Stein Leikanger		
Producer:	Nicholas Berglund		
Client:	Ikea, "Broom / Rug"		

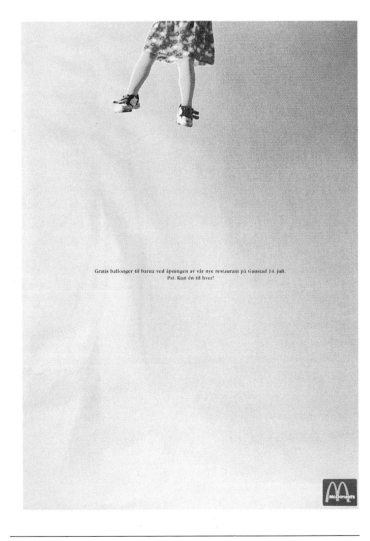

Gratis ballonger til barna ved åpningen av vår nye restaurant på Gaustad 14. juli. Pst. Kun én til hver!

Agency:	Hasan & Partners, Helsinki	One after another, bastketballs drop through a net while the voice-off points out that God-given talent such as this only occurs every 2,000 years or so. As the camera pulls back, viewers discover that the balls are being thrown out of a pram. While the baby gurgles with contentment, the voice-off continues to explain that ordinary mortals must rely on great equipment.
Copywriter:	Petri Pesonen	
Art Director:	Kimmo Kivilahti	
Production:	Woodpecker Filmi	
Director:	Arto Päivinen	
Producer:	Merja Metsävaara	
Client:	Elmo Sport Stores	

Agency:	Leo Burnett, Oslo	Free balloons for children at the opening of our new restaurant at Gaustad on July 14th. Only one balloon each!
Creative Director:	Øistein Borge	
Copywriter:	Stig Bjølbakk	
Art Director:	Henrik Sander	
Photographer:	Tommy Normann Hansen	
Client:	McDonald's	

Riktig kinamat haller själen i trim.

Agency:	Bergström & Sund, Stockholm	Real Chinese food keeps your soul in shape.	**Agency:** Ajans Ultra Reklam Hizmetleri, Istanbul
Creative Director:	Per Sund		**Creative Director:** Hakki Misirlioglu
Copywriter:	Mikael Bergström		**Photographer:** Eyüp Gorgüler
Client:	Kejsaren Chinese Restaurant		**Client:** Myott Cafe, Coffee House

Agency:	Leo Burnett, Oslo
Copywriters:	Erik Hersoug
	Eirik Hovland
Art Directors:	Erik Hersoug
	Eirik Hovland
Production:	Leo Film Jarowskij
Director:	Rolf Solman
Producers:	Kerstin Anderson
	Espen Horn
Client:	Thorn Rental Services,
	"Guitar" & "Kitchen"

A couple solemnly draw straws and the husband wins. He's delighted because it means he can buy the guitar he wants, whereas his wife's hopes for a new washing machine are put on hold. With Thorn's low monthly rents both their wishes could have come true.

In the second commercial a couple arm wrestle to decide if the husband gets a new television or if the wife's dream of a vacation in Jamaica finally comes true. The wife wins and cannot control her joy, while the husband is despondent, but life's not like that with Thorn Rentals.

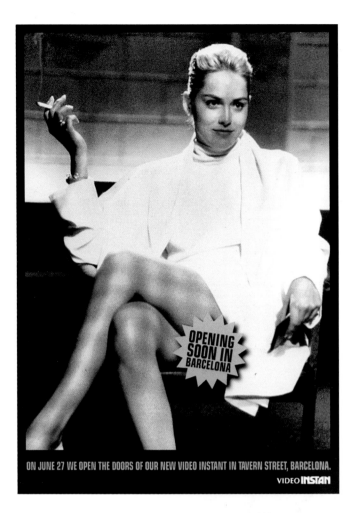

ON JUNE 27 WE OPEN THE DOORS OF OUR NEW VIDEO INSTANT IN TAVERN STREET, BARCELONA.

VIDEO **INSTAN**

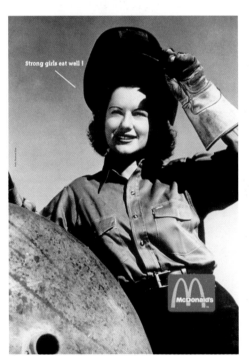

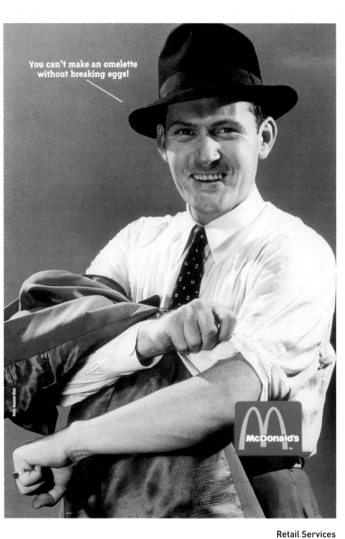

Agency:	Vinizius/Young & Rubicam, Barcelona	Agency:	Futura, Ljubljana
Creative Directors:	Jose Maria Pujol	Creative Director:	Marko Vicic
	Jose Maria Roca	Copywriter:	Bostjan Tadel
Copywriters:	Jose Maria Pujol	Art Director:	Ermin Mededovic
	Jose Maria Roca	Client:	McDonald's
Art Director:	Javier Melendez		
Client:	Video Instant, Video Rental Stores		

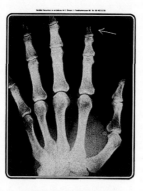

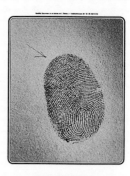

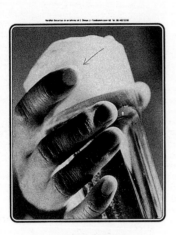

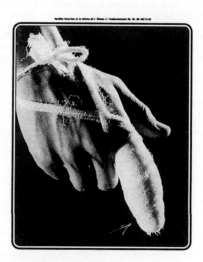

Agency:	Nordin & Co., Stockholm	Instead of an expensive stockbroker.
Creative Director:	Tom Nilson	A close-up portrait of a Nordnet stockbroker.
Copywriter:	Per Aronsson	
Art Directors:	Tom Nilson	The business card of a Nordnet stockbroker.
	Katrin Gullström	
Photographer:	Lasse Kärkkäinen	Let your Nordnet stockbroker take a break
Client:	Nordnet,	from time to time.
	Stockmarket	
	Transactions	Don't panic, you've got more than one
	on the Internet	Nordnet stockbroker. Nordnet stock.
		Close at hand.

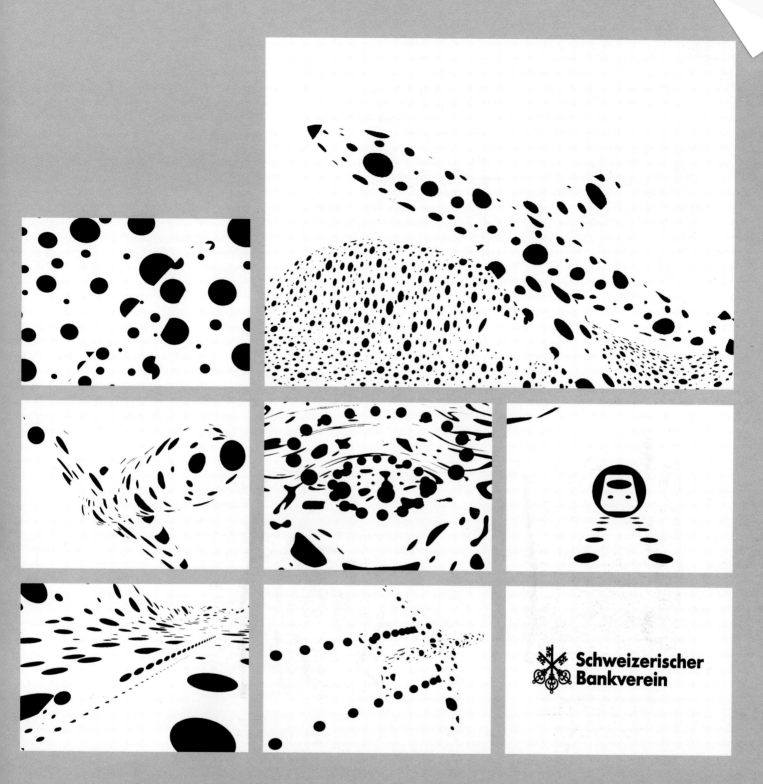

Schweizerischer
Bankverein

Agency:	Weber, Hodel, Schmid, Zurich	Production:	Passion Pictures, London
		Director:	Jonathan Hodgson
Creative Director:	Reinhold Weber	Producers:	Guy Thomson
Copywriters:	Daniel Krieg		Karin Giger
	Michael Kathe		Didi Knall
	Beat Egger	Client:	Swiss Bank Corporation,
Art Directors:	Hans Tanner		Key Club, "Travel"
	Tatjana Korol		

A jet plane takes off out of a random pattern of black dots that represent Key Club bonus points. The plane is transformed into a swimming pool, out of which emerges a high speed train. The background sounds are appropriate to each subject: jet engines roar, passengers chat, water splashes and bathers cry out with joy. The Swiss Bank Corporation invites viewers to collect points and travel for free with their Key Club bonus system.

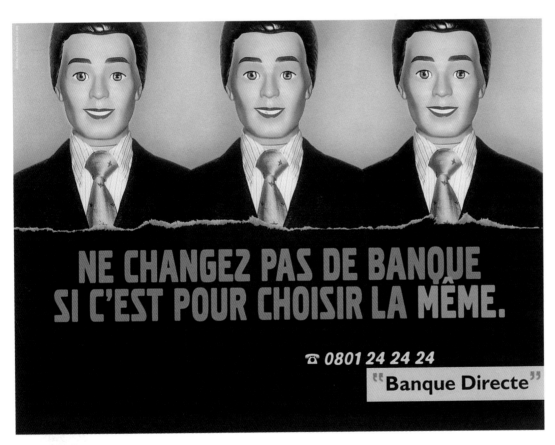

NE CHANGEZ PAS DE BANQUE
SI C'EST POUR CHOISIR LA MÊME.

☎ 0801 24 24 24

"Banque Directe"

Agency:	Garbergs Annonsbyrå, Stockholm	
Copywriter:	Johan van der Schoot	
Art Director:	Patrick Emt	
Production:	Traktor	
Producers:	Charlotte Most Charlotte Lundqvist	
Client:	SBAB Mortgages, "Hijacker"	

The SBAB agent, who has a reputation for boring people with talk of mortgages, is lecturing two fellow passengers when he accidently trips up a hijacker and causes him to lose his bomb. The SBAB man recovers the explosive devise and, unaware of the danger, calls out for its owner. This immediately attracts the attention of everyone on the plane and the mortgage agent can finally lecture non-stop to a captive audience that gives him their undivided attention. "We know nothing but mortgages," explains SBAB.

Agency:	Louis XIV, Paris
Creative Director:	Bertrand Suchet
Copywriter:	Luc Chomarat
Art Director:	Stephane Goddard
Photographer:	Geoffroy de Boismenu
Client:	La Banque Directe, Telephone Banking

Don't change banks if you want more of the same.

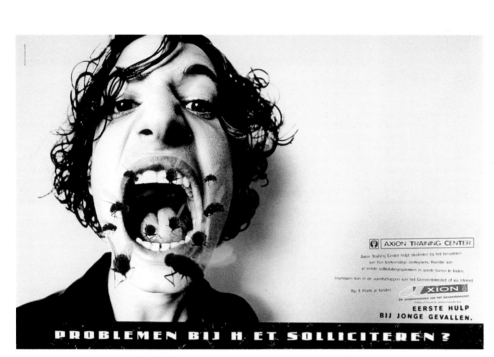

PROBLEMEN BIJ H ET SOLLICITEREN ?

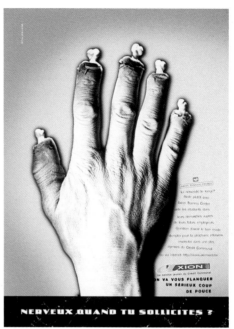

NERVEUX QUAND TU SOLLICITES ?

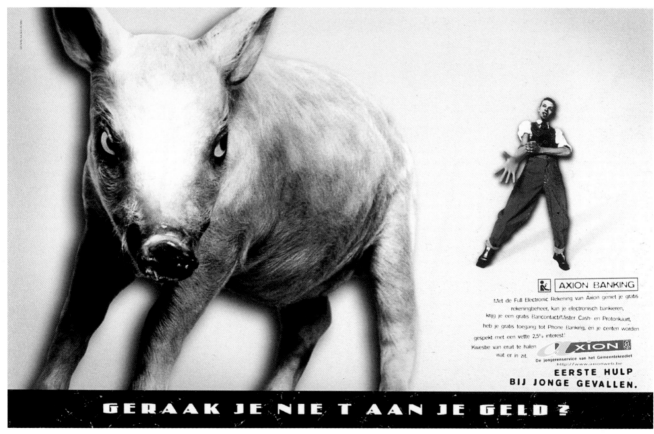

GERAAK JE NIE T AAN JE GELD ?

Agency:	Duval Guillaume, Brussels	Problems when you apply (for a job)?
Creative Director:	Guillaume van der Stighelen	Nervous when you apply (for a job)?
Copywriter:	Jens Mortier	Can't get your hands on your money?
Art Director:	Philippe De Ceuster	We'll lend you a hand.
Photographer:	Koen De Muynck	
Client:	Axion Youth Banking Services	

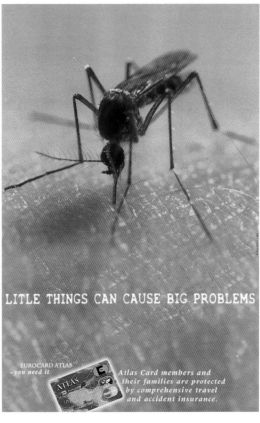

LITLE THINGS CAN CAUSE BIG PROBLEMS

EUROCARD ATLAS
–you need it

Atlas Card members and their families are protected by comprehensive travel and accident insurance.

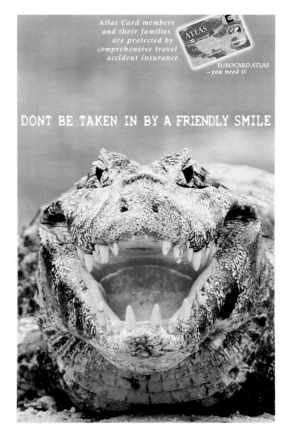

Atlas Card members and their families are protected by comprehensive travel accident insurance.

EUROCARD ATLAS –you need it

DONT BE TAKEN IN BY A FRIENDLY SMILE

IIO Financial Services

Agency:	ATCW, Istanbul
Production:	Tara Productions
Director:	Ali Tara
Producer:	Oguz Eruzun
Client:	Yapi Kredi Telecard, "Betrayal"

A dejected bank manager calls Mustapha, his brother-in-law, from a telephone booth in the rain and begs for his help. When Mustapha arrives, the two men take shelter in a nearby café and the banker explains how he has been betrayed by his wife, Mustapha's sister. He produces the woman's credit card as proof: its been issued by Yapi Kredi, a rival bank. Mustapha leaves and the bank manager succeeds in insulting another customer, who throws him out of the window into the muddy street.

Agency:	The White House, Reykjavik
Creative Director:	Sverrir Bjornsson
Copywriter:	Sverrir Bjornsson
Art Director:	Kristjan Sigurdsson
Client:	Eurocard Atlas Credit Card

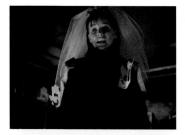

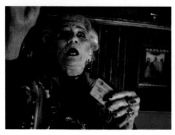

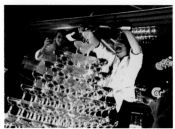

a part of your personality

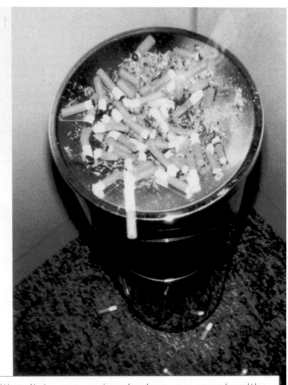

A Warning to the Health Authorities: Waiting lists can seriously damage your health.

Agency:	Garbergs Annonsbyrå, Stockholm	
Copywriter:	Martin Gumpert	
Art Directors:	John Mara	
	Niklas Bergström	
Production:	Mekano Film & Television	
Director:	Axel Laubscher	
Producers:	Anders Landström	
	Anna Sjöberg	
	Nils Tunebjer	
Client:	Diners Club Credit Card, "The Psychic"	

A bride, who has been stood up at her wedding, visits a psychic to find out what has become of her future husband. She takes his jacket with her so that the woman can contact his spirit. Looking for something personal inside the jacket, the psychic finds the man's Diners Club card, which helps her to predict his eventual return. At the same time, we see the errant groom enjoying some final moments of freedom before he discovers that he has no credit card to pay the bill. "It's part of your personality," claims Diners.

Agency:	Delvico Bates, Madrid
Creative Directors:	Pedro Soler
	Enrique Astuy
Copywriters:	Nacho Santos
	Juan Carlos Salas
Art Director:	Angel Villalba
Client:	Sanitas
	Health Insurance

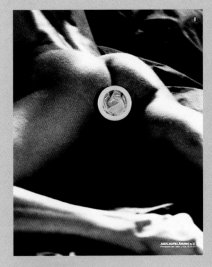

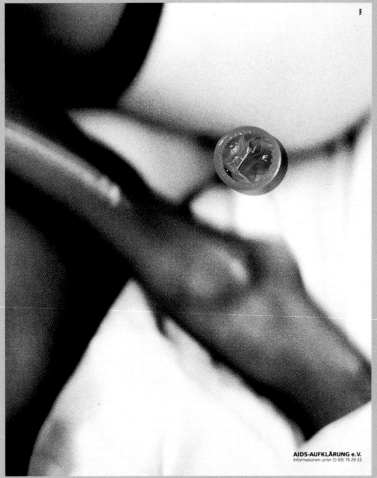

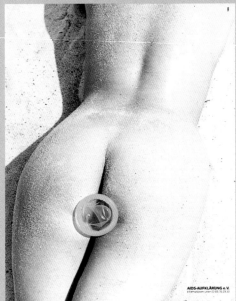

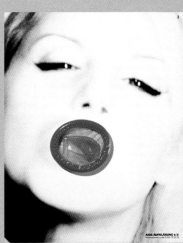

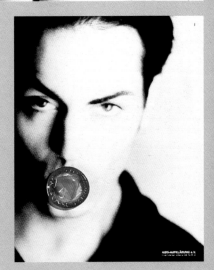

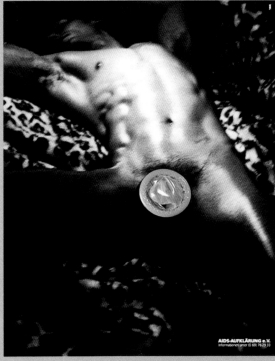

Public Interest

Agency:	Young & Rubicam, Frankfurt
Creative Directors:	Juergen Braun Reiner Dewenter Laszlo Körössy
Art Director:	Sven Klohk
Photographer:	Markus Nikot
Client:	Aids-Aufklärung, Aids Awareness Hotline

Agency:	FCB/Tapsa, Madrid
Creative Director:	Julian Zuazo
Copywriter:	Enrique Pigni
Art Director:	Julian Zuazo
Production:	Strange Fruit
Directors:	Enrique Caruncho
	Julian Zuazo
Producer:	Jesus Becedas
Client:	Once, "Wheelchair"

Two friends, David and Jamie, announce that they have just qualified as lawyers and are now looking for jobs. However, they explain, one of them will have more difficulty finding employment because he's in a wheelchair. The two men joke with each other but the audience never learns which of them is handicapped. "Does it matter?" the voice-off asks, since both are, "Ready, willing and able to form part of any team."

Soy locutora de radio.

Buscamos trabajo.

Cinco años estudiando juntas.

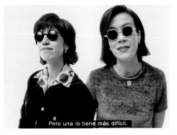

Pero una lo tiene más difícil.

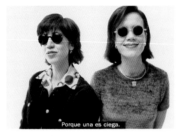

Porque una es ciega.

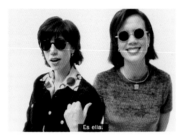

Es ella.

Soy Juan. Soy Paco.

Buscamos trabajo...

Qué más da cual sea sordo.

Tú no, soy yo.

Pero uno de los dos lo tiene más difícil...

Porque uno de los dos

es sordo.

Fundación ONCE
para la cooperación e integración social
de personas con minusvalías

ONCE

PREPARADOS. LISTOS. YA.

114 Public Interest

Agency:	FCB/Tapsa, Madrid
Creative Director:	Julian Zuazo
Copywriter:	Enrique Pigni
Art Director:	Julian Zuazo
Production:	Strange Fruit
Directors:	Enrique Caruncho
	Julian Zuazo
Producer:	Jesus Becedas
Client:	Once,
	"Blind" & "Deaf"

Two more commercials from the Once campaign featuring pairs of friends, one of whom is handicapped, but who both have the proper skills for the job they're seeking. Loisa and Carmen are trained radio announcers, but one of them is blind. Paco and Juan are computer experts, but one is deaf. Again, the audience never discovers which person is handicapped and is asked if this matters, since both are, "Ready, willing and able."

Agency:	Noordervliet & Winninghoff/	A contract and a death sentence, on two
	Leo Burnett, Amsterdam	consecutive pages, are separated by
Copywriter:	Herbert van Hoogdalem	a sheet of carbon paper to encourage
Art Directors:	Maarten Bakker	western companies to take human rights
	Edwin van Praet	into account when doing business with
Client:	Amnesty International	China.

The drunkest guys always wind up in trouble

The drunkest guys say the silliest things

The drunkest guys puke without warning

It's somethin' all girls know

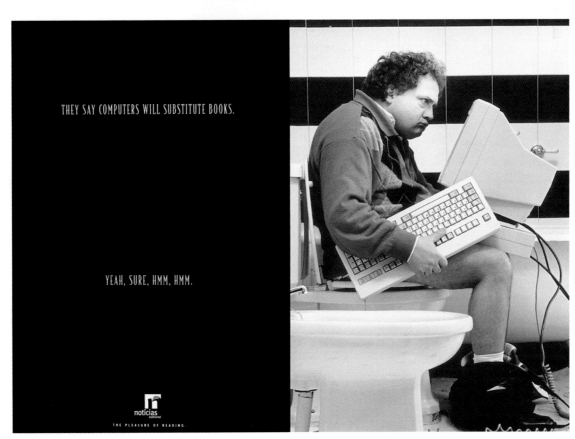

THEY SAY COMPUTERS WILL SUBSTITUTE BOOKS.

YEAH, SURE, HMM, HMM.

noticias
editorial

THE PLEASURE OF READING.

Agency:	JBR Parkveien, Oslo	A very drunk man, who's been in a fight,	
Copywriter:	Frode Karlberg	climbs into a taxi with a pretty girl.	
Art Director:	Eivind Solberg	He mumbles something into her ear and	
Production:	JBR Film	then vomits onto the floor. "The drunkest	
Director:	Peder Norlund	guys always wind up in trouble, tell silly	
Producer:	Jørgen Mjelva	stories and puke without warning," explains	
Client:	Community of Oslo,	the voice-off, while the girl gets out of the	
	Anti-Alcohol Campaign,	cab and walks away, "it's something all	
	"The Drunkest Guys"	girls know."	

Agency:	Edson Comunicação, Lisbon
Creative Director:	Edson Athayde
Copywriter:	Edson Athayde
Art Director:	Paulo Henrique Pereira
Photographer:	Francisco Aragão
Client:	Editorial Noticias, Reading Incentive Campaign

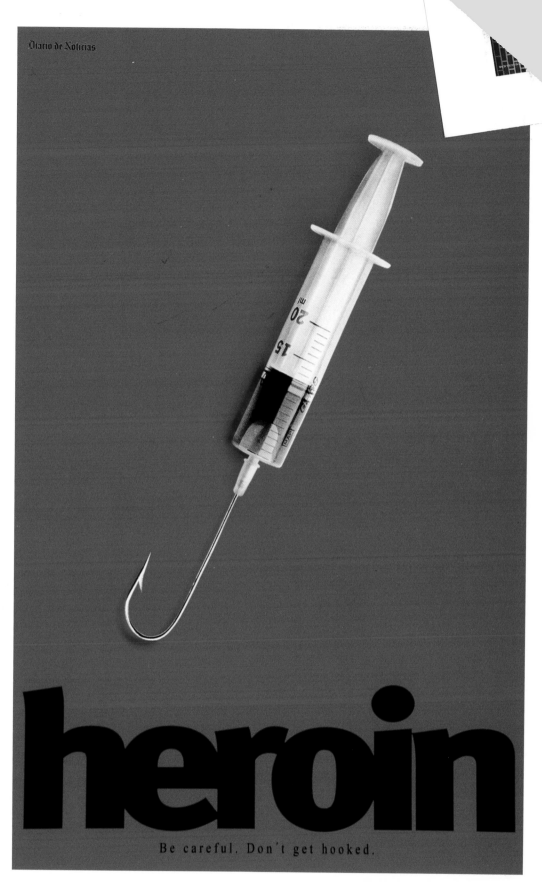

Agency:	Edson Comunicação, Lisbon
Creative Director:	Edson Athayde
Copywriter:	Edson Athayde
Art Director:	Paulo Henrique Pereira
Photographer:	Carlos Ramos
Client:	Diário de Noticias, Anti-Drugs

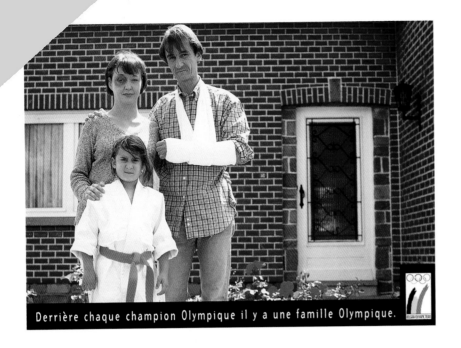

Derrière chaque champion Olympique il y a une famille Olympique.

It's hard to believe that someone you love, trust and hope to share a future with could have HIV without knowing... and infect you. Love him, trust him, but... **ASSUME NOTHING.**

The Terrence Higgins Trust
Helpline 0171 242 1010

"I'm HIV positive, I just assumed he was too. He never mentioned condoms."

"I think I'm negative. I assumed he was also, he didn't use condoms. If he had HIV he'd say... wouldn't he?" **ASSUME NOTHING.**

The Terrence Higgins Trust
Helpline 0171 242 1010

Agency:	Duval Guillaume, Brussels	Behind every Olympic champion, there's an Olympic family.
Creative Director:	Guillaume Van der Stighelen	
Copywriter:	Jens Mortier	
Art Director:	Philippe De Ceuster	
Photographer:	Frank Uyttenhove	
Client:	Belgian Olympic Committee	

Agency:	Spencer Landor, London
Art Directors:	Shaun Whelan Juliet Barclay
Photographer:	Peter Dazeley
Client:	The Terrence Higgins Trust, Aids Awareness

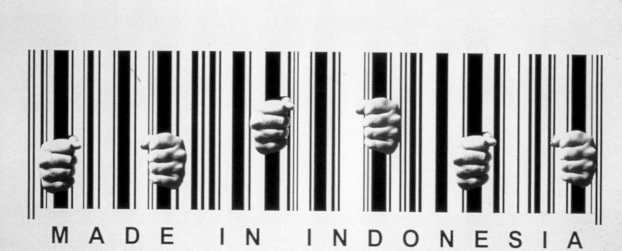

MADE IN INDONESIA

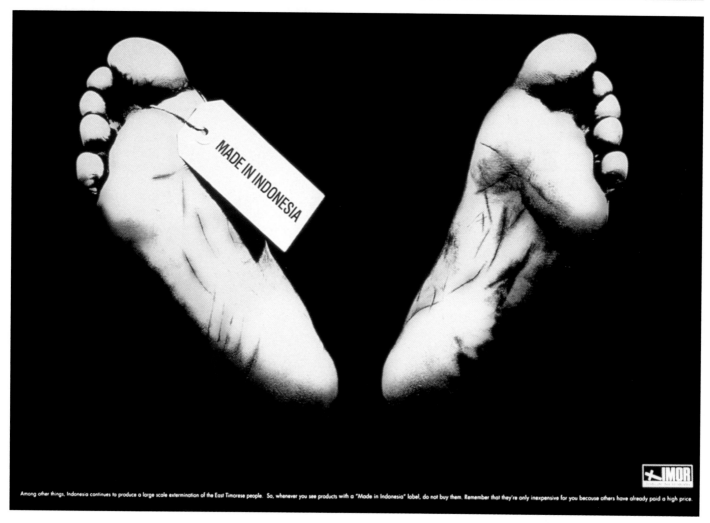

MADE IN INDONESIA

Among other things, Indonesia continues to produce a large scale extermination of the East Timorese people. So, whenever you see products with a "Made in Indonesia" label, do not buy them. Remember that they're only inexpensive for you because others have already paid a high price.

Agency:	Young & Rubicam, Lisbon
Creative Directors:	Elisabete Vaz Mena Cristiano Zancuoghi
Copywriter:	Elisabete Vaz Mena
Art Director:	Cristiano Zancuoghi
Client:	Union of Journalists, Human Rights in Timor

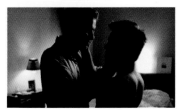

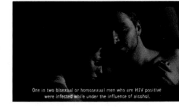

Agency:	Ambrosio & Maoloni, Rome	Mothers of mentally disabled adults hug their offspring and recite the words of a traditional Italian nursery rhyme; "Who shall I give this baby to? I'll give him to the man in black and for one month he won't be back." This association of relatives of disabled adults then changes the second refrain to: "I'll give him to his mother who'll sing him a lullaby," in order to challenge the indifference of people who consider the mentally disabled as abnormal.
Copywriter:	Gabriella Ambrosio	
Art Director:	Luca Maoloni	
Production:	Cineteam	
Director:	Valentina Torti	
Producer:	Aldo Raparelli	
Client:	ANFFAS, Association of Relatives of Disabled Adults, "Lullaby"	

Agency:	Garbergs Annonsbyrå, Stockholm	A heavy drinker picks up a woman in a bar and has sex with her, later he's seen kissing another man, eventually he returns home, quite drunk, and climbs into bed with his sleeping wife. The Swedish Health Institute points out that one in two bisexual or homosexual men who are HIV positive were infected while under the influence of alcohol, and asks, "Are you sober enough to have safe sex?"
Copywriter:	Jöns Hellsing	
Art Director:	Sven Dolling	
Production:	Pettersson & Åkerlund/ Anders Skog Film	
Director:	Anders Skog	
Producer:	Lars Pettersson	
Client:	National Institute of Public Health, Anti-Alcohol, "The Hangover"	

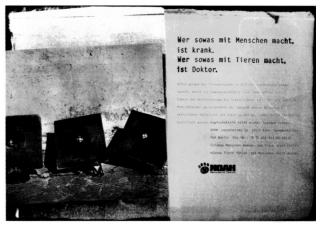

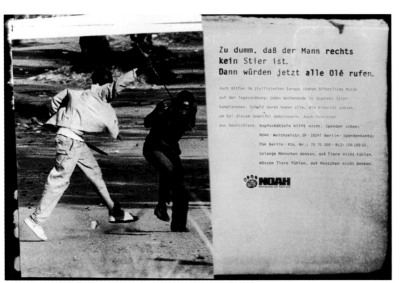

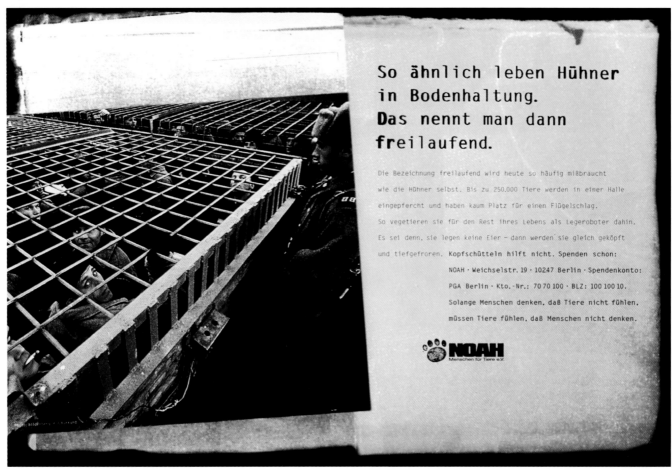

Agency:	JvM, Hamburg	Anyone who does this to people is sick.
Creative Director:	Hermann Waterkamp	Anyone who does this to animals is a scientist.
Copywriters:	Frank Dovidat	Too bad the man on the right isn't a bull.
	Thomas Wildberger	Then they'd all be shouting "Olé."
Art Director:	Lars Kruse	
Photographers:	Joseph E. Rock	Hens live in similar conditions.
	H. J. Burkard	They call it free-range.
Client:	Noah, Campaign Against Cruelty to Animals	

HANDLED WITH CARE

MARIE STOPES
VASECTOMY CLINIC
CALL IN CONFIDENCE 0800 590 390

Agency:	McCann-Erickson, Belfast	A police press conference focuses on the hunt for Ireland's most deadly serial killer. A criminal psychologist describes his profile: a typical middle-class family man, but with more than 400 victims to his credit. The press is shown video footage of a typical suspect under clinical observation: an ordinary-looking man is seen getting into a car, but once behind the wheel his pleasant demeanour is transformed into an expression of rage. "Speeding. Only you can stop the serial killer...inside."
Creative Directors:	David Lyle Julie Anne Bailie	
Copywriters:	David Lyle Julie Anne Bailie	
Production:	Toytown Films, Dublin	
Director:	Gerry Poulson	
Producers:	Celine Cawley Sonia Laughlin	
Client:	National Safety Council, "Serial Killer"	

Agency:	McCann-Erickson, Manchester
Creative Director:	Keith Ravenscroft
Copywriter:	Neil Lancaster
Art Director:	Dave Price
Photographer:	Geoff Smith
Client:	Marie Stopes· Vasectomy Clinics

This just might become true.

If you don't use a condom,

It's not funny - AIDS is deadly serious.

FREE PRESS

Article 19

Agency:	S Team Bates Saatchi & Saatchi Advertising Balkans, Belgrade
Creative Director:	Dragan Sakan
Copywriter:	Nadezda Milenkovic
Art Director:	Boris Miljkovic
Production:	S Team Production
Director:	Boris Miljkovic
Producer:	Dusan Ercegovac
Client:	Jazas, Aids Awareness, "God I'm Coming"

The leader strip at the end of a spool of film flips over the screen while a couple is heard making love in the background. The man's exclamation, "Oh God, I'm coming!" is followed by the warning that this might literally be true, without a condom.

Agency:	S Team Bates Saatchi & Saatchi Advertising Balkans, Belgrade
Creative Director:	Dragan Sakan
Copywriter:	Milos Ilic
Art Director:	Milos Ilic
Photographer:	Aleksandar Kujucev
Client:	Article 19, Free Press

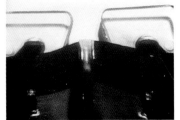

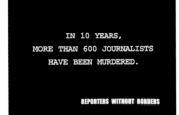

IN 10 YEARS,
MORE THAN 600 JOURNALISTS
HAVE BEEN MURDERED.

REPORTERS WITHOUT BORDERS

30 VISITORS
per day

ROMAN
remains

17th CENTURY
church

15 VISITORS
per day

City art
GALLERY

1 visitor
PER DAY

Medieval
CHURCH

2 VISITORS

Agency:	DDB, Paris	Typewriter keys punch out a series of full stops on a white sheet of paper. These are followed by three bullet holes, accompanied by the sound of gunshots, to make the point that more than 600 journalists have been murdered over the last decade.
Creative Director:	Christian Vince	
Copywriter:	Patrice Maire	
Art Director:	Jean Baptiste Chretien	
Production:	PAC	
Director:	Franck Vroegop	
Producer:	Antoine Granger	
Client:	Reporters Without Borders, "The Typewriter"	

Agency:	Saatchi & Saatchi Advertising, Rome	To help save Italy's artistic heritage from decay, the commercial shows abandoned sites and the number of visitors they receive each day. A run-down 17th century church has 30 visitors, but they're all rats. Roman remains attract 15 cats daily, while only one spider frequents a municipal art gallery, and a medieval church gets two visitors, but they're both looters. "There's one thing all of us can do for art," concludes Civita, "...not abandon it."
Creative Directors:	Luca Albanese Stefano Maria Palombi	
Copywriter:	Francesco Taddeucci	
Art Director:	Francesca Risolo	
Production:	Groucho Film	
Director:	Riccardo Paoletti	
Producers:	Giuliana Del Punta Lorella Stortini	
Client:	Civita, Protection of Italy's Artistic Heritage	

Campaign for non-violent toys

JUNTA DE ANDALUCIA canal sur

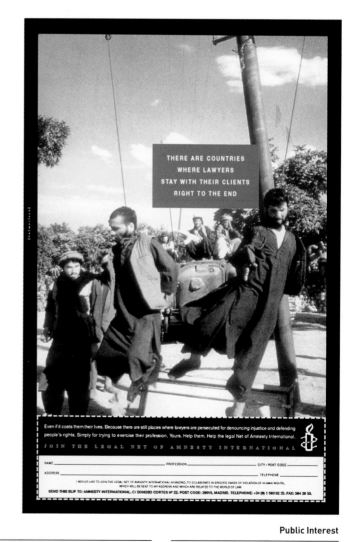

THERE ARE COUNTRIES
WHERE LAWYERS
STAY WITH THEIR CLIENTS
RIGHT TO THE END

Even if it costs them their lives. Because there are still places where lawyers are persecuted for denouncing injustice and defending people's rights. Simply for trying to exercise their profession. Yours. Help them. Help the legal Net of Amnesty International.

JOIN THE LEGAL NET OF AMNESTY INTERNATIONAL

NAME _____ PROFESSION _____ CITY / POST CODE _____
ADDRESS _____ TELEPHONE _____
I WOULD LIKE TO JOIN THE LEGAL NET OF AMNESTY INTERNATIONAL IN MADRID, TO COLLABORATE IN SPECIFIC CASES OF VIOLATION OF HUMAN RIGHTS, WHICH WILL BE SENT TO MY ADDRESS AND WHICH ARE RELATED TO THE WORLD OF LAW.
SEND THIS SLIP TO: AMNESTY INTERNATIONAL, C/ DONOSO CORTES Nº 22, POST CODE: 28015, MADRID. TELEPHONE: +34 (9) 1 593 02 33. FAX: 594 29 55.

Agency:	Contrapunto, Madrid	
Creative Directors:	Antonio Montero	
	Ana Hidalgo	
Copywriter:	Juan Silva Lopez	
Art Director:	Antonio Montero	
Production:	Puente Aereo	
Director:	Joan Cruells	
Producers:	Gemma Soler	
	Luis Felipe Moreno	
Client:	Junta de Andalucia,	
	Anti-Violence,	
	"Trafficker"	

The campaign for non-violent toys presents Santa Claus as an international criminal. "Between all of us we have made this man into one of the biggest arms dealers on the planet. He moves around with complete freedom year after year. With every act he commits, he contributes to the violence in our society."

Agency:	Valmorisco Comunicacion, Madrid
Creative Director:	Manolo Valmorisco
Copywriter:	Manolo Montes
Art Director:	Jose Antonio Bosch
Client:	Amnesty International

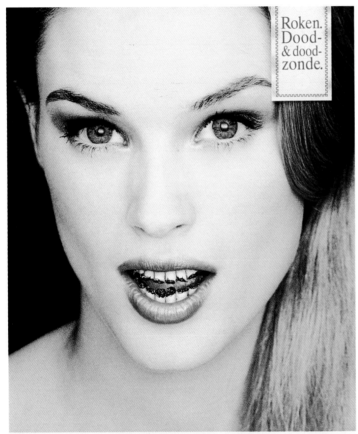

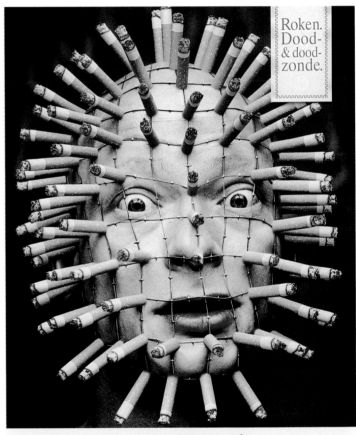

126 **Public Interest**

Agency:	Saatchi & Saatchi
	Advertising, Paris
Creative Director:	Gilles Soulier
Copywriter:	Edgard Montjean
Art Director:	Bertrand Pallatin
Producer:	Carole Potisk
Client:	SOS Racisme,
	"Colour Bars"

Normal commercial breaks are interrupted by this TV test-pattern, suggesting to viewers that something might be wrong with their sets. Then the following anti-racism text appears over the colour bars; "Do you have a problem with colours? Immediately adjust your brain."

Agency:	BvH, Rotterdam
Copywriter:	Erik Jousma
Art Director:	Ron Gessel
Photographer:	Gerdjan vander Lugt
Client:	Stivoro,
	Anti-Smoking
	Campaign

Smoking. Lethal habit, terrible waste.

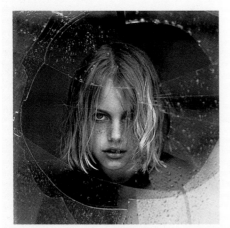

Vill du göra något åt våldet?
Missa inte årets viktigaste seminarium.

 Om.

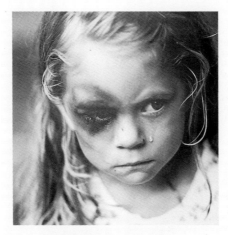

Om vi skall stoppa våldet
måste vi stoppa det där det börjar.

 Om.

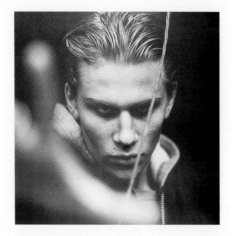

Han är rädd.
Därför är han farlig.

Mr. Aznar,
 Here are eight arguments for questioning the safety of the Almaraz nuclear power station.
 How many more do you need?

Strangely deformed new-born children. Birds with no eyes. Hundreds upon hundreds of men and women with cancer in their bones, in their skin. With leukaemia. Even cows with two heads. Isn't this enough? Isn't it time to look into what's happening at Almaraz? Be careful, Mr. Aznar. To support us, call 902 100 505. GREENPEACE

Agency:	HLR & Co/BBDO, Stockholm	Do you want to do something against violence?	Agency:	Grupo Barro-Testa, Madrid
Creative Director:	Torbjörn Lindgren		Creative Directors:	Urs Frick
Copywriter:	Lotta Åstrand	If we are to stop violence we have to stop		Uschi Henkes
Art Director:	Torbjörn Lindgren	it where it begins.		Manolo Moreno Marquez
Photographer:	Denise Grönstein		Copywriter:	Manolo Moreno Marquez
Client:	Skandia Insurance,	He's afraid. That's why he's dangerous.	Art Director:	Uschi Henkes
	Anti-Violence		Client:	Greenpeace,
	Campaign			Anti-Nuclear Campaign

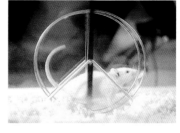

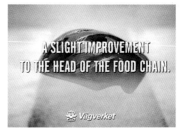

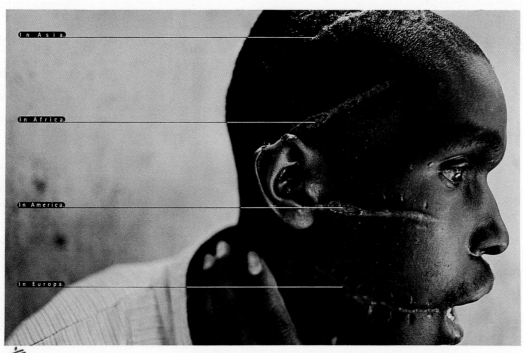

Agency:	Hjärta Reklambyrå, Stockholm	A tongue-in-cheek commentary on the creation of life: in the sea, in the air and on land. "At the head of the food chain God created man, and gave him intelligence;" we see a man, on his bicycle, crash into the opening door of a stationary truck. At this point the commentator appears and, looking up to heaven, asks God if this is really the best he can do. The sky darkens, lightning flashes, and the commentator is eliminated on the spot. The commercial recommends bicycle helmets as, "A slight improvement to the head of the food chain."	**Agency:**	Saatchi & Saatchi Advertising, Rome	Where there are wars, epidemics and natural disasters, we're there too. Every day, for 25 years, sowing up the world's wounds.
Creative Directors:	Anders Tempelman Ninna Ekbom		**Creative Directors:**	Luca Albanese Stefano Maria Palombi	
Copywriter:	Anders Tempelman		**Copywriter:**	Stefano Maria Palombi	
Art Director:	Ninna Ekbom		**Art Director:**	Grazia Cecconi	
Production:	Mekano Film & Television		**Photographer:**	James Nachtwey	
Director:	Mats Stenberg		**Client:**	Doctors Without Borders	
Producer:	Elisabeth Somp				
Client:	Swedish National Road Administration, "Arne vs. God"				

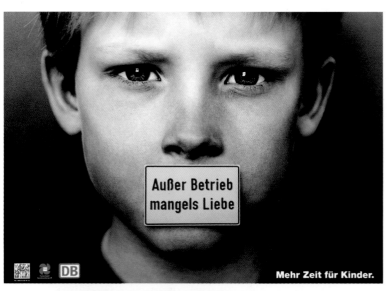

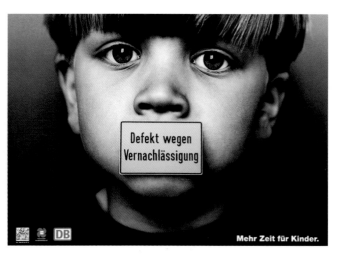

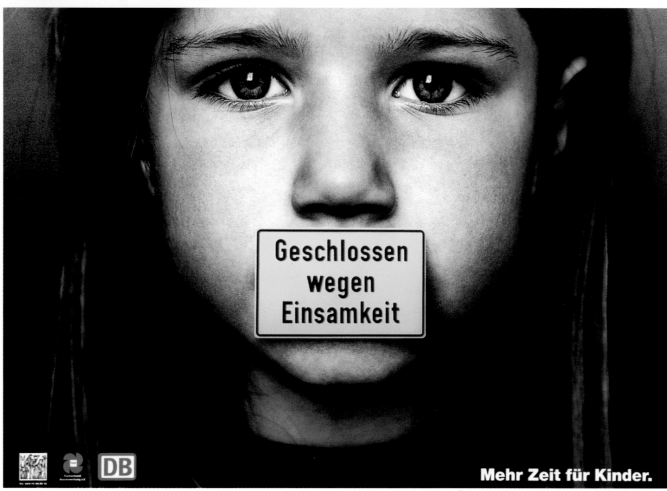

Agency:	JvM, Hamburg	Defective because of neglect.
Creative Director:	Stefan Zschaler	
Copywriter:	Martin Paesler	Out of order for lack of love.
Art Director:	Baerbel Biwald	
Photographer:	Antonina Gern	Closed because of loneliness.
Client:	Deutsche Bahn Medien, More Time for Children Campaign	

Agency:	The é Company, Stockholm	Mr. Green, a committed environmentalist, is still unaware of the pollution that belches from the exhaust pipe of his old car. His daughter is labelled "a little materialist" for suggesting that they buy a new car, and is made to walk home as punishment in a message from the Swedish car industry.	**Agency:** Begemot, Moscow
Creative Director:	Lars Norén		**Creative Director:** Pavel Poliantsev
Copywriter:	Lars Norén		**Copywriter:** Alexander Diakonov
Art Directors:	Håkan Sjöström, Jonas Bergström		**Art Director:** Sergey Diachenko
Production:	Jarowskij		**Photographer:** Mikhail Kocolev
Director:	Johan Rheborg		**Client:** Begemot, Human Rights in Belorussia
Producer:	Katharina Berggren		
Client:	The Swedish Car Industry, "Mr. Green's Off Again"		

TENEUR GARANTIE EN VITAMINES Aaah ET Hmm.

FORME ANATOMIQUE

LES PRÉSERVATIFS. LES AVEZ-VOUS TOUS ESSAYÉS ?

MANIX HOT RUBBER SOFT SOUTIENNENT L'ACTION DE AIDES **AIDES** Association de lutte contre le sida Reconnue d'Utilité Publique

LE PRÉSERVATIF EST UTILE À LA PRÉVENTION DES MALADIES SEXUELLEMENT TRANSMISSIBLES

HABILLE ÉGALEMENT L'HOMME FORT.

EASY OU KING SIZE

LES PRÉSERVATIFS. LES AVEZ-VOUS TOUS ESSAYÉS ?

MANIX HOT RUBBER SOFT SOUTIENNENT L'ACTION DE AIDES **AIDES** Association de lutte contre le sida Reconnue d'Utilité Publique

LE PRÉSERVATIF EST UTILE À LA PRÉVENTION DES MALADIES SEXUELLEMENT TRANSMISSIBLES

AVEC DE LA VANILLE ET TOUT PLEIN DE BONNES CHOSES DEDANS.

GOÛT VANILLE, COCO, FRAISE, MENTHE OU CHOCOLAT

LES PRÉSERVATIFS. LES AVEZ-VOUS TOUS ESSAYÉS ?

MANIX HOT RUBBER SOFT SOUTIENNENT L'ACTION DE AIDES **AIDES** Association de lutte contre le sida Reconnue d'Utilité Publique

LE PRÉSERVATIF EST UTILE À LA PRÉVENTION DES MALADIES SEXUELLEMENT TRANSMISSIBLES

Agency:	BDDP, Paris	Also available for the larger man.
Creative Director:	Jean-Pierre Barbou	
Copywriter:	Olivier Camensulli	Contains vitamins Aaah and Hmm.
Art Director:	Hervé Lopez	
Photographer:	Roger Turqueti	Vanilla flavoured and filled with lots
Client:	Aides,	of other good things.
	Aids Awareness	

BECAUSE AIDS EXISTS.
ABRAÇO

WATCH OUT
IT'S RIGHT UNDER
YOUR NOSE

COUP
DE TÊTE AU
FRONT
VOTE
JUNE FIRST

132 **Public Interest**

Agency:	TBWA EPG, Lisbon		**Agency:**	Hemisphere Droit, Paris
Creative Director:	Pedro Bidarra		**Creative Director:**	Frank Tapiro
Copywriter:	Gonçalo Moralis Leitão		**Copywriter:**	Frank Tapiro
Art Director:	Pedro Caixado		**Art Director:**	Pier Noel
Production:	Diamantino Filmes		**Client:**	Coup de Tête au Front
Producer:	Frederico Cerejeiro			
Client:	Abraço, Aids Awareness, "Vultures"			

Scenes alternate, in silence, between two young lovers and a hungry flock of vultures. When the man produces a condom the vultures realise they're out of luck and fly off, squawking. "Condoms compulsory - because Aids exists."

Agency:	S Team Bates Saatchi & Saatchi Advertising Balkans, Belgrade	**Agency:**	Clark & Taylor, London
Creative Director:	Dragan Sakan	**Creative Director:**	Rodger Williams
Copywriters:	Ana Vehauc	**Copywriter:**	Peter Evans
	Vera Stankovic	**Art Director:**	Barry Batchelor
Art Director:	Slavimir Stojanovic	**Client:**	Save the Children
Photographer:	Aleksandar Kujucev		
Client:	Save the Children		

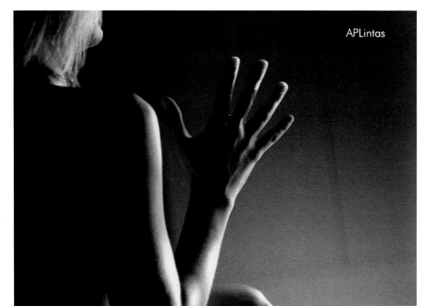

APLintas

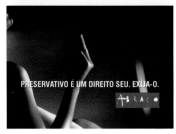

PRESERVATIVO É UM DIREITO SEU. EXIJA-O.

- Hello to you, hello to you, I said
since I hadn't quite made up my mind yet.

Want to talk to someone about bisexuality, homosexuality, HIV or safer sex?
Call the RFSL-information line: 08-736 02 19. Always use a condom. Avoid sperm in your mouth.

Agency:	Ammirati Puris Lintas, Lisbon	
Creative Director:	Leandro Alvarez	
Copywriter:	Leandro Alvarez	
Art Director:	Paal Myhre	
Production:	Diamantino Filmes	
Director:	Ricardo Albinãna	
Producers:	Alberto Rodrigues	
	Ana Rondão	
Client:	Abraço,	
	Aids Awareness,	
	"Fingers"	

A young woman checks off on her fingers the five things one should say to a man who doesn't want to use a condom: "No, you won't feel the difference, you're being selfish," and "I don't know who you've been with." She can't remember the fifth retort, but her finger gesture says it all. "No condom, no sex," concludes Abraco.

Agency:	Manne & Co., Stockholm
Copywriter:	Martin Stadhammar
Art Directors:	Sten Åkerblom
	Richard Baynham
	Kalle Haasum
	Oskar Wård
	Jan Stenmark
Client:	RFSL, Swedish Organisation for Homosexual Rights

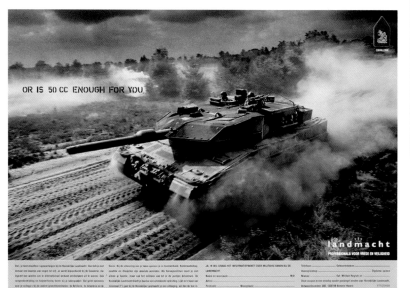

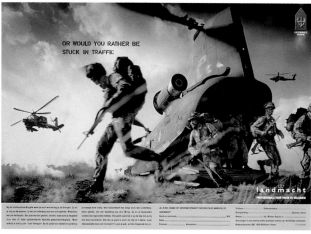

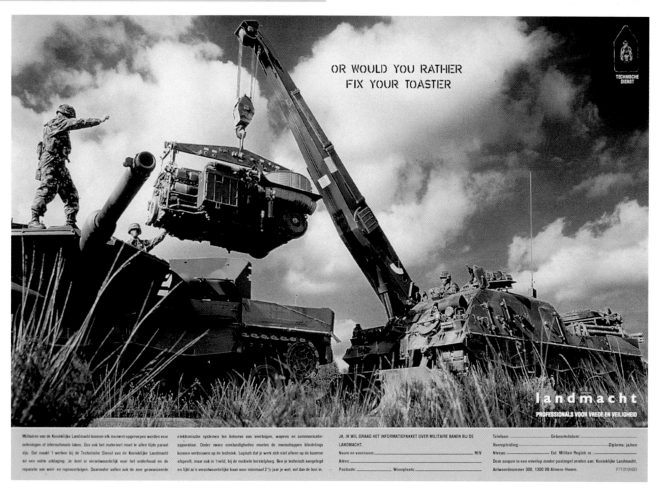

Agency:	DMB&B, Amsterdam
Creative Director:	Peter van den Engel
Copywriters:	Celine Rosier
	Robert Vierdag
Art Director:	Peter van den Engel
Photographer:	Boudewijn Smit
Client:	Royal Dutch Army
	Airborne Brigade,
	Recruitment

Both Sides of Peace

Israeli and
Palestinian
Political Posters
City Gallery of
Contemporary Art,
Raleigh,
North Carolina
December 7,
1996

Agency:	Clark & Taylor, London	An orca, crying with anguish, is trapped inside a sardine can to highlight the predicament of whales and dolphins that are confined in inadequate pools at marine parks throughout the world.	Agency:	Lemel Glazer Bar, Tel Aviv	NB: The connecting threads, in the colours of the Israeli and Palestinian flags, symbolise lines of communication between the two nations.
Creative Director:	Rodger Williams		Creative Director:	Yossi Lemel	
Copywriter:	Dave Smith		Copywriter:	Dana Bartelt	
Art Director:	Mike Holmes		Art Director:	Yossi Lemel	
Production:	Will van der Vlugt		Photographer:	Israel Cohen	
Director:	Jamie Courtier		Client:	City Gallery of Contemporary Art (Raleigh, N.C.), Political Poster Exhibition	
Producers:	Audrey Hawkins Sally Lipsius				
Client:	Whale & Dolphin Conservation Society				

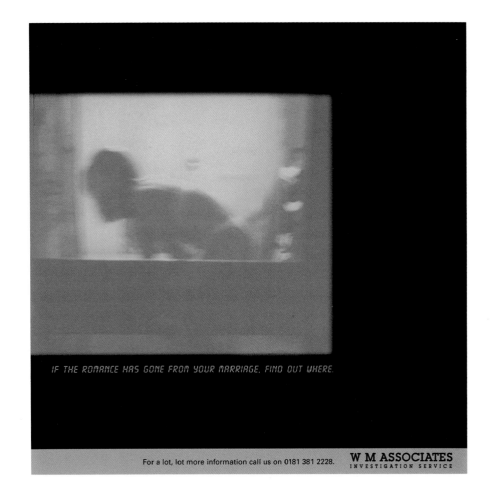

IF THE ROMANCE HAS GONE FROM YOUR MARRIAGE, FIND OUT WHERE.

For a lot, lot more information call us on 0181 381 2228.

W M ASSOCIATES
INVESTIGATION SERVICE

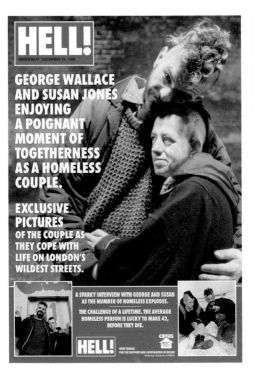

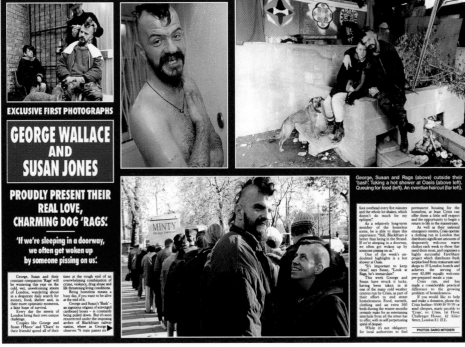

Agency:	Bates Dorland, London
Creative Director:	Chips Hardy
Copywriter:	David Prideaux
Art Director:	Nick Simons
Client:	WM Associates, Detective Agency

Agency:	Bates Dorland, London
Creative Director:	Tim Ashton
Copywriters:	Chips Hardy
	Tim Ashton
Art Director:	Tim Ashton
Photographer:	David Mitterdieri
Client:	Crisis, Charity for the Homeless

r ight

w rong

r ight

w rong?

r ight

w rong

GREENPEACE

Agency:	Generator, Stockholm	Line drawings and a life-like sound track tell the story of a man who is dragged away from his typewriter, tied-up, tortured and hung. "The world is sick," concludes Amnesty, while the film rewinds to the opening shot of the man and his typewriter, "but you can change it - join Amnesty International."
Creative Director:	Åsa Vesterlund	
Copywriter:	Helena Isacsson	
Art Directors:	Åsa Vesterlund Johan Perjus	
Production:	Pettersson & Åkerlund	
Director:	Emma Hvengaard	
Producer:	Lars Pettersson	
Client:	Amnesty International	

Agency:	FHV/BBDO, Amstelveen	It used to be easy to tell the difference between right and wrong, but the increasing use of toxics in today's world means that even innocent toys and some foodstuffs can be contaminated, resulting in more cancer and less fertility. A toxic-free life is a matter of choice, says Greenpeace, "Don't experiment with your body."
Copywriter:	David Snellenberg	
Art Director:	Pepijn Rooijens	
Production:	Spaghetti, Amsterdam	
Director:	René Nuijens	
Producers:	Imko Nieuwenhuys Christ Bloemheuvel	
Client:	Greenpeace, Anti-Toxic Ingredients, "Right and Wrong"	

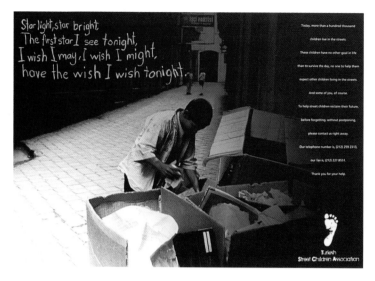

Star light, star bright
The first star I see tonight,
I wish I may, I wish I might,
have the wish I wish tonight.

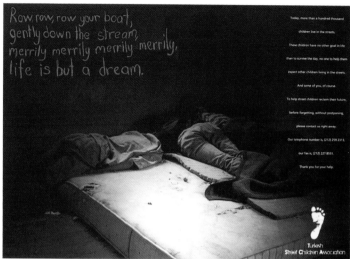

Row row, row your boat,
gently down the stream,
merrily merrily merrily merrily,
life is but a dream.

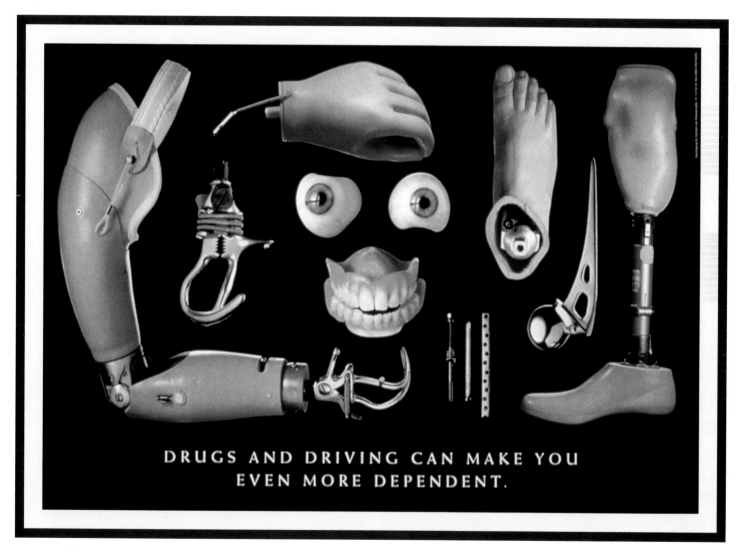

DRUGS AND DRIVING CAN MAKE YOU
EVEN MORE DEPENDENT.

Agency:	Ajans Ultra Reklam
	Hizmetleri, Istanbul
Creative Director:	Hakki Misirlioglu
Copywriter:	Liza Sardinas
Art Director:	Ulas Eryavuz
Photographer:	Monica Fritz
Client:	Sokak Çocuklari
	Vakfi, Foundation for
	Homeless Children

Agency:	McCann-Erickson,
	Geneva
Creative Director:	Frank Bodin
Copywriter:	Stefan Gigon
Art Director:	Urs Hartmann
Photographer:	Urs Maurer
Client:	Union of Families
	of Traffic Accident
	Victims

Agency:	Abbott Mead Vickers BBDO, London	A one-legged Asian girl gathers massive support as she treks from her home to Ottawa for the ratification of an international treaty banning anti-personnel land mines. "Is your country going to sign?" asks the Red Cross.
Production:	Tony Kaye & Partners	
Director:	Jason Harrington	
Producer:	Paul McPadden	
Client:	Red Cross, Anti-Land Mines, "Journey"	

Agency:	Saatchi & Saatchi Advertising, London	An older woman describes the effects of hard drugs in great detail and explains the different ways that crack and heroin can be taken. One is convinced that she's an experienced user or a recovering addict, until the camera pulls back to reveal her Salvation Army uniform. "First we have to understand people's problems, then we try to solve them," explains the charity. "Nice people, nasty job."
Creative Directors:	Adam Kean Alexandra Taylor	
Copywriter:	Joel Bradley	
Art Directors:	Phil Clarke Roger Kennedy	
Production:	Tony Kaye & Partners	
Director:	Graham Cornthwaite	
Producers:	Yvonne Chalk Arnold Pearce	
Client:	Salvation Army, "Drugs"	

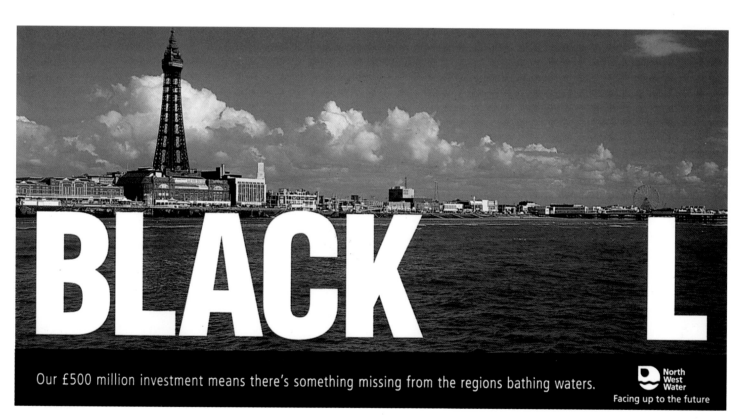

Our £500 million investment means there's something missing from the regions bathing waters.

North West Water

Facing up to the future

Agency:	Arks Advertising, Dublin	**Agency:**	BDH Communications, Manchester
Creative Director:	Killian O'Donnell		
Copywriter:	Killian O'Donnell	**Creative Director:**	Al Dickman
Art Director:	Carol Lambert	**Copywriter:**	Gary Hulme
Photographer:	Dave Campbell	**Art Director:**	Ken Davies
Client:	Voices for Peace	**Photographer:**	Roy Chonchie
		Client:	North West Water Authority

STADSMISSIONEN I GÖTEBORG
Pg: 90 02 09–8

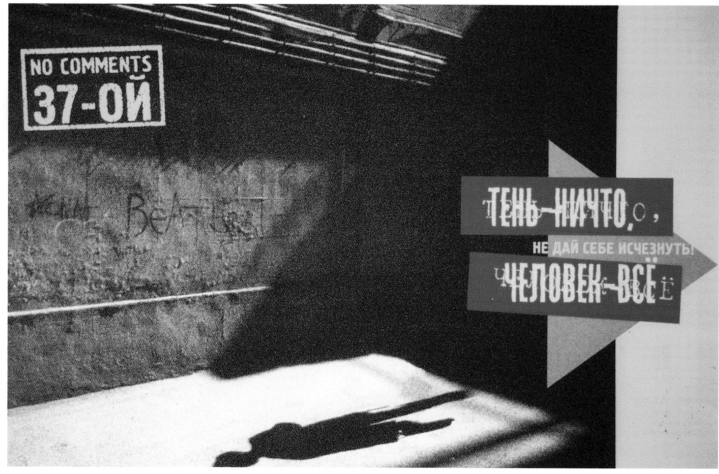

Agency:	Peppar & Co., Gothenburg	Agency:	C-Pro Production, Moscow	The shadow is nothing, the individual is everything. Don't let yourself disappear.
Creative Director:	Anders Wallin	Creative Director:	Aleksey Fadeev	(The text is based on a Russian proverb,
Copywriter:	Daniel Röjnemark	Copywriter:	Andrey Bychkov	while the number 37 refers to the Soviet
Art Director:	Fredrik Ganslandt	Art Director:	Aleksey Andreev	repressions of 1937).
Photographer:	Christer Ehrling	Photographers:	Aleksey Fadeev	
Client:	Stadsmissionen i Göteborg, Christmas Support for the Homeless		Nikolay Orlov	
		Client:	C-Pro Production	

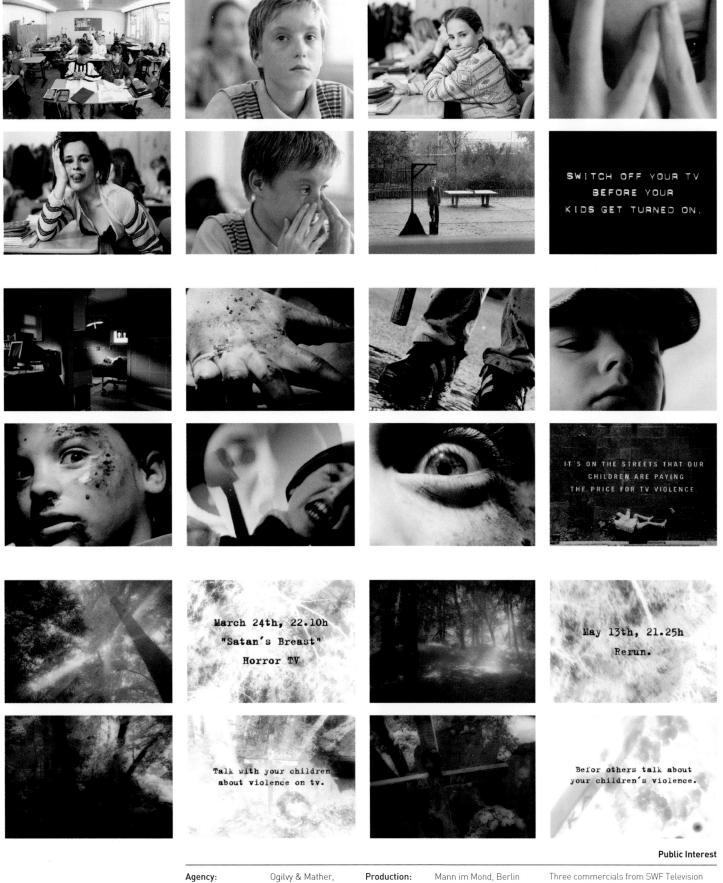

Agency:	Ogilvy & Mather, Frankfurt	**Production:**	Mann im Mond, Berlin Dieter Eikelpoth,

Three commercials from SWF Television to protest against excessive violence on TV and to encourage greater parental involvement. In "Daydream," a schoolboy is terrified by visions of TV violence transposed into his classroom. "Blue Eyes" shows the hospitalised young victim of a pre-teen street gang attack. In "Rerun," a horror movie is announced for a certain date on TV and is re-enacted live, some weeks later, resulting in the ritual killing of a young girl.

Agency: Ogilvy & Mather, Frankfurt
Creative Directors: André Aimaq, Dietmar Reinhard, Delle Krause
Copywriters: André Aimaq, Felix Glauner, Christoph Herold
Art Directors: Dietmar Reinhard, Delle Krause

Production: Mann im Mond, Berlin, Dieter Eikelpoth, Dusseldorf, Filmhaus, Vienna
Directors: Nico Beyer, Dieter Eikelpoth, Victor Dittrich
Producers: Uli Beyer, Janina Steiner, Thomas Brunner
Client: SWF Anti-Violence in Media, "Daydream", "Blue Eyes" & "Rerun"

Stomach Cancer

Prostate Cancer

Breast Cancer

It's much easier to cut out meat

According to the World Cancer Research Fund, cancer affects one in three people.

And, on Friday, the Government issued a warning that eating meat can increase your risk of cancer, while eating more fresh fruit and vegetables can help prevent the disease. In fact, a study published in the British Medical Journal estimates that vegetarians have up to 40% less risk of becoming victims.

Adopting a vegetarian diet can be easier than you might think. And if you don't know where to start, we're here to help.

Our free starter pack is full of information, advice and superb recipes. If you'd like one, call us on 0161 928 0793. You might decide that meat, like cancer, is best avoided.

THE VEGETARIAN SOCIETY
Feeding you the facts.

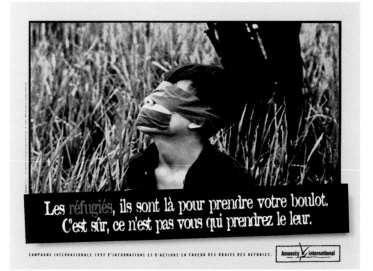

Les réfugiés, ils sont là pour prendre votre boulot. C'est sûr, ce n'est pas vous qui prendrez le leur.

CAMPAGNE INTERNATIONALE 1997 D'INFORMATIONS ET D'ACTIONS EN FAVEUR DES DROITS DES REFUGIES.

Amnesty international

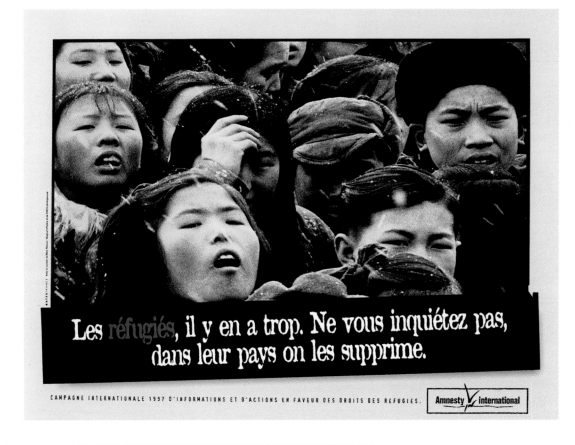

Les réfugiés, il y en a trop. Ne vous inquiétez pas, dans leur pays on les supprime.

CAMPAGNE INTERNATIONALE 1997 D'INFORMATIONS ET D'ACTIONS EN FAVEUR DES DROITS DES REFUGIES.

Amnesty international

Agency:	OgilvyOne Worldwide, London	**Agency:**	Bates France, Paris
Creative Director:	Rory Sutherland	**Creative Director:**	Jean-Claude Davallan
Copywriter:	Graham Daldry	**Copywriter:**	Mehdi Elalj
Art Director:	Harvey Lee	**Art Director:**	Ivan Pierens
Client:	The Vegetarian Society	**Photographers:**	Paul Schutzer
			Marc Riboud
		Client:	Amnesty International

Refugees are out to take your job.
But would you take theirs?

Too many refugees? Not for long.
They're being eliminated at the source.

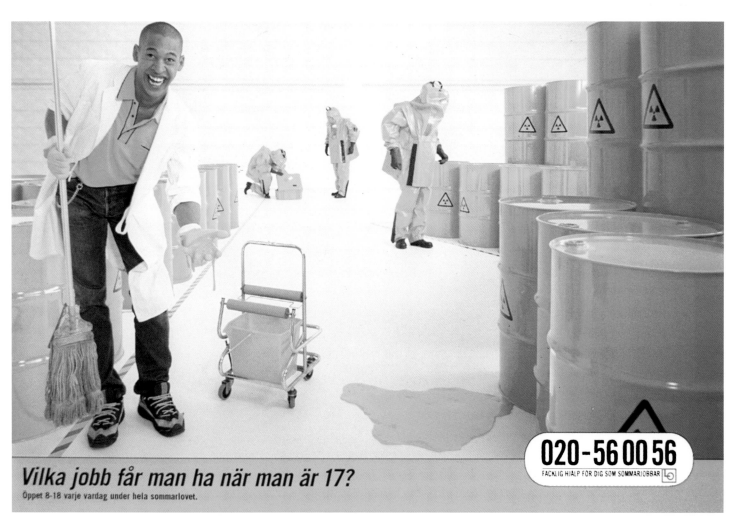

Vilka jobb får man ha när man är 17?
Öppet 8-18 varje vardag under hela sommarlovet.

020-56 00 56
FACKLIG HJÄLP FÖR DIG SOM SOMMARJOBBAR

Agency:	Lemel Glazer Bar, Tel Aviv	
Creative Director:	Yossi Lemel	
Copywriter:	Yossi Lemel	
Art Director:	Yossi Lemel	
Client:	Amnesty International	

Agency:	Annonsbyrå 3, Stockholm	What sort of job can you have at 17?
Copywriter:	Fredrik Dahlberg	
Art Director:	Mathias Wikström	
Photographer:	Toby Maudsley	
Client:	Swedish Trade Union Council, Youth Employment Rights.	

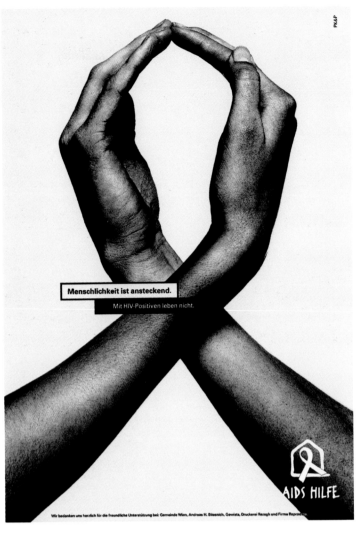

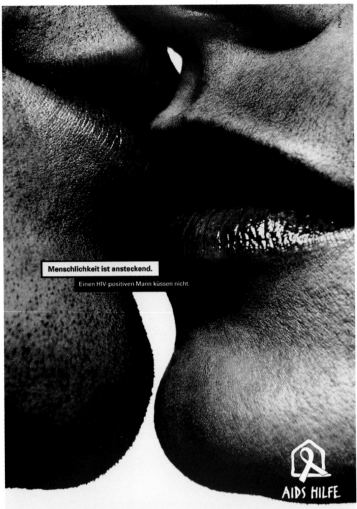

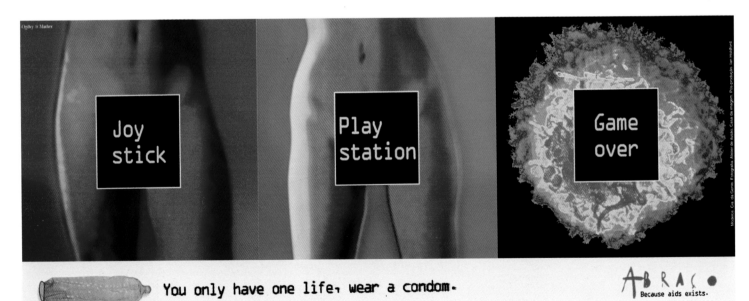

Agency:	Palla, Koblinger & Partner, Vienna	Humanity is infectious. Living with someone who's HIV positive is not.	
Creative Director:	Roman Sindelar		
Copywriter:	Annemarie Mitterhofer	Humanity is infectious. Kissing an HIV positive man is not.	
Art Director:	Bernd Fliesser		
Photographer:	Andreas Bitesnich		
Client:	Aidshilfe, Aids Awareness		

Agency:	Ogilvy & Mather, Lisbon
Creative Director:	José Manuel Abrantes
Copywriter:	Carlos Silva
Art Director:	Pedro Oliveira
Client:	Abraço, Aids Awareness

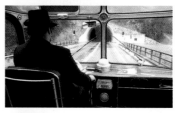

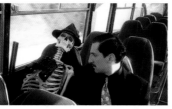

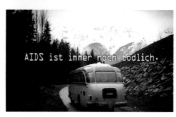

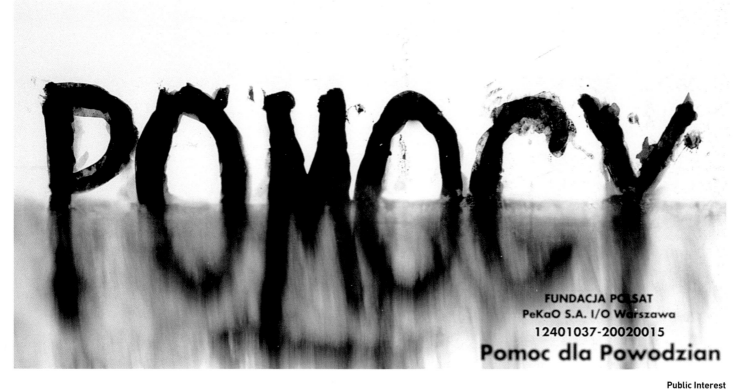

Agency:	McCann-Erickson, Frankfurt	
Creative Directors:	Hartmut Gruen	
	Peter Schenk	
Copywriters:	Gisela Brückl	
	Martin Hagemeier	
Art Directors:	Michael Ohnrich	
	Christina Spira	
Production:	Cineteam	
Director:	Emir Kusturica	
Client:	Aidshilfe Frankfurt, Aids Awareness, "Magic Bus"	

A collection of marginal characters wait for a bus. Two of them make love behind the shelter while another man injects himself. Once on the bus, the characters start to disappear every time the bus goes through a tunnel: a gay couple vanish completely while an old hunter is reduced to a skeleton. Eventually the driver goes too and only a small baby remains on the bus as a reminder that, "Aids is still deadly."

Agency:	Leo Burnett, Warsaw
Creative Director:	Jonathan Hoffman
Copywriter:	Darek Wojciechowski
Art Director:	Michak Bobrowski
Client:	Polsat Foundation, Flood Relief Campaign

Help (for flood victims).

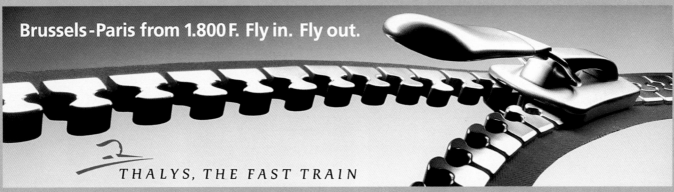

Brussels-Paris from 1.800 F. Fly in. Fly out.

THALYS, THE FAST TRAIN

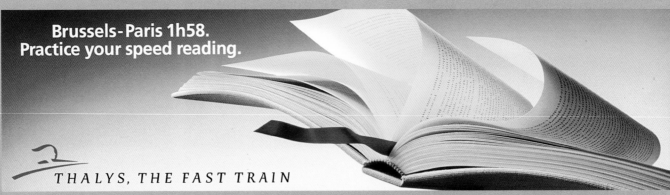

Brussels-Paris 1h58.
Practice your speed reading.

THALYS, THE FAST TRAIN

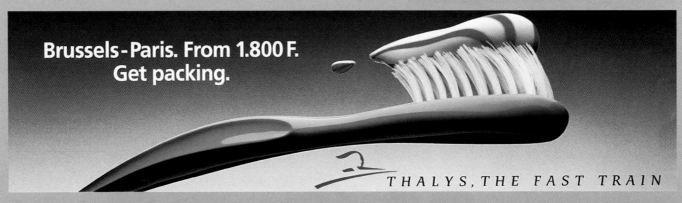

Brussels-Paris. From 1.800 F.
Get packing.

THALYS, THE FAST TRAIN

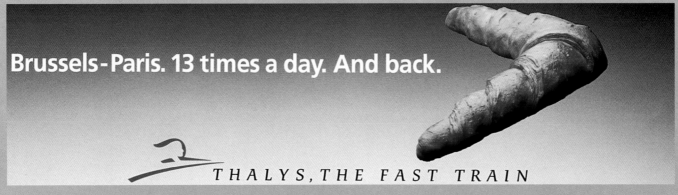

Brussels-Paris. 13 times a day. And back.

THALYS, THE FAST TRAIN

148　**Transport & Communication**

Agency:	Ogilvy & Mather, Brussels
Creative Director:	Mark Hilltout
Copywriters:	Ian Brower
	Jan Parys
	Olivier Roland
	Bill Bilquin
Art Director:	Geert Joostens
Photographer:	Frank Uyttenhove
Client:	Westrail, Thalys Fast Trains

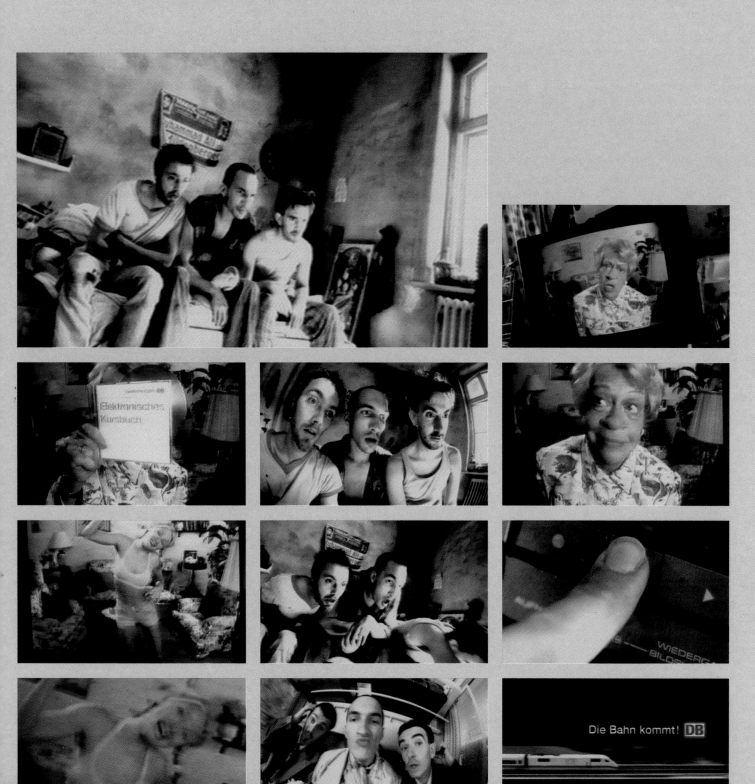

Agency: JvM, Hamburg
Creative Director: Stefan Zschaler
Copywriters: Bernhard Lukas
 Sabine Manecke
Art Director: Oue Gley
Production: Markenfilm, Wedel
Director: Veit Helmer
Producers: Glenn Bernstein
 Henning Stamm
Client: Deutsche Bahn,
 "Grandma"

Grandmother sends a video message to her three grubby grandsons in Munich. She complains that they never visit her in Hamburg and reminds them of the low fares on German Railways. As a clever afterthought, the woman mentions that their cousin is staying with her and a sexy blonde jumps into the picture, waving at the boys. They do a double-take and reach for the rewind button in unison. Cut to the three boys on their way to Hamburg, all spruced up and looking their best.

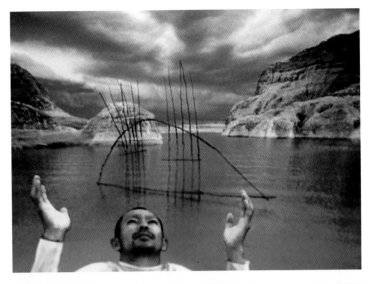

AEROFLOT
Russian International Airlines

TAKING OFF

Agency: Saatchi & Saatchi, London
Production: Tony Kaye & Partners
Director: Erick Ifergan
Producer: Meredyth Frattolillo
Client: Delta Airlines, "My Word"

People all over the world write one or two words on slips of paper and let them float into the sky on helium balloons. A hostess is seen carefully placing the slips of paper on airline seats, the words read: home, the wedding, Rebecca, the thrill etc. "There are many reasons to fly today, but only one that matters to you. At Delta Airlines it's our pleasure to get you to the place you want to be."

Agency: Premier SV, Moscow
Creative Director: Juri Bokser
Copywriters: Nicolai Sosnovsky
Juri Bokser
Art Director: Ilia Klimov
Photographer: Michail Coroliov
Client: Aeroflot Airlines

This is what we say to pollution.

RATP
LA MEILLEURE FAÇON D'AVANCER.

(No caption).

RATP
LA MEILLEURE FAÇON D'AVANCER.

Another ad for the underground.

RATP
LA MEILLEURE FAÇON D'AVANCER

Agency:	Euro RSCG Babinet Erra Tong Cuong, Paris	This is what we say to pollution. (M stands for the Métro but also for "merde": shit).
Creative Director:	Rémi Babinet	No comment (no traffic jams on the underground).
Copywriter:	Gabriel Gaultier	
Art Director:	Hervé Riffault	
Photographer:	Denys Vinson	Another ad for the underground. RATP.
Client:	RATP, Paris Metro System	The best way to get ahead.

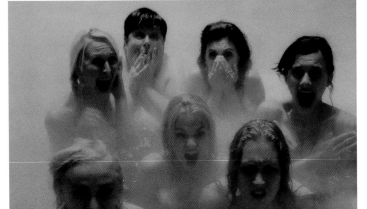

Amsterdam and beyond.

KLM AirUK Fly from East Midlands Airport to 150 destinations worldwide. Call **0990 074 074** or contact your local travel agent.

Agency:	Euro RSCG Babinet Erra Tong Cuong, Paris	A man walks into a Turkish bath dressed in nothing but a towel, and finds himself	**Agency:**	Carlson, London
Creative Director:	Rémi Babinet	face to face with a crowd of naked women.	**Creative Directors:**	Alan Docherty
Copywriter:	Fabrice Dubois	If he'd looked in the Yellow Pages, he		Joe Fraine
Art Director:	Sophie Legendre	would have known that it was Ladies Day.	**Copywriter:**	Joe Fraine
Production:	Big Production		**Art Director:**	Mike Molyneux
Directors:	David Fauche		**Client:**	KLM/Air UK, East
	Mathieu Mantovani			Midlands Route
	Julien Rambaldi			
Producers:	Pierre Rambaldi			
	Anne Girod			
Client:	Yellow Pages, "Hamman"			

Agency:	Rönnberg McCann, Stockholm	"There's a new word for luxury. . .Haikko"
		"Selma & Lovisa"
Copywriter:	Staffan Ryberg	"Alice in Wonder (Fin) Land"
Art Director:	Oscar Liedgren	"Let your HAIR down here"
Client:	Silja Line Cruises	"Out of Finland"
		"The Cruise"
		"Shopping Crazy"
		"Helsinki"

What you would never do in your place,

please don't do in ours.

Agency:	JvM, Hamburg	An ordinary middle class family nonchalantly soils their living room by extinguishing cigarettes on the floor, knocking over drinks, sticking chewing gum on the furniture and urinating on the carpet. "What you would never do in your place, please don't do in ours," requests the German Railways as part of their "clean station" initiative.
Creative Director:	Stefan Zschaler	
Copywriter:	Bernhard Lukas	
Art Director:	Holger Bultmann	
Production:	Neue Sentimental Film	
Director:	Johan Kramer	
Producers:	Karoline Kousidonis Claudia Wiencke	
Client:	Deutsche Bahn, "At Home"	

Agency:	Ammirati Puris Lintas, Hamburg	A young poser takes his date for a ride in his newly restored convertible. The windows and the aerial work, but the electric soft-top creates havoc. The angry girl abandons him, maybe he should have consulted the experts. "The Yellow Pages make life easier."
Creative Directors:	Michael Bondzio Christian Franke	
Copywriter:	Peer Hartog	
Art Director:	Gerd Schulte Döinghaus	
Production:	Final Touch	
Director:	Marius Holst	
Producer:	Gerhard Leppen	
Client:	Yellow Pages, "Convertible"	

795 WORDS ON WHY YOU SHOULD USE DUBLIN BUS.

DUBLIN BUS
CHANGING WITH THE CITY

A subsidiary of **Córas Iompair Éireann**

A couple of lines on the advantages of Dublin Bus.

A subsidiary of **Córas Iompair Éireann**

DUBLIN BUS
CHANGING WITH THE CITY

Agency:	DDFH&B Advertising, Dublin
Creative Director:	Ronnie Trouton
Copywriter:	Kevin Murry
Art Director:	Steve Browning
Client:	Dublin Bus Services

 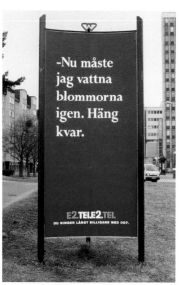

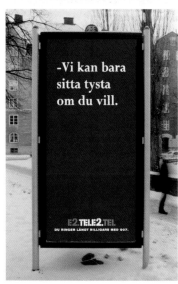 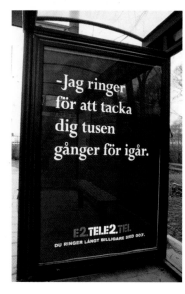 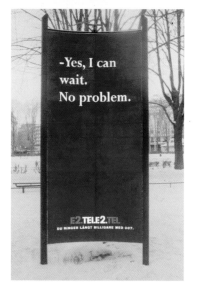

Agency:	Paradiset DDB,	– Now I've got to change ear again.
	Stockholm	– OK, now I've scrambled the eggs. Then what?
Creative Director:	Joakim Jonason	– It's me again.
Copywriter:	Linus Karlsson	– I won't hang up before you tell me that you love me.
Art Director:	Paul Malmström	– Aren't I a clever one who can count up to a hundred, grandma?
Photographer:	Peter Gehrke	– Now I have to water my flowers again. Hold on.
Client:	Tele2	– We can just sit in silence if you want.
	Telecommunications	– I'm calling to thank you a thousand times for yesterday.

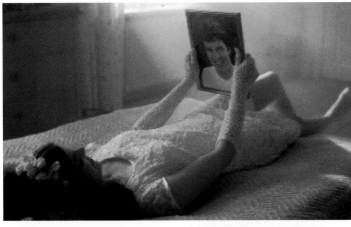

Agency:	Observera/Grey, Stockholm
Copywriter:	Roland Norell
Art Director:	Magnus Wretblad
Production:	Blink Productions, London
Director:	Pat Holden
Producers:	Stephen Blink
	Erika Edman
Client:	Scandinavian Airlines System, Domestic Youth Fares, "Goin' Home"

A boy's car breaks down on the way to visit his fiancée so he decides to continue the long journey on foot. Meanwhile the girl is inundated by other suitors, mostly unacceptable. After a while she concludes that her man has abandoned her and settles on a persistent nerd who's the best of the bunch. Then, ensconced on the porch with her spouse, the boyfriend eventually turns up, much to her chagrin. "Don't waste people's lives," advises Scandinavian Airlines, announcing inexpensive youth fares.

Agency:	Stenström & Co., Stockholm
Copywriter:	Olle Zackrisson
Art Director:	Bertil Aström
Production:	Jarowskij
Director:	Rolf Sohlman
Producers:	Kerstin Anderson
	Lars-Göran Uddman
Client:	Telia Telecom, Internet Services, "Benny"

Benny, a travelling computer salesman, visits a rural village to introduce its inhabitants to the Internet. "You'll need a little box to convert computer language into telephone signals," he explains patiently. "Modem," comments an old farmer, and poor Benny soon discovers that almost the entire village is already on the net, thanks to Telia Telecom's "Internet for everybody," policy.

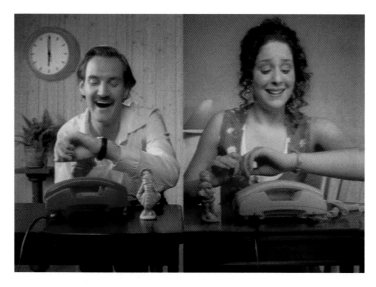

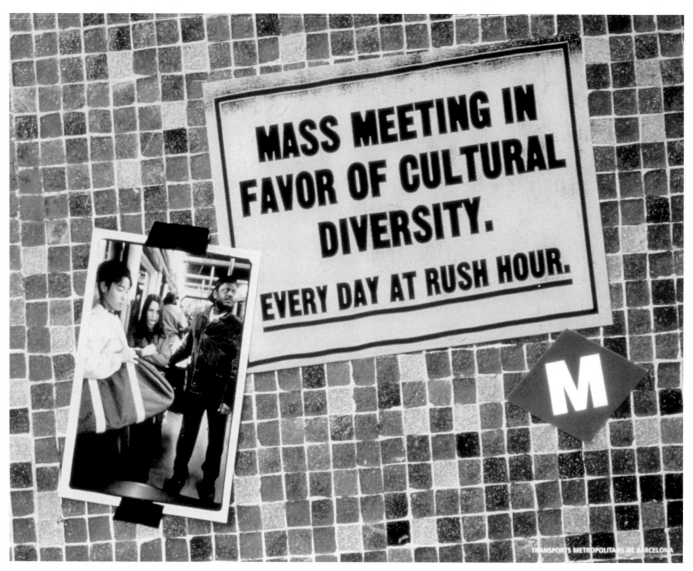

Agency:	Allansson & Nilsson, Gothenburg	A man and a woman wait eagerly beside their telephone while the seconds tick down to 6pm. Precisely on the hour they call each other, only to hear the busy tone. The spot announces half-price calls after 6 o'clock.	Agency:	Delvico Bates, Barcelona
Creative Director:	Magnus Wikman		Creative Directors:	Julio Wallovits
Copywriter:	Olof Gustafsson			Elvio Sanchez
Art Director:	Christer Allansson		Copywriter:	Julio Wallovits
Production:	Jarowskij		Art Directors:	Elvio Sanchez
Director:	Magnus Wikman			Pau Serra
Producers:	Karl Wessblad		Photographer:	Domingo
	Jessica Linder			Perez Torres
	Ulf Nilsson		Client:	Barcelona
Client:	Telia Nära, Telecommunications			Underground

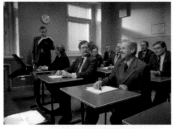

Minicall Pager
With or without vibrations

vett och etikett med mobiltelefon **trevligare telefoni i trafiken**

Låt gärna mobiltelefonen vila om du inte har **fler** angelägna nyheter att berätta än att du sitter på bussen.

vett och etikett med mobiltelefon **trevligare telefoni på lokal**

Prata **helst** med den du dansar med.

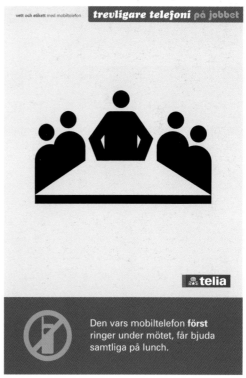

vett och etikett med mobiltelefon **trevligare telefoni på jobbet**

Den vars mobiltelefon **först** ringer under mötet, får bjuda samtliga på lunch.

Agency:	Allansson & Nilsson, Gothenburg	A girl in a canteen, a businessman at a seminar and a young man in a library draw attention to themselves by giggling and twitching from time to time. The commercial announces new mini-pagers, available with or without vibrations.	**Agency:** Morgondagen, Stockholm **Client:** Telia Mobile Phones
Copywriter:	Olof Gustafsson		
Art Director:	Patrick Waters		
Production:	Jarowskij		
Producers:	Magnus Wikman Jessica Linder Ulf Nilsson		
Client:	Telia Nära, Mini-Pager, "Vibrations"		

Your call from the bus should say more than that you're calling from the bus.

Talk to the person you're dancing with instead.

The person whose mobile rings first has to treat everyone else to lunch.

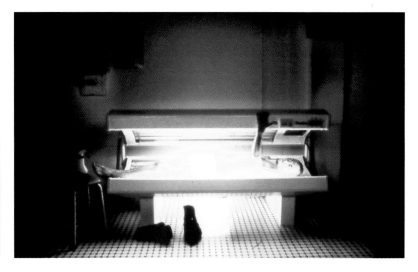

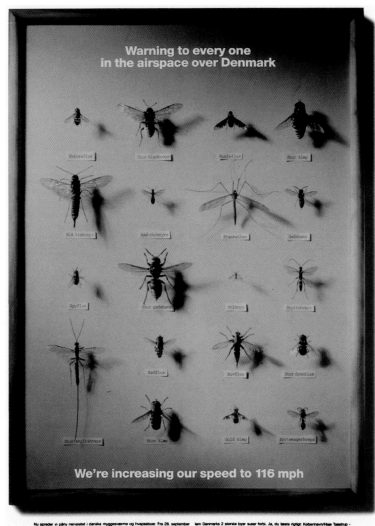

Agency:	Michael Conrad & Leo Burnett, Frankfurt
Creative Directors:	Christophe Barth Stefan Karl
Copywriter:	Lisa Schaller
Art Director:	Natalie Schommler
Production:	Laszlo Kadar Films, Hamburg
Director:	Laszlo Kadar
Producers:	Barbara Kranz Maresi McNab
Client:	Condor Vacation Carrier, "Solarium"

A man closes the lid of his sunbed and relaxes. The powerful Turbo-Tanner 5000 starts humming and blue solar lights glow. Then the poor man sneezes and the lid falls, trapping him inside the machine. His attempts to free himself result in the control panel falling off and he's reduced to timid calls for help. "Need some sun?" asks Condor, the vacation airline.

Agency:	Young & Rubicam, Copenhagen
Creative Directors:	Peder Schack Flemming Slebsager
Copywriter:	Flemming Slebsager
Art Director:	Peder Schack
Photographer:	Christian Gravesen
Client:	Danish Railways, Intercity Passenger Trains

Får vi lov att föreslå en kryssning istället?
Spanska Veckor i mars. Från 72 kronor.

Med en spansk meny, flamenco, tapas, musik, dans, specialimporterade viner och shopping hjälper vi dig att frosta av lagom till den kommande våren. Vår populära Viking Buffé har också fått en spansk touch. Mellan 1 och 26

mars har vi avgångar varje dag från Stockholm till Åbo och Helsingfors. Söndag t.o.m. onsdag reser du för halva priset. Vi har också förmånliga buss & båt-paket från många orter utanför Stockholm. Välkommen ombord och till bords.

OLÉ) VIKING LINE

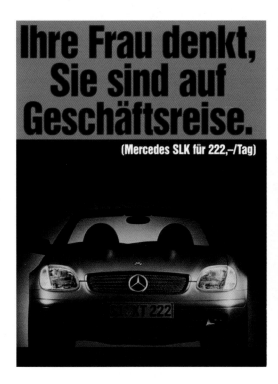

Ihre Frau denkt, Sie sind auf Geschäftsreise.

(Mercedes SLK für 222,–/Tag)

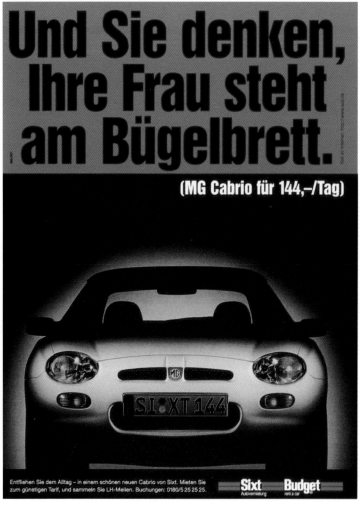

Und Sie denken, Ihre Frau steht am Bügelbrett.

(MG Cabrio für 144,–/Tag)

Entfliehen Sie dem Alltag – in einem schönen neuen Cabrio von Sixt. Mieten Sie zum günstigen Tarif, und sammeln Sie LH-Meilen. Buchungen: 0180/5 25 25 25.

Sixt Autovermietung **Budget** rent a car

Agency:	Hollingworth/ Mehrotra, Stockholm	Might we suggest going on a cruise instead. Spanish week in March, from
Creative Director:	Frank Hollingworth	72 SEK (receipts for a frozen paella and
Copywriter:	Hans Malm	a video rental total 72 SEK).
Art Director:	Max Munck	
Client:	Viking Line Cruises	

Agency:	JvM, Hamburg	Your wife thinks you're on a business trip.
Copywriters:	Stefan Meske	
	Sebastian Hardieck	And you think your wife's ironing.
Art Director:	Thomas Pakull	
Photographer:	Andreas Burz	
Client:	Sixt Car Rentals	

And we call her Narcis.

Bulbs *It is planting time again.*

They grow up so fast.

Bulbs 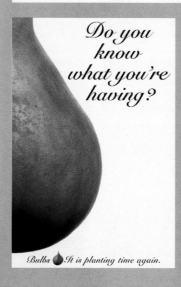 *It is planting time again.*

A new addition at the Tulip family.

Bulbs It is planting time again.

Do you know what you're having?

Bulbs It is planting time again.

Agency:	DSDS, Amsterdam
Copywriter:	Ton Druppers
Art Director:	Rob Sluijs
Photographer:	Dirk Karsten
Client:	Internationaal Bloembollen Centrum, Flower Bulbs

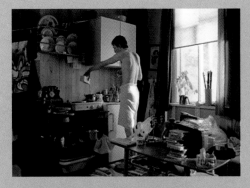
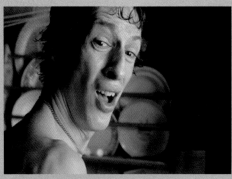

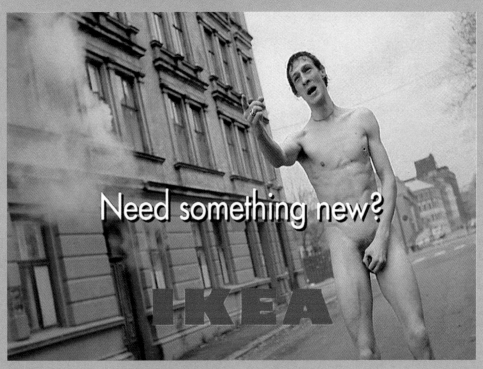

Need something new?

IKEA

Agency:	New Deal DDB, Oslo	
Copywriter:	Knut Georg Andresen	
Art Director:	Tone Garmann	
Production:	Big Deal Film	
Director:	Calle Åstrand	
Producer:	Turind Øversveen	
Client:	Ikea Furniture & Furnishings, "Bad Day"	

Everything that can go wrong, goes wrong, in rapid succession, for this young bachelor who has just started his breakfast. First his milk boils over, then a leg comes off the kitchen table and a cupboard falls off the wall. He manages to throw a towel over the saucepan but it catches fire, while the helpless man holds up the table with one hand and the cupboard with the other. He then notices his car being towed away in the street below. "Need something new?" asks Ikea.

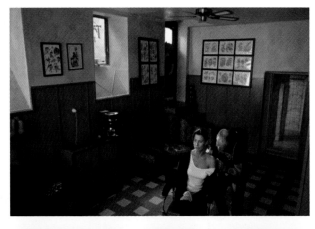

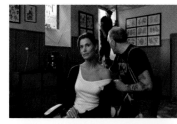

WE HAVE GIVEN ELECTRICITY TO
THE SWEDES SINCE 1909

VATTENFALL

164 **Home Furnishings & Appliances**

Agency:	Och, Stockholm
Copywriter:	Lennart Häger
Art Director:	Lars Liljendahl
Photographer:	Tomas Boman
Production:	Easy Film, Copenhagen
Director:	Johan Gulbranson
Producer:	Martin Elley
Client:	Vattenfall, Energy Supplier, "Tattoo" & "The Plank"

A tattoo artist is working on a woman's shoulder when a collegue comes in and unplugs his electric needle in order to make some coffee. The artist and his client turn simultaneously towards the unwelcome visitor who quickly reconnects the power. When the woman turns back to face the camera, we discover that she now also has a neat moustache tattoo.

A second Vattenfall commercial features a carpenter who is drilling a hole in a small plank when a fellow construction worker inadvertently unplugs his tool. The angry carpenter holds up his drill to complain, with the bit still embedded in the piece of wood. When the power is restored, the plank spins and wallops the man's head. Both spots remind Swedes that Vattenfall has supplied them with electricity since 1909.

Agency:	Ogilvy & Mather, Amsterdam	Habitat opens largest store in Largest Port (Grootste Havenstad means literally, Largest Port).	
Creative Directors:	Willem van Harrewijen Mike Weinberg		
Copywriter:	Willem van Harrewijen		
Art Director:	Mike Weinberg		
Photographer:	Paul Ruigrok		
Client:	Habitat Home Furnishings		

Agency:	Alice, Paris	It's not only spring that makes the Habitat nouvelle cuisine so fresh.	
Creative Director:	Jacques Vauchelle		
Copywriter:	Catherine Beroff		
Art Director:	Marie Jose Mathez		
Photographer:	Christian Kettiger		
Client:	Habitat Home Furnishings		

altrex
Insist on Altrex.

60% of all casualties take place in and around the house.

WE RE-
BEDS AS WELL. AND
DINNING TABLES AND
SITS AND BEDSIDE
STORE
TABLES. BOOKSHELVES,
DESKS AND CHESTS. WE
WILL RESTORE ANY
WARD-
PIECE OF FURNITURE.
ONLY FURNITURE.
WHATEVER ITS SIZE.
ROBES

EL TALLER
DE
SUSANA

Agency:	Noordervliet & Winninghoff/ Leo Burnett, Amsterdam	
Creative Director:	Raymond Waltjen	
Copywriter:	Mark van den Bergh	
Art Director:	Raymond Waltjen	
Photographer:	Carlfried Verwaayen	
Client:	Altrex Household Ladders	

60% of all casualties take place in and around the home.

Agency:	Grupo Barro-Testa, Madrid
Creative Directors:	Urs Frick
	Uschi Henkes
	Manolo Moreno Marquez
Copywriter:	Alberto Delgado
Art Directors:	Judith Francisco
	Maria Nieto
Client:	El Taller de Susana, Furniture Restoration

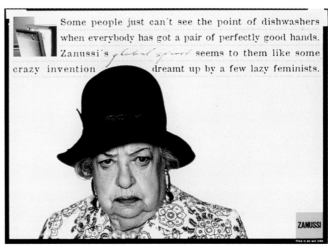

Some people just can't see the point of dishwashers when everybody has got a pair of perfectly good hands. Zanussi's *global spirit* seems to them like some crazy invention dreamt up by a few lazy feminists.

ZANUSSI
Time is on our side

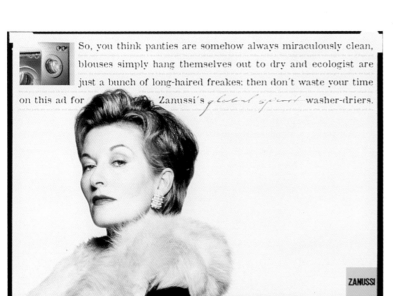

So, you think panties are somehow always miraculously clean, blouses simply hang themselves out to dry and ecologist are just a bunch of long-haired freakes: then don't waste your time on this ad for Zanussi's *global spirit* washer-driers.

ZANUSSI
Time is on our side

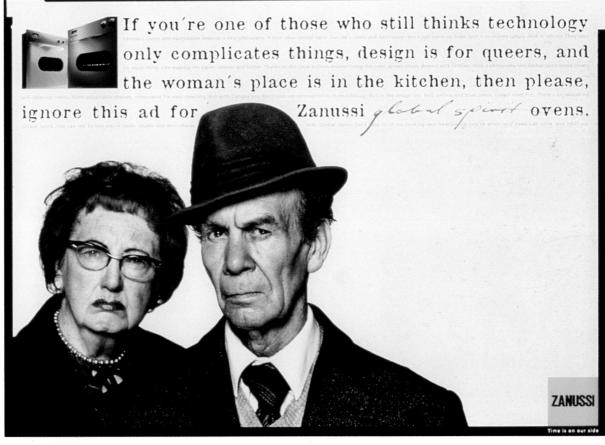

If you're one of those who still thinks technology only complicates things, design is for queers, and the woman's place is in the kitchen, then please, ignore this ad for Zanussi *global spirit* ovens.

ZANUSSI
Time is on our side

Agency:	Grupo Barro-Testa, Madrid
Creative Directors:	Urs Frick
	Uschi Henkes
	Manolo Moreno Marquez
Copywriter:	Manolo Moreno Marquez
Art Director:	Uschi Henkes
Photographer:	Javier Salas
Client:	Zanussi Dishwashers

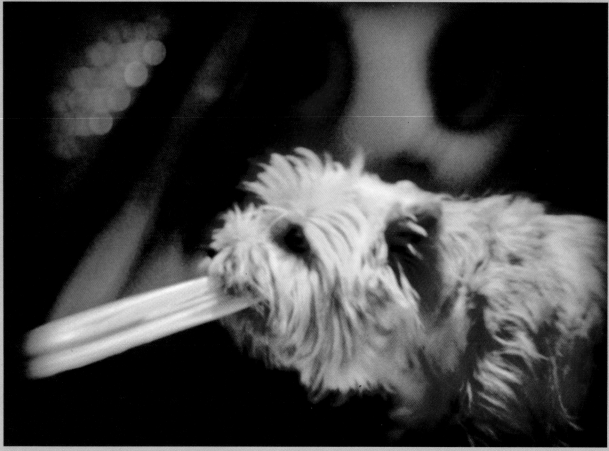

Agency:	TBWA, Paris	A laboratory technician demonstrates that
Creative Directors:	Christophe Coffre	a Mapa rubber glove can stretch up to six
	Nicolas Taubes	times its original size. A small dog grabs
Copywriter:	Christophe Coffre	the inflating glove and a tug-of-war ensues.
Art Director:	Nicolas Taubes	The dog stretches the glove to its limit
Production:	Movie Box	before it catapults the poor animal back
Director:	Enda McCallion	across the screen. "Do humans really need
Producer:	Bob Dutertre	such a glove?" wonders Mapa, who point
Client:	Mapa Rubber Gloves,	out that there's nothing stronger.
	"The Dog"	

VIZIR FUTUR EN POUDRE

Enlevez les taches de transpiration sans vous faire suer.

NOUVEAU! futur VIZIR

LA FORCE VIZIR CONTRE LE PIRE

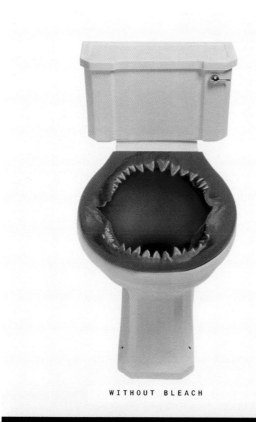

WITHOUT BLEACH

WITH BLEACH

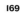

Only El León bleach guarantees the cleanliness and total germ-free condition of the toilet or of anything else that requires full disinfection.

THERE'S NO DANGER WITH BLEACH.

Agency:	Grey, Paris	Remove perspiration stains with no sweat.	**Agency:**	TBWA, Barcelona
Creative Directors:	Antoine Barthuel		**Creative Directors:**	Joan Teixidó
	Daniel Fohr			Kike Fernández
Copywriter:	Olivier Henry		**Copywriter:**	Kike Fernández
Art Director:	Mathias Gaillard		**Art Director:**	Marielo Gil
Client:	Procter & Gamble,		**Photographer:**	Vicente San Nicolás
	Vizir Futur		**Client:**	Lejía El León Bleach
	Laundry Detergent			

Sadolin Robust. Makes wood even stronger.

Sadolin Prestige. Makes wood even stronger.

170 **Household Maintenance**

Agency:	Foote, Cone & Belding, London	Agency:	TBWA, Brussels
Creative Director:	John Bacon	Creative Director:	Andre Rysman
Copywriter:	Pete Cayless	Copywriter:	Eric Maerschalck
Art Director:	Mitchell Gumbley	Art Director:	Erik Vervroegen
Illustrator:	Andy Lennard	Photographer:	Jean-Pierre van der Elst
Client:	Raid, Domestic Insecticide	Client:	Sadolin, Wood Treatment Products

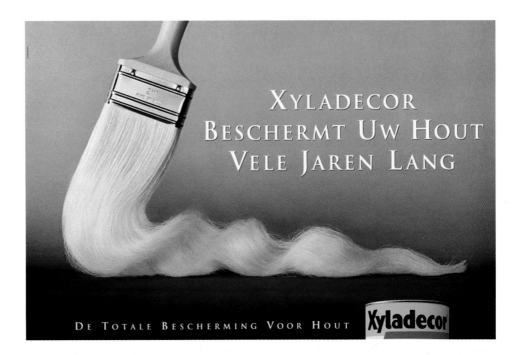

XYLADECOR BESCHERMT UW HOUT VELE JAREN LANG

DE TOTALE BESCHERMING VOOR HOUT **Xyladecor**

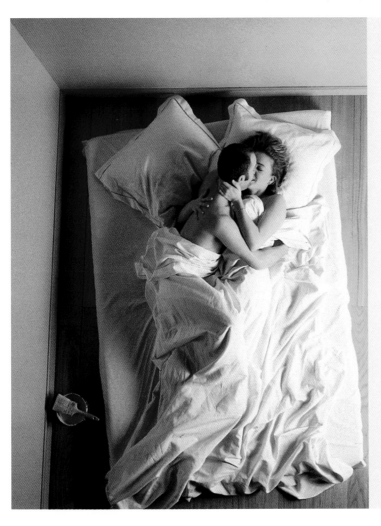

**Repeignez votre chambre à 19h30.
Baptisez-la à 20h.**

PEINTURE MONOCOUCHE.
SÈCHE EN 30 MINUTES.

Les bonnes choses n'attendent pas. Voici donc la peinture Chambre et Séjour créée

par Astral. Elle est sans odeur, très facile à appliquer, et sèche en trente minutes.

De plus, elle est monocouche, que vous la préfériez mate ou satinée. Et pour varier

un peu les plaisirs, notre peinture est disponible en une cinquantaine de teintes.

astral

De la matière grise dans les couleurs.

Agency:	Euro RSCG United, Brussels	Xyladecor protects your wood for a very long time.
Creative Director:	Veronique Hermans	
Copywriter:	Frederik Dewispelaere	
Art Director:	Minou Van de Kerckhove	
Photographer:	Hans Kroeskamp	
Client:	Xyladecor, Wood Treatment Products	

Agency:	Jean & Montmarin, Paris	Paint your bedroom at 7:30 pm. Celebrate it at 8:00 pm.
Creative Director:	Gérard Jean	
Copywriter:	Olivier Couradjut	
Art Director:	Rémy Tricot	
Photographer:	Bruno Suet	
Client:	Astral House Paints	

Audiovisual Equipment & Accessories

Agency:	S Team Bates Saatchi & Saatchi Advertising Balkans, Belgrade
Creative Director:	Dragan Sakan
Copywriter:	Slavimir Stojanovic
Art Director:	Slavimir Stojanovic
Client:	Sony Walkman

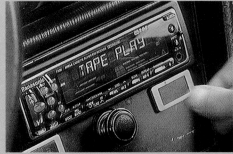

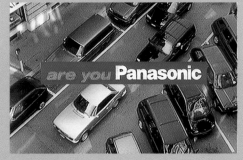

Agency:	Honegger/von Matt, Zürich
Creative Director:	David Honegger
Copywriter:	Claudia Fehringer
Art Directors:	Dany Bieri
	Susan Gehrig
Production:	Wirz & Fraefel
Director:	Ernst Wirz
Producer:	Stefan Fraefel
Client:	Panasonic Automobile Sound Systems, "The Power of Panasonic"

A man runs out of petrol in heavy city traffic and soon provokes a cacophony of honking horns from the impatient motorists behind. He calmly slips a rap tape into his Panasonic in-car sound system and the loud beat of the music bounces his car forward in leaps and starts.

Nécessaire de voyage

CAMESCOPE A ECRAN COULEUR

SONY

Agency:	Lansdown Conquest, London	**Agency:**	DDB, Paris
Creative Directors:	Simon Frank	**Creative Director:**	Christian Vince
	John Trainor	**Copywriter:**	Guislain de Villoutreys
Copywriter:	Dave Bell	**Art Director:**	Olivier Courtemanche
Art Director:	Jim Bucktin	**Photographer:**	Philip Habib
Photographer:	Alastair Thain	**Client:**	Sony Video Cameras
Production:	SVC, London		
Director:	Alastair Thain		
Producers:	Ben Hills		
	Eileen Quirke		
Client:	Nikon F5 Camera		

Black and white footage shows an elderly woman visiting the seaside. The quality of the images is excellent but one has the impression that the movement is not quite seamless. The voice-off explains, "You are watching a modern-day miracle because this film was shot on a camera that only takes stills." It's the Nikon F5, technically the quickest camera in the world.

The traveller's necessities.

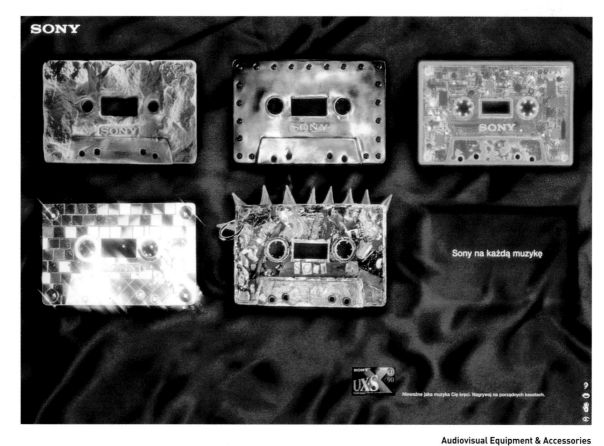

Agency:	Bates Belgium, Brussels	A pair of babies cry miserably while watching two different children's programmes on a JVC split-screen television. A woman calmly switches their positions on the sofa, while the voice-off explains that now everyone can watch their favourite programmes at the same time on the same screen. Once they are sitting opposite the programmes of their choice the two babies start to giggle with joy.	**Agency:**	Leo Burnett, Warsaw	Sony, for any kind of music.
Creative Director:	Gert Mahieu		**Creative Directors:**	Jonathan Hoffman	
Copywriter:	Gert Mahieu			Darek Zatorski	
Art Director:	Andre Plaisier		**Copywriter:**	Leszek Kwiatkowski	
Production:	Zabriskie		**Art Director:**	Darek Zatorski	
Director:	Patrick van Hautem		**Photographer:**	Sebastian Hanel	
Client:	JVC Twin TVs, "Babies Cool"		**Client:**	Sony Audio Tapes	

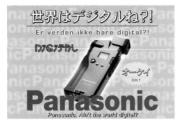

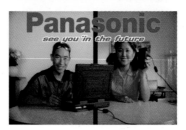

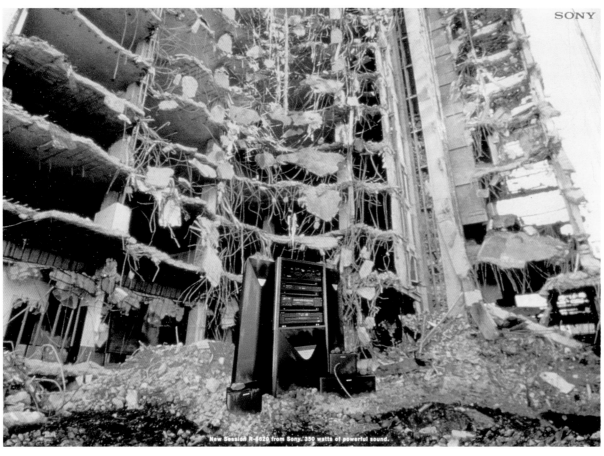

176 **Audiovisual Equipment & Accessories**

Agency:	Umwelt Advertising, Copenhagen
Creative Director:	Smike Käszner
Copywriter:	Christian Nielsen
Art Director:	Frank Andersen
Production:	Locomotion
Director:	Peder Pedersen
Producers:	Rasmus Ejlers
	Mif Damgaard
Client:	Panasonic Digital Still Camera, "Separated and Yet Together"

Yamato and Kyoko present the advantages of Panasonic's digital cameras, in Japanese with sub-titles. A split-screen helps them imagine that he's in Copenhagen, telephoning her in Osaka. He asks what she's doing and she claims to be in bed, but she's too shy to tell him what she's wearing. "Then show me," says Yamato, and Kyoko modestly moves off-screen to take a picture of herself which she then pretends to send him over the Internet. "Wow!" exclaims Yamato, as he reaches over to the other side of the screen for a better view. "See you in the future," they conclude, with laughter.

Agency:	Tandem Campmany Guasch DDB, Barcelona
Creative Director:	J. L. Rois
Copywriter:	J. L. Rois
Art Directors:	Jürgen T. Krieger
	Jaume Badia
Client:	Sony New Session, Hi-Fi Equipment

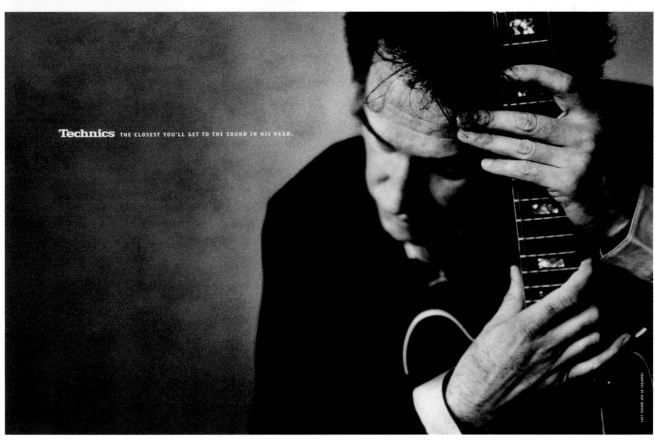

Audiovisual Equipment & Accessories 177

Agency:	McCann-Erickson, London
Creative Directors:	Gary Betts
	Malcolm Green
Copywriter:	Chris McDonald
Art Director:	Matt Statham
Client:	Technics Specialist Audio Equipment

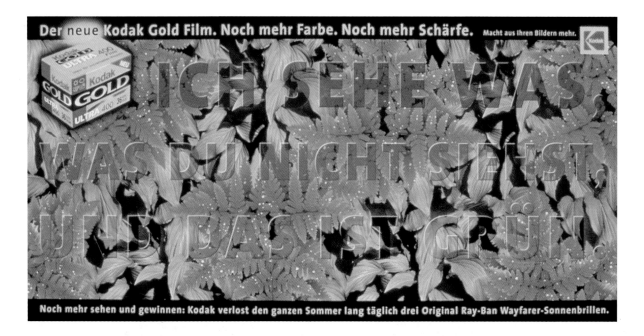

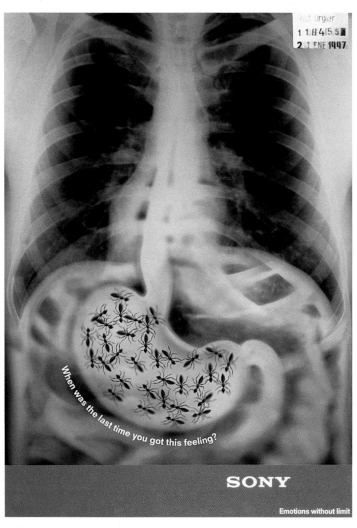

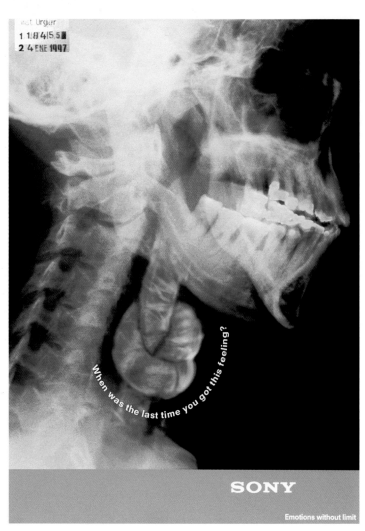

Agency:	Grill & Gull Thompson, Vienna	I see something you don't see and it's green.
Creative Director:	Alexander Lauber	
Copywriter:	Alexander Lauber	
Art Director:	Stefan Brodnik	
Client:	Kodak Gold Film	

Agency:	Tandem Campmany Guasch DDB, Barcelona
Creative Director:	J. L. Rois
Art Director:	Jürgen T. Krieger
Client:	Sony Audiovisual Equipment

The definition of a conventional television. The definition of Super Trinitron from Sony. **SONY**

Super **Trinitron**
The best in definition

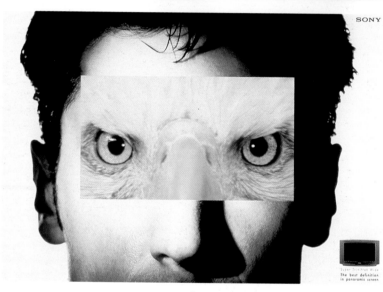

SONY

Super Trinitron Wide
The best definition
in panoramic screen

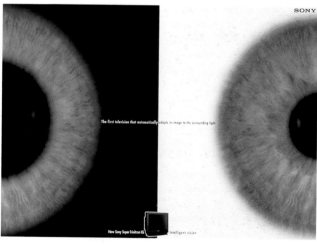

SONY

The first television that automatically adapts its image to the surrounding light

New Sony Super Trinitron IQ · Intelligent vision

Audiovisual Equipment & Accessories **179**

Agency:	Tandem Campmany Guasch DDB, Barcelona	The definition of a conventional television. The definition of a Super Trinitron from Sony.
Creative Director:	J. L. Rois	
Copywriter:	J. L. Rois	Super Trinitron Wide. The best definition in
Art Directors:	Jürgen T. Krieger Jaume Badia	a panoramic screen.
Photographers:	J. M. Roca Clinica Barraquer (Eyes)	The first television that automatically adapts its image to the surrounding light.
Client:	Sony Super Trinitron Televisions	

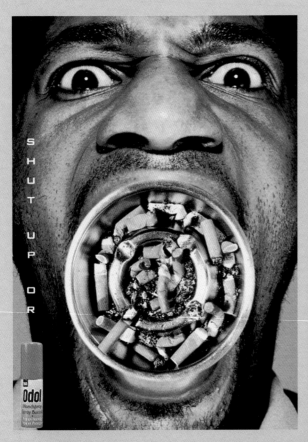

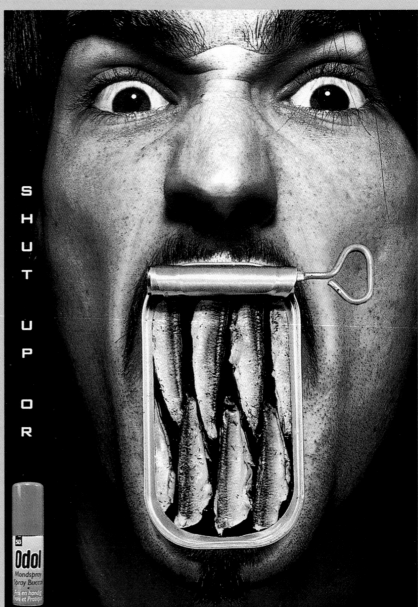

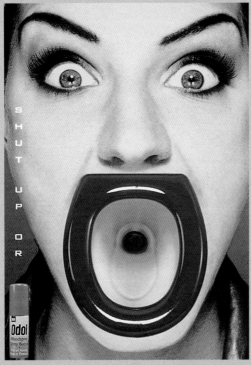

Toiletries

Agency:	Not Just Film, Amsterdam
Creative Director:	Bas Coolwijk
Copywriter:	Rom Wittebol
Art Director:	David Bergmans
Photographer:	Kees Tabak
Client:	Odol Mouth Freshener

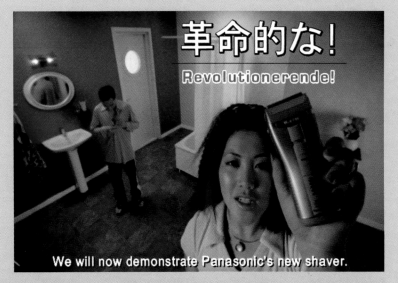

革命的な!

Revolutionerende!

We will now demonstrate Panasonic's new shaver.

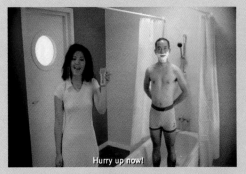

Hurry up now!

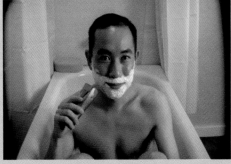

Wet + dry = Panasonic.

湿っていても、乾いていても、
パナソニック!

Våd + tør = Panasonic!

大胆に、より大胆に、パナソニック!

Vild, vildere, Panasonic!

新しい
Ny!

Panasonic

Panasonic. It's incredible what they think of!

Panasonic

see you in the future

Agency:	Umwelt Advertising, Copenhagen	Yamato and Kyoko demonstrate the revolutionary new Panasonic shaver,
Creative Director:	Smike Käszner	in Japanese with sub-titles. Yamato strips
Copywriter:	Christian Nielsen	to his underwear and gets into the bath
Art Director:	Frank Andersen	where he proceeds to shave. He plunges
Production:	Locomotion	his head below the surface of the water
Director:	Peder Pedersen	and continues shaving while Kyoko
Producers:	Rasmus Ejlers	explains how the wet and dry electric
	Mif Damgaard	shaver defies all the laws of physics.
Client:	Panasonic Shavers,	"See you in the future," they conclude
	"Yamato in the Tub"	joyfully (see also page 176).

NEW PROFIDÉN
Profidén
WILD PLANTS

Agency: Ammirati Puris Lintas, London
Creative Director: Nick Welch
Copywriter: Laurence Blume
Art Director: Fraser Adamson
Production: The Gang Films, Paris
The Pink Film Company, London
Director: Fabrice Carazo
Producers: Julia Fetterman
Penny Nash
Client: Rexona Sure Deodorant, "The Truth"

Somewhere in outer space, a young woman has engineered the daring theft of a top secret prototype, but she is clearly the prime suspect. An electronic body search reveals nothing and the nervous girl just has time to apply some deodorant to her fingertips before being subjected to a lie detector test. Her hands are clamped into a metallic device while her interrogator explains that perspiration on the fingertips is an infallible test. The girl denies all knowledge of the theft and the machine declares her innocent. "We know she's lying! How is this possible?" asks the bewildered examiner. But the girl goes free, thanks to her Sure anti-perspirant deodorant spray.

Agency: Vinizius/Young & Rubicam, Barcelona
Creative Director: Jose Maria Pujol
Copywriters: Jose Maria Pujol
Joan Finger
Art Director: Jordi Almuni
Photographer: David Levin
Client: Profiden Dentifrice

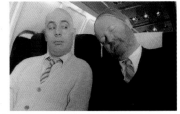

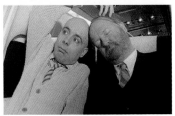
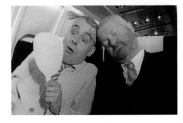

Viviscal
A Better way to new hair.

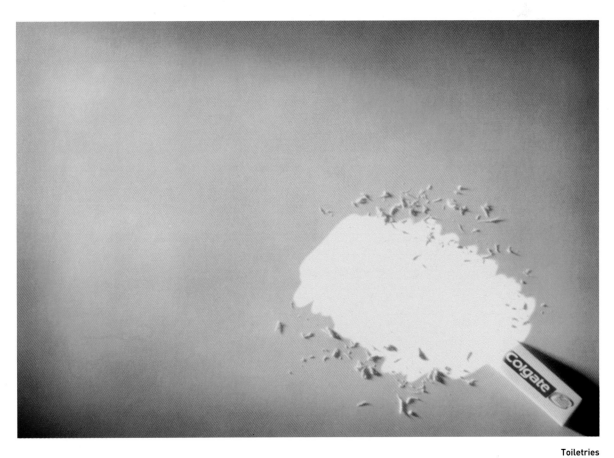

Agency:	Rönnberg McCann, Stockholm
Creative Director:	Bo Rönnberg
Copywriter:	Peter Kandimaa
Production:	Rönnberg McCann
Director:	Peter Cederqvist
Producer:	Mary Lee Copeland
Client:	Viviskal Hair Products, "Bald Man"

Two airline passengers, one bald and the other nearly bald, are seated side-by-side at 10,000 feet. The almost bald man appears proud of his scant follicle advantage and the hairless one is clearly envious of his relatively hirsute neighbour. When the man with hair falls asleep his fellow passenger "borrows" his hair and admires himself with delight in a mirror. Viviskal proposes "a better way to new hair."

Agency:	Young & Rubicam, Madrid
Creative Director:	Jose Maria Pujol
Copywriters:	Jose Maria Pujol Sisco Sanchez Anselmo Ramos
Art Director:	Cassio Moron
Photographer:	Iñaki Preisler
Client:	Colgate Sensation White Dentifrice

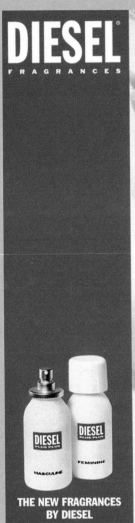

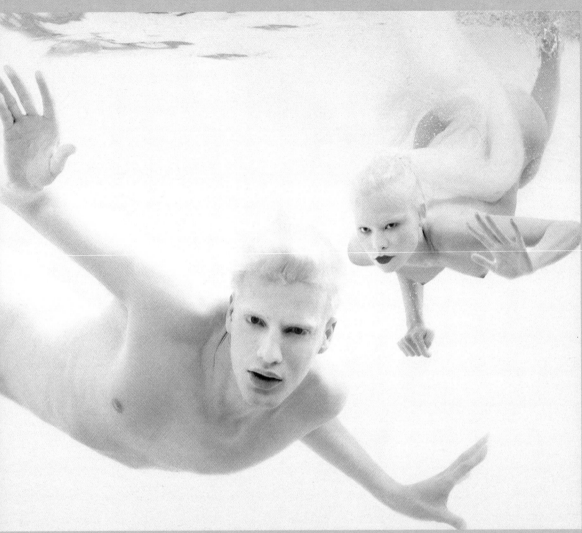

THE NEW FRAGRANCES BY DIESEL

184 Beauty Products

Agency:	Pickl Advertising Agency, Munich
Creative Director:	Alexander Pickl
Art Director:	Alexander Pickl
Photographer:	Karina Taira
Client:	Diesel Plus Plus Fragrances

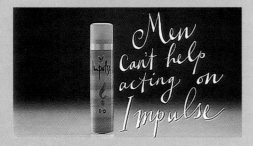

Agency:	Ogilvy & Mather, London
Creative Director:	Christen Monge
Copywriter:	Justin Hooper
Art Director:	Christian Cotterall
Production:	Stark Films
Director:	Jeff Stark
Producers:	Cathy Green
	Vicki Baldacchino
Client:	Elida Fabergé Impulse, "Art School"

A young female art student is late and hurriedly sprays on some Impulse before joining her class. She catches the attention of the nude model who is clearly pleased to see her and has a hard time maintaining his pose. Suggestive images of a feather rising from a radiator and the big hand of a clock moving upwards leave viewers in no doubt as to what's going on. The poor man is clearly embarassed but the students are delighted by this unexpected turn of events, brought about because "men can't help acting on Impulse."

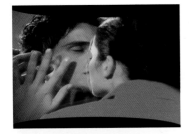

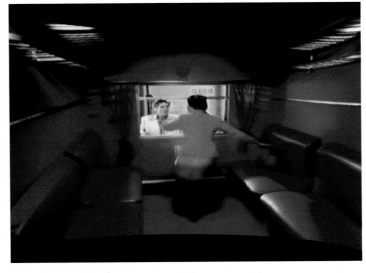

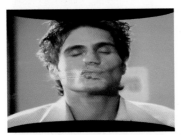

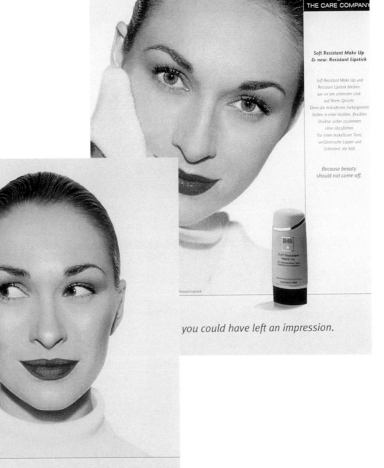

Shame, *You've left traces.*

you could have left an impression.

Agency:	Springer & Jacoby, Hamburg
Creative Directors:	Arndt Dallmann, Guido Heffels
Copywriter:	Patricia Pätzold
Art Director:	Jonas Ohlhaver
Production:	Markenfilm, Wedel
Director:	Jan Paul Wentz
Producers:	Guido Heffels, Jonas Ohlhaver, Patricia Pätzold
Client:	Blistex Lip Balm, "Train"

A man sees his girlfriend off on a train. She enters her compartment and they enjoy a last, lingering kiss through the glass of the closed window. When the train starts to pull out, the poor boy's lips remain stuck to the window. "Chapped lips?" asks the advertiser, "Blistex - it's magic."

Agency:	Michael Conrad & Leo Burnett, Frankfurt
Creative Director:	Shapoor Batliwalla
Copywriter:	Iris Laszicki
Art Director:	Annette Apel
Photographer:	Leiff Schmodde
Client:	Ellen Betrix Cosmetics

HIDRATA
PERO NO ENGRASA.

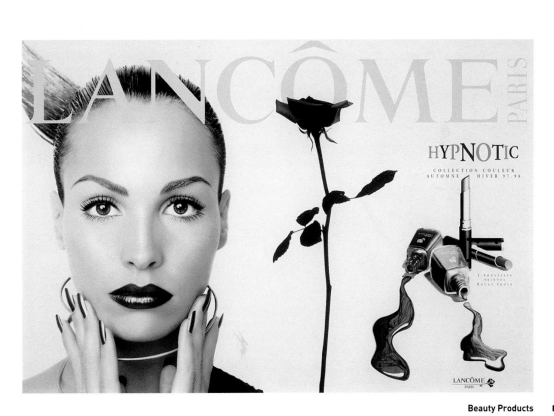

Agency:	Delvico Bates, Barcelona	A woman rides her bicycle through the countryside. The tranquility of the scene is spoilt by the irritating squeak of a poorly oiled chain. She dismounts to do something about it and cleverly applies some handcream to the offending part. When she sets off again the squeak persists, because Mediterraneo cream just moisturises, it's not greasy.	**Agency:**	Publicis Conseil, Paris
Creative Directors:	Julio Wallovits Elvio Sanchez		**Creative Director:**	Denis Rognon
Copywriter:	Isabel Lopez		**Art Director:**	Marion Viellefaure
Art Director:	Antonio Gomez		**Photographer:**	Ruven Afanador
Production:	Pespuntes		**Client:**	Lancôme Hypnotic Cosmetics
Director:	Antonio Gomez			
Producer:	Lluis Puntes			
Client:	Esencial Mediterraneo Hand Cream, "Bicycle"			

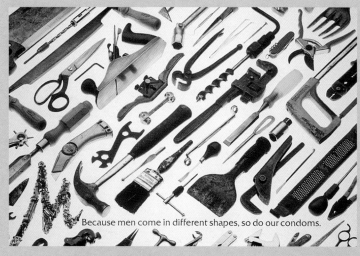

Because men come in different shapes, so do our condoms.

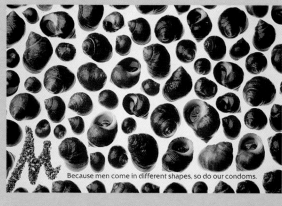

Because men come in different shapes, so do our condoms.

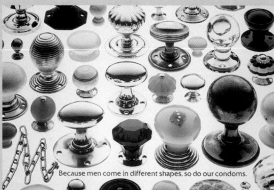

Because men come in different shapes, so do our condoms.

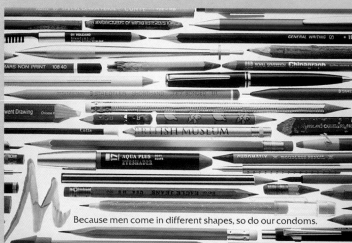

Because men come in different shapes, so do our condoms.

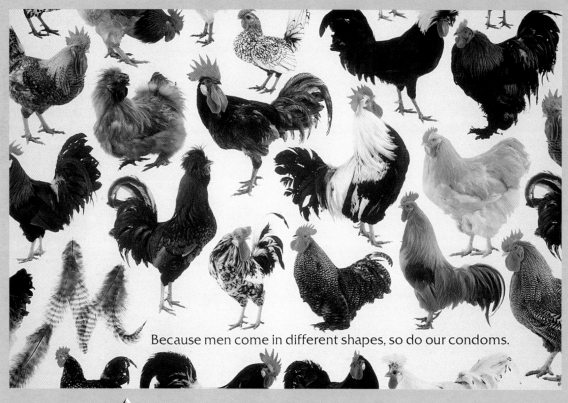

Because men come in different shapes, so do our condoms.

Agency:	Ray, Leach, EMO London	NB: Tools, winkles, knobs, pencils and cocks are all English slang names for a man's penis.
Creative Director:	Andy Ray	
Copywriter:	Stuart Leach	
Art Director:	Andy Ray	
Photographer:	Martin Thompson	
Client:	Mates Condoms	

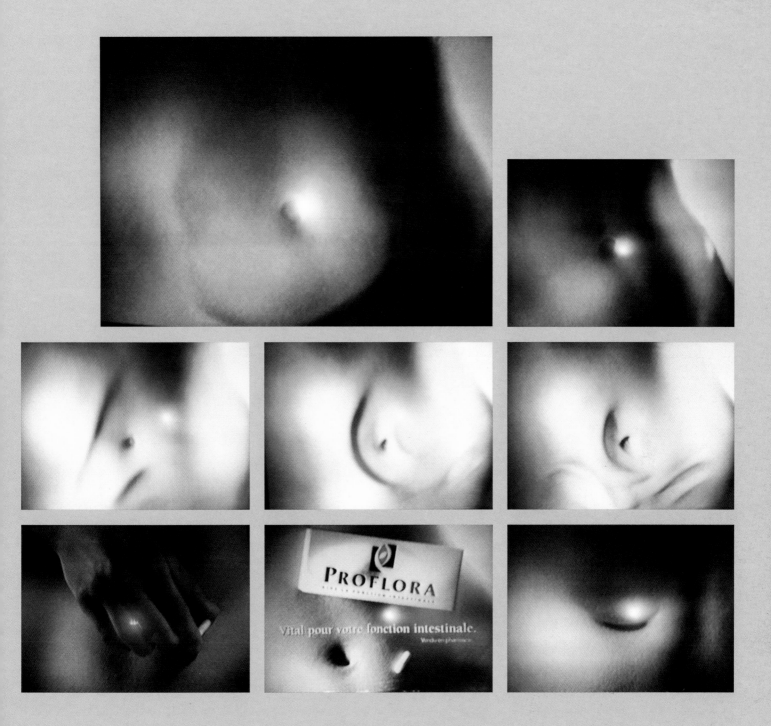

Agency:	Ogilvy & Mather, Brussels
Creative Director:	Mark Hilltout
Copywriter:	Olivier Roland
Art Director:	Marc Hendrix
Production:	Banana Split
Producer:	Marleen Gordts
Client:	Proflora Intestinal Medication, "The Belly"

The surface of a stomach ripples and undulates in an alarming fashion, accompanied by the sound of thunder, gunfire, pneumatic drills and rough seas. Only when a Proflora capsule is placed next to the navel does the movement subside, because "Proflora is vital in restoring your intestinal function."

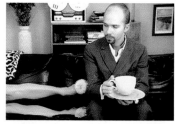

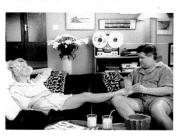

Agency:	Bates Sweden, Stockholm	A woman talks about the difficulty in finding a moisturiser that she feels comfortable	**Agency:**	McCann-Erickson, Amstelveen	Splitting headache? New Nurofen 400.
Copywriter:	Anders Byström	with. With double entendre, she complains	**Creative Director:**	Kees Rijken	
Art Director:	Christer Holmqvist	that they are either too dry, too greasy	**Copywriter:**	Joost van Praag Sigaar	
Production:	Mekano Film & TV, Stockholm	or too sticky. Each criticism is illustrated by a corresponding type of man: boring,	**Art Director:**	Dees van der Geer	
Director:	Jesper Ericstam	macho and vain. Finally she finds the right	**Photographer:**	Jaap Vliegenthart	
Producers:	Ola Rutz	one, and we discover a chubby suitor who	**Client:**	Boots Healthcare, Nurofen 400	
	Anders Wallter	is enthusiastically massaging her feet.			
Client:	Fenuril Moisturising Cream, "Frotté"	"Fenuril, for whenever your skin feels dry."			

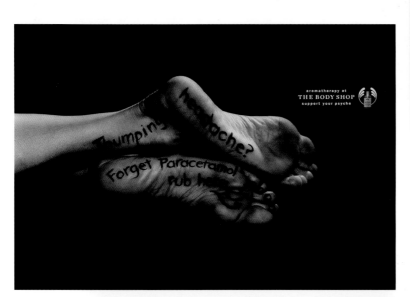

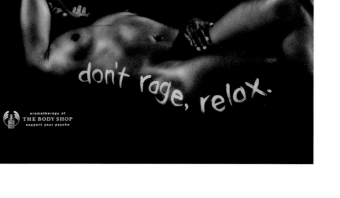

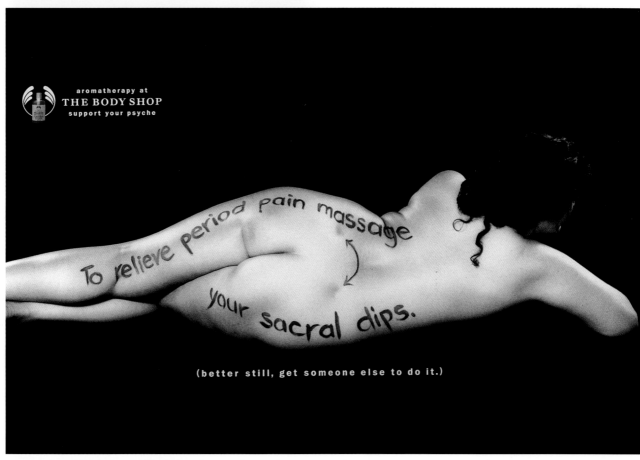

Agency:	Bean Andrews Norways Cramphorn, London
Creative Director:	Graeme Norways
Copywriters:	Jeff Ford
	Graeme Norways
	Gary Sollof
Art Directors:	Jeff Ford
	Graeme Norways
	Gary Sollof
Photographer:	Nadav Kander
Client:	The Body Shop, Aromatherapy Products

Yorkshire County Hospital, 1941

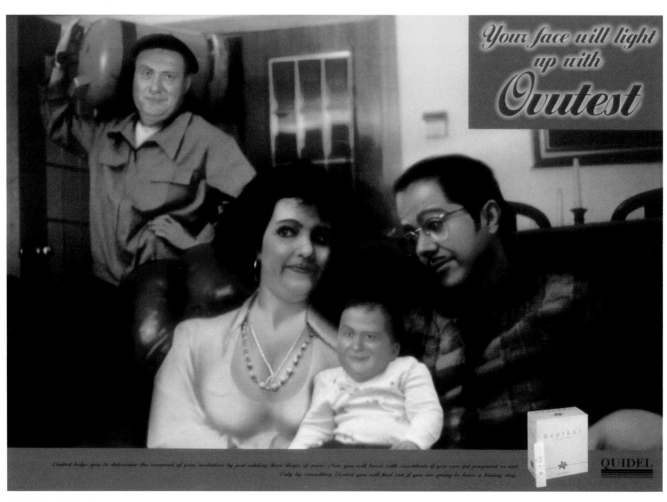

Your face will light up with *Ovutest*

QUIDEL

Agency:	Garbergs Annonsbyrå, Stockholm	
Copywriter:	Martin Gumpert	
Art Director:	Sven Dolling	
Production:	Traktor Film	
Directors:	Patrik von Krusenstierna Ulf Johansson	
Producer:	Charlotte Most	
Client:	Treo Pain Killer, "The Hospital"	

The action takes place in the orthopaedic department of the Yorkshire County Hospital in 1941. A young American soldier has come to visit a woman whose neck brace has just been removed. She runs towards him joyfully and crashes head first into an opening door that suddenly blocks her path. A nurse is quickly in attendance with a glass of Treo, for fast and effective head-ache relief, but it's the doctor who opened the door who takes the medication.

Agency:	Contrapunto, Madrid
Creative Director:	Antonio Montero
Copywriter:	Rosa Garcia
Art Director:	Antonio Montero
Photographer:	Paco Moro
Client:	Quidel Ovutest, Ovulation Tester

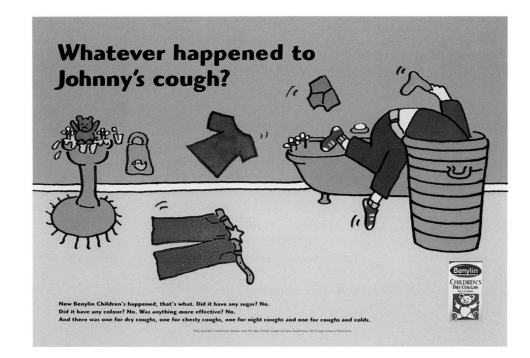

Whatever happened to Johnny's cough?

New Benylin Children's happened, that's what. Did it have any sugar? No.
Did it have any colour? No. Was anything more effective? No.
And there was one for dry coughs, one for chesty coughs, one for night coughs and one for coughs and colds.

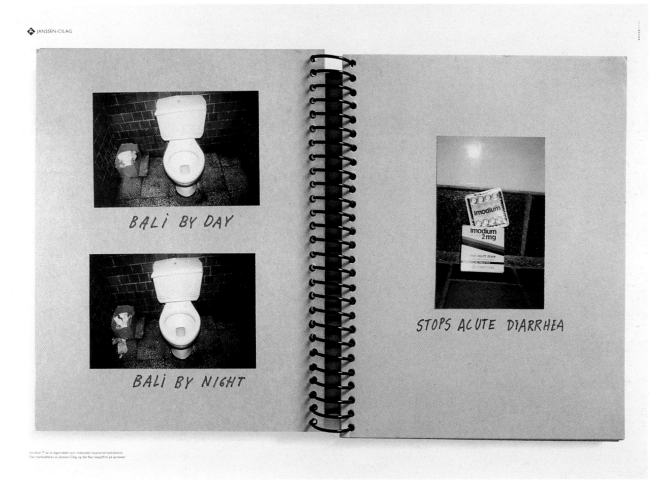

BALI BY DAY

BALI BY NIGHT

STOPS ACUTE DIARRHEA

Agency:	Bates Dorland, London	Agency:	Bates Backer, Oslo
Creative Director:	Dominick Lynch Robinson	Copywriter:	Stig Bjølbakk
Copywriter:	Daniel Bryant	Art Director:	Eivind S. Platou
Art Director:	Lynda Kennedy	Photographers:	Linda Cartridge
Illustrator:	Lynda Kennedy		Eivind S. Platou
Client:	Benylin Children's Cough Remedy		Jarle Nyttingnes
		Client:	Imodium

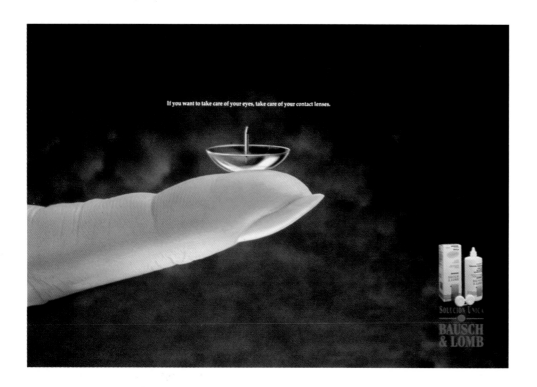

If you want to take care of your eyes, take care of your contact lenses.

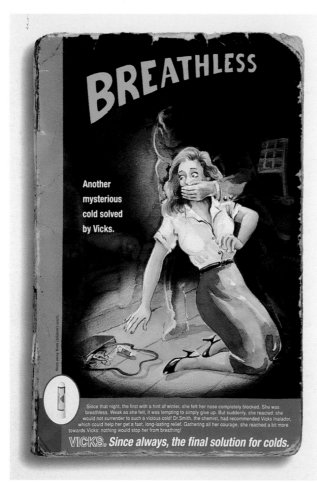

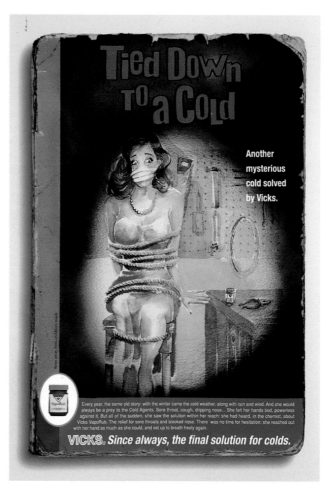

OTC Products & Services

Agency:	Contrapunto, Madrid		**Agency:**	Cineponto/Leo Burnett, Lisbon
Creative Director:	Antonio Montero		**Creative Director:**	Jose Ricardo Cabaço
Copywriter:	Sergio Baltasar		**Copywriter:**	Claudia Cristovão
Art Director:	Victor Aguilar		**Art Director:**	João Roque
Client:	Bausch & Lomb Contact Lens Solution		**Illustrator:**	Maria do Carmo Cunha
			Client:	Vicks Cold Treatment Products

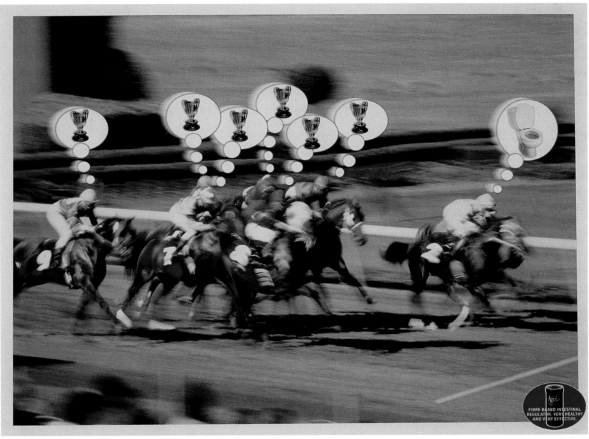

Agency:	Delvico Bates, Madrid	If this wasn't an Odoreater insole you'd be dead by now.	Agency:	Euro RSCG, Barcelona
Creative Directors:	Pedro Soler Enrique Astuy		Creative Director:	Carlos Permanyer
Copywriter:	Nacho Santos		Art Director:	Corina Roselló
Art Director:	Angel Villalba		Photographer:	Ana Torres
Photographer:	Alfonso Zubiaga		Client:	Agiolax Intestinal Regulator
Client:	Odoreater Insoles			

Agency:	McCann-Erickson, London
Creative Director:	Jerry Green
Copywriter:	Chris McDonald
Art Director:	Matt Statham
Photographer:	Mike Parsons
Client:	Durex Select Fruit Flavoured Condoms

Cerebrum Forte. Makes you stronger from head to toe.

Always Handy.

farga
Agente in Portugal

Agency:	TBWA EPG, Lisbon	Agency:	Z. Publicidade, Lisbon	NB: The staple is real since the ad was
Creative Director:	Pedro Bidarra	Creative Director:	José Carlos Campos	always placed in magazine centerfolds.
Copywriter:	Gonçalo Morais Leitão	Copywriter:	Ricardo Adolfo	
Art Director:	Joana Arez	Art Director:	Miguel Coimbra	
Client:	Cerebrum Forte	Photographer:	Fábio Praça	
		Client:	Farga Plasters	

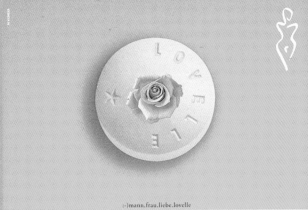

:-)mann.frau.liebe.lovelle

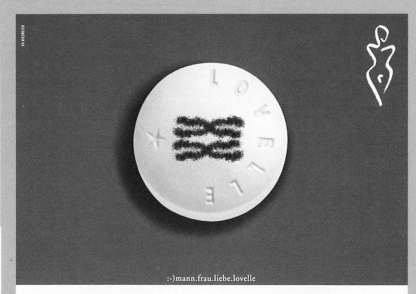

:-)mann.frau.liebe.lovelle

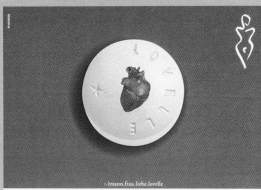

:-)mann.frau.liebe.lovelle

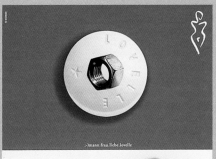

:-)mann.frau.liebe.lovelle

Agency:	RG Wiesmeier, Munich	Man. Woman. Love. Lovelle.
Creative Directors:	Joerg Jahn	
	Gudrun Müllner	
Copywriter:	Joerg Jahn	
Art Directors:	Gudrun Müllner	
	Martina Schwertlinger	
Client:	Lovelle	
	Birth Control Pills	

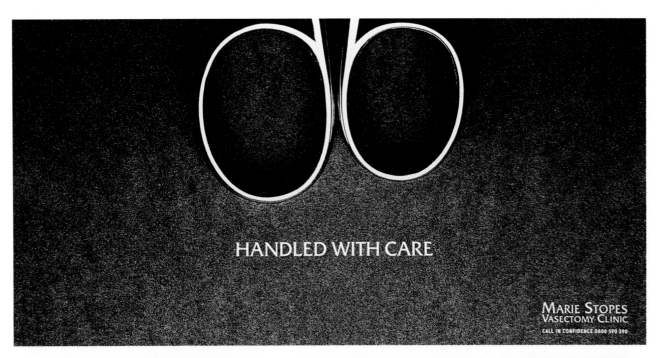

HANDLED WITH CARE

MARIE STOPES
VASECTOMY CLINIC
CALL IN CONFIDENCE 0800 590 390

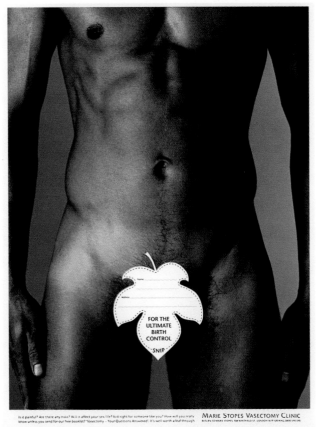

FOR THE
ULTIMATE
BIRTH
CONTROL

SNIP

MARIE STOPES VASECTOMY CLINIC

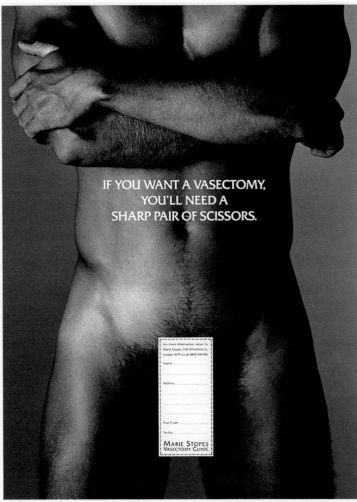

IF YOU WANT A VASECTOMY,
YOU'LL NEED A
SHARP PAIR OF SCISSORS.

MARIE STOPES
VASECTOMY CLINIC

Agency: McCann-Erickson,
 Manchester
Creative Director: Keith Ravenscroft
Copywriter: Neil Lancaster
Art Director: Dave Price
Photographer: Geoff Smith
Client: Marie Stopes
 Vasectomy Clinics

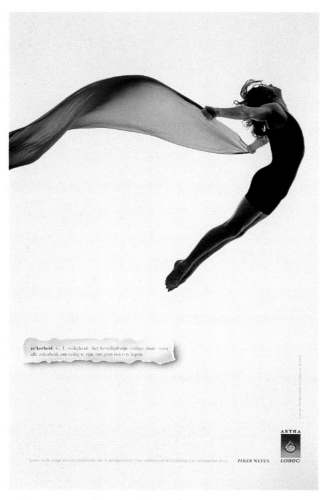

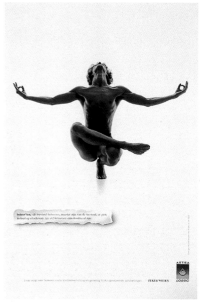

ious

Zantac

Glaxo

redible

Zantac

Glaxo

tastic

Zantac

Glaxo

200 **Prescription Products & Services**

Agency:	HWP & Grey, Utrecht	Losec stands for security, balance,
Creative Director:	Walter Schulte	effectiveness, etc. Here are two of five ads
Copywriter:	Richard Hol	that use the dictionary definition of each
Art Director:	Walter Schulte	of these words to explain exactly what the
Photographer:	Annemarieke	product does.
	van den Broek	
Client:	Astra Losec Antacid	

Agency:	Paling Walters Targis, London
Creative Director:	Frank Walters
Copywriter:	Sarah Sowerby
Art Director:	Frank Walters
Photographer:	Joan Ferarah
Client:	Glaxo Zantac Stomach Ulcer Treatment

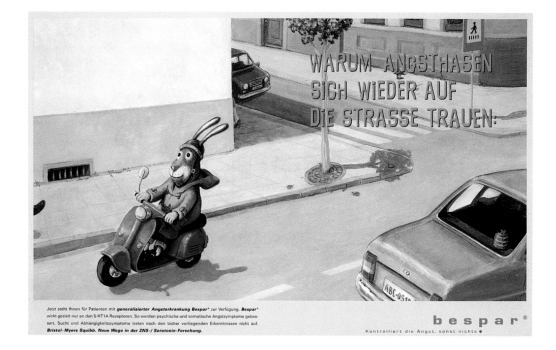

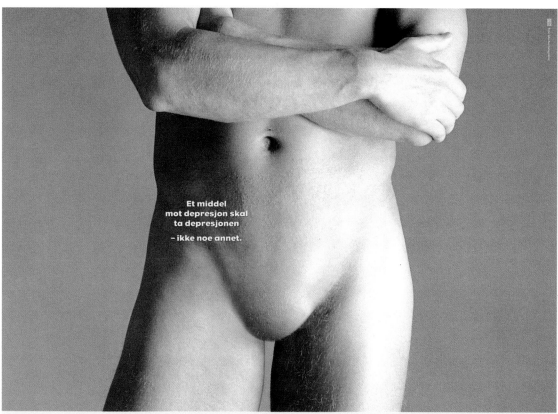

Agency:	RG Wiesmeier, Munich	Why scaredy-cats are daring to go out on the road again. (In Germany scaredy-cats are known as timid-hares).
Creative Director:	Joerg Jahn	
Copywriters:	Joerg Jahn	
	Gerald Shorter	
Art Directors:	Marie-Luise Dorst	
	Stefan Oevermann	
Illustrator:	Rudi Hurzlmeier	
Client:	Bespar, Anxiety Relief Medicine	

Agency:	Kontoret, Oslo	It takes away only the depression. Nothing else.
Copywriter:	Pål Sparre-Enger	
Art Director:	Knut Roethe	
Photographer:	Johs Bøe	
Client:	Nefadar Antidepressant	

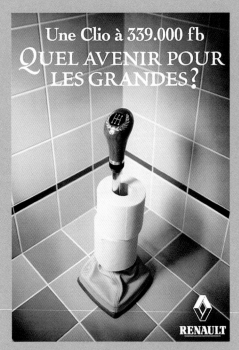

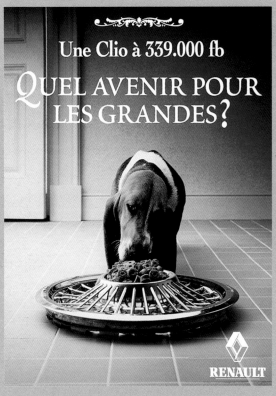

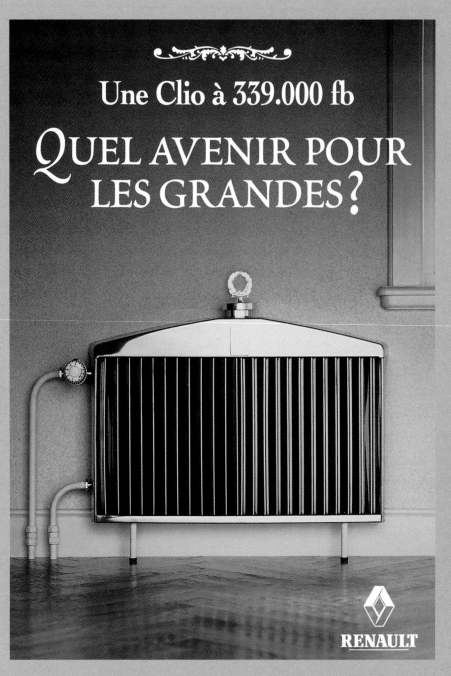

Agency: Publicis, Brussels
Creative Director: Marco Calant
Copywriter: Gilles De Bruyère
Art Director: Jean-Marc Wachsmann
Photographer: Hans Kroeskamp
Client: Renault Clio Oasis

A Clio Oasis for 339.000 BF. What's the future for big cars?

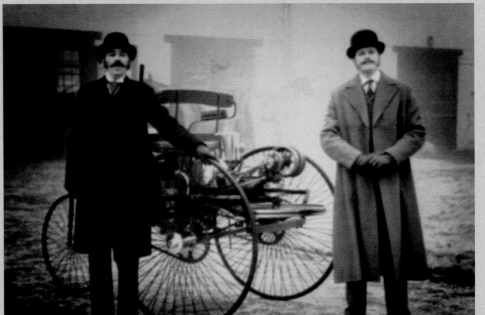

Agency:	Lowe & Partners, New York	Proud Mercedes-Benz factory workers, racing drivers, chauffeurs, owners and their families sing the popular love song, "Falling in Love Again," from the beginnings of the marque up to the latest models. The film mixes authentic archive footage with perfectly matched shots of the singers, cut into their appropriate epoch, to underline a passion for Mercedes that's remained intact up to the present day.
Creative Directors:	Andy Hirsch Randy Saitta Marty Orzio	
Production:	Gerard de Thame Films, London	
Director:	Gerard de Thame	
Producers:	Fabyan Daw Rachel Novak	
Client:	Mercedes-Benz, "Falling in Love Again"	

 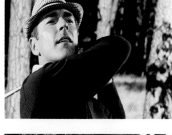 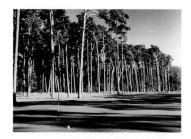

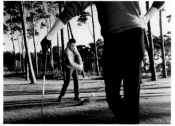

 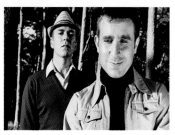 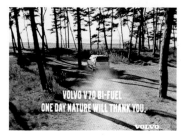

Agency:	Forsman & Bodenfors, Gothenburg	An art teacher inspects the progress of her young students. Their pictures are quite normal: a girl draws a mother with a pram, a boy draws an apple tree and so on. A little later, however, the boy has added long horizontal lines to the right side of everything in his pictures. The teacher is clearly concerned by these visual appendages but we discover their meaning when the boy climbs into his father's Volvo V40 after school and traces a speeding car on the inside of the window as they drive away.
Copywriters:	Oscar Askelöf Filip Nilsson	
Production:	Traktor, Stockholm	
Director:	Ulf Johansson	
Producers:	Charlotte Most Maria Bergkvist	
Client:	Volvo S40 T4, "The Teacher"	

Agency:	Forsman & Bodenfors, Gothenburg	Two golfers tee off on a short hole. The first player strikes his ball cleanly to within putting distance of the flag. His opponent slices his shot into the forest, only to see it ricochet off the trees back onto the green and into the hole. "One day nature will thank you," observes Volvo, as the fortunate man arranges his clubs in the back of an environmentally-friendly V70 Bi-Fuel model.
Copywriters:	Oscar Askelöf Filip Nilsson	
Production:	Traktor, Stockholm	
Director:	Ulf Johansson	
Producers:	Charlotte Most Maria Bergkvist	
Client:	Volvo V70 Bi-Fuel, "The Golfer"	

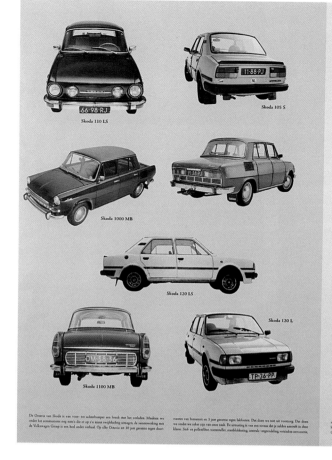

Genoeg gelachen.

De Octavia van Skoda is van voor- tot achterbumper een breuk met het verleden. Maakten we onder het communisme nog auto's die je op z'n minst twijfelachtig imagen, de samenwerking met de Volkswagen Groep is een heel ander verhaal. Op elke Octavia zit 10 jaar garantie tegen doorroesten van binnenuit en 3 jaar garantie tegen lakfouten. Dat doen we niet uit voortzeg. Dat doen we omdat we zeker zijn van onze zaak. De uitrusting is van een niveau dat je zelden aantreft in deze klasse. Stof- en pollenfilter, toerenteller, startblokkering, centrale vergrendeling, vetzinkte carrosserie, stuurbekrachtiging, airbag, elektronische beveiliging tegen acculegloop, een stuur dat zowel van boven naar beneden als van voor naar achter verstelbaar is; het zit er allemaal standaard op. De Octavia met 1.6 ltr motor (SLX) heeft behalve ABS ook EDS, een tractiecontrolsysteem dat spinnende wielen op gladde oppervlakken voorkomt. Is er dan helemaal niks dat nog aan het oude Skoda herinnert? Toch wel. De prijs. U rijdt al Octavia vanaf f.28.995. Bel 071-5600221 voor uw dichtstbijzijnde dealer. Internet www.skoda.nl **Octavia. Het nieuwe gezicht van Skoda.**

Golf Cabriolet

Agency:	Grey, Amsterdam	Enough jokes. Octavia, the new face of Skoda.	**Agency:**	GGK, Basel
Creative Director:	Kor van Velzen		**Creative Directors:**	Martin Denecke
Copywriters:	Job van Dijk			Mark Stahel
	Stan Lommers		**Copywriter:**	Lorenz Spinas
	Massimo van der Plas		**Art Director:**	Alfred Burkard
Art Directors:	Joep de Kort		**Photographer:**	Nikolas Monkewitz
	Bart Bus		**Client:**	Volkswagen
Photographer:	Jaap Vliegenthart			Golf Cabriolet
Client:	Skoda			

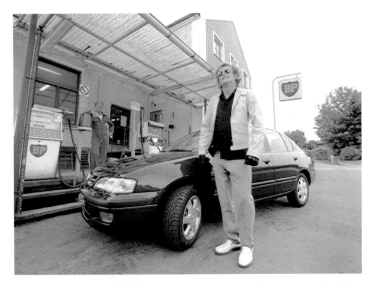

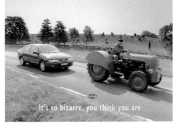
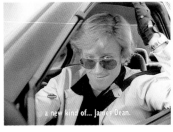
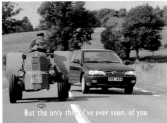
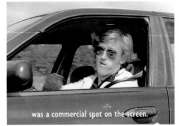

Agency:	Hollingworth/ Mehrotra, Stockholm	A likeable poseur shows-off his new Primera while the Nissan logo bounces over the background lyrics, Karaoke-style; "You think you look like Steve McQueen while you're driving in your car, and you think you're James Bond when you're smoking your cigar, it's so bizarre. You think you're some kind of James Dean, but the only thing I've seen of you was a commercial spot on the screen. Moviestar, oh moviestar, you think you are a moviestar." "Just like driving an expensive car," concludes the voice-off.	**Agency:**	TBWA, Paris	Sorry, the Nissan Primera GT doesn't come in these colours.
Creative Director:	Frank Hollingworth		**Creative Directors:**	Christophe Coffre	
Copywriter:	Peter Fjäll			Nicolas Taubes	
Art Directors:	Frank Hollingworth		**Copywriter:**	Vincent Pambaguian	
	Max Munck		**Art Director:**	Stephan Ferens	
Production:	Traktor		**Photographer:**	Vincent Dixon	
Client:	Nissan Primera, "Moviestar"		**Client:**	Nissan Primera GT	

Audi A4 1.8 SV Turbo

Side airbags are now standard

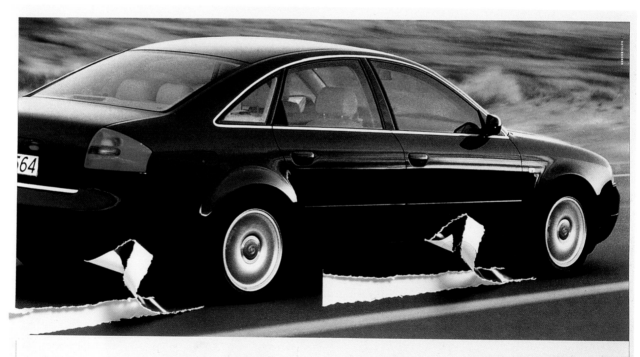

The world's first with a V6 TDI

Audi A6 V6 TDI

Agency:	Bates Backer, Oslo
Copywriter:	Aris Theophilakis
Art Director:	Thorbjørn Naug
Client:	Audi

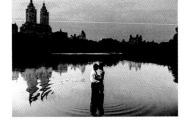

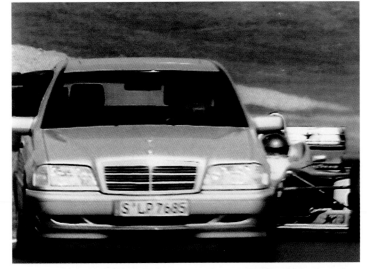

208 **Automobiles**

Agency:	Springer & Jacoby, Hamburg
Creative Directors:	Kurt Georg Dieckert Stefan Schmidt
Copywriters:	Judith Stoletzky Thomas Chudalla
Art Director:	Elke Erschfeld
Production:	Petersen Naumann Film Première Heure, Paris
Director:	Frederic Planchon
Producer:	Natascha Teidler
Client:	Mercedes-Benz SLK, "Day Dream"

A young woman enjoys the life of a New York celebrity. Her boyfriend gives her a necklace from Tiffany's, they cruise the city at night in an open SLK Roadster and drive through a ticker-tape parade before eventually being transported to a moonlit lake... Suddenly, the girl snaps out of her daydream. We discover she's really a traffic warden, about to leave a ticket on the windscreen of an illegally parked SLK. She sighs reluctantly, then writes on the ticket, "Sorry."

Agency:	Springer & Jacoby, Hamburg
Creative Directors:	Kurt Georg Dieckert Stefan Schmidt
Copywriter:	Stefan Schmidt
Production:	Radical Media, London
Director:	Tarsem
Producer:	Natascha Teidler
Client:	Mercedes-Benz C-Class, "Trick"

To demonstrate the speed of the new C-Class Mercedes, Grand Prix driver Mika Hakkinen competes against his own Formula 1 McLaren Mercedes at the wheel of the Mercedes sedan. Surprisingly, the production car records a close win, but the reason becomes clear when we discover that the racing car has been driven by Boris Becker, who challenges Hakkinen after the race, "Tomorrow - tennis."

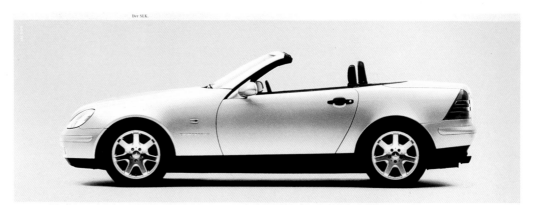

Der SLK.

Sex sells.

▶ Daß man mit Erotik gut verkauft, ist eine der ältesten Werbeweisheiten der Welt. Und sie stimmt bis heute. Als zum ersten Mal Bilder des SLK in Autozeitschriften gezeigt wurden, fanden ihn viele Menschen so sexy, daß sie ihn sofort haben wollten. Bereits nach kürzester Zeit übertrafen die Vorbestellungen alle Erwartungen bei weitem. Und das, bevor die erste Anzeige der Kampagne erschienen war. Die lag längst fertig in der Schublade der Agentur. Und war vor dem Start schon überflüssig. Weil die beste Werbung bereits gemacht war. Vom SLK selbst. Dem neuen Roadster von Mercedes-Benz. Denn wie schon gesagt: Sex sells.

Mercedes-Benz

Die E-Klasse von Mercedes-Benz.

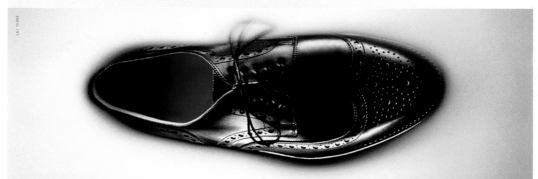

Jetzt mit dem neuen 300 TURBODIESEL.

▶ Klassische Eleganz und Sportlichkeit sind keinesfalls zwei Paar Schuhe. Diese Kriterien sollte ein Auto schon erfüllen, mit dem man nicht nur Kurzstrecken fährt. Sondern gern auch mal länger unterwegs ist. So ein Auto ist der E 300 TURBODIESEL.

▶ Er ist ausdauernd, spurtstark und äußerst komfortabel. Um seine Qualitäten zu entwickeln, verlangt er von seinem Fahrer nur minimale Beinarbeit. Ein Tippen mit der Schuhspitze aufs Gaspedal genügt, und dank des 6-Zylinder-Motors absolviert er die flache Gerade zwischen Hamburg und Berlin genauso leise und laufruhig wie den Drackensteiner Hang auf der A 8. Auch dann, wenn sich der Abgasturbolader zu einem kraftvollen Zwischenspurt in Gang setzt. Dabei kann man schnell vergessen, daß man Diesel statt Benzin tanken muß.

▶ Das allerdings hat Zeit. Denn das Anfahren von Tankstellen ist das einzige, was mit dem E 300 TURBODIESEL länger dauert. Als erfahrener Läufer geht er äußerst sparsam mit seinem Kraftstoff um. Wenn Sie weitere Informationen über den E 300 TURBODIESEL wünschen, rufen Sie doch einfach an. Sie erreichen uns unter 0130/0140.

Mercedes-Benz

Agency:	Springer & Jacoby, Hamburg	NB: A special ad for the ADC yearbook (German Art Directors' Club).
Creative Directors:	Kurt Georg Dieckert	
	Stefan Schmidt	
Copywriter:	Thomas Chudalla	
Art Director:	Axel Thomsen	
Client:	Mercedes-Benz SLK	

Agency:	Springer & Jacoby, Hamburg	The E-Class from Mercedes-Benz. Now with the new 300 Turbo-Diesel.
Creative Directors:	Kurt Georg Dieckert	
	Stefan Schmidt	
Copywriter:	Thomas Chudalla	
Art Director:	Doris Fuhrhop	
Photographer:	Oliver Reindorf	
Client:	Mercedes-Benz E-Class	

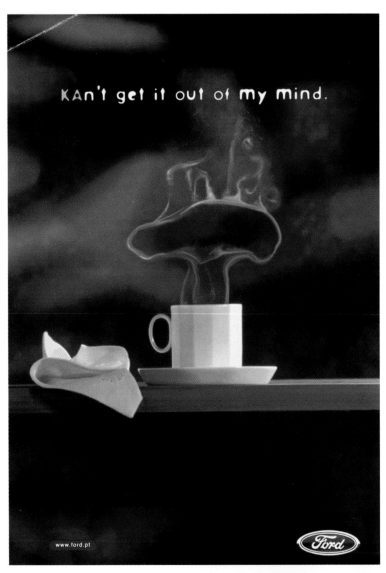

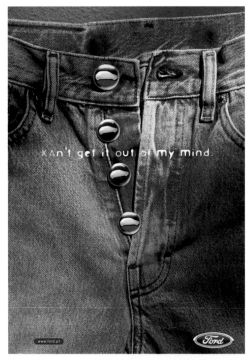

Agency:	Ogilvy & Mather, Lisbon
Creative Director:	José Manuel Abrantes
Copywriter:	Pedro Aguiar
Art Director:	Sheila Nunes
Client:	Ford Ka

Kunst met een grote Ka. *Ford*

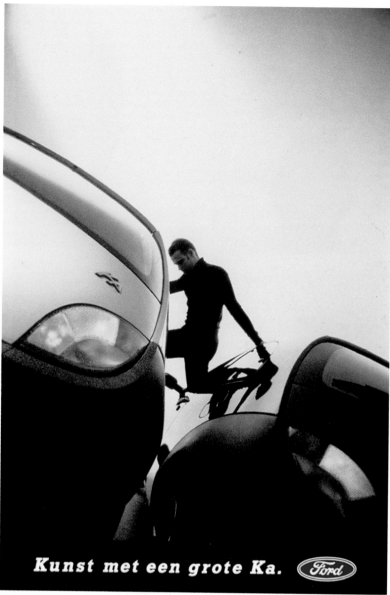

Kunst met een grote Ka. *Ford*

Kunst met een grote Ka. *Ford*

Kunst met een grote Ka. *Ford*

Agency:	Ogilvy & Mather, Amsterdam	Art with a capital A (in Dutch, art is "kunst" and the letter K is pronounced "ka").
Creative Directors:	Willem van Harrewijen Mike Weinberg	
Copywriter:	Willem van Harrewijen	
Art Director:	Mike Weinberg	
Photographer:	Yani	
Client:	Ford Ka	

The Fiesta 1.4 does 0-60 in 10.8 seconds.
0345 286 287

The Fiesta 1.4 does 0-60 in 10.8 seconds.
0345 286 287

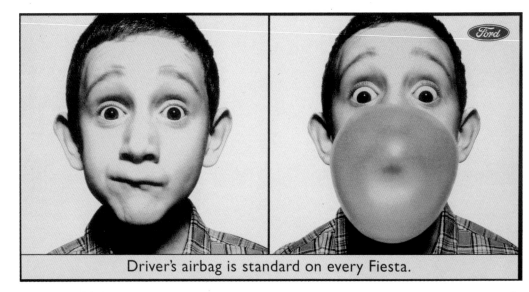

Driver's airbag is standard on every Fiesta.

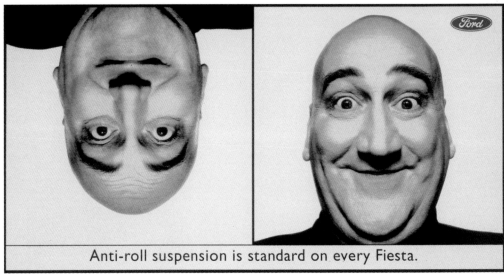

Anti-roll suspension is standard on every Fiesta.

Agency: Ogilvy & Mather, London
Creative Director: Leon Jaume
Copywriters: Meg Rosoff
Vicki Maguire
Art Director: Dorte Nielsen
Production: The Pink Film Company
Director: Harald Zwart
Producers: Bash Robertson
Sue Lee
Client: Ford Fiesta, "0 to 60"

A small baby is transformed into an old man in 10.8 seconds to make the point that the Ford Fiesta 1.4 goes from 0 to 60 (mph) in the same amount of time.

Agency: Ogilvy & Mather, London
Creative Director: Leon Jaume
Copywriters: Meg Rosoff
Vicki Maguire
Art Director: Dorte Nielsen
Photographer: Kiran Master
Client: Ford Fiesta

Die Römer haben dieses Sicherheitskonzept erfunden.

Wir haben es perfektioniert. Der Audi A4.

Jeder mag was anderes. Die Ausstattungslinien im Audi A4.

Schön, wenn man die Wahl hat.

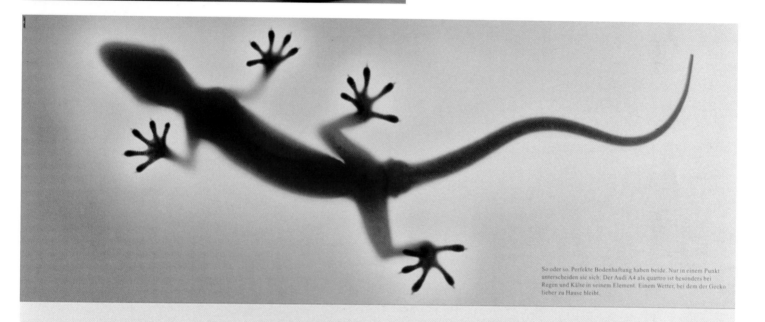

So oder so. Perfekte Bodenhaftung haben beide. Nur in einem Punkt unterscheiden sie sich: Der Audi A4 als quattro ist besonders bei Regen und Kälte in seinem Element. Einem Wetter, bei dem der Gecko lieber zu Hause bleibt.

Perfekte Bodenhaftung ist angeboren. Oder eingebaut. Der Audi A4 quattro.

Agency:	JvM, Hamburg	We didn't invent this safety concept.
Creative Director:	Hermann Waterkamp	Just perfected it. The Audi A4.
Copywriter:	Martin Paesler	
Art Director:	Uli Guertler	Tastes vary. So it's nice to have a choice.
Photographers:	Uwe Duettmann	The Audi A4 interiors.
	Simon Stock	
Client:	Audi A4	Perfect grip is either inborn, or inbuilt.
		The Audi A4 quattro.

214 **Automobiles**

Agency:	Stenström & Co., Stockholm	A salesman's confidence in the safety and performance features of the new Audi A3 is tested by a customer who puts the car through its paces in an action-packed trial. The commercial announces a special test drive offer.
Copywriter:	Greger Stenström	
Art Director:	Hans Ahlgren	
Production:	Mod:Film	
Director:	Jonas Frick	
Producer:	Mikael Flodell	
Client:	Audi A3, "Test"	

Agency:	Result DDB, Amstelveen	The noise of a motor revving in the desert reminds viewers of the famous Paris-Dakar rally, but turns out to be an old Volkswagen engine powering a primitive irrigation system.
Creative Director:	Michael Jansen	
Copywriter:	Massimo van der Plas	
Art Director:	Enrico Bartens	
Production:	Jonkers Hofstee Film, Amsterdam	
Director:	Hans Jonkers	
Producers:	Karin Smit Cees Hofstee	
Client:	Volkswagen, "Desert"	

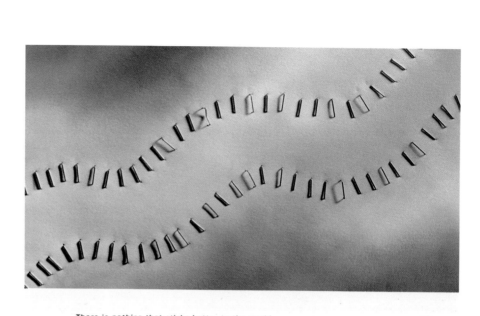

There is nothing that sticks better to the world

than an Audi with quattro traction.

Audi ⊂⊃⊃⊃⊃
At the vanguard of technology

While they have grown various centimeters in a short time Audi has grown in security. Audi will continue growing when they have stopped and are able to drive an Audi. Creating and incorporating the most advanced security methods available in the world to protect them. Such as we are doing now; offering four Airbags as standard in the whole Audi range.

Four Airbags in the Audi range.

Audi ⊂⊃⊃⊃⊃
At the vanguard of technology

Agency:	Tandem Campmany Guasch DDB, Barcelona	Agency:	Tandem Campmany Guasch DDB, Barcelona
Creative Director:	J. L. Rois	Creative Director:	J. L. Rois
Copywriter:	Alberto Astorga	Copywriter:	Alberto Astorga
Art Director:	Dani Ilario	Art Director:	Dani Ilario
Photographer:	Josep M. Roca	Photographer:	Ricardo Miras
Client:	Audi Quattro	Client:	Audi

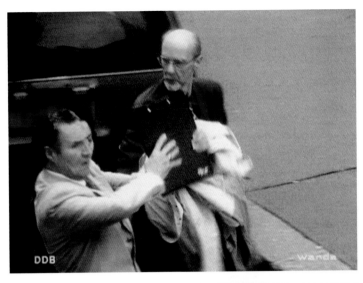

Maybe had you forgotten
the sound of emergency breaking.

The new Polo Pack
with standard A.B.S. from Volkswagen.

Evitate
i comportamenti
a rischio.

Pensate
anche al vostro
partner.

Prendete
le giuste
precauzioni.

Scegliete
la sicurezza.

Usate una Golf.
Da oggi con doppio airbag
e ABS inclusi nel prezzo.

Agency:	DDB, Paris	A hidden camera films pedestrians' instinctive reactions to the sound of hard braking and squealing tyres. "Maybe you had forgotten the sound of emergency braking," asks Volkswagen, as they announce the new Polo Pack with ABS.
Creative Director:	Christian Vince	
Copywriter:	Arnaud Roussel	
Production:	Wanda	
Director:	Arnaud Roussel	
Producer:	Christophe Starkman	
Client:	Volkswagen Polo Pack ABS, "Candid Camera"	

Agency:	Verba DDB, Milan	A man picks up a girl in a crowded night club. They kiss passionately in the elevator as they hurry away towards the parking lot and kiss again against his car. Meanwhile, messages on the screen read, "Avoid risky situations...Think of your partner...Take precautions." When the man searches desperately for something in his pockets, viewers are expecting a safe sex message to conclude the spot. Fortunately, the girl has what he's looking for, not a condom, but the keys to his Golf. "Always choose safety," advises Volkswagen as they drive away.
Creative Directors:	Gianfranco Marabelli Enrico Bonomini	
Copywriter:	Alessandro Omini	
Art Director:	Marcello Porta	
Production:	Film Master	
Director:	Alek Keshishian	
Producers:	Franco Cuccu Giuseppe Brandolini Simona Butta	
Client:	Volkswagen Golf, "Social Campaign"	

Golf GTI.

La Golf GTI a 20 ans. Joli début de carrière. VW

Why do Germans build such solid cars ?

We are what we eat.
We certainly do not intend to develop any simplistic theories here, but after all, you will agree that the same qualities are needed to make a Wurst* and to perfect a German car. Take the Polo, for example : just like the Wurst, its conception shows how much the designer wants to give the consumer value for money.
Demonstration : the Wurst is economical, rich, solid,

convivial, emanates frankness and honesty. The Polo, (even though much more physically attractive than the Wurst) is also very economical, unbelievably rich (dual air bags, immotoric starter-blocking system, dust and pollen filter, power steering, automatic front seatbelts, bumpers and door mirrors of the same color as the body...), solid and convivial (reinforced body, reinforced lateral

crossover bars, rearseat folds down, adjustable steering-wheel) and of course, as for frankness and honesty, it is indeed a Volkswagen.
To conclude, we would just like to say that the only difference between the Wurst and the Polo is that the Polo is perfectly digestible for non-Germans.
*German sausage.

Why would I buy anything but a Polo ?

Agency:	DDB, Paris	The Golf GTI is 20 years old. Good for a starter.	**Agency:** DDB, Paris
Creative Director:	Christian Vince		**Creative Director:** Christian Vince
Copywriter:	Céline Lescure		**Copywriter:** Dominique Marchand
Art Director:	Laurent Chehere		**Art Director:** Jean-Michel Alirol
Photographer:	Laurent Chehere		**Photographer:** Heinz Cibulka
Client:	Volkswagen Golf GTI		**Client:** Volkswagen Polo

You have heard: holiday '96
in a conventional car.

You have seen: holiday '97
in the new Mégane Scénic.

RENAULT
AUTOS·
ZUM LEBEN

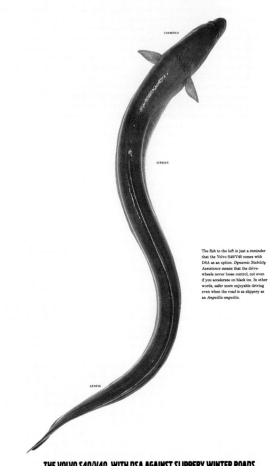

The fish to the left is just a reminder that the Volvo S40/V40 comes with DSA as an option. *Dynamic Stability Assistance* means that the drive-wheels never loose control, not even if you accelerate on black ice. In other words, safer more enjoyable driving even when the road is as slippery as an *Anguilla anguilla*.

THE VOLVO S40/V40. WITH DSA AGAINST SLIPPERY WINTER ROADS.

VOLVO

Agency:	Publicis, Frankfurt
Creative Directors:	Christoph Herold
	Felix Glauner
Copywriter:	Christoph Hildebrand
Art Director:	Gudrun Muschalla
Production:	Laszlo Kadar Films,
	Hamburg
Director:	Laszlo Kadar
Producer:	Karin Huys
Client:	Renault Mégane Scenic,
	"Have a Nice Trip"

A couple with two small children drive peacefully to the beach while a loud in-car family fight can be heard on the soundtrack. The children whine and the parents argue while their new Renault cruises peacefully through an attractive country landscape. The voice-off explains, "You have heard holiday '96 in a conventional car. You have seen holiday '97 in a new Mégane Scenic."

Agency:	Forsman & Bodenfors,
	Gothenburg
Copywriter:	Filip Nilsson
Art Director:	Mikko Timonen
Photographer:	Jäger Arén
Client:	Volvo S40/V40
	"Chamonix, Verbier,
	Geneva."

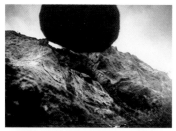

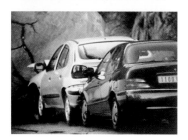
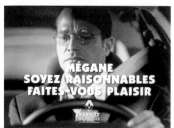

MÉGANE
SOYEZ RAISONNABLES
FAITES-VOUS PLAISIR

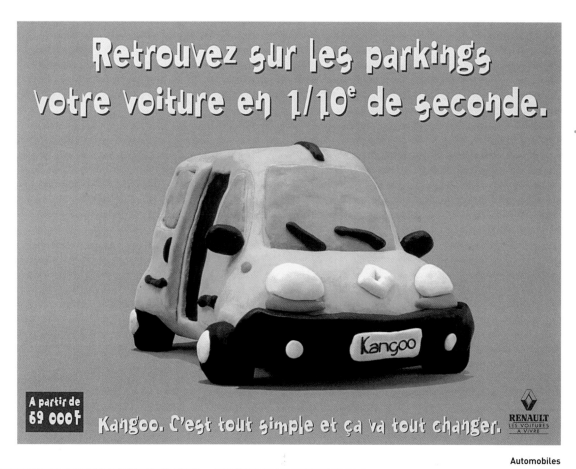

Retrouvez sur les parkings
votre voiture en 1/10ᵉ de seconde.

A partir de
69 000F

Kangoo. C'est tout simple et ça va tout changer.

RENAULT
LES VOITURES
À VIVRE

Agency:	Publicis Conseil, Paris	A Mégane driver narrowly avoids a falling boulder and stops within inches of a second huge rock that falls onto the road, thanks to his car's perfect road-holding and excellent brakes. Seconds later, however, another car crashes violently into the back of his Renault. The voice-off explains that because not everyone is fortunate enough to drive a Mégane, it's also fitted with programmed-restraint seat belts.
Creative Director:	Lucie Pardo	
Copywriter:	Olivier Desmettre	
Art Director:	Fabrice Delacourt	
Production:	Wanda	
Director:	Michel Gimbard	
Producer:	Sylvie Roselier	
Client:	Renault Mégane, "The Rock"	

Agency:	Publicis Conseil, Paris	Find your car in a parking lot in 1/10th of a second. Kangoo. It is very simple and it's going to change everything. From 79.000 FF.
Creative Directors:	Lucie Pardo Jean-Paul Lichtenberg	
Copywriter:	Christophe Trouve Dugeny	
Art Director:	Thierry Meunier	
Photographer:	Philip Habib	
Client:	Renault Kangoo	

Last words

"They can't hit us from that dist"
General Armstrong, † 1864
in the American Civil War

"Carry me to the car,
I'll drive you home"

Soltan G., 23 Jahre, † 1995
Bernd P., 22 Jahre, † 1995
Corina N., 20 Jahre, † 1995
Anette Z., 19 Jahre, † 1995
Karsten F., 18 Jahre, † 1995
Heiko S., 18 Jahre, † 1995
Thomas H., 24 Jahre, † 1995
Leila Ö., 17 Jahre, † 1995
Frank B., 25 Jahre, † 1995
Michael S., 19 Jahre, † 1995

"The fish is really fantas"
Restaurant critic from Michelin,
† 1969 in "Cheval d'Or"

"Carry me to the car,
I'll drive you home"
Michael S., 19 Jahre, † 1995

Christian B., 18 Jahre, † 1995
Gregor W., 20 Jahre, † 1995
Heiko P., 20 Jahre, † 1995
Doro P., 24 Jahre, † 1995
Daniela P., 17 Jahre, † 1995
Claudia C., 25 Jahre, † 1995
Oliver U., 17 Jahre, † 1995
Carmen D., 19 Jahre, † 1995
Manuel R., 22 Jahre, † 1995
Liana F., 19 Jahre, † 1995
Sebastian S., 20 Jahre, † 1995
Manuela P., 22 Jahre, † 1995
Timo S., 19 Jahre, † 1995
Kemer A., 18 Jahre, † 1995
Frank M., 20 Jahre, † 1995
Jeanine S., 18 Jahre, † 1995
Kirsten F., 24 Jahre, † 1995
Valentin R., 17 Jahre, † 1995
Alexander J., 20 Jahre, † 1995
Mirjam O., 23 Jahre, † 1995
Heiko B., 19 Jahre, † 1995
Julius K., 22 Jahre, † 1995
Eva M., 19 Jahre, † 1995
Christos P., 18 Jahre, † 1995

Don't drink and drive.

Please.

RENAULT
AUTOS
ZUM LEBEN

Drive 30 km/h in residential areas.
Faster is madness.

Agency:	Publicis, Frankfurt
Creative Directors:	Christoph Herold
	Felix Glauner
Copywriter:	Fritz Enlers
Art Director:	Stefan Herrmann
Production:	Das Werk
Directors:	Fritz Ehlers
	Stefan Herrmann
Producer:	Karin Huys
Client:	Renault,
	"Last Words"

Humorous last words of lesser-known historical figures end with a more recent quote, "Carry me to the car, I'll drive you home." These famous last words are followed by a long list of 1995's road accident victims' names that scroll across the screen in an anti drink-driving appeal from Renault in Germany.

Agency:	Publicis, Frankfurt
Creative Directors:	Christoph Herold
	Felix Glauner
Copywriter:	Andreas Sturm
Art Director:	Natalie Schommler
Production:	Final Touch, Hamburg
Director:	Caspar-Jan Hogerzeil
Producer:	Karin Huys
Client:	Renault,
	"Louisa"

The voice-off explains how a serious mental disease kills 220 German schoolchildren each year and maims 1,000 more. Meanwhile, a young girl is seen moving beads on an abacus counting board. The girl is in a wheelchair and the culprit is the speed maniac. Renault encourages drivers to go 30 km/h in residential areas, "Faster is madness."

Kinky toy

Bob Hahn Klassieke Porsches.
Tel. 036-5346729

Agency:	B.S.U.R., Amsterdam	NB: A special ad for up-market gay magazines.
Creative Directors:	Hjarald Agnes	
	Joost Perik	
Copywriter:	Job van Dijk	
Art Directors:	Hjarald Agnes	
	Jeff de Wolf	
Photographer:	Henri ter Hall	
Client:	Bob Hahn	
	Classic Porsches	

Agency:	McCann-Erickson,	Power.
	Moscow	
Creative Director:	Joanna Cavarzan	
Copywriter:	Albert Nekrasov	
Art Director:	Tim Brown	
Photographer:	Joris van Veltzen	
Client:	Chevrolet Blazer	

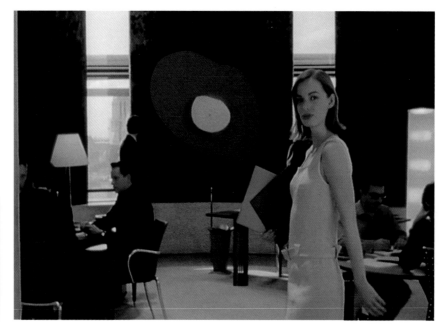

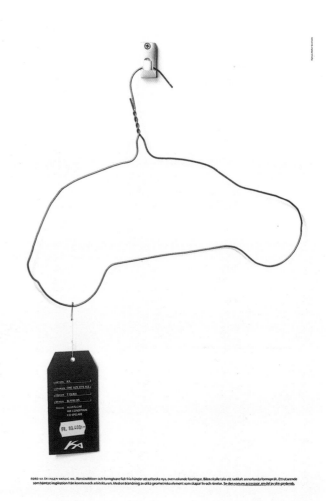

Agency:	Louis XIV, Paris	The image switches from an Audi A6 in	**Agency:**	Ogilvy & Mather,
Creative Director:	Bertrand Suchet	action, to people's admiring reactions to		Stockholm
Copywriter:	Luc Chomarat	its female driver. "Women notice me," she	**Creative Director:**	Mats Gardmo
Art Director:	Stéphane Goddard	states, as other women turn to the camera	**Copywriter:**	Mats Gardmo
Production:	Première Heure	and smile. "People show me respect,"	**Art Director:**	Petros Zazanis
Director:	Fréderic Planchon	she continues, "I've got something special."	**Photographer:**	Jörgen Ahlström
Producers:	Patrice Haddad	No, it's not the car. The final scene shows	**Client:**	Ford Ka
	Carole Tirli	the woman at last and we discover she's		
	Isabelle Dufour	in an advanced state of pregnancy. "Think		
Client:	Audi A6,	forward," suggests Audi.		
	"The Winner"			

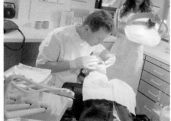

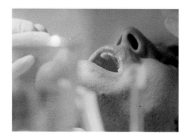

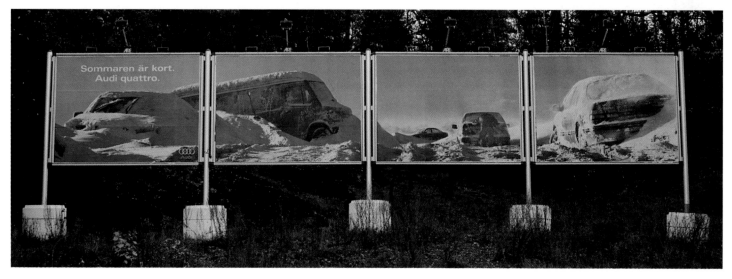

Agency:	BMP DDB, London	A patient is reluctant to open his mouth wide enough, so his dentist casually mentions that he bought a new Golf GTI recently and it only cost £14,650. The patient opens his mouth wide with amazement at this news. "That's better," says the dentist with satisfaction.	
Creative Director:	Tony Cox		
Copywriter:	Andrew Frazer		
Art Director:	Andrew Frazer		
Production:	Outsider, London		
Director:	Paul Gay		
Photographer:	Barry Ackroyd		
Producers:	Robert Campbell		
	Jason Kemp	A woman with hiccups is having breakfast while reading her morning paper. The hiccups persist until she notices an ad for the VW Polo from only £7,990.	
	Howard Spivey		
Client:	Volkswagen,		
	"Dentist" & "Hiccups"		

Agency:	Stenström & Co., Stockholm
Copywriter:	Greger Stenström
Art Director:	Hans Ahlgren
Photographer:	Adrian Burt
Client:	Audi Quattro

Summer is short (the first three billboards, without text, appeared one after the other, building-up to the full panoramic spread when Audi is identified).

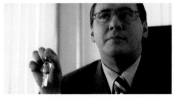
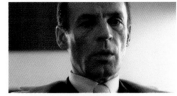
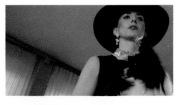

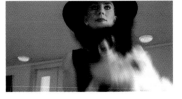

224 **Automobiles**

Agency:	Andrén Werne/Leo Burnett, Stockholm
Creative Director:	Thomas Andrén
Copywriter:	Nils Åhrström
Art Director:	Eric Larsson
Production:	Mekano
Director:	Axel Laubscher
Producer:	Anders Landström
Client:	Fiat, "The Lawyer"

A couple are getting divorced in a lawyer's office. The atmosphere is tense, but they seem to agree on who will keep what: the house, dog, boat etc., until the subject of their car comes up. There's no question of agreement on this and an argument quickly becomes a full scale fight. The lawyer escapes into his secretary's office and explains the situation with one word, "Fiat."

Agency:	Z. Publicidade, Lisbon
Creative Director:	José Carlos Campos
Copywriter:	Ricardo Adolfo
Art Director:	Miguel Coimbra
Production:	Diamantino Filmes
Director:	Diamantino Ferreira
Client:	Mercedes-Benz, "People"

People accidently slip, bump into each other and fall down in a variety of humorous ways. The final incident is reflected in a car's window, that rolls down to reveal a Mercedes-Benz logo on the steering wheel inside. Meanwhile, the voice-off explains, "At 5 km/h, an unexpected movement may have serious consequences. At high speed, its better to be well protected."

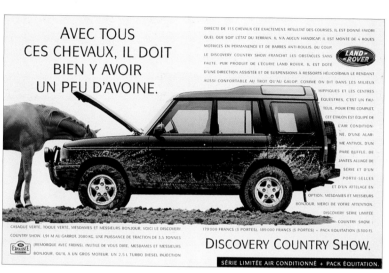

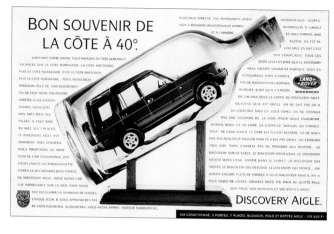

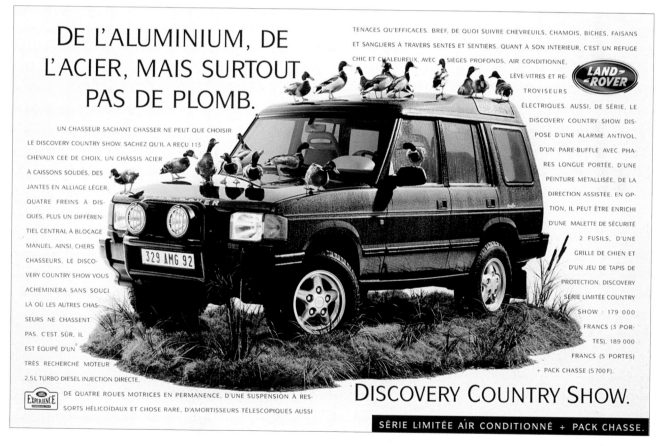

Agency:	Jean & Montmarin, Paris	Nice souvenir from "la côte" at 40° (in French, "la côte" means both the coast and a hill).
Creative Director:	Gérard Jean	
Copywriter:	Loïc Froger	With so many horses, there must be
Art Director:	Thierry Fèvre	some oats.
Photographer:	Jean-Louis Beaudequin	
Client:	Land Rover Discovery	Aluminium, steel, but certainly no lead.

 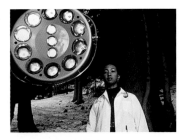

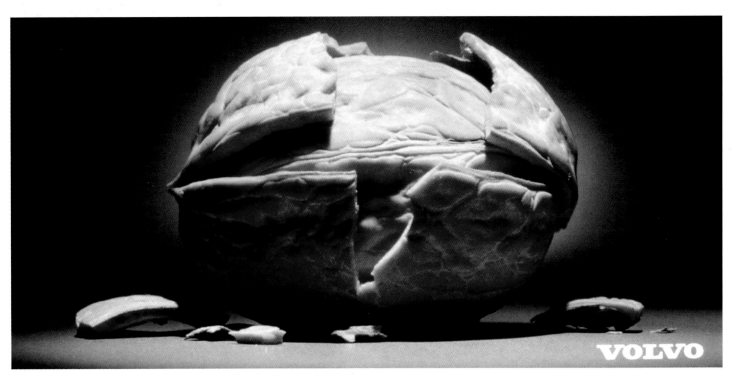

Agency:	Abbott Mead Vickers/BBDO, London		**Agency:**	Pirella Göttsche Lowe, Milan
Copywriter:	Tom Carty		**Creative Directors:**	Aldo Cernuto
Art Director:	Walter Campbell			Roberto Pizzigoni
Production:	Patricia Murphy Films		**Copywriter:**	Aldo Cernuto
Director:	Patricia Murphy		**Art Director:**	Roberto Pizzigoni
Client:	Volvo 850 AWD, "Climber"		**Photographer:**	Maurizio Cigognetti
			Client:	Volvo

A crashed helicopter hangs precariously on the edge of a precipice, while a young female doctor masters treacherous winter driving conditions to save the pilot's life. The doctor explains the need for split-second timing and a car that's both quick and safe, her calm commentary contrasting brutally with spectacular shots of the mountain rescue. "A car you can belive in," promises Volvo, announcing their V70 all-wheel-drive model.

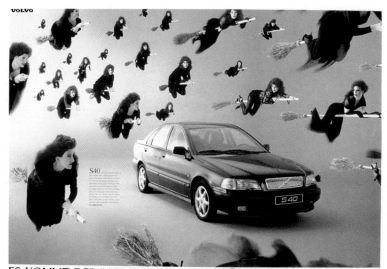

ES KOMMT DER MOMENT, WO ALLES FÜR EINEN VOLVO SPRICHT.

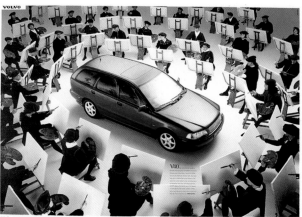

ES KOMMT DER MOMENT, WO ALLES FÜR EINEN VOLVO SPRICHT.

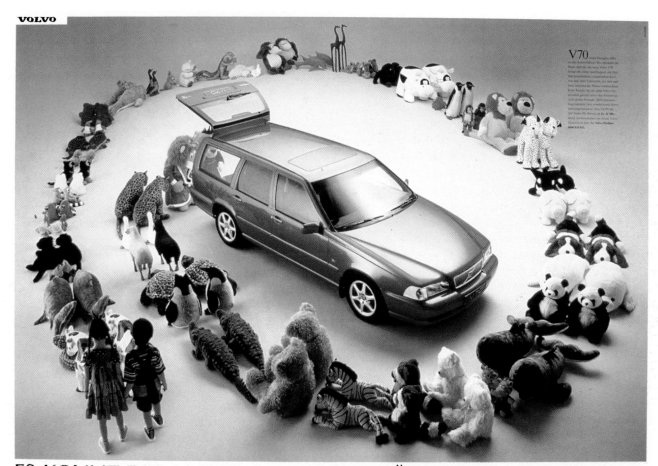

ES KOMMT DER MOMENT, WO ALLES FÜR EINEN VOLVO SPRICHT.

Agency:	Aebi, Strebel, Zürich	There comes a time when everything
Creative Director:	Jean Etienne Aebi	speaks in favour of a Volvo.
Copywriter:	Beat Reck	
Art Director:	René Sennhauser	
Photographer:	David Stewart	
Client:	Volvo	

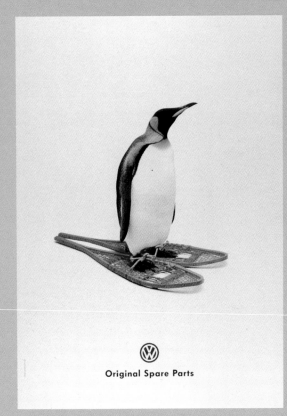

Original Spare Parts

Original Spare Parts

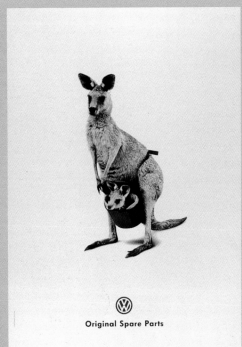

Original Spare Parts

Agency: Tandem Campmany
 Guasch DDB, Barcelona
Creative Director: Fernando Macia
Copywriters: David Guimaraes
 Alvar Suñol
Art Director: Lluís Diez
Client: Volkswagen Spare Parts

Agency:	PPGH/JWT, Amsterdam	A Formula 1 Ferrari, at speed, is refuelled
Creative Director:	Peter Hebbing	by a low-flying aeroplane in a carefully
Copywriter:	Victor Silvis	choreographed sequence, shot in real-time
Art Director:	Peter Clercx	with no special effects. "Where cars are
Production:	RSA, Los Angeles	a passion, the fuel is Shell."
Director:	Allan van Rijn	
Producers:	Vincent Oster	
	Michael Hall	
Client:	Shell Petrol,	
	"Refuelling"	

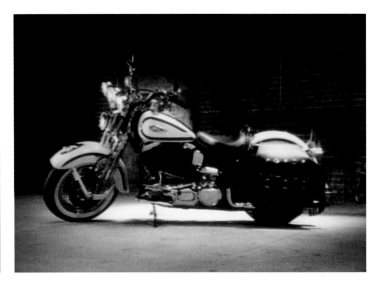

RESPECTED. EVERYWHERE.

Rain tyres.

ROYAL INEX OVLAŠĆENI DISTRIBUTER

MICHELIN kléber

Agency:	Carmichael Lynch, Minneapolis	**Agency:**	S Team Bates Saatchi & Saatchi Advertising Balkans, Belgrade
Creative Directors:	Tom Gabriel, Jack Supple	**Creative Director:**	Dragan Sakan
Copywriter:	Jim Nelson	**Copywriter:**	Slavimir Stojanovic
Art Director:	Warren Johnson	**Art Director:**	Slavimir Stojanovic
Production:	Tony Kaye & Partners, London	**Client:**	Michelin Tyres
Director:	Peter Nydrie		
Producers:	John Marshall, Kris Wiinikainen		
Client:	Harley Davidson Motorcycles, "Birds"		

A flock of pigeons alight on the rafters of an old barn above a Harley Davidson. One by one they move to either side of the motorcycle. "Respected everywhere," reads the super, while the birds' droppings can be heard hitting the floor.

New PIRELLI P200 Aquachrono. The best tyre in water.
Maximum control. Maximum performance. Maximum grip. No problems.

Agency:	TBWA EPG, Lisbon	Agency:	Vinizius/Young &
Creative Director:	Pedro Bidarra		Rubicam, Barcelona
Copywriter:	Gonçalo Morais Leitão	Creative Directors:	Xavi Moreno
Art Director:	Pedro Caixado		Rafa Blasco
Client:	Volvo Spare Parts	Copywriter:	Camil Roca
		Art Directors:	Jordi Almuni
			Quim Ribes
		Photographer:	David Levin
		Client:	Pirelli P200
			Aquachrono Tyres

POWER IS NOTHING WITHOUT CONTROL

PIRELLI

GOOD YEAR

Agency:	Young & Rubicam, London	**Agency:**	McCann, Copenhagen
Copywriter:	Judy Kingsley	**Creative Director:**	Mads Rørstrøm
Art Director:	Mark Edwards	**Copywriter:**	Jesper Hansen
Production:	Gerard de Thame Films	**Art Director:**	Robert Cerkez
Director:	Gerard de Thame	**Photographer:**	Klaus Thymann
Producers:	Fabyan Daw Gail Hartland	**Client:**	Goodyear Tyres
Client:	Pirelli Tyres, "Goddess"		

A bare-footed Marie-Jo Pérec, the French Olympic champion, outruns a monster-like creature that manifests itself in the forces of nature. She escapes avalanches, icebergs, volcanoes and torrents of gushing water eventually to gain refuge at the top of a tall rock in the desert. There, the sprinter briefly checks the Pirelli P6000 tread pattern on the soles of her feet before leaping into the void to continue her superhuman exploit.

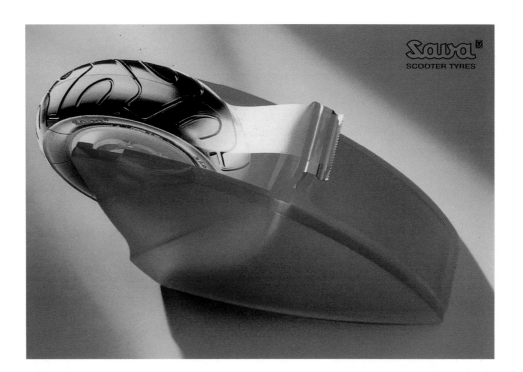

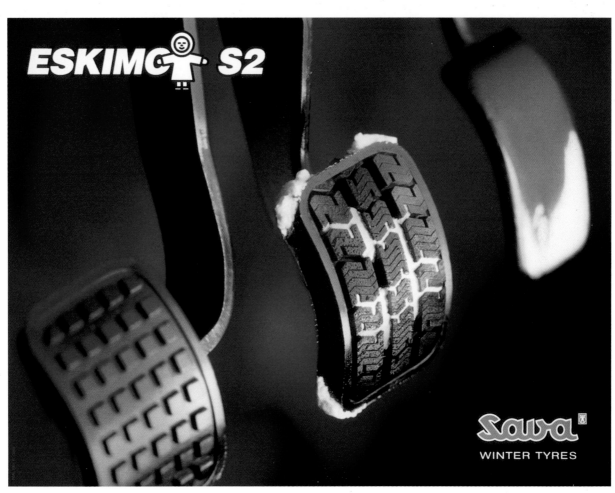

Agency:	Pan, Kranj	Agency:	Pan, Kranj
Creative Director:	Mitja Petrovic	Creative Director:	Mitja Petrovic
Copywriters:	Mitja Petrovic	Copywriter:	Mitja Petrovic
	Zoran Smiljanic	Art Directors:	Ines Petrovic
	Ines Petrovic		Riccardo Callin
Art Directors:	Ines Petrovic	Photographer:	Riccardo Callin
	Riccardo Callin	Client:	Sava Eskimo S2
Photographer:	Riccardo Callin		Winter Tyres
Client:	Sava Scooter Tyres		

With the new IBM Network Station on their desks, your people will fit perfectly into the bigger picture. They'll have access to the information they need, as soon as they need it, over intranets, extranets and the Internet.

IBM Network Stations. The smartest way to get everybody in your company working as one.

And best of all, they work with your existing systems - there's no need to start over. Simple. Flexible. Affordable. Is there a pattern emerging here? Phone 0800 222 3333 or visit www.ibm.com/nc for more details.

Solutions for a small planet **IBM**

Agency:	Ogilvy & Mather, Paris
Creative Director:	Susan Westre
Copywriter:	Brian Millar
Art Director:	Marcus Fernandez
Photographers:	David Scheinmann
	Rob Silvers
Client:	IBM Systems
	& Services

EPSON Stylus COLOR 600
1440 dpi*

* 1440 x 720 Points par pouce

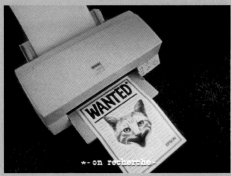

Agency:	DDB, Paris	A bulldog chases a cat across a lawn
Creative Director:	Christian Vince	and around flower pots towards a cat-flap
Copywriter:	Arnaud Roussel	in a white door. In hot pursuit, the dog
Production:	Wanda	crashes into the flap, knocking itself
Director:	Arnaud Roussel	senseless. The cat-flap turns out to be
Producer:	Patrick Barbier	a life-like Epson print attached to the door.
Client:	Epson Stylus Colour	But the dog plots its revenge; the final
	600 Printer,	shot shows the cat's portrait on a "Wanted"
	"The Dog"	poster emerging from the same Epson
		colour printer.

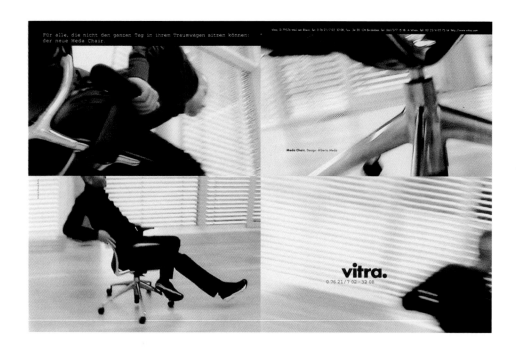

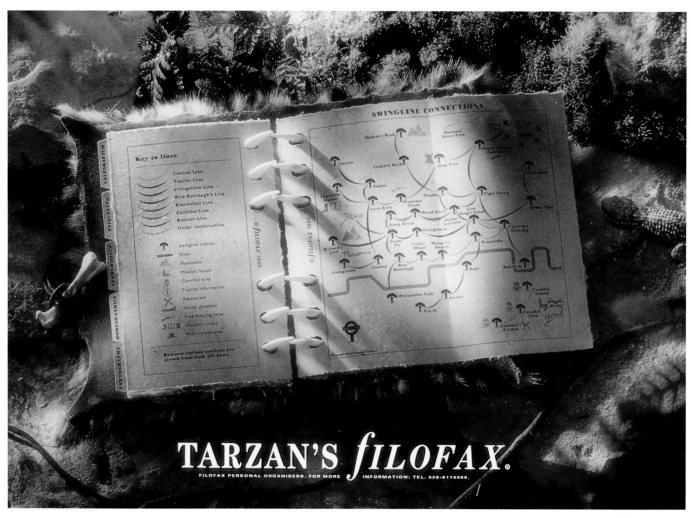

Agency:	Scholz & Friends, Berlin	For those who can't spend all day sitting in the car of their dreams: the new Meda chair.
Creative Director:	Moi Soltek	
Copywriter:	Robert Krause	
Art Director:	Lutz Plümecke	
Photographer:	Uwe Duettmann	
Client:	Vitra Office Furniture	

Agency:	B.S.U.R., Amsterdam
Creative Directors:	Hjarald Agnes
	Joost Perik
Copywriters:	Job van Dijk
	Joost Perik
Art Directors:	Hjarald Agnes
	Jeff de Wolf
Model Maker:	Rebecca Steuer
Photographer:	Rob Flapper
Client:	Filofax Personal Organisers

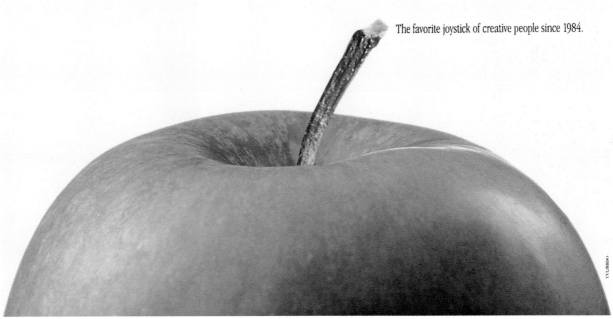

Apple Belgium
http://www.apple.be

The favorite joystick of creative people since 1984.

Agency:	Fägrell & Borlin, Stockholm	Don't you remember me...Lars...Lars Andersson?		**Agency:**	VVL-BBDO, Brussels
Creative Director:	Göran Broberg			**Creative Director:**	Willy Coppens
Copywriter:	Henrik Hallberg			**Copywriter:**	Vincent Abrams
Art Director:	Magnus Svensson			**Art Director:**	Stéphane Abinet
Client:	Relieftryck, Business Cards & Office Stationery Printers			**Photographer:**	Jean-Pierre Vanderelst
				Client:	Apple Computers

MISSBRUK INSIKT HÄNSYN

Därför att det är ont om jordklot

ÖVERGREPP SJÄLVFÖRSVAR ANSVAR

Därför att det är ont om jordklot

**Kensington Turbo Mouse.
De snelste muis ter wereld.**

Agency:	Shout Advertising, Gothenburg	Abuse. Understanding. Consideration.
Copywriter:	Peter Roane	Outrage. Self-defence. Responsibility.
Art Director:	Barrie Philip	
Photographer:	Jan Söderström	
Client:	Siemens Nixdorf, Environmentally-Friendly Computers	

Agency:	HVR Advertising, The Hague	The fastest mouse in the world.
Copywriter:	Arjen de Jong	
Art Director:	Marsel van Oosten	
Photographer:	Gerrit Schreurs	
Client:	Chipmunk International, Kensington Turbo Mouse	

Agency:	Grey, Amsterdam
Creative Director:	Kor van Velzen
Copywriter:	Stan Lommers
Art Director:	Bart Bus
Photographer:	Simon Warmer
Client:	Eurobridge, Softwear & Computer Distributors

50 Möglichkeit en für Kreative,

im Hamburger Karolinenviertel ihr Glücksgefühl zu steigern.

[Achtung, Suchtgefahr]

Agency: JvM, Hamburg

Creative Director: Hermann Waterkamp

Art Director: Bettina Pasker

Client: JvM, Recruitment
& Self-Promotion,
"Ecstasy"

50 ways for creative talents to feel happier in
Karolienviertel Hamburg. Warning: may cause
addiction (the last image is JvM's doorbell).

Choose a faster internet

 Telenordia

Agency:	Garbergs Annonsbyrå, Stockholm	
Copywriter:	Johan van der Schoot	
Art Director:	Petter Ödeen	
Production:	Mekano Film & TV	
Director:	Axel Laubscher	
Producer:	Elisabeth Andersson	
Client:	Telenordia Internet Services	

A young woman is late for a date with a man she's met on the Internet. His picture is slowly downloading onto her computer screen, while she talks excitedly to a friend on the telephone. "He looks like Kevin Costner," she says, before leaving in a hurry to meet him. After she's left we finally see the whole picture. The good-looking man is just a poster on the wall, below it is her date: a somewhat obese and vulgar gentleman whose homepage trick is to belch repeatedly. "Choose a faster Internet," advises Telenordia, the first operator to use a 56 Kbs modem for quicker downloading of images and information.

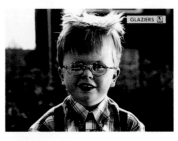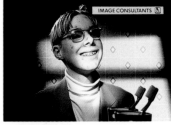

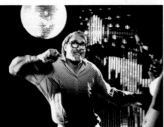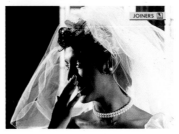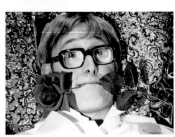

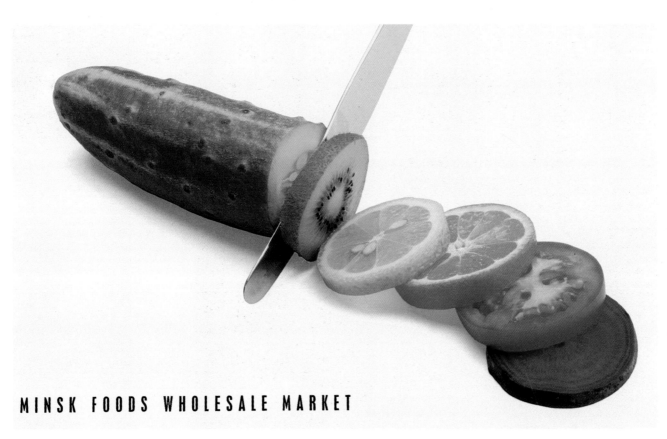

MINSK FOODS WHOLESALE MARKET

Agency:	Abbott Mead Vickers BBDO, London
Creative Director:	David Abbott
Production:	Patricia Murphy Films
Director:	Patricia Murphy
Client:	Yellow Pages, "Life"

The cycle of life goes from one generation to the next with a dozen appropriate section headings from the Yellow Pages announcing each step along the way. "Accommodation" describes a pregnant woman's swollen stomach, "Alarm Systems" announces the crying baby, "Glaziers" for a small boy with his football, "Image Consultants" are needed for his teenage acne, "Fireworks" when he meets his future bride, and so on back to "Accommodation" again to announce the imminent arrival of twins and the beginning of a new cycle.

Agency:	Kryn Creative Advertising Agency, Minsk
Creative Director:	Alexander Shevelevich
Art Director:	Vladimir Cesler
Photographer:	Andrew Schukin
Client:	Minsk Wholesale Food Market

IF YOU DON'T FIND IT HERE, PATENT IT.

Tremendously useful.

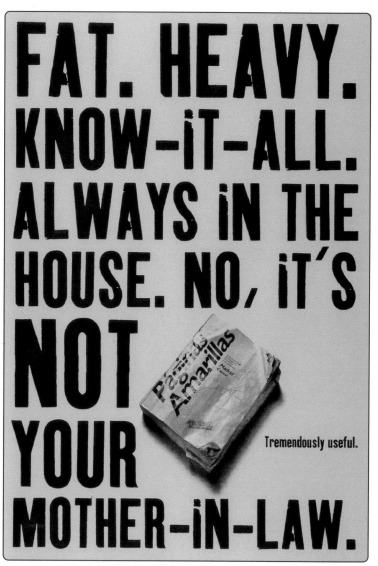

FAT. HEAVY. KNOW-IT-ALL. ALWAYS IN THE HOUSE. NO, IT'S NOT YOUR MOTHER-IN-LAW.

Tremendously useful.

THERE ARE PEOPLE WHO SUCCEED IN LIFE BY READING JUST ONE BOOK.

Tremendously useful.

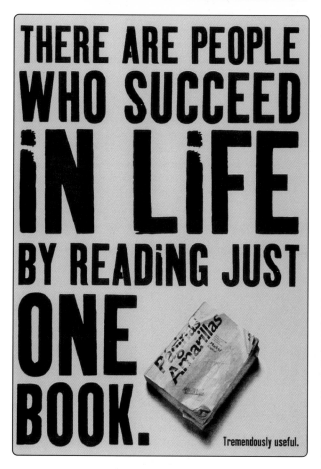

THIS IS THE BEST IMAGE OF OUR PRODUCT WE CAN OFFER YOU.

Tremendously useful.

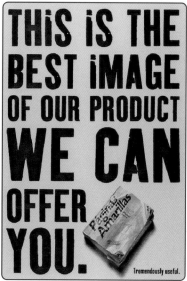

Business Services 243

Agency:	Young & Rubicam, Madrid
Creative Director:	Jose Maria Pujol
Copywriter:	Anselmo Ramos
Art Director:	Cassio Moron
Photographer:	Iñaki Preisler
Client:	Yellow Pages

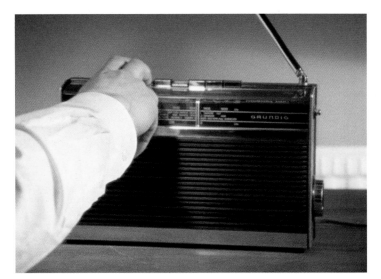

INITIATIVE
UNIVERSAL
Your Media Consultant

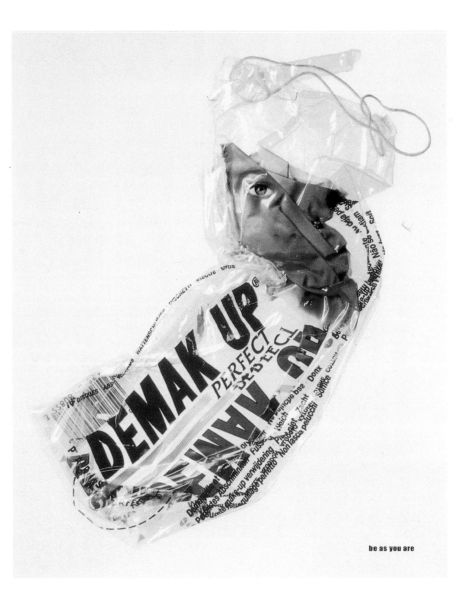

be as you are

Agency:	Rönnberg McCann, Stockholm
Copywriter:	Staffan Ryberg
Art Director:	Oscar Liedgren
Production:	Mekano Film & TV
Director:	Jesper Ericstam
Producer:	Mary Lee Copeland
Client:	Initiative Universal Media Buyers, "Right Media"

"Good advertising is one thing, but knowing where to place it is another. That's where we come in," announces Initiative Universal in a (televised) radio commercial. The film continues, "For more information, cut out and send in this coupon. Choose the right media, choose Initiative Universal."

Agency:	B.S.U.R., Amsterdam
Creative Directors:	Hjarald Agnes
	Joost Perik
Copywriter:	Joost Perik
Art Directors:	Hjarald Agnes
	Jeff de Wolf
Photographer:	David de Jong
Client:	B.S.U.R. Self-Promotion

NB: B.S.U.R. is pronounced "be as you are." The agency encourages individuality, hence the visual shows an empty pack of a well-known make-up remover.

Who knows what could have happened if he had hired us.

Who knows what could have happened if he had hired us.

Agency:	Grupo Barro-Testa, Madrid	Lenon. Greatest hits 1980-1995.
Creative Directors:	Urs Frick	Who knows what could have happened if he
	Uschi Henkes	had hired us.
	Manolo Moreno Marquez	
Copywriter:	Manolo Moreno Marquez	
Art Directors:	Uschi Henkes	
	David Villarrubia	
Photographer:	Alfonso Zubiaga	
Client:	Grupo Barro-Testa, Self-Promotion, "Latest Awards"	

Agency:	Young & Rubicam, Madrid
Creative Director:	Miguel Angel Laborda
Copywriter:	Anselmo Ramos
Art Director:	Cassio Moron
Client:	Barcelona Proteccion y Seguridad, Bodyguard Services

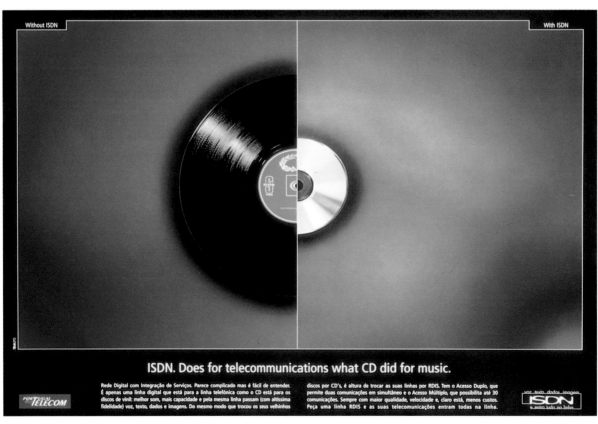

Without ISDN **With ISDN**

ISDN. Does for telecommunications what CD did for music.

Rede Digital com Integração de Serviços. Parece complicado mas é fácil de entender. É apenas uma linha digital que está para a linha telefónica como o CD está para os discos de vinil: melhor som, mais capacidade e pela mesma linha passam (com altíssima fidelidade) voz, texto, dados e imagens. Do mesmo modo que trocou os seus velhinhos discos por CD's, é altura de trocar as suas linhas por RDIS. Tem o Acesso Duplo, que permite duas comunicações em simultâneo e o Acesso Múltiplo, que possibilita até 30 comunicações. Sempre com maior qualidade, velocidade e, claro está, menos custos. Peça uma linha RDIS e as suas telecomunicações entram todas na linha.

PORTUGAL TELECOM ISDN

Agency:	Egeberg Advertising Agency, Copenhagen	A businessman appears to be enjoying a romantic dinner in his hotel room. He	**Agency:** TBWA EPG, Lisbon
Creative Director:	Jesper Winge Leisner	smiles seductively and plays with a white	**Creative Director:** Pedro Bidarra
Copywriter:	Jesper Winge Leisner	rose that's slapped playfully against his	**Copywriter:** Pedro Bidarra
Art Directors:	Ole Kaarsberg	face. The camera cuts occasionally to his	**Art Directors:** Jose Heitor
	Kjeld Poulsen	"date's" legs, in black stockings and high	Claudia Portela
Production:	Locomotion	heels. In fact, the poor man is all alone,	**Photographer:** João Palmeiro
Director:	Peder Pedersen	half-dressed as a woman and admiring	**Client:** Portugal Telecom,
Producer:	Erik Wilstrup	himself in a mirror. "Missing something?"	ISDN
Client:	Paradise	asks the Paradise Escort Service," With us	Telecommunication
	Escort Service,	the client always comes first."	System
	"Beautiful Legs"		

Agency:	Aebi, Strebel, Zürich	Your advertisement on the director's desk.
Creative Director:	Jean Etienne Aebi	
Copywriter:	Beat Reck	Your advertisement on the way to work.
Art Director:	René Sennhauser	
Illustrators:	Michael Sowa	Your advertisement in good company.
	Rudi Hurzlmeier	
Client:	Publicitas,	Your advertisement in a favourite place.
	Media Brokers	Only print enables you to place your
		message, and therefore your product, in
		front of the target, wherever and whenever.

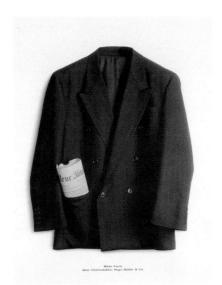

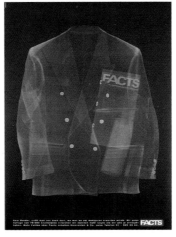

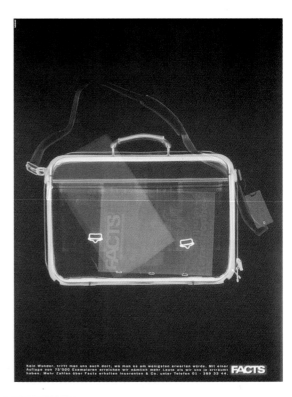

Agency:	Aebi, Strebel, Zürich	More facts about chief editors Jacques Pilet, Markus
Creative Director:	Jean Etienne Aebi	Gisler, Hugo Bütler, Jürg Wildberger & Co.
Copywriter:	Matthias Freuler	
Art Director:	Erik Voser	NB: Jacques Pilet, Markus Gisler and Hugo Bütler are
Photographer:	Chris Frazer Smith	editors of competitive publications. Jürg Wildberger is
Client:	Facts, News Magazine	the editor of Facts, the X-ray shows that he also reads
		another magazine, Focus, the German publication which
		was the model for the Facts launch in Switzerland.

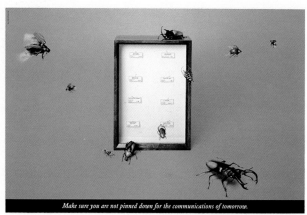

Make sure you are not pinned down for the communications of tomorrow.

The new Ascotel ISDN telecommunications system: ascom *thinks ahead*

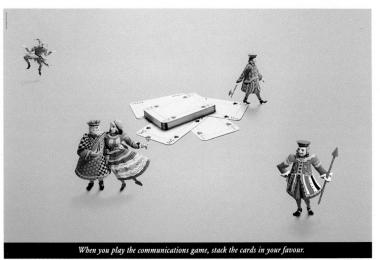

When you play the communications game, stack the cards in your favour.

The new Ascotel ISDN telecommunications system: ascom *thinks ahead*

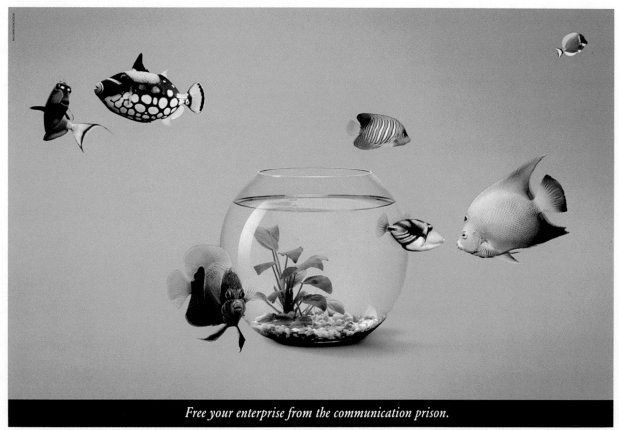

Free your enterprise from the communication prison.

The new Ascotel ISDN telecommunications system: ascom *thinks ahead*

Business Services **249**

Agency:	McCann-Erickson, Zürich
Creative Director:	Edi Andrist
Copywriter:	Markus Sidler
Art Director:	Nicolas Vontobel
Client:	Ascotel ISDN Telecommunication System

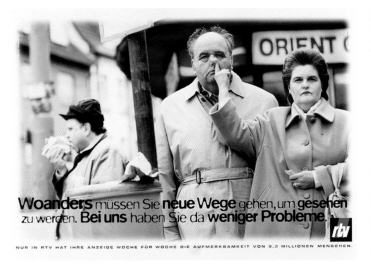

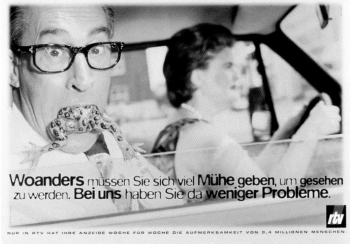

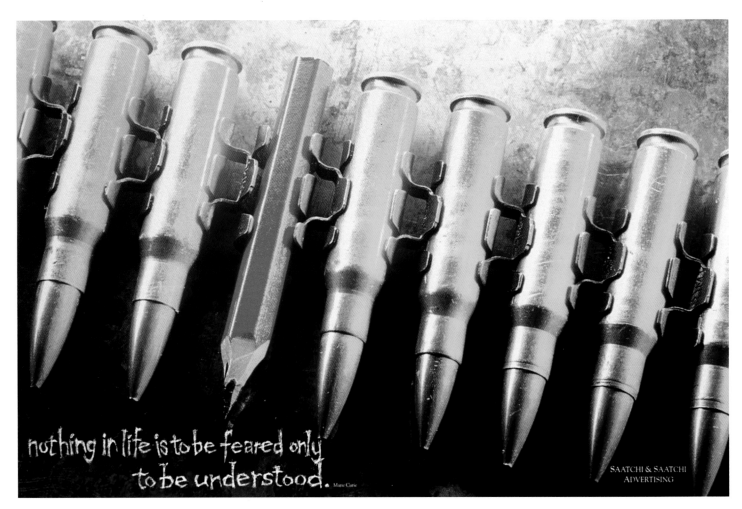

nothing in life is to be feared only to be understood. Marie Curie

SAATCHI & SAATCHI
ADVERTISING

Agency:	Ogilvy & Mather, Frankfurt	**Agency:**	Saatchi & Saatchi Advertising, Cape Town
Creative Directors:	André Aimaq Dietmar Reinhard	**Creative Director:**	Eric Frank
Copywriter:	André Aimaq	**Copywriter:**	Mark Legward
Art Directors:	Alexander Heil Judith Heinz	**Art Director:**	La Peace Kakaza
Photographer:	Dieter Eikelpoth	**Photographer:**	Alain Proust
Client:	Deutscher Supplement Verlag, TV Supplement	**Client:**	Saatchi & Saatchi Advertising, Self-Promotion

In some places you have to go to great lengths to make sure you're seen. With us it's easier.

Only in rtv does your ad catch the eye of 9.4 million people every week.

Agency:	Creator-Grey, Helsinki
Creative Director:	Pentti Pilve
Copywriters:	Pentti Pilve
	Pirkko-Liisa Mustonen
Art Directors:	Inka Happo
	Laura Valkonen
Photographer:	Timo Päivinen
Client:	Finnish Periodical
	Publishers' Association

The human mind needs a pause too, something to hold on to - the periodical.

Agency:	Intevi Werbeagentur, Cologne	Dragonfrog red stays dragonfrog red.
Creative Director:	Frank Schätzing	Toucan yellow stays toucan yellow.
Copywriter:	Frank Schätzing	
Art Director:	Dieter Groll	Mandrill blue stays mandrill blue.
Photographer:	Uwe Nohlen	
Client:	Spies Hecker, Car Refinishing Paints	

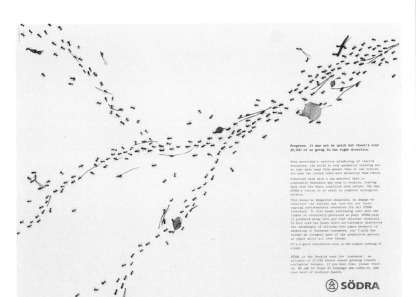

Progress: it may not be quick but there's over 50,000 of us going in the right direction.

From yesterday's careless plundering of limited resources, the world is very gradually learning not to take more away from nature than it can restore. For some the lesson comes more naturally than others.

Foresters work with a raw material that is constantly renewable and easy to recycle, leaving them very few basic conflicts with nature. One day, SÖDRA's vision is to exist in complete ecological balance.

This means no dangerous chemicals, no damage to sensitive old forests and last but not least, ongoing environmental execution for all SÖDRA foresters. It also means continuing care when the timber is eventually processed as pulp. SÖDRA pulp is produced using zero per cent chlorine chemicals. In fact over the years since our customers discovered the advantages of chlorine-free paper products in marketing to European consumers, our Z-pulp has become an integral part of the production process at paper mills all over Europe.

It's a quiet revolution even in the simple turning of a page.

SÖDRA is the Swedish word for 'southern', an alliance of 51,039 forest owners growing towards ecological balance. If you have time, please visit us. We can be found at homepage www.sodra.se, and over most of southern Sweden.

△ SÖDRA

Powerhouse: the united vision of over 50,000 independent foresters.

It's true that we would not be nearly as strong alone, but together we have grown into a quietly effective force. SÖDRA's strength is a solidarity rooted in the shared lives of the forests and the work which lies at the heart of it.

[body text, illegible]

SÖDRA is the Swedish word for 'southern', an alliance of 51,039 forest owners growing towards ecological balance. If you have time, please visit us. We can be found at homepage www.sodra.se, and over most of southern Sweden.

△ SÖDRA

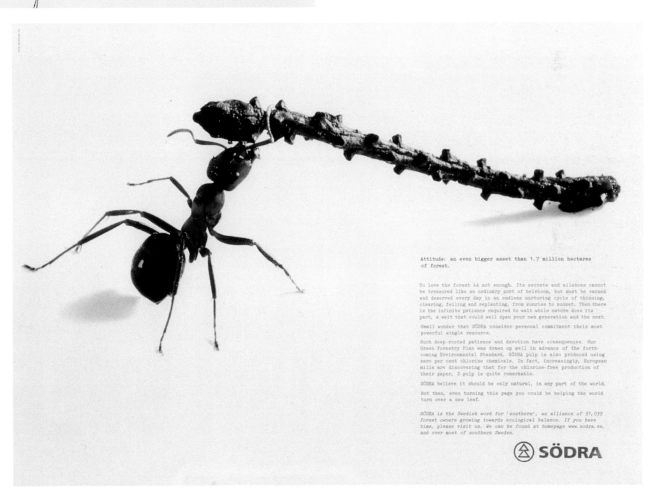

Attitude: an even bigger asset than 1.7 million hectares of forest.

To love the forest is not enough. Its secrets and silences cannot be treasured like an ordinary sort of heirloom, but must be earned and deserved every day in an endless nurturing cycle of thinning, clearing, felling and replanting, from sunrise to sunset. Then there is the infinite patience required to wait while nature does its part, a wait that could well span your own generation and the next.

Small wonder that SÖDRA consider personal commitment their most powerful single resource.

Such deep-rooted patience and devotion have consequences. Our Green Forestry Plan was drawn up well in advance of the forthcoming Environmental Standard. SÖDRA pulp is also produced using zero per cent chlorine chemicals. In fact, increasingly, European mills are discovering that for the chlorine-free production of their paper, Z-pulp is quite remarkable.

SÖDRA believe it should be only natural, in any part of the world.

But then, even turning this page you could be helping the world turn over a new leaf.

SÖDRA is the Swedish word for 'southern', an alliance of 51,039 forest owners growing towards ecological balance. If you have time, please visit us. We can be found at homepage www.sodra.se, and over most of southern Sweden.

△ SÖDRA

Industrial & Agricultural Equipment **253**

Agency:	Garbergs Annonsbyrå, Stockholm
Creative Director:	Håkan Karlsvärd
Copywriter:	Jöns Hellsing
Art Director:	Karin Ahlgren
Photographer:	Lasse Kärkkäinen
Client:	Södra Chlorine-Free Pulp

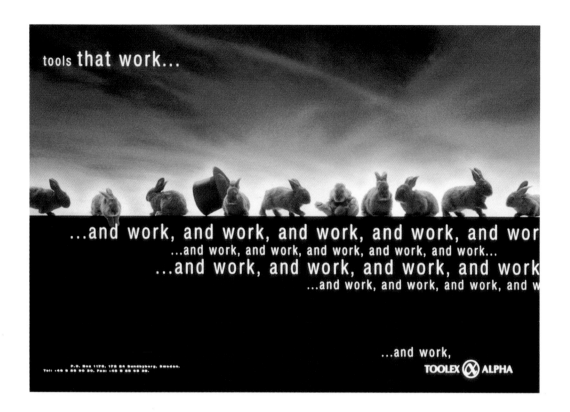

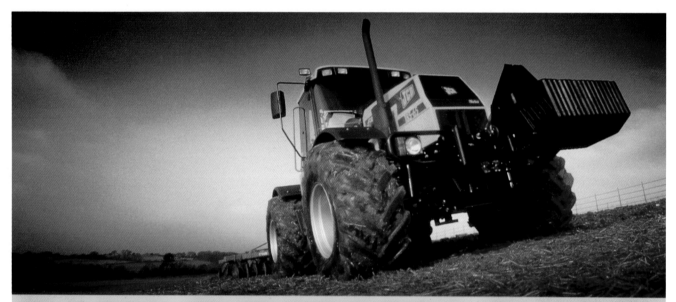

254 **Industrial & Agricultural Equipment**

Agency:	MMC Sweden, Stockholm	**Agency:**	Brookes & Vernons, Uttoxeter	
Copywriter:	Ruby Windrup	**Creative Director:**	Ian Davies	
Art Director:	Fredrik Gustavsson	**Copywriter:**	Ian Davies	
Client:	Toolex Alpha Replication Systems	**Art Director:**	Dino Maddalena	
		Photographer:	Richard Prescott	
		Client:	JCB Fastrac Tractors	

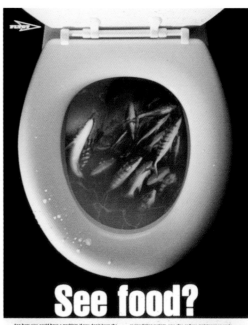

See food?

See how you could have a problem if you don't keep the water in your raising ponds clean? See how it could affect the quality of your product? Yet disposing of all that waste matter isn't easy. Today's tough environmental laws mean you can't just flush it away.

ITT Flygt aquaculture equipment makes it easier to treat waste material, and keep ponds and drains clean. With our world-beating submersible pumps, mixers and aerators in a recirculating system, you also reduce maintenance costs and use less new fresh water.

So you keep the fish healthy, your customers happy, and the environment stays in good shape. See how easy it is to please everyone?

See your local ITT Flygt representative for more information, or call ITT Flygt AB.

Tel: +46 8 627 6500. Fax: +46 8 627 6900.

ITT Flygt

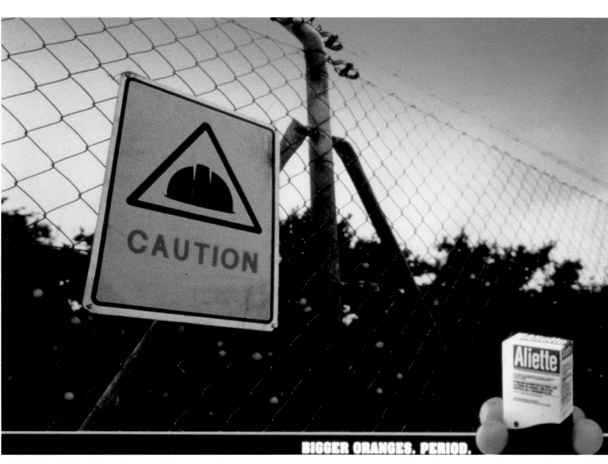

CAUTION

BIGGER ORANGES. PERIOD.

Agency:	MMC Sweden, Stockholm	**Agency:**	Vitruvio/Leo Burnett, Madrid
Copywriter:	Graeme Forster	**Creative Director:**	Rafa Anton
Art Director:	Eric Dowell	**Art Director:**	Rafa Anton
Client:	ITT Flygt Submersible Pumps	**Photographer:**	Aurelio Rodriguez
		Client:	Aliette Fertilizer

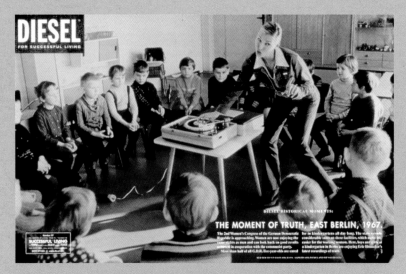

THE MOMENT OF TRUTH, EAST BERLIN, 1967.

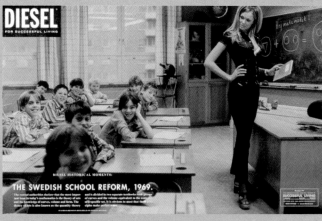

THE SWEDISH SCHOOL REFORM, 1969.

SUN CITY, 1975.

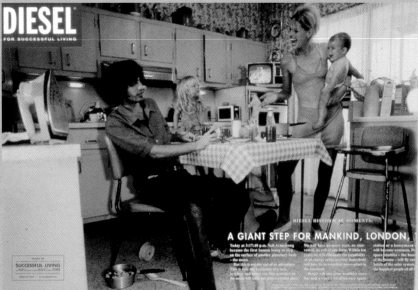

A GIANT STEP FOR MANKIND, LONDON, 1969.

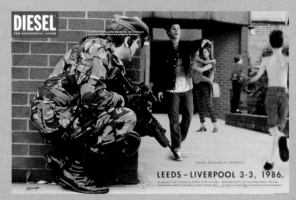

LEEDS – LIVERPOOL 3-3, 1986.

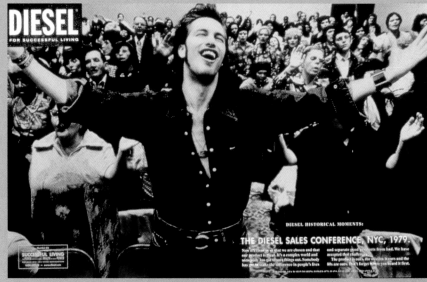

THE DIESEL SALES CONFERENCE, NYC, 1979.

Agency: Paradiset DDB,
 Stockholm
Creative Director: Joakim Jonason
Copywriter: Jacob Nelson
Art Director: Joakim Jonason
Photographer: Peter Gehrke
Client: Diesel Jeans
 & Workwear

Agency:	Paradiset DDB, Stockholm
Creative Director:	Joakim Jonason
Copywriter:	Jacob Nelson
Art Director:	Joakim Jonason
Production:	Traktor
Directors:	Pontus Löwenhielm
	Mats Lindberg
Producers:	Richard Ulfvengren
	Stefan Öström
	Mia Kleist
Client:	Diesel Jeans & Workwear, "A Day in P'yongyang"

A young North Korean argues with his drunken father and decides to leave home. He picks up his girlfriend and catches a bus to the city where he's refused entry to the community hall because he's wearing jeans. His girlfriend is allowed in, however, and she abandons him. The despondent young man then decides to end it all and heads for a high bridge. He's about to jump when his girlfriend returns, now also wearing jeans, and joins him on the parapet. They jump together...and land in the back of a passing rubbish truck. "Diesel - for successful living."

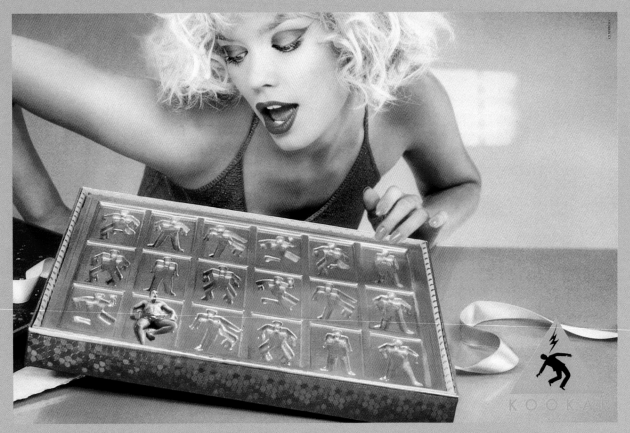

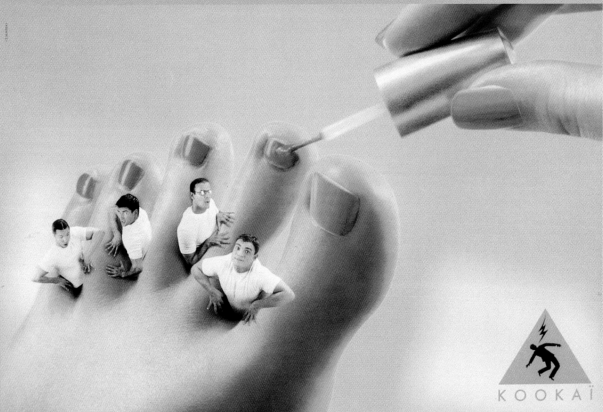

Agency:	CLM/BBDO, Paris
Creative Director:	Anne de Maupeou
Copywriters:	Frédéric Temin
	Guillaume de la Croix
Art Director:	Nicolas Chauvin
Photographer:	Les Guzman
Client:	Kookaï
	Women's Fashions

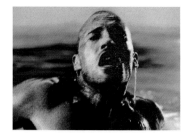
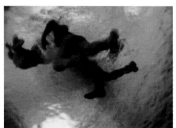

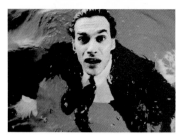

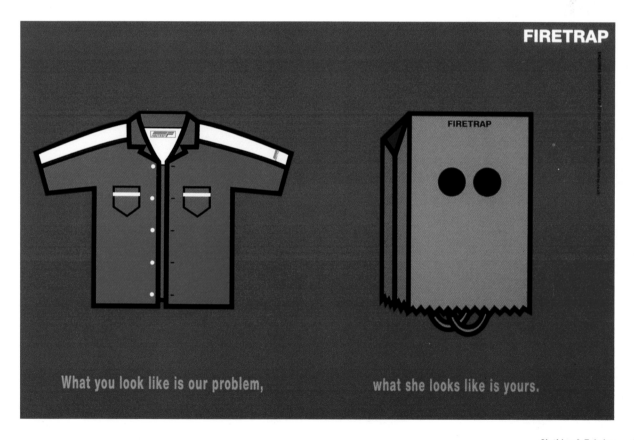

What you look like is our problem, **what she looks like is yours.**

Agency:	CLM/BBDO, Paris	Four young men fall into deep water.
Creative Director:	Anne de Maupeou	In a state of panic, they struggle to avoid
Copywriters:	Frédéric Temin	drowning and desperately kick their way
	Guillaume de la Croix	to the surface. The men look up anxiously
Art Director:	Anne de Maupeou	while the camera pulls back and we
Production:	Telema	discover that they're in a toilet bowl.
Director:	Julien Seri	A Kookaï girl looks down at them with
Producer:	Pascale Petit	distain, then flushes them away.
Client:	Kookaï Women's	
	Fashions,	
	"The Battle	
	of the Sexes"	

Agency:	Bean Andrews
	Norways Cramphorn,
	London
Creative Director:	Graeme Norways
Copywriter:	Gary Sollof
Art Directors:	Jeff Ford
	Graeme Norways
Illustrator:	Jon Rogers
Photographer:	Arial von Stracken
Client:	Firetrap Clothing

Vive la France !

FOR SUCCESSFUL LiViNG:

Agency:	Paradiset DDB, Stockholm
Creative Director:	Joakim Jonason
Copywriter:	Jacob Nelson
Art Director:	Joakim Jonason
Production:	Traktor
Directors:	Pontus Löwenhielm
	Mats Lindberg
Producers:	Richard Ulfvengren
	Stefan Öström
	Mia Kleist
Client:	Diesel Jeans & Workwear, "Little Rock"

Little Rock, 1873: two men put on their guns and prepare to confront each other. The hero is squeaky-clean, he kisses his pretty wife goodbye and helps an old lady across the road on his way to the showdown. The villain is bad. He leaves his ugly whore in bed, steals a lollipop from a little girl and kicks a dog out of his way. They face each other on the street in classic western style, good vs evil, then go for their guns. A single shot rings out and the hero drops dead. The villain picks his nose nonchalantly and heads back towards the saloon for more, "successful living."

Agency:	Paradiset DDB, Stockholm
Creative Director:	Joakim Jonason
Copywriter:	Jacob Nelson
Art Director:	Joakim Jonason
Production:	Mod : Film, Stockholm
Director:	Jhoan Camitz
Producers:	Maria Tamander
	Stefan Öström
	Mia Kleist
Client:	Diesel Jeans & Workwear, "The Battle of the Ardennes"

It's the mobilisation of 1940. A young postman delivers call-up papers to an unpleasant Frenchman who twists his pretty wife's nose, with an evil laugh, before leaving to defend the Republic. Later, the postman returns to the same house with news of the soldier's demise and wastes no time in marrying the man's widow. However, the devil is at their wedding. In the guise of a stone angel, he takes flight towards the organist. The organist turns, flashing an evil smile. We recognise the late husband.

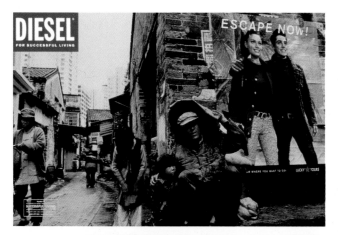

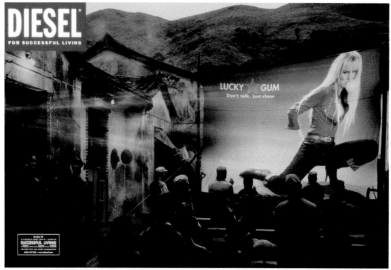

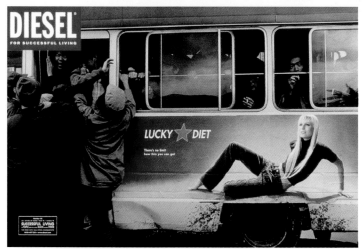

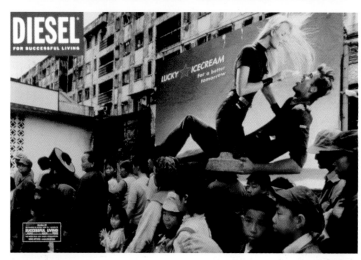

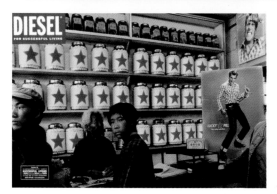

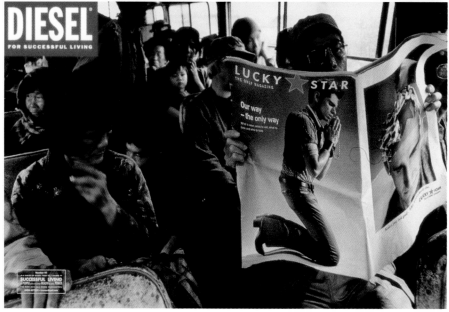

Agency:	Paradiset DDB, Stockholm
Creative Director:	Joakim Jonason
Copywriter:	Jacob Nelson
Art Director:	Joakim Jonason
Photographer:	Peter Gehrke
Client:	Diesel Jeans & Workwear

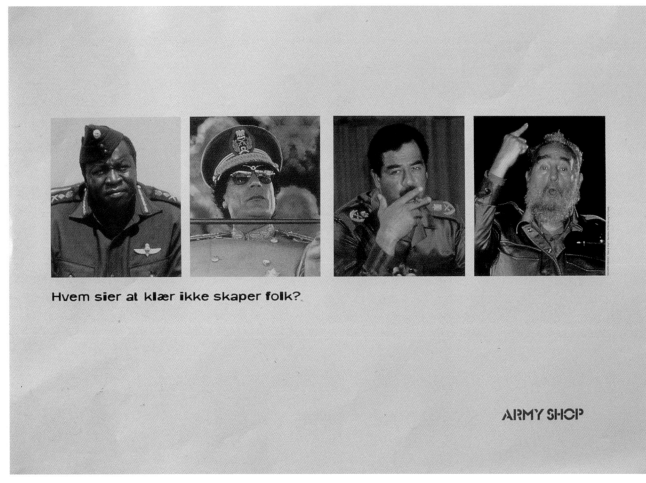

Hvem sier at klær ikke skaper folk?

ARMY SHOP

Agency:	Grey, Düsseldorf	Act of love.	**Agency:**	JBR/McCann Indigo, Oslo	Who says clothes don't make the man?
Creative Director:	Annchen M. Stiens				
Copywriter:	Barbara Kotte	Attractiveness.	**Copywriter:**	Lars Killi	
Art Director:	Claudia Mertmann		**Art Directors:**	Klaus Og	
Photographer:	Steffen Jagenburg	Silicon.		Jo Espen	
Client:	Lee California Jeans		**Client:**	Army Shop Clothes	

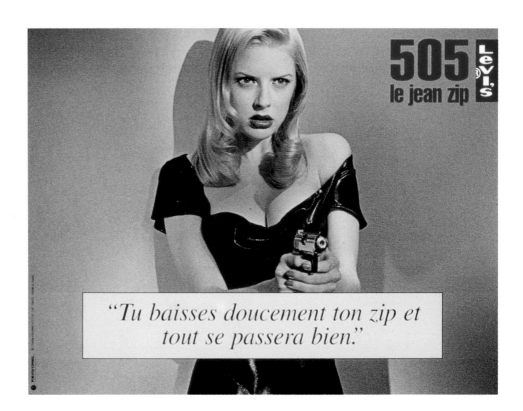

"*Tu baisses doucement ton zip et tout se passera bien.*"

Agency:	Publicis Conseil, Paris	Just pull your zip down slowly and nobody
Creative Director:	Dominique Chevallier	will get hurt.
Copywriter:	Dominique Chevallier	
Art Director:	Kamar Shafie	
Photographer:	Thierry le Goues	
Client:	Levi's 505 Jeans	

Agency:	Springer & Jacoby, Hamburg
Creative Directors:	Arndt Dallmann
	Guido Heffels
Copywriter:	Thomas Grabinger
Art Director:	Rainer Kollender
Illustrators:	Erik Hart
	Stefan Leick
Photographers:	Carli Hermes
	Gary Owens
Client:	Levi Strauss Clothing

Agency:	Garbergs Annonsbyrå, Stockholm & Amsterdam
Copywriters:	Mark Aink
	Paul Falla
Art Director:	John Mara
Production:	Stillking Films, Prague
Producers:	Jan Velicky
	Daniel Bergmann
Client:	Pepe Jeans, "No Way Out"

A young man in Pepe jeans kisses his mother goodbye at the front door of their apartment and attempts to leave the building. First, he's intercepted by a blonde neighbour, who invites him into her flat. After the blonde, in the elevator, he meets a scantily-dressed brunette, who pulls the emergency stop lever. Leaving the elevator, he's ambushed by two others with a fire hose, gang raped by a female football team and hooked by a woman with a fishing rod. Seeking refuge, the boy returns home where, to his dismay, he discovers his mother, also in Pepe jeans, eager to follow in his footsteps.

Production:	Tony Kaye & Partners, London
Director:	Rupert Sanders
Producer:	Amy Appleton
Client:	Philip Treacy, "Circles"

Philip Treacy's collection of avant-garde head-dresses (exotic hats, turbans and other creations incorporating feathers, flowers, zip fasteners, etc.) is presented in circles on the screen.

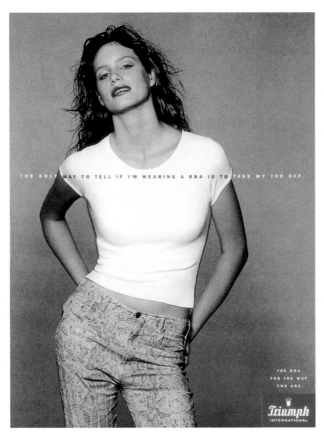

THE ONLY WAY TO TELL IF I'M WEARING A BRA IS TO TAKE MY TOP OFF.

THE BRA
FOR THE WAY
YOU ARE.

Triumph
INTERNATIONAL

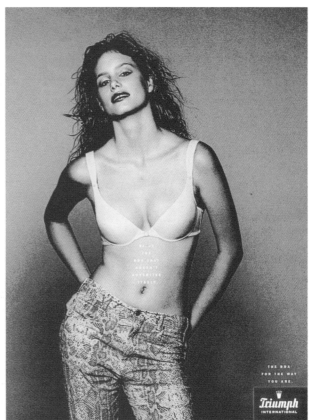

THE BRA
FOR THE WAY
YOU ARE.

Triumph
INTERNATIONAL

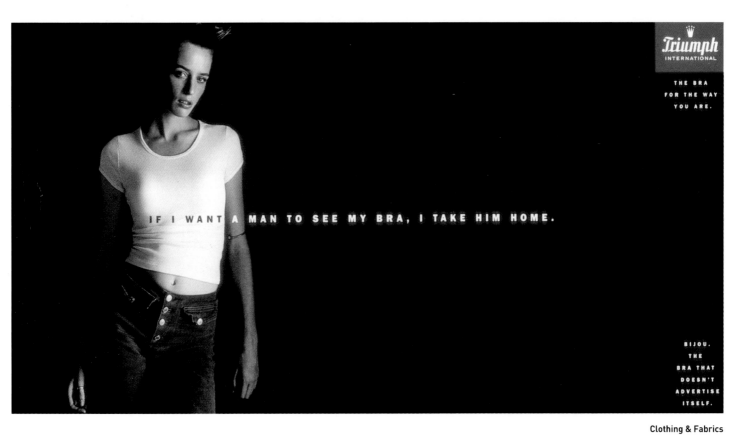

Triumph
INTERNATIONAL

THE BRA
FOR THE WAY
YOU ARE.

IF I WANT A MAN TO SEE MY BRA, I TAKE HIM HOME.

BIJOU.
THE
BRA THAT
DOESN'T
ADVERTISE
ITSELF.

Agency:	Delaney Fletcher Bozell, London	NB: When readers turn the page they discover that the girl's T-shirt is printed on an acetate overlay.	**Agency:**	Delaney Fletcher Bozell, London
Creative Directors:	Greg Delaney Brian Stewart		**Creative Directors:**	Greg Delaney Brian Stewart
Copywriter:	Peter Kew		**Copywriter:**	Mark Waldron
Art Director:	Ronnie Brown		**Art Director:**	Alex Bamford
Photographer:	Warren du Preez		**Photographer:**	Warren de Preez
Client:	Triumph Bijou Bra		**Client:**	Triumph Bijou Bra

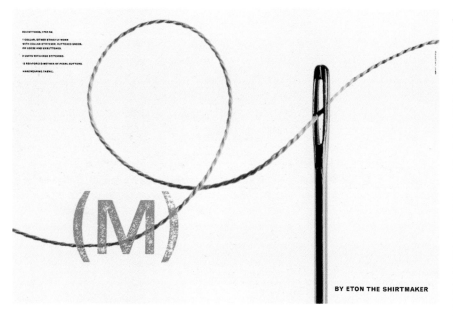

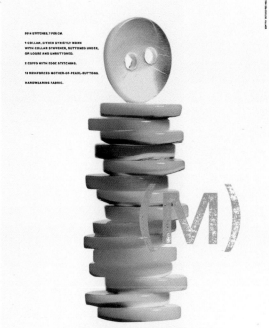

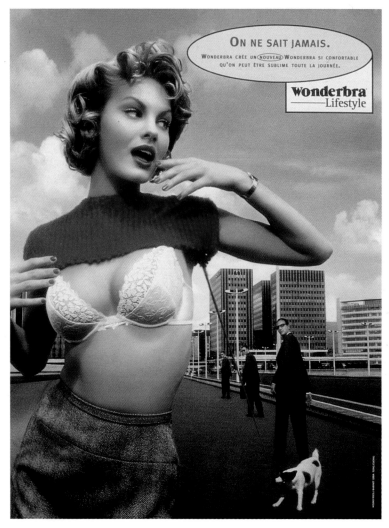

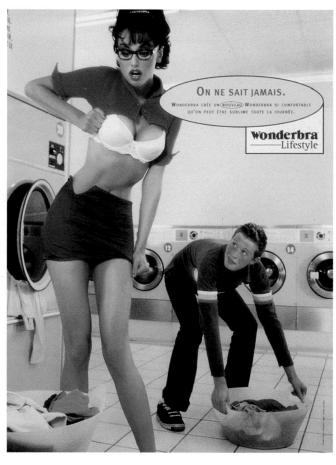

Agency:	Villmer Advertising, Stockholm	**Agency:**	Euro RSCG Babinet Erra Tong Cuong, Paris

Agency: Villmer Advertising, Stockholm
Copywriter: Hanna Holmqvist
Art Director: Anja Uddenfeldt
Photographer: Per Sihlberg
Client: Eton Shirt Makers

Agency: Euro RSCG Babinet Erra Tong Cuong, Paris
Creative Director: Rémi Babinet
Copywriter: Sophie Anduze
Art Director: Antoinette Beatson
Photographer: Les Guzman
Client: Playtex Wonderbra

You never know. Wonderbra creates a new Wonderbra that's so comfortable you can be sublime all day long.

UNITED COLORS
OF BENETTON.

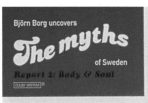

Agency:	United Colors Communication, Lugano	Agency:	Paradiset DDB, Stockholm
		Creative Director:	Joakim Jonason
Creative Director:	Oliviero Toscani	Copywriter:	Linus Karlsson
Art Director:	Oliviero Toscani	Art Director:	Paul Malmström
Photographer:	Oliviero Toscani	Photographer:	Peter Gehrke
Client:	Benetton Clothing	Client:	Björn Borg Underwear

IHRE KINDER SIND DIE EINZIGEN,
DENEN ES WIRKLICH EGAL IST, WIE SIE AUSSEHEN.

RENÉ LEZARD
Men's Women's Collection

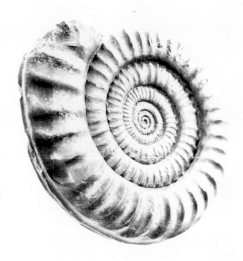

UND WIE LANGE WOLLEN SIE NOCH WARTEN,
UM VON JEDEM BEWUNDERT ZU WERDEN?

RENÉ LEZARD
Men's Women's Collection

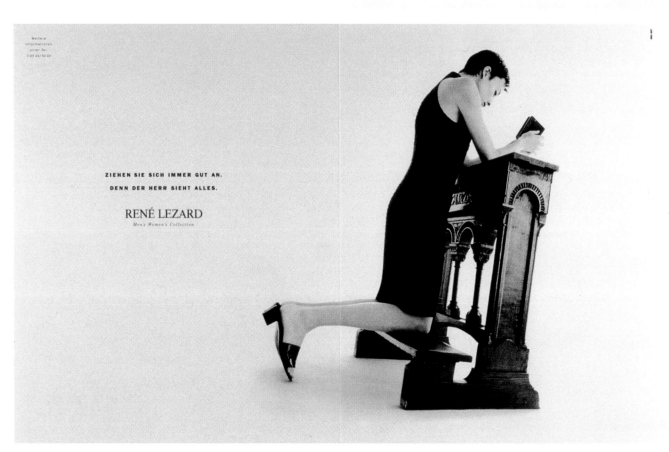

ZIEHEN SIE SICH IMMER GUT AN.

DENN DER HERR SIEHT ALLES.

RENÉ LEZARD
Men's Women's Collection

Agency:	JvM, Hamburg	Your children are the only ones who really don't mind what you look like.
Creative Director:	Hermann Waterkamp	
Copywriters:	Doerte Spengler	
	Ralf Nolting	Just how long will you wait for someone to admire you?
Art Director:	Lars Kruse	
Photographer:	Uwe Duettmann	
Client:	René Lezard	Make sure you're well-dressed. Someone is always watching you.
	Fashion	

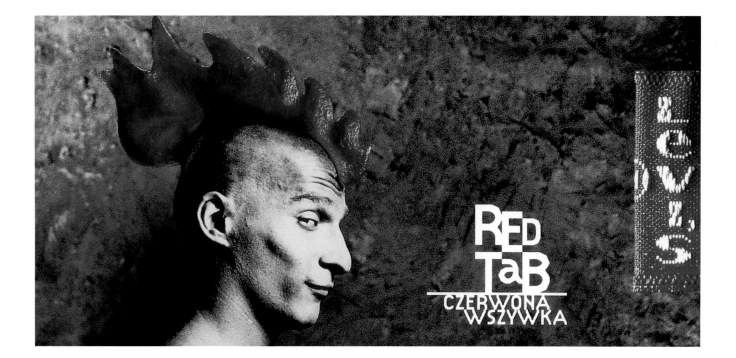

RED TaB
CZERWONA WSZYWKA

we missed the sun...

Zeki

Agency:	Corporate Profiles DDB, Warsaw	**Agency:**	M.A.R.K.A., Istanbul
Creative Director:	Marcin Mroszczak	**Creative Director:**	Hulûsi Derici
Copywriter:	Hubert Stadnicki	**Copywriter:**	Özlem Cengiz
Art Director:	Jacek Dyga	**Art Director:**	Ferit Yantur
Photographer:	Tomek Sikora	**Client:**	Zeki Triko Swimwear
Client:	Levi's Red Tab Jeans		

NB: The photo shows Mustafa Kemal Atatürk, founder of the Turkish Republic, who is often referred to as "the sun."

LIFE IS A REMIX

THE RIGHT CLOTHING AT THE RIGHT TIME
http://www.pash.com

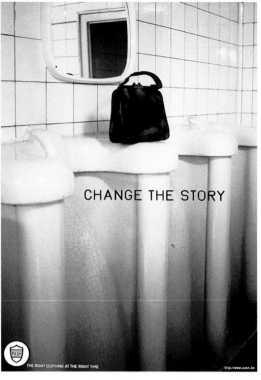

CHANGE THE STORY

THE RIGHT CLOTHING AT THE RIGHT TIME
http://www.pash.de

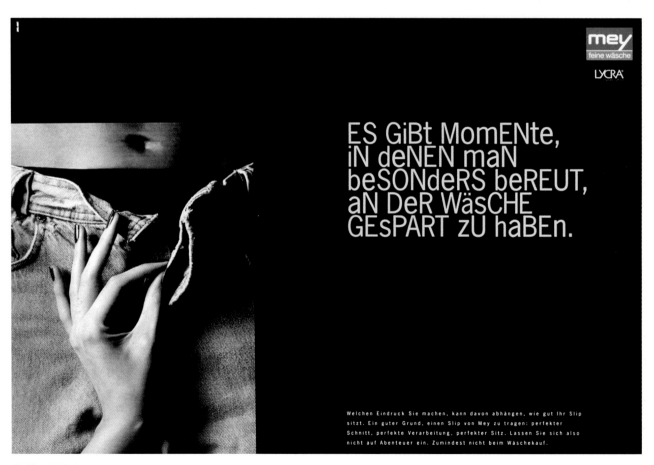

mey
feine wäsche

LYCRA

ES GiBt MomENte,
iN deNEN maN
beSONdeRS beREUT,
aN DeR WäsCHE
GESPART zU haBEn.

Welchen Eindruck Sie machen, kann davon abhängen, wie gut Ihr Slip
sitzt. Ein guter Grund, einen Slip von Mey zu tragen: perfekter
Schnitt, perfekte Verarbeitung, perfekter Sitz. Lassen Sie sich also
nicht auf Abenteuer ein. Zumindest nicht beim Wäschekauf.

270 **Clothing & Fabrics**

Agency:	.Start Advertising, Munich	**Agency:** JvM, Hamburg
Creative Director:	Gregor Woeltje	**Copywriter:** Dásá Szekely
Copywriter:	Gregor Woeltje	**Art Director:** Bettina Olf
Art Directors:	Gabor Thier / Peter Langer	**Photographer:** Uwe Duettmann
Photographer:	Armin Smailovic	**Client:** Mey Fine Underwear
Client:	Pash Fashions	

There are moments when you really regret skimping on underwear.

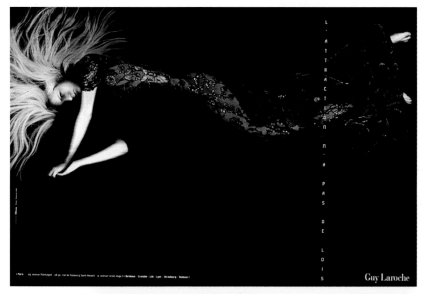

Agency:	Nouvel Eldorado, Paris	Angels don't fall.
Creative Director:	Antoine Choque	Attraction defies every law.
Copywriter:	Paul-Henri Moinet	
Art Director:	Damien Peyret	Heavenly bodies.
Photographer:	Katerina Jabb	
Client:	Guy Laroche Couture	

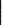

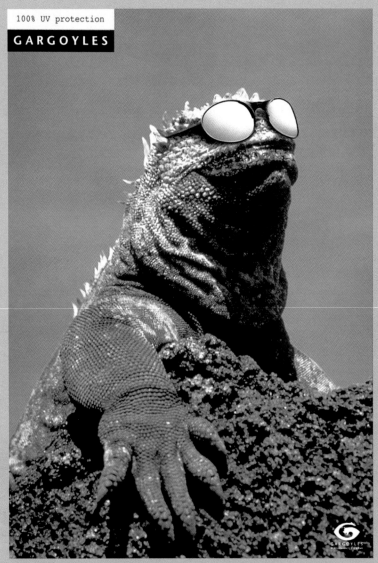

100% UV protection
GARGOYLES

Zero distortion
GARGOYLES

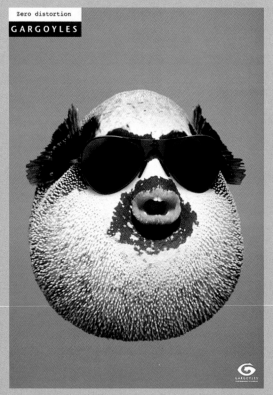

Non-slip
GARGOYLES

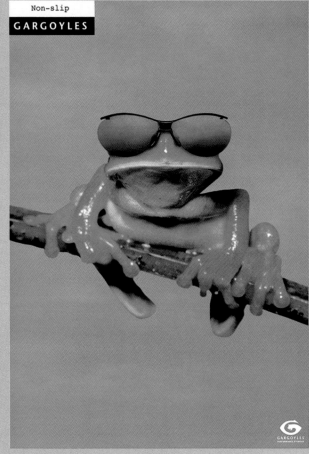

Wraparound vision
GARGOYLES

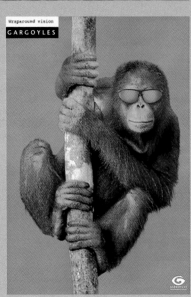

Agency:	Cowan Kemsley Taylor, London
Creative Director:	Tim Johnson
Copywriter:	Tim Johnson
Art Director:	Tim Johnson
Client:	Gargoyl Sunglasses

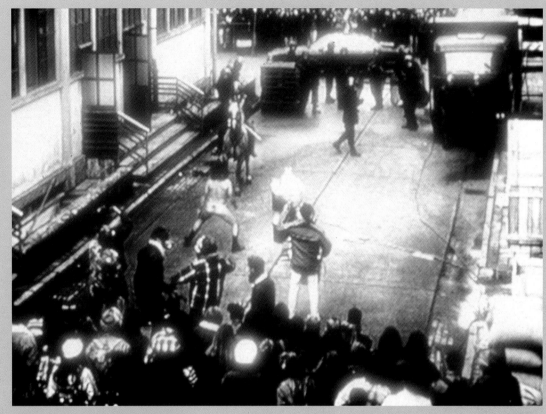

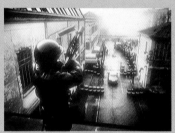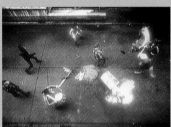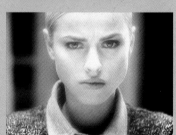

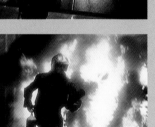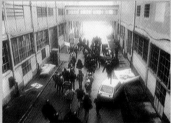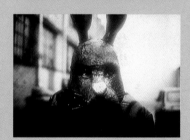

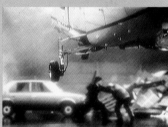

Agency:	Pirella Göttsche Lowe, Milan
Creative Directors:	Roberto Pizzigoni Pino Rozzi
Copywriter:	Pino Rozzi
Art Director:	Roberto Pizzigoni
Production:	BRW & Partners
Director:	Tarsem
Producers:	Federico Fasolino Franco Cipolla
Client:	Superga Shoes, "The Challenge" (see also p.12)

Riot police employ brute force to keep an animal rights demonstration under control outside a factory. Cars are overturned, tear-gas fills the air, a police horse falls in the mêlée and a man's clothes catch fire. The Prodigy song, "Firestarter" keeps the adrenaline flowing. The factory owner leaves in his limousine, calmly reading a newspaper. One asked protester succeeds in reaching the car, only to lose a Superga shoe on its bonnet. Cut to the boss having dinner with his family. The atmosphere is tense. He bends down to retrieve something from the floor and discovers, to his horror, that his daughter is missing one of her Superga shoes.

Agency:	Barbella Gagliardi Saffirio DMB&B, Milan	"How long is a Swatch minute?" asks the opening super. Swatch then proceeds to answer the question with dozens of responses that range from 2 seconds, for a couple making love, to 1,000 light years, for a girl looking into space through a telescope. Other examples include 25 minutes for a hesitant man on a high diving board, 9 months for the birth of a child and 19.32 seconds for the 200m world record. "Time is what you make of it," concludes Swatch.
Creative Director:	Pasquale Barbella	
Copywriter:	Roberto Greco	
Art Director:	Franco Tassi	
Production:	Filmgo	
Director:	Gary Johns	
Producers:	Richard Ronan Francesca Nussio	
Client:	Swatch Watches, "Time is What You Make of It"	

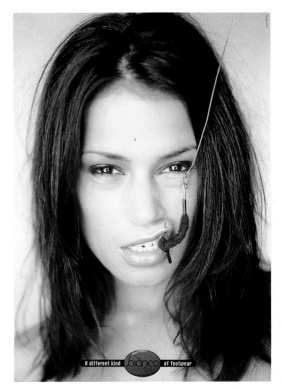
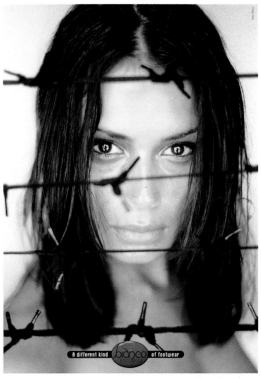

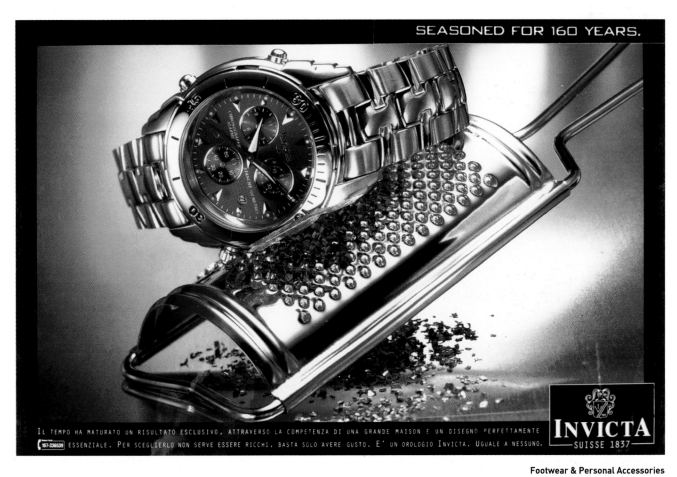

SEASONED FOR 160 YEARS.

IL TEMPO HA MATURATO UN RISULTATO ESCLUSIVO, ATTRAVERSO LA COMPETENZA DI UNA GRANDE MAISON E UN DISEGNO PERFETTAMENTE ESSENZIALE. PER SCEGLIERLO NON SERVE ESSERE RICCHI, BASTA SOLO AVERE GUSTO. E' UN OROLOGIO INVICTA. UGUALE A NESSUNO.

INVICTA
SUISSE 1837

Agency:	Grey Aarhus, Egaa	**Agency:**	McCann-Erickson, Milan
Creative Director:	Thomas Hoffmann		
Copywriter:	Thomas Hoffmann	**Creative Director:**	Milka Pogliani
Art Director:	Thomas Hoffmann	**Copywriter:**	Grazia Usai
Photographer:	Michael Berg	**Art Director:**	Antonio Mele
Client:	Bianco Shoes	**Photographer:**	Stefan Kirshner
		Client:	Invicta Watches

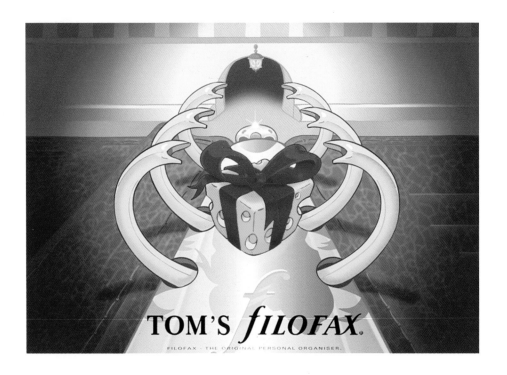

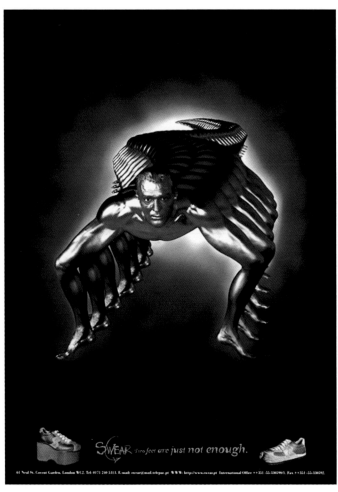

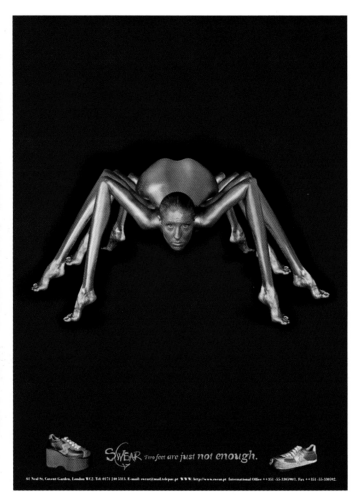

Agency:	B.S.U.R., Amsterdam		**Agency:**	Mellors Reay &
Creative Directors:	Hjarald Agnes			Partners, London
	Joost Perik		**Creative Director:**	Tim Mellors
Copywriter:	Dieuwke Reehoorn		**Copywriter:**	Gary Dawson
Art Director:	Ro Mulder		**Art Director:**	Scott Bain
Illustrator:	Bert Tier		**Illustrator:**	James Deville
Client:	Filofax		**Photographer:**	Simon Somerville
	Personal Organisers		**Client:**	Swear Shoes

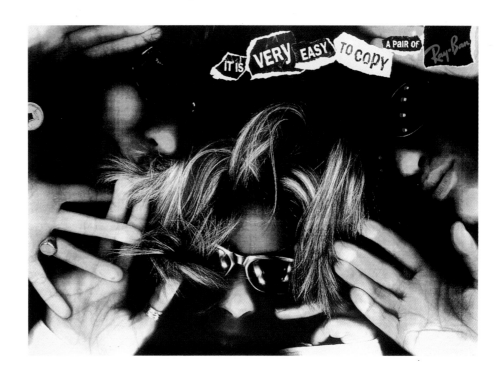

Louis Vuitton. Writing.

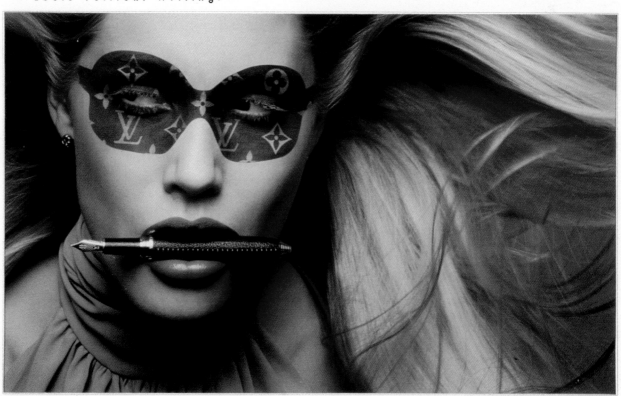

Louis Vuitton luggage and accessories are available only in exclusive Louis Vuitton shops
Paris · Monaco · Tokyo · New York · Los Angeles · Hong Kong ·
Beijing · London · Rome · Milan · Munich · Düsseldorf · Geneva · Zurich · Sydney

LOUIS VUITTON

Agency:	Contrapunto, Madrid	**Agency:**	Euro RSCG Grégoire
Creative Director:	Antonio Montero		Blachère Huard Roussel,
Copywriter:	Marcos Garcia		Paris
Art Director:	Siro Garcia-Quijada	**Creative Directors:**	Pascal Grégoire
Photographer:	Manuel Alvarez		Maurice Betite
Client:	Ray Ban Sunglasses	**Copywriter:**	John Loobart
		Art Director:	Maurice Betite
		Photographers:	Inez Van Lamsweerdere
			Vinoodh Matadin
		Client:	Louis Vuitton Writing
			Instruments

www.reebok.com

Agency:	.Start Advertising, Munich
Creative Director:	Gregor Woeltje
Copywriters:	Marc Strotmann
	Ernst Huberty
Art Director:	Gabor Thier
Production:	Jo!Schmid, Hamburg
Director:	Markus Janowski
Producer:	Martin Schmid
Client:	Reebok, "Champions League"

Young boys play football on the street with all the passion and commitment of professionals in two commercials that were aired once only, on the occasion of the 1997 European Champion League Cup Final, sponsored by Reebok. In the first spot the excited commentator announced the arrival of the two teams, Borussia Dortmund and Juventus Turin. The roar of the crowd added to the tension of the moment, as if the event was being covered live. The second film ran after the match to celebrate Borussia's victory. The commercials ran on German TV only and were unashamedly biased in favour of the national team. An alternative, more subdued, post-match spot was also shot for use in the event of an Italian victory.

Achicachicachic.

Aïe. **Aïe.** **Aïe.**

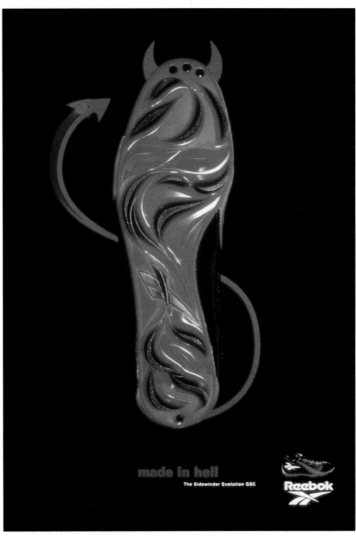

made in hell
The Sidewinder Evolution GSC

Agency:	BL/LB, Paris
Creative Director:	Bruno Lacoste
Copywriter:	Franck Lanfry
Art Director:	Emmanuel Allaire
Photographer:	Kay Mucke
Client:	Reebok

NB: Pre-match, self-motivating battle-cry of French footballers, also a popular song (untranslatable).

Agency:	Noordervliet & Winninghoff/Leo Burnett, Amsterdam
Creative Directors:	Frans Brand
	Martijn van Sonsbeek
Copywriters:	Astrid Kopper
	Aslan Kilinger
Art Directors:	Ray Breg
	Aslan Kilinger
Client:	Reebok

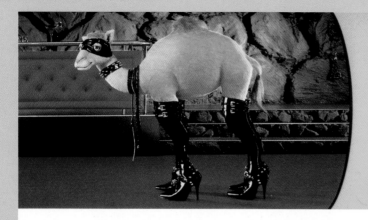

Take intense pleasure from your Camel.

Roken schaadt de gezondheid. Het kan longkanker of hartklachten veroorzaken. Kon. besluit van 29.4.1981,Stb.329.

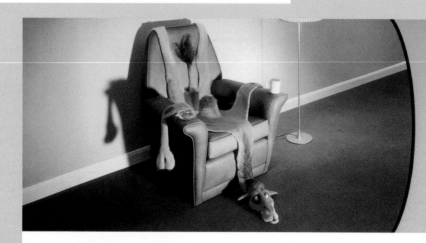

Never sit on your Camels.

Roken schaadt de gezondheid. Het kan longkanker of hartklachten veroorzaken. Kon. besluit van 29.4.1981,Stb.329.

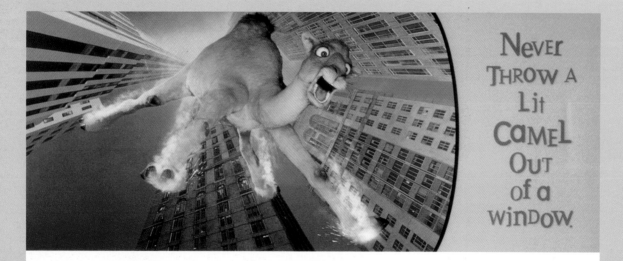

Never throw a lit Camel out of a window.

Roken schaadt de gezondheid. Het kan longkanker of hartklachten veroorzaken. Kon. besluit van 29.4.1981,Stb.329.

Agency:	McCann-Erickson, London
Creative Director:	Jerry Green
Copywriter:	David Green
Art Director:	David Brown
Photographer:	Malcolm Venville
Client:	Camel Cigarettes

Bonsoir.

This is a game from Gauloises Blondes.

Hello. This is the text that you have to read.

Ooups! A fiendish trap. Another text. What are you goin[g]

distract you. Absolutely nothing. Stay in the line you've d[...]

We'll take a look at the bottom. You can't read three lines. Y[ou]

laughing. And are having enormous fun. You're the only on[e]

Did you know that only 10% of all the people

GAULOISES
Blondes

 Tobacco & Accessories 281

Agency:	Kolle Rebbe Werbeagentur, Hamburg	
Creative Director:	Stefan Kolle	
Copywriter:	Catrin Rohr	
Art Directors:	Heike Sperling Kris Krois	
Production:	Cut-Up Vision, Cologne	
Director:	Heike Sperling	
Producers:	Stefan Kolle Catrin Rohr	
Client:	Gauloises Blondes	

A cinema promotion for Gauloises Blondes. The audience is invited to find two French words in a text that's about to appear on the screen, to write them down and to hand in their entry forms after the film. The game is easy at first, with a single line of text moving horizontally across the screen. Soon it becomes harder, however, as a second line of text appears, then a third, each one encouraging viewers to look elsewhere for the solution.

Die EG-Gesundheitsminister: Rauchen gefährdet die Gesundheit. Der Rauch einer Zigarette dieser Marke enthält 0,4 mg Nikotin und 4 mg Kondensat (Teer). (Durchschnittswerte nach ISO)

Die EG-Gesundheitsminister: Rauchen gefährdet die Gesundheit. Der Rauch einer Zigarette dieser Marke enthält 0,3 mg Nikotin und 4 mg Kondensat (Teer). (Durchschnittswerte nach ISO)

282 **Tobacco & Accessories**

Agency:	TBWA, Berlin
Art Directors:	Martina Traut
	Roland Gehrmann
Photographers:	Hans Kroeskamp
	Stefan Indlekofer
	Hans Gissinger
Client:	Philip Morris
	Light American
	Cigarettes

Το Υπουργείο Υγείας προειδοποιεί:

ΤΟ ΚΑΠΝΙΣΜΑ ΒΛΑΠΤΕΙ ΣΟΒΑΡΑ ΤΗΝ ΥΓΕΙΑ

Το Υπουργείο Υγείας προειδοποιεί:

ΤΟ ΚΑΠΝΙΣΜΑ ΒΛΑΠΤΕΙ ΣΟΒΑΡΑ ΤΗΝ ΥΓΕΙΑ

Tobacco & Accessories **283**

Agency: Adel/Saatchi & Saatchi, Athens
Creative Director: Takis Yiatras
Art Director: Antonis Stavropoulos
Client: Silk Cut Cigarettes

Agency:	Forsman & Bodenfors, Gothenburg	This local campaign for the classified section of Göteborgs-Posten, Gothenburg's largest morning paper, consists of more than 1,400 different posters. Each poster is hand-made and unique, and refers to an actual small ad published in the newspaper during the week in question.	- Hello, hello! Who's got a front-loading washing machine and a tumble dryer for sale? I've got an ad under "Wanted" in GP on Sunday.
Copywriters:	Björn Engström Martin Ringqvist		- I've got 10 rolls of this wallpaper left over. 70,- per roll. Unused. Look for my ad in GP on Sunday.
Art Directors:	Staffan Forsman Henrik Delehag		- Kids should wear H.E.L.M.E.T.S. We've got a white one with red stripes. Suitable for skiing, etc., for sale in GP on Sunday. Only 100,- (cheap life insurance).
Client:	Göteborgs-Posten, Classified Section		- Imagine sitting here exercising. It's yours for only 200,- in GP on Saturday.

- Call me and I'll blast things. You'll find my ad in GP everyday this week. PS: serious business, I don't do safes.
- Emergency! I had to return the TV I borrowed and now I don't want to miss "Friends" on Monday. So now I want a TV and a VCR quickly! Before Monday. See my ad in GP on Thursday.
- We're getting married! Look for our ad in GP on Saturday.
- Buy my detective books in GP on Sunday. Or else....
- We've sold our car! On Wednesday we'll sell the tyres as well (we had two spares) in GP!

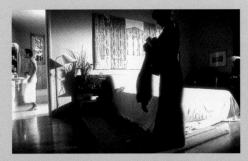

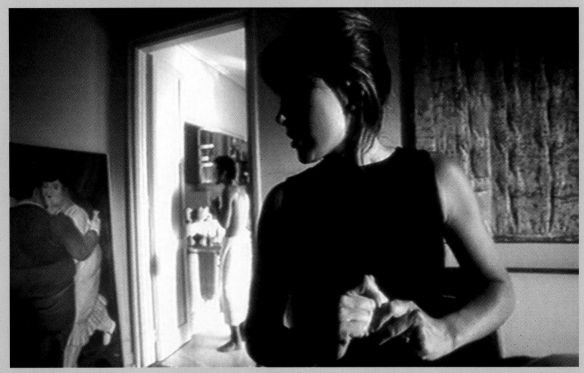

Agency:	Delvico Bates, Barcelona
Creative Directors:	Julio Wallovits Elvio Sanchez
Copywriter:	Julio Wallovits
Art Director:	Elvio Sanchez
Production:	Group Films
Director:	Angeles Reine
Client:	Planeta Publications, Larousse Encyclopaedia, "Matches"

A man sings happily to himself while shaving when his wife discovers a phone number on a pack of matches in his trouser pocket. She questions him and his mood changes rapidly. He sounds less than convincing as he explains, hesitantly, that it's the Planeta number that he wrote down to take advantage of a generous trade-in offer for the new 30-volume Larousse Encyclopaedia. "Can this be true?" asks the advertiser, echoing our own thoughts, "Find out by calling..."

the *famous* JaCK DOCHeRTy.
?????????
?????
weeknights 11pm

Agency:	Mother, London
Creative Director:	Robert Saville
Copywriter:	Mark Waites
Art Director:	Libby Brockhoff
Production:	Blink
Director:	Trevor Melvin
Producer:	Zoe Bell
Client:	Channel 5 Television, The Jack Docherty Show, "Blanked," "Microphone," "Police" & "Kick"

The first of four commercials for Channel 5's late-night Jack Docherty Show. Jack Docherty himself interviews people on the street and becomes increasingly frustrated because nobody recognises him, nobody has watched his show, and nobody has even heard of it. In desperation, he shouts out, "Has anyone seen my show?" "Where did you leave it?" a cocky voice replies from the crowd.

The second spot continues in the same vein. The talk-show host stops another passerby and poses the same questions but with similar results. "Looking forward to the Jack Docherty Show on Channel 5?" he asks. "Never heard of it," replies the man politely. Docherty's patience is running out, "So you wouldn't recognise him if he just walked up to you on the street and hit you in the face with a microphone?" Whereupon, he does just that. The sound engineer quickly intervenes and pacifies the angry interviewer.

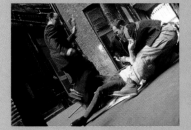

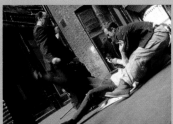

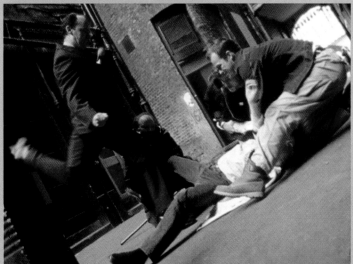

The police have arrived in the third commercial to investigate the assault. In reponse to their request for identification, Docherty continues to maintain that everyone knows who he is. He tries to remain calm, still insisting on the correct pronounciation of his name, and advises the officer that he's making a fairly serious career mistake.

"Put the camera down and help me," Docherty shouts in the final film, while other members of his crew pin a man down on the pavement. "Right, you're not going to forget Jack Docherty now, are you?" he exclaims, kicking the man hard in the groin. His victim cries out with pain and Docherty continues, "What was that? Another one? Fine!" In goes the boot again and Docherty finally gets the chance to work off his frustration.

Agency:	S Team Bates Saatchi & Saatchi Advertising Balkans, Belgrade	**Agency:**	Laboratorium, Amsterdam
Creative Director:	Dragan Sakan	**Photographer:**	Yani
Copywriter:	Slavimir Stojanovic	**Client:**	Nes Street Theatre
Art Director:	Slavimir Stojanovic		
Photographer:	Aleksandar Kujucev		
Client:	New Moment Magazine		

Agency:	Aebi, Strebel, Zürich	More facts about Nicolas Hayek & Co. (Nicolas Hayek,
Creative Director:	Jean Etienne Aebi	"Mr. Swatch," always wears several watches; the X-ray
Copywriter:	Matthias Freuler	shows a Japanese watch alongside his own products).
Art Director:	Erik Voser	
Photographer:	Chris Frazer Smith	More facts about Mother Hingis & Co. (a book by Peter
Client:	Facts News Magazine	Graf, "The Best Tax Tips," is in the bag of Melanie Hingis,
		mother of the Swiss tennis star, Martina Hingis).

More facts about our national bank chief, Hans Meyer & Co. (a gold bar, marked "Deutsche Reichsbank," is hidden in the toilet of the president of the Swiss National Bank).

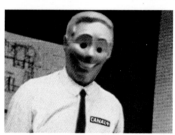

MOVIES WITHOUT THE NEWS BREAK, 9PM NIGHTLY.

He never said:
"I'll be back...
...after the news."

Agency:	Paradiset DDB, Stockholm	Bob Gutz, a freelance American investigator, describes his obsessional interest in a mystery man whom he tracks across the globe via newspaper articles and film clips. The enigmatic character, whom Gutz comes to admire, is no less than the distinctive Canal+ figure, who is seen meeting high-profile people at important sporting events and on movie sets, handing out briefcases full of money. "He buys for billions - you pay peanuts," discloses the cable TV operator.
Copywriter:	Jacob Nelson	
Art Director:	Malin Carlsson	
Production:	Traktor	
Directors:	Pontus Löwenhielm Mats Lindberg	
Producers:	Richard Ulfvengren Stefan Öström Camilla Ögren	
Client:	Canal+, Pay TV Channel, "Mr. Canal+"	

Agency:	Mother, London
Creative Director:	Robert Saville
Copywriter:	Mark Waites
Art Director:	Libby Brockhoff
Client:	Channel 5 Television

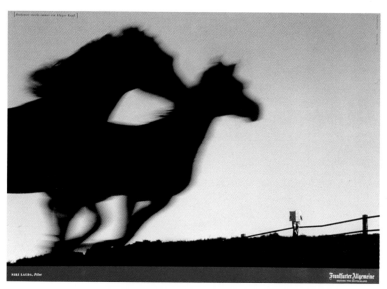

Agency:	Scholz & Friends, Berlin	There's always a clever mind behind it.
Creative Director:	Sebastian Turner	
Copywriter:	Sebastian Turner	
Art Director:	Petra Reichenbach	
Photographer:	Alfred Seiland	
Client:	Frankfurter Allgemeine Zeitung	

292 **Media & Entertainment**

Agency:	Garbergs Annonsbyrå, Stockholm
Creative Director:	Martin Gumpert
Copywriters:	Anna Qvennerstedt
	Totte Stub
Art Director:	John Mara
Photographer:	Lasse Kärkkäinen
Client:	MTV Music Channel, "Manifesto"

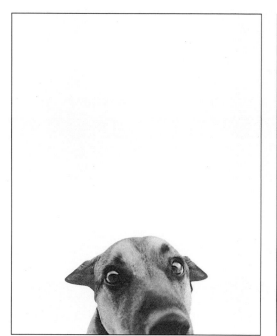

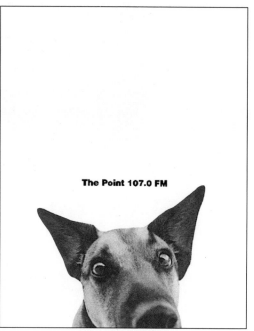

The Point 107.0 FM

Story

Agency:	Yellow M, Newcastle	**Agency:**	Result DDB, Amstelveen
Creative Director:	Iain Allan	**Creative Director:**	Michael Jansen
Copywriter:	Michael Maxwell	**Copywriter:**	Bas Engels
Art Director:	Ian Fletcher	**Art Director:**	Sanne Braam
Photographer:	Thia Konig	**Client:**	VNU Telepress Publications,
Client:	The Point Radio Station		Story

Agency:	Robson Brown Advertising, Newcastle	**Agency:**	Forsman & Bodenfors, Gothenburg	My son is going to have a real Scalectrix car racing track. The kind I never had. Complete or parts only. Everything is of interest. Look for my ad in GP on Sunday.
Creative Director:	Duncan McEwan	**Copywriters:**	Björn Engström	
Copywriter:	Chris Berry		Martin Ringqvist	
Art Director:	Roy Weatherley	**Art Directors:**	Staffan Forsman	
Client:	Madam Sian, Clairvoyant		Henrik Delehag	Some things are hard to do yourself. I do wood cutting cheap - all you have to do is answer my ad in GP on Thursday.
		Client:	Göteborgs-Posten, Classified Section (press campaign, see also p.284)	

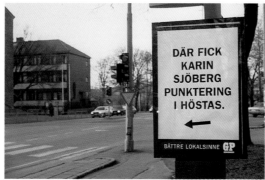

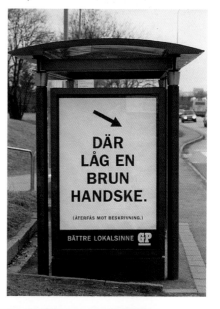

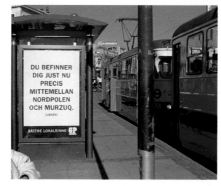

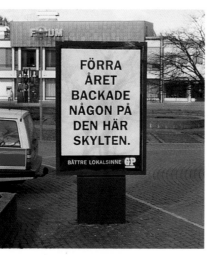

Agency:	Forsman & Bodenfors, Gothenburg
Copywriter:	Björn Engström
Art Director:	Staffan Forsman
Client:	Göteborgs-Posten

This campaign for Göteborgs-Posten emphasizes the newspaper's local knowledge, as every poster comments on something in close proximity to the poster site. The claim in each ad is the same: "The local newspaper. GP."

- Hey look! Isn't that the flag of Japan hanging there?
- Take it easy! Mrs Anderson sprained her ankle here last year.
- Really comfortable park seat.
- You are here. So are we.
- Karin Sjöberg got a flat tyre here last autumn.
- Brown glove found here will be returned on giving its description.
- You are now exactly between the North Pole and Murzuq (Libya).
- That street light needs changing.
- Last year someone reversed into this sign.
- Walk with care! These paving stones cost 600,- per m² to lay.

Agency:	Akcio Advertising Agency, Budapest	
Creative Director:	Peter Geszti	
Copywriter:	Peter Fazakas	
Art Director:	Peter Fendrik	
Production:	Skyfilm	
Director:	Peter Fazakas	
Producer:	Gabor Herendi	
Client:	Magyar Narancs, "You'll Get What You Deserve"	

A Hungarian newsreel from the 1970s shows supervisors from the Ministry of Education visiting a supposedly progressive nursery school. The commentary is well-laced with clichés from the communist era; happy children in a modern environment, benefitting from the most advanced educational techniques to become free-thinking and responsible citizens, ready for social life etc. Only one little rebel really has a mind of his own, however, and he ends up getting slapped repeatedly for insulting the inspectors. "You'll get what you deserve," concludes Magyar Narancs, promising independent and informative news coverage.

Agency:	BDDP, Paris
Creative Director:	Jean-Pierre Barbou
Art Director:	Hervé Lopez
Illustrator:	Stanislas Bouvier
Client:	Le Monde, Newspaper

Great Irish
PUBS
Serve Sky Sports on Cablelink.

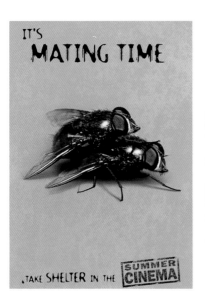

IT'S **MATING TIME**

.TAKE SHELTER IN THE **SUMMER CINEMA**

COMING SOON TO A **GARDEN** NEAR YOU

TAKE SHELTER IN THE **SUMMER CINEMA**

YOU MAY BE THE **CHOICE** OF THIS NEW **GENERATION**

TAKE SHELTER IN THE **SUMMER CINEMA**

Agency: McCann-Erickson, Dublin
Creative Directors: Gerry McCloskey, Eoghan Nolan
Copywriter: Jonathan Stanistreet
Art Director: Shay Madden
Photographer: Donal Maloney
Typographer: Mark Ryan
Client: Cablelink, Cable TV

NB: Familiar pub names have been changed to the names of famous soccer players in the UK's Premiership League.

Agency: Young & Rubicam, Copenhagen
Creative Directors: Peder Schack, Flemming Slebsager
Copywriter: Ane Helmer Nielsen
Art Director: Marie Bonnesen
Client: United International Pictures, Summer Cinema Promotion

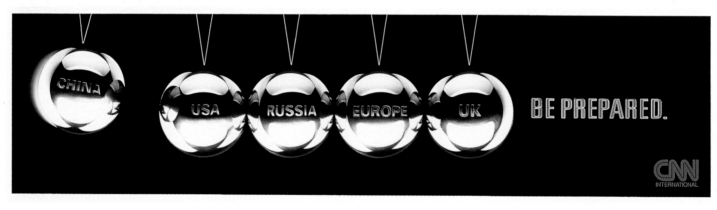

Agency:	Mother, London		**Agency:**	Lansdown Conquest, London
Creative Director:	Robert Saville		**Creative Directors:**	Simon Frank
Copywriter:	Mark Waites			John Trainor
Art Director:	Libby Brockhoff		**Copywriters:**	Simon Frank
Photographer:	Jack Daniels			John Trainor
Client:	Magic AM Radio		**Art Directors:**	John Trainor
				Adrian Richards
			Photographer:	Gary Bryan
			Client:	CNN International

WANT TO HAVE A GOOD LAUGH ABOUT THE HIGH AND THE MIGHTY? BUY CARTOONIST NICO'S NEW ANNUAL. Tages Anzeiger

WANT TO HAVE A GOOD LAUGH ABOUT THE HIGH AND THE MIGHTY? BUY CARTOONIST NICO'S NEW ANNUAL. Tages Anzeiger

WANT TO HAVE A GOOD LAUGH ABOUT THE HIGH AND THE MIGHTY? BUY CARTOONIST NICO'S NEW ANNUAL. Tages Anzeiger

Media & Entertainment **299**

Agency: McCann-Erickson, Zürich
Creative Director: Edi Andrist
Copywriter: Claude Catsky
Art Director: Nicolas Vontobel
Client: Tages Anzeiger,
The Nico Yearbook

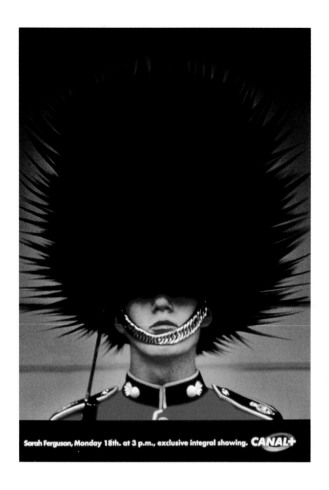

Sarah Ferguson, Monday 18th. at 3 p.m., exclusive integral showing. **CANAL+**

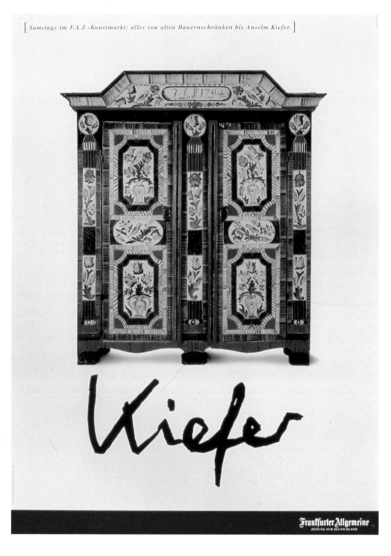

[*Samstags im F.A.Z.-Kunstmarkt: alles von alten Bauernschränken bis Anselm Kiefer.*]

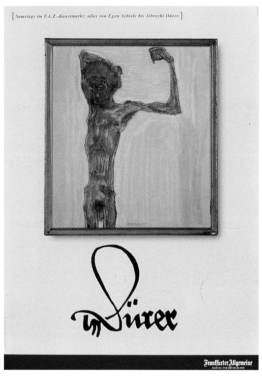

[*Samstags im F.A.Z.-Kunstmarkt: alles von Egon Schiele bis Albrecht Dürer.*]

Frankfurter Allgemeine
ZEITUNG FÜR DEUTSCHLAND

Frankfurter Allgemeine
ZEITUNG FÜR DEUTSCHLAND

Agency:	Contrapunto, Madrid	**Agency:**	Scholz & Friends, Berlin
Creative Director:	Ana Hidalgo		
Copywriter:	Alberto Macho	**Creative Director:**	Sebastian Turner
Art Director:	Rebecca Diaz	**Art Directors:**	Petra Reichenbach
Client:	Canal+,		Raban Ruddigkeit
	Pay TV Channel	**Client:**	Frankfurter
			Allgemeine Zeitung,
			Art Supplement

NB: Word-plays on the names of well-known artists; Dürer, in German, means a very thin person, while Kiefer means pine tree.

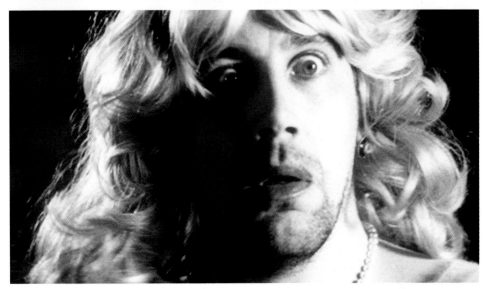

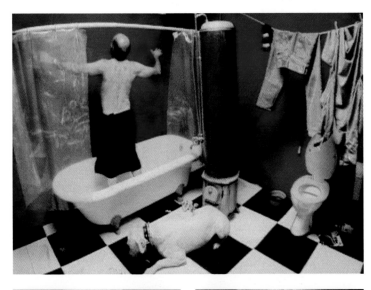

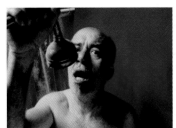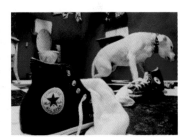

Agency:	The Bridge, Glasgow	A woman returns home unexpectedly	**Agency:**	Publicis Virgo,

Agency: The Bridge, Glasgow
Creative Director: Jonathan D'Aguilar
Copywriter: Pete Armstrong
Art Director: Rufus Wederburn
Production: MTP, Glasgow
Director: Terence Prior Stevens
Producers: Simon Mallinson
Gillian Brown
Client: The Scottish Daily
Express, Clothes
Show Promotion,
"Gerald"

A woman returns home unexpectedly to discover her husband in drag. He's admiring himself in the mirror with two melons substituting for breasts. The commercial announces cheap tickets to the Clothes Show Scotland, courtesy of the Scottish Daily Express. "Perhaps you know someone who'd just love to go."

Agency: Publicis Virgo,
Belgrade
Creative Director: Zaklina Nikolic
Copywriter: Zaklina Nikolic
Art Director: Zaklina Nikolic
Director: Igor Kusic
Client: B92 Books

An old rocker, amid all the trappings of youth culture, does a Mick Jagger imitation in his shower in a spot that announces a new book on The Rolling Stones called, "The Art of Rebellion."

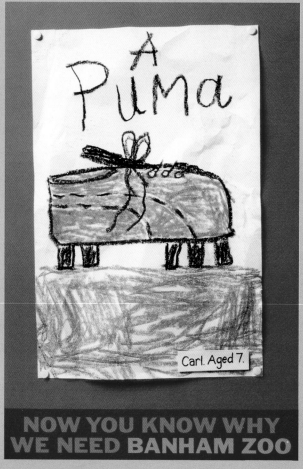

Carl. Aged 7.

**NOW YOU KNOW WHY
WE NEED BANHAM ZOO**

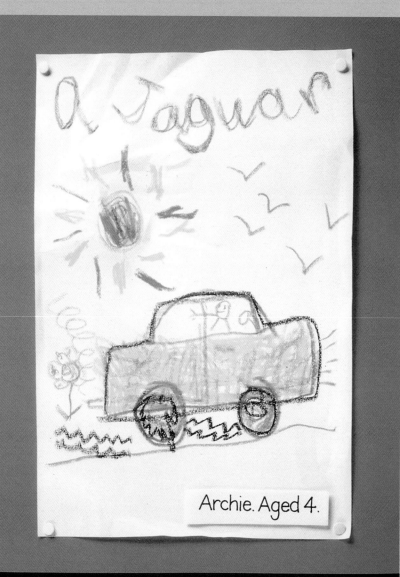

Archie. Aged 4.

**NOW YOU KNOW WHY
WE NEED BANHAM ZOO**

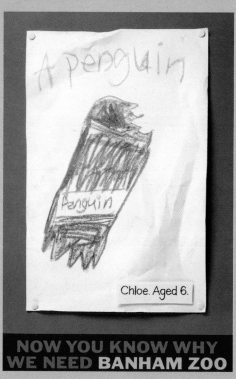

Chloe. Aged 6.

**NOW YOU KNOW WHY
WE NEED BANHAM ZOO**

Agency:	Bates Dorland, London
Creative Director:	Tim Ashton
Copywriter:	Stefan Jones
Art Director:	Tom Burnay
Illustrator:	Stefan Jones
Photographer:	David Chalmers
Client:	Banham Zoo

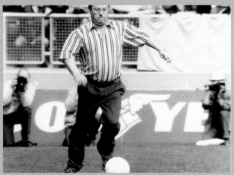

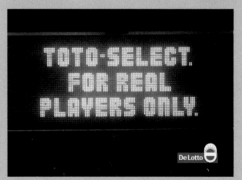

Agency:	Result DDB, Amstelveen
Copywriter:	Marcel Hartog
Art Director:	Jeroen van Zwam
Production:	Cellusion Films, Amsterdam
Director:	Rick Lenzing
Producers:	Paul Brand
	Marcel Dijkhuizen
	Yolande van der Meulen
	Wies Verbeek
Client:	Toto Select Lottery, "For Real Players Only"

Ordinary people in their everyday clothes compete with professional footballers in a crowded stadium. A man in a business suit out-jumps an opponent to head the ball away, a middle-aged man beats a sliding tackle, while a grandmother fouls a defender and argues vehemently with the referee. Finally an attractive young woman gets the ball, dribbles past the keeper and scores with a well-placed kick into the open goal. She's lifted in triumph by her teammates while the scoreboard announces, "Toto Select, for real players only."

Agency:	New Deal DDB, Oslo	A butler milks a cow at an idyllic mountain
Copywriter:	Ivar Vereide	retreat and takes the fresh milk to his
Art Director:	Ingvar Moi	mistress who's still in bed. "Will there
Production:	Moland Film	be anything else, Madame?" he asks.
Director:	Marius Holst	The woman smiles seductively and nods
Producer:	Håkon Øverås	her head. The butler reacts politely, but
Client:	Norsk Tipping Lottery,	his expression suggests that this extra
	"The Butler"	service is a fairly regular request. "Lotto -
		a girl's best friend."

Agency:	Tiempo/BBDO,
	Barcelona
Creative Director:	Siscu Molina
Copywriter:	Oriol Villar
Art Director:	Jordi Comas
Photographer:	Jordi Oliver
Client:	Gran Teatre del Liceu

Agency:	KesselsKramer, Amsterdam
Creative Directors:	Erik Kessels
	Johan Kramer
Copywriters:	Johan Kramer
	Tyler Whisnand
Art Director:	Erik Kessels
Photographer:	Zambuki
Client:	Hans Brinker
	Budget Hotel

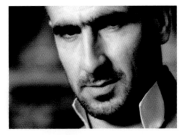

ERIC CANTONA

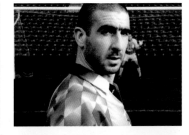

STRYKTIPSET
THE SWEDISH FOOTBALL POOLS

MORE THAN JUST LUCK

Leaves you breathless.
Rather like the air in London.

For your free brochure packed with Autumn Gold Special Offers call 0990 511 511.
Or visit our Tourist Information Office, 19 Cockspur St. Nearest tube station Charing Cross (Bakerloo exit). www.autumn.scotland.net

SCOTLAND
When will you go?

Agency:	Fältman & Malmén, Stockholm
Copywriter:	Mikael Friberg
Art Director:	Claes Henning
Production:	Mekano
Director:	Axel Laubscher
Producers:	Anders Lanström
	Ture Ågren
Client:	Svenska Spel Stryktipset, Football Pools, "Cantona"

Manchester United's star, Eric Cantona, explains how to bet on English football while a goalie in front of him feigns boredom. His advice is simple: you mark 1 if United plays at home or 2 if they're away, to predict a Manchester victory in both cases. "How do I know?" he asks, "I know. It's my job to know." He then turns his attention to the goalkeeper whose nerves are beginning to show. "Wah!" he shouts, and his opponent dives out of the way, knocking himself out on the goalpost. "More than just luck," the Swedish Football Pools remind viewers.

Agency:	Faulds Advertising, Edinburgh
Creative Director:	Jim Downie
Copywriter:	Pete Bastiman
Art Director:	Brian McGregor
Photographer:	Colin Prior
Client:	Scottish Tourist Board

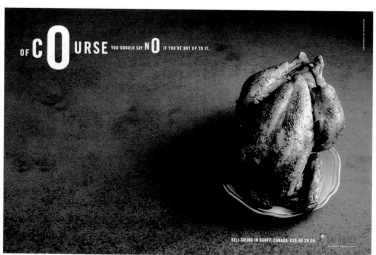

OF C**O**URSE YOU SHOULD SAY N**O** IF YOU'RE NOT UP TO IT.

HELI-SKIING IN BANFF, CANADA. 020-56 28 59.

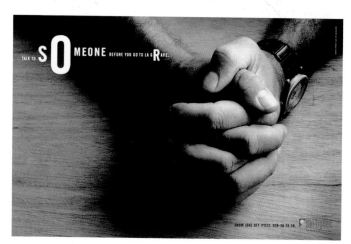

TALK TO S**O**MEONE BEFORE YOU GO TO LA G**R**AVE.

SNOW JOKE OFF-PISTE. 020-56 28 59.

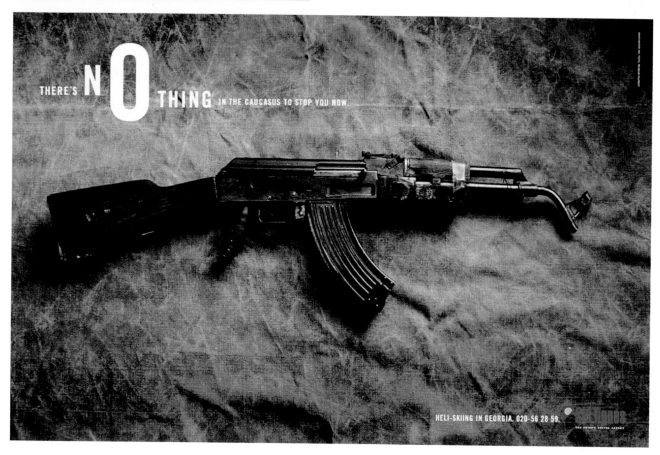

THERE'S N**O**THING IN THE CAUCASUS TO STOP YOU NOW.

HELI-SKIING IN GEORGIA. 020-56 28 59.

Agency:	P2 Reklambyrå, Gothenburg
Copywriter:	Tim DeBurg
Art Director:	Tom van der Erkk
Photographer:	Magnus Pajnert
Client:	Ski Tignes, Ski Vacations

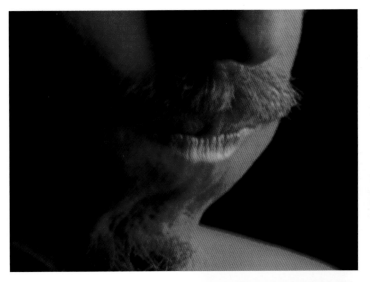

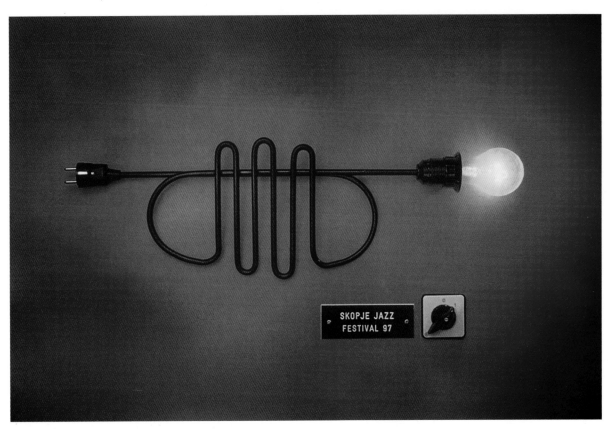

Agency:	S Team Bates Saatchi & Saatchi Advertising Balkans, Belgrade	A jazzy soundtrack accompanies a musician who produces electricity from the stylized trumpet that symbolizes the 1997 Skopje Jazz Festival.
Creative Director:	Dragan Sakan	
Copywriter:	Slavimir Stojanovic	
Art Director:	Boris Miljkovic	
Production:	S Team Production	
Director:	Boris Miljkovic	
Producer:	Dusan Ercegovac	
Client:	Skopje Jazz Festival, 1997	

Agency:	S Team Bates Saatchi & Saatchi Advertising Balkans, Belgrade
Creative Director:	Dragan Sakan
Copywriter:	Slavimir Stojanovic
Art Director:	Slavimir Stojanovic
Photographer:	Aleksandar Kujucev
Client:	Skopje Jazz Festival, 1997

Agency:	Demner, Merlicek	Come.		**Agency:**	Bates Camp, Oslo
	& Bergmann, Vienna	Come and escape.		**Copywriter:**	Bendik Romstad
Creative Director:	Mariusz Jan Demner			**Art Director:**	Anne Gravingen
Copywriter:	Karin Kammlander			**Illustrator:**	Bjørn Brochmann
Art Directors:	Daniel Meier			**Client:**	Oslo Gay & Lesbian
	Francesco Bestagno				Festival
Photographer:	Staudinger Franke				
Client:	Vienna Festival, 1997				

Agency:	Wibroe Duckert & Partners, Copenhagen	The practical joker, now a well-established character in the Danish Football Pools campaign, laughs with derision at the size of a bigger man's sexual equipment in a sauna. "Bored with life?" asks the advertiser, "Try the pools instead."	**Agency:**	Delvico Bates, Barcelona
Creative Director:	Henrik Juul		**Creative Directors:**	Julio Wallovits
Copywriters:	Henrik Juul			Elvio Sanchez
	Johan Gulbranson		**Copywriter:**	Dirk Graells
	Stein Leikanger		**Art Director:**	Roger Gual
Photographer:	Thomas Boman		**Photographer:**	Stephan Zähring
Production:	Wibroe Duckert & Partners Productions		**Client:**	La Molina, Ski Resort
Director:	Stein Leikanger			
Producer:	Gitie Sørensen			
Client:	Danish Football Pools, "Sauna"			

's Zomers naar Artis

Agency:	Bozell, Brussels	
Creative Director:	Gerardo Pavone	
Copywriter:	Bernard Fiacre	
Art Director:	Bernard Fiacre	
Photographer:	Bernard Foubert	
Client:	Eastpak Bags	

Agency:	FHV/BBDO, Amstelveen	It's summer in our zoo.
Copywriter:	Bart Oostindie	
Art Director:	Ap Mollinga	
Client:	Artis, Amsterdam Zoo	

Agency:	Saatchi & Saatchi Advertising, Oslo	
Creative Director:	Kjell Bryngell	
Copywriters:	Morten Andresen	
	Truls Schau Fjellstad	
Art Directors:	Kjell Bryngell	
	Katja Krogh	
Photographer:	G. B. Alessandri	
Client:	Henie Onstad Art Centre, Frida Kahlo Exhibition	

Agency:	Scholz & Friends, Berlin	Germany's most alive city. Berlin.
Creative Directors:	Sebastian Turner	
	Olaf Schumann	
Art Directors:	Lutz Plumecke	
	Martin Pross	
	Joachim Schöpfer	
Photographer:	Linus Lintner	
Client:	Max Magazine, Berlin Promotion	

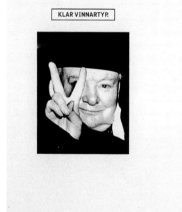

Agency:	Vitruvio/Leo Burnett, Madrid	Agencies:	McCann, Malmö & Rönnberg McCann, Stockholm	A long flight.
Creative Director:	Rafa Anton			
Art Director:	Rafa Anton	Copywriter:	Bo Rönnberg	Caused a revolution.
Photographer:	Aurelio Rodriguez	Art Director:	Arne Wickström	A typical winner.
Client:	Palladium Fitness Centre	Client:	Spalding Topflight Golf Balls	Always good for a round.

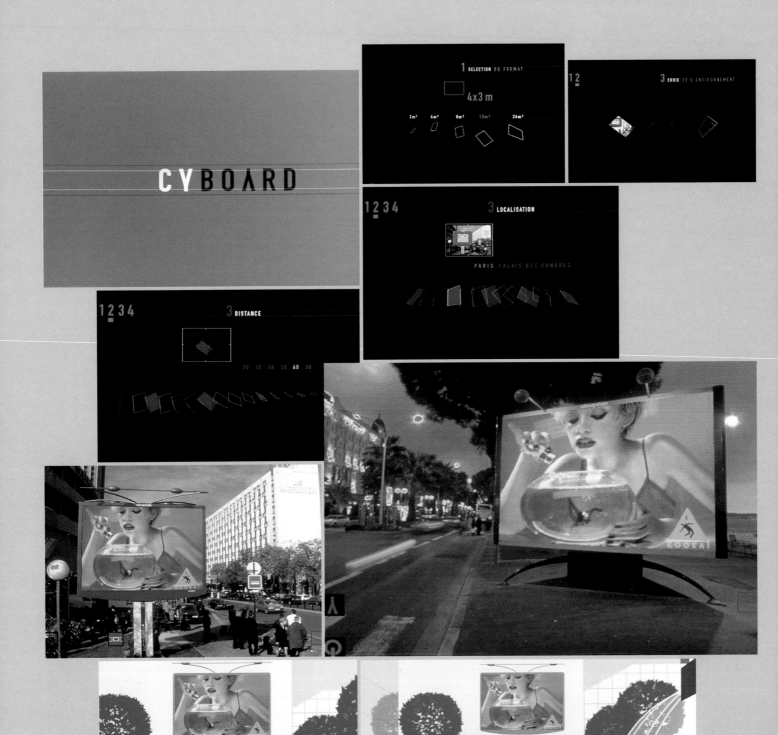

Agency:	McCann Interactif, Paris
Creative Director:	Gregory Pignot
Copywriter:	Emmanuel Deschamps
Programme:	Ackia
Producer:	Emmanuel Karas
Client:	Dauphin, Cyboard CD-ROM Poster Simulator

The Cyboard CD-ROM is the first personal poster simulator. It's designed to help agency creative directors to visualize and test their poster projects, whatever the format. They can choose the environment in which the posters will be seen, the viewing distance, the location and the angle of vision. Cyboard was produced for Dauphin, one of the leading French poster contractors.

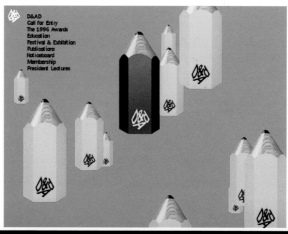

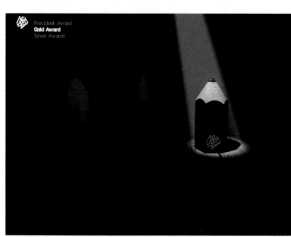

Agency:	Mondo, Copenhagen	As a player of Explorien, one's mission is to save the Lego spaceship and bring it back into orbit. There are, however, a number of problems that must be solved that will require the player to explore the spaceship and to dialogue with other Exploriens around the world.
Creative Director:	David Ingemann	
Illustrators:	Mogens Jacobsen	
	Søren Bech	
Director:	Mogens Jacobsen	
Producer:	Karsten Pers	
Client:	Lego Explorien	
	Internet Game	
	(www.lego.com)	

Agency:	Hyperinteractive, London	The British Design & Art Direction website contains up-to-date information on the activities of this creative club, including results of the annual D&AD awards. It's aimed at the most visually-literate and critically-minded audience imaginable and must, therefore, employ a graphic language that inspires the entire creative industry towards on-line excellence.
Creative Director:	Richard Mellor	
Copywriter:	Marcelle Johnson	
Art Director:	Richard Mellor	
Client:	D&AD Internet Site	
	(www.dandad.org)	

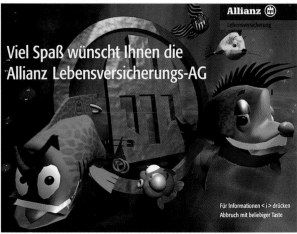

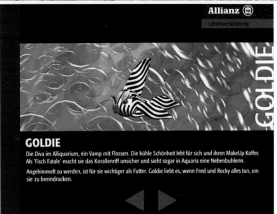

Agency:	Rauser Advertainment, Reutlingen	Through a mixture of artificial intelligence and random behaviour, this virtual aquarium screen saver is in a state of constant flux. Each of the five fish inside it has its own distinctive personality and a specific relationship with each of its neighbours. The owner can influence events by feeding the fish; if they are over-fed they become fat and lazy, if starved, they become skinny and sad. Alliquarium has achieved cult status among private and business PC users in Germany, Austria and Switzerland.
Creative Directors:	Thorsten Rauser Alexandra Grammatikopoulos	
Illustrators:	Bone Buddrus Stefanie Baumheuer	
Programmers:	Jörn Galka Thomas Galka Jörg Meister Siegfried Hanisch	
Client:	Allianz Life Insurance, Alliquarium Screen Saver	

Agency:	Sunbather, London	Ozone Interactive incorporates conventional broadcast material, provided digitally by the BBC, into the lateral environment of the web. It enhances the broadcast content through a host of features including a 3D chat area, personalised members pages, audio toys and graphic tools that enable users to interact with one another in a digital environment. This provides a continually evolving situation which matures as the system builds, profiling the users and responding to their individual tastes.
Creative Director:	Mike Bennet	
Production:	BBC	
Client:	BBC, The Ozone Interactive	

real pet fish

virtual pet fish

www.hp.com/go/fish

Agency:	Carolina Welin Kommunikation, Stockholm		The "Children's Larder" website was developed for Sweden's largest supermarket chain. It contains over 100 pages of recipes, play-tips, games and information about the environment and food.
Creative Director:	Lars Ohlsson		
Copywriter:	Jonas Åkerlind		
Art Director:	Christoffer Pertoft		
Illustrators:	Christoffer Pertoft Olle Eriksson		
Client:	ICA Stores, Barnens Skafferi Internet Site (www.ica.se/barn)		

Agency:	Global Beach, Twyford	MOPy (Multiple Original Printouts) is a life-like virtual pet fish with artificial intelligence that lives on a PC screen so long as it's cared for. With regular feeding and exercise it becomes a friend and thrives, but if neglected it gets upset and eventually dies. Owners are rewarded with points every time they send a document to print multiple originals. The points can be exchanged for accessories such as rocks, plants, air bubbles and a thermometer. With 3,200 points the owner can obtain aphrodisiac fish food that makes MOPy particularly happy.
Creative Director:	Clive Jackson	
Art Director:	Clive Jackson	
Photographer:	Dan Northover	
Client:	Hewlett-Packard, MOPy Screen Saver (www.globalbeach. com/mopy)	

Agency:	Brand Sellers DDB, Helsinki	The Finlandia website is aimed at professionals in the worldwide alcoholic drinks industry: distributors, retailers, bar and restaurant personnel. It presents product information and promotional material in an entertaining and user-friendly fashion and features the first virtual bar in the world.
Creative Director:	Kare Hellén	
Copywriter:	Jan Wellmann	
Art Director:	Elmeri Härkönen	
Production:	Sarajärvi & Hellén	
Client:	Finlandia Vodka Internet Site (www.finlandia-vodka.com)	

Agency:	Strand & Lund, Oslo	The website presents life in the Munkholm monastery since 1536 and describes the monks' traditional interest in beer, which resulted in the discovery of a brew that keeps its good taste without containing alcohol. The content is entertaining and focuses on the brand without becoming an agressive sales pitch.
Creative Director:	Rune Glad	
Copywriter:	Harald S. Lund	
Art Director:	Rune Glad	
Client:	Munkholm Beer Internet Site (www.munkholm.no)	

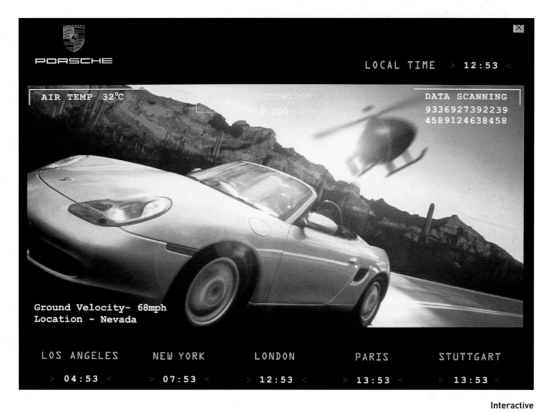

Agency:	Pilot, Leeds	Cheestrings is a children's lunchbox filler	**Agency:**	Global Beach, Twyford	The two-part Porsche programme starts

Agency: Pilot, Leeds
Creative Director: Chris Hemingway
Copywriter: Chris Hemingway
Art Director: Chris Hemingway
Client: Golden Vale, Cheestrings Internet Site (www.cheestrings.co.uk)

Cheestrings is a children's lunchbox filler made from real cheese that peels into strings. The Internet site, aimed exclusively at kids, is highly interactive and fast. It features comics and games, with different levels of difficulty that encourage users to re-visit the site to beat their previous scores and those of other players. Pilot also designed the Cheestrings packaging that provides an on-going link with developments on the brand's website.

Agency: Global Beach, Twyford
Creative Director: Clive Jackson
Art Director: Clive Jackson
Photographer: Dan Northover
Client: Porsche Boxster Screen Saver & World Time Zone Utility (www.globalbeach.com/porsche)

The two-part Porsche programme starts as a standard screen saver incorporating six digital world time zone clocks which can be customised according to the user's choice of location. The user interface resembles a satelite tracking station which monitors the movement of the Boxster around the world. Users can interact by clicking on specific locations for exclusive footage of the car in action. Part two is a 30 second video, with sound, of a dramatic Boxster car chase through central London.

Just a reminder.
There are over half a
million people
on the streets with
very cold hands.

THE BIG
ISSUE

Agency: BDDP GGT, London
Creative Director: Trevor Beattie
Copywriter: Jonathan Budds
Art Director: Christine Jones
Client: The Big Issue,
 Heat-Sensitive Postcard

The Big Issue is a magazine sold by
homeless people on the streets of London
and other cities in the UK. The postcard
appears entirely black until the warmth of
one's hand reveals the message above.

tizer

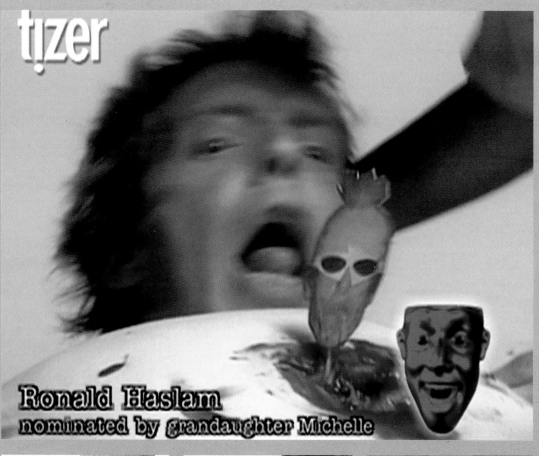

Ronald Haslam
nominated by grandaughter Michelle

Charlotte Daisley
nominated by husband Walter

Betty Denham, Carlisle.

Jason Richard, Altrincham.

Gemma Hooper
nominated by best friend Lauren

Laura Stanley, Hale.

Ade Horgan, Macclesfield.

Christina Ames
nominated by daughter Francesca

Christian James, Hastings.

Michael Whitcombe
nominated by sister Sarah

Agency:	BDH Communications, Manchester
Creative Director:	Al Dickman
Copywriters:	Danny Brooke-Taylor
	Gary Hulme
Art Directors:	Danny Brooke-Taylor
	Gary Hulme
Production:	BDH Communications
Directors:	Danny Brooke-Taylor
	Gary Hulme
Producer:	Neil Armstrong
Client:	Tizer Soft Drink, "Refresh Your Head"

Tizer sponsors the weekly Chart Show on TV and invites viewers to send in photos of family and friends who are in serious need of refreshment. The agency then produces a collection of amusing vignettes using the best photos. These are broadcast two weeks later as part of Tizer's "Refresh your head" operation. The photos might appear inside a baby's diapers, under a Scotsman's kilt, over a flasher's private parts or on a protruding tongue. More than 100 faces have been used and it's intended that the best will also feature on the Tizer packaging at a later date.

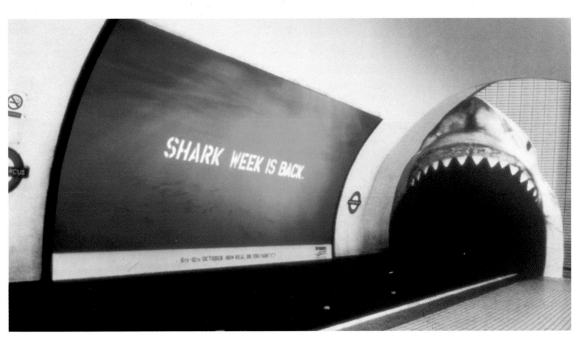

Agency:	Hall & Cederquist/Y&R, Stockholm
Copywriter:	Henrik Haeger
Art Director:	Lars Hansson
Production:	Oh-la-la Filmproduktion
Director:	Pelle Seth
Producers:	Niclas Peyron
	Ola Cronholm
Client:	Gevalia Coffee, 3D Commercial

A spaceship lifts-off successfully and the female astronaut aboard enjoys the sensation of weight-lessness until a simple fly causes panic at mission control. No longer able to rely on her terrestrial guidance system, the astronaut takes control and steers her craft through a field of meteorites to a safe landing back on earth. There, she's befriend-ed by two golfers and thinking she's on another planet, she offers them Gevalia, the coffee for un-expected visitors. The commercial, like Gevalia's print ads, was produced in 3D. Glasses were widely distributed and viewers knew in advance when the film was to be shown.

Agency:	Bates Dorland, London
Creative Director:	Chips Hardy
Copywriter:	Paul Alderman
Art Director:	Peter Ogden
Photographer:	Nick Read
Client:	The Discovery Channel, Shark Week, "Train Eater"

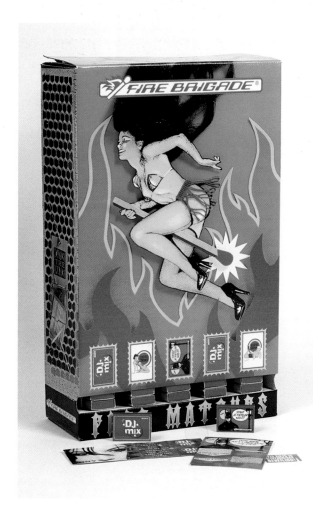

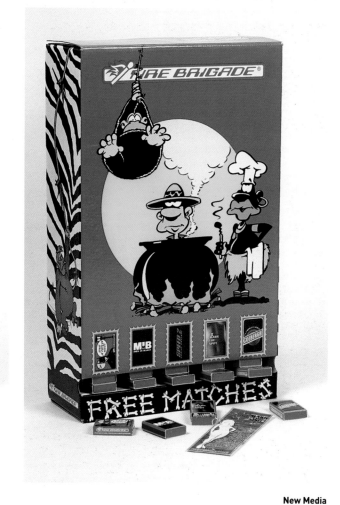

Agency: B.S.U.R., Amsterdam
Creative Directors: Hjarald Agnes
Joost Perik
Copywriter: Huub Lensvelt
Art Director: Bas Moreu
Client: Hooters Bars,
Braille T-Shirt

Hooters is slang for breasts and is also the name of a chain of bars in which all the waitresses are sexy, well-shaped women. Their T-shirts feature the Hooters name, in braille.

Agency: Borremans & Ruseler,
Amsterdam
Creative Director: Robin Blitzblum
Client: FireBrigade Nederland,
Free Matches

FireBrigade introduced a new twist to the idea of matchbox advertising by offering clients the opportunity to advertise inside the boxes. In addition to about a dozen free matches, each box contains a small folded leaflet featuring a special offer on products and services such as Virgin Vodka, Sony CDs, the America Today retail chain, body-piercing and Chinese motorcycles. For example, United International Pictures proposed free posters of the film, "Mission: Impossible." Redemption rates as high as 90% were achieved on some offers. The matchboxes are packed in cardboard distributors and displayed in 500 cafés and pubs throughout Holland.

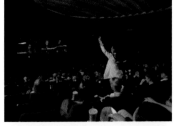

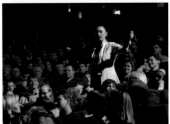

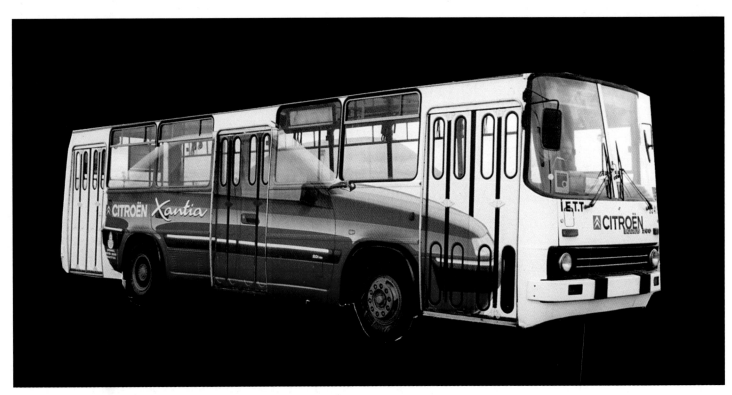

Agency:	Lowe Brindfors, Stockholm	**Agency:**	Magic Marketing & Communication Services, Istanbul
Copywriter:	Björn Ståhl	**Creative Director:**	Senay Kansu Tayyar
Art Director:	Jari Ullakko	**Art Director:**	Senay Kansu Tayyar
Production:	Rally TV	**Client:**	Citroën Xantia
Director:	Mikael Rosengren		
Producers:	Henrik Ihre		
	Mark Baughen		
Client:	Folk Opera, Interactive Cinema Commercial		

The cinema commercial begins, on screen, with auditions for the Folk Opera. The producer complains to his colleague about how difficult it is to find good singers. "I can sing," cries out a woman at the back of the theatre. Eventually she catches the attention of the man on screen who challenges her to prove it, which she does, much to the delight of the audience. The Folk Opera people immediately offer her a role and she leaves the theatre ecstatic. The operation launched the new season at the Folk Opera, where every performance is in Swedish.

A full-size Citroën Xantia features on the side of municipal buses with one-way-vision film enabling the passengers to enjoy a normal view through the windows.

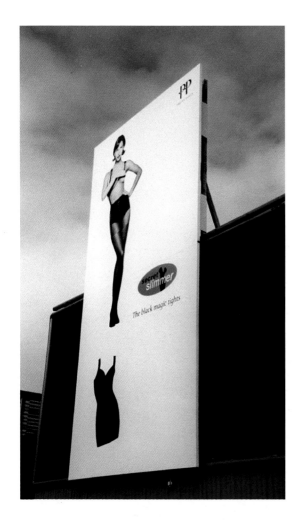

Agency:	BDDP GGT, London	The model's black dress is removed
Creative Director:	Trevor Beattie	and then replaced, to reveal her Secret
Copywriters:	Paula Jackson	Slimmer Tights underneath.
	Trevor Beattie	
Art Director:	Jay Pond-Jones	
Client:	Pretty Polly Secret	
	Slimmer Tights	

Agency:	Garbergs Annonsbyrå,	Pop stars and young people were invited
	Stockholm	to create their own political messages on
Creative Director:	Martin Gumpert	MTV posters in the windows of the H&M
Copywriter:	Anna Qvennerstedt	department store. This is just 3 of more
Art Director:	John Mara	than 50 posters that were made this way.
Client:	MTV Music Channel	They were then displayed as an art exhibition
		in the Stockholm underground.

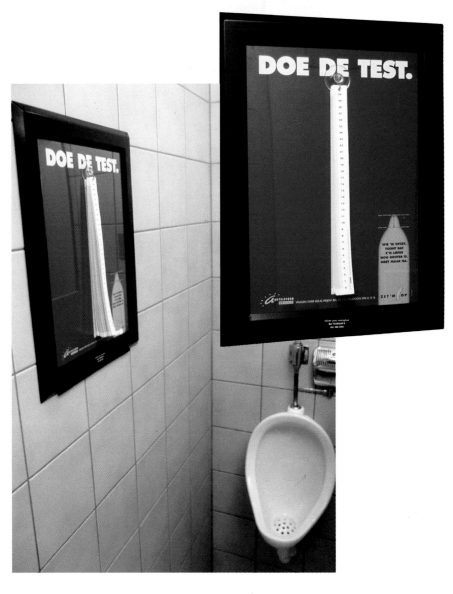

Agency:	Young & Rubicam, London
Creative Director:	Mike Cozens
Copywriter:	Dave West
Art Director:	Richard Denney
Production:	Tony Kaye & Partners
Director:	Mark Williams
Producers:	Benji Howell
	Sarah Goode
Client:	St. Mungo's Charity, "Remember Me?"

The man in the St. Mungo's cinema commercial sits outside the theatre every night the commercial is screened. "Remember me?" he asks the audience, "You might have ignored me outside the cinema, but you can't ignore me now, can you?" He goes on to explain how St. Mungo's helped him when he was homeless and how he is trying to help the charity now. "Hope you enjoy the film," he concludes, "I'll be outside again at the end, collecting for St. Mungo's. Please don't ignore me."

Agency:	VVL/BBDO, Brussels
Copywriter:	Willem De Geyndt
Art Director:	Peter Aerts
Client:	Aids Telefoon, "Take The Test"

Put one on and show how big your love is. Just measure it afterwards. (Tape-measures, given away in men's toilets, encourage the use of condoms because of the extra length created by the reservoir tips.)

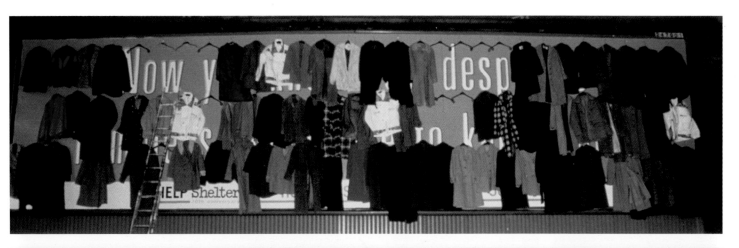

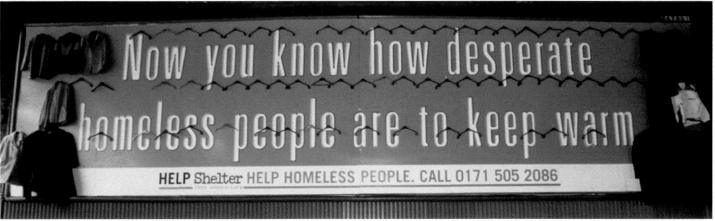

Now you know how desperate homeless people are to keep warm

HELP Shelter HELP HOMELESS PEOPLE. CALL 0171 505 2086

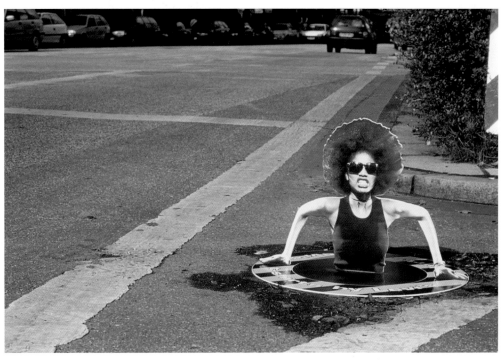

Agency:	Foote, Cone & Belding, London	Agency:	Springer & Jacoby, Hamburg	These displays were installed in large cities, close to Levi's stores, while the "Tank Top" ad was running (see page 263).
Creative Director:	John Bacon	Creative Directors:	Arndt Dallmann	
Copywriter:	Neil Frisby		Guido Heffels	
Art Director:	Richard Coggin	Copywriter:	Thomas Grabinger	
Photographer:	Stuart Lugg	Art Director:	Rainer Kollender	
Client:	Shelter Charity Live Ad	Illustrator:	Erik Hart	
		Photographer:	Carli Hermes	
		Client:	Levi's Live Ad	

I'm so very grateful that I'm still here! After all it's been five years since I was diagnosed as HIV positive. When I first received the diagnosis in 1988 I naturally went through a huge crisis. I saw a psychologist regularly for about a year, which helped me a lot. It was my husband who infected me - unintentionally. He's dead now!
Every year on my birthday we have a huge party where we celebrate the fact that I have been allowed to see another year, and watch my children grow a year older, too. Because that has really been my main concern - having to leave my children when they were still young. I've also lived long enough to become a grandmother to a beautiful girl who's now three years old.

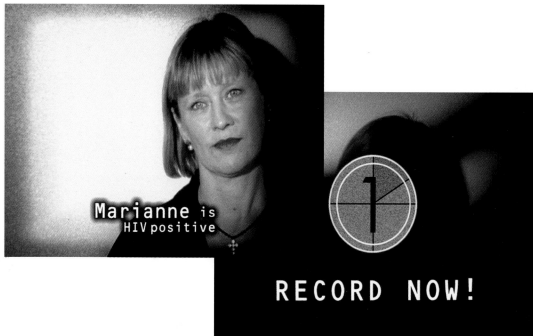

Marianne is HIV positive

RECORD NOW!

Due to illness I quit my job two years ago. This has helped me a lot, because it enables me to do everything at my own tempo - I can rest when I need to without having to feeling guilty. Two days a week I take adult education classes, which helps me maintain my social life.
Seven months ago, I started taking the new combination medication and this has improved my immune system - so I'm optimistic about the future....

National Board of Health

You can also find Marianne's story on Text-TV, page 608.

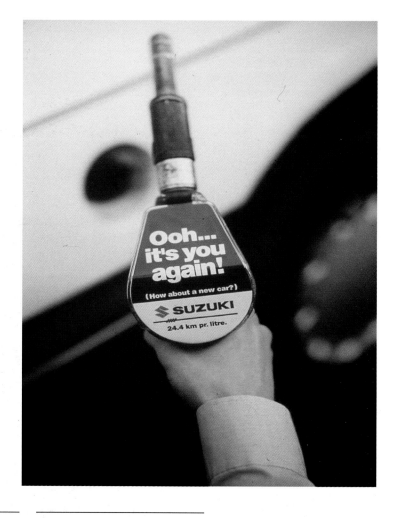

Ooh... it's you again!
(How about a new car?)
$ SUZUKI
24.4 km pr. litre.

Agency:	Courage/BDDP, Copenhagen	**Agency:**	Grey, Copenhagen
Creative Director:	Annemette Allerup	**Creative Directors:**	Michael Robert
Copywriters:	Annemette Allerup		Kim Boisen
	Michael Toft	**Copywriter:**	Kim Boisen
Art Director:	Peter Stenbaek	**Art Director:**	Michael Robert
Production:	Bullet	**Client:**	Suzuki Cars
Director:	Peter Stenbaek		
Producer:	Thomas Busch		
Client:	Danish Health Council, Aids Awareness, "Marianne"		

A two-part interactive operation to promote Aids awareness. The first spot simply shows Marianne, who's HIV positive, and explains that a second film will be shown in the next commercial break. Viewers are asked to record it on their VCRs and to watch it frame-by-frame to find out more about Marianne's life. The second film contains a number of subliminal images and frames of text that, when stopped with the "pause" button, recount in detail the whole story of Marianne's life: how she became HIV positive and how she lives under the threat of contracting Aids.

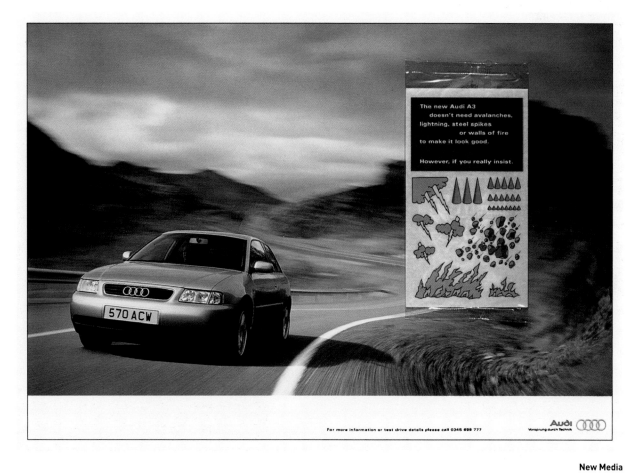

Agency: Vinizius/Young & Rubicam, Barcelona

Creative Directors: Jose Maria Pujol
Jose Maria Roca

Copywriters: Jose Maria Pujol
Jose Maria Roca

Art Director: Jordi Almuni

Photographer: David Levin

Client: Llongueras
Hairdressers

Try your new hairstyle at Llongueras.
(The reader can see her own reflection
in the ad).

Agency: Limbo, London

Creative Director: Steven Stretton

Copywriter: Simon Antenen

Art Director: Steven Stretton

Photographer: Jean-Luc Bernard

Client: Audi A3,
Interactive Ad

NB: The sachet contains real transfers that
the reader can attach to the magazine ad.

Agency:	Milénio, Lisbon
Creative Director:	Gonçalo Geraldes Cardoso
Copywriter:	Gonçalo Geraldes Cardoso
Art Director:	Gilson Lopes
Illustrator:	Alain Voss
Production:	Estúdios 126
Producers:	José Teixeira
	François Barbier
	Fernanda Pité
Client:	Sonae Imobiliária,
	Norteshopping Shopping
	Centre (Also a Finalist in
	the Interactive Category)

A two-part operation to encourage retailers to rent space in a new shopping centre. First, two actors, dressed as security guards deliver a briefcase to prospective clients. The briefcase contains a large quantity of false money and a sound system that activates when the lid opens. A three-dimensional model of the shopping centre emerges from under the cash, together with sales brochures and an invitation to visit the new development in a time travel spaceship.

The second part takes place at the Norteshopping Marketing Suite, where the prospect is escorted into a false elevator that seems to take him up to the 21st floor. There, he discovers a sophisticated control station and a spacecraft on its launch pad. The prospect enters the module, attaches his helmet and takes off for an 8 minute voyage of discovery: an animated, virtual reality cruise through the new shopping centre. During the "flight," the walls shake and the platform re-volves, bringing the prospect back to the ground floor where a sales team is waiting.

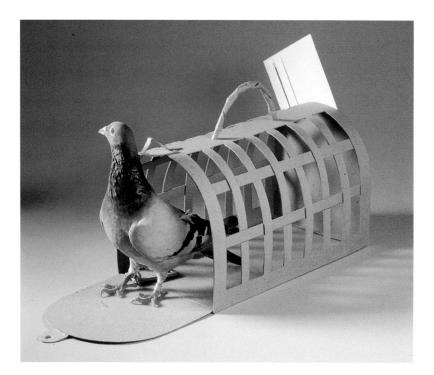

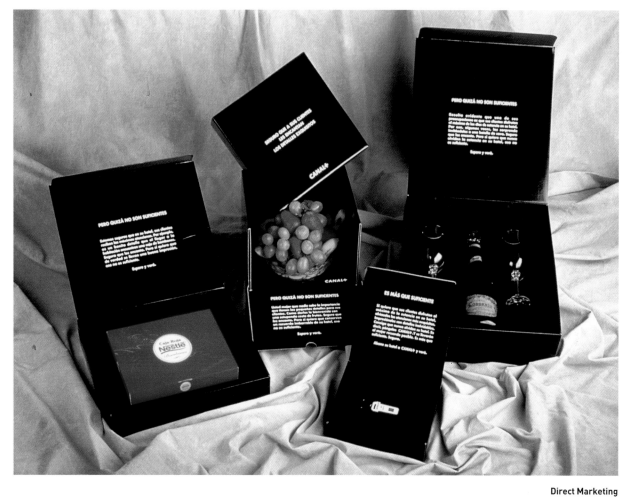

Agency:	Ammirati Puris Lintas, Warsaw	**Agency:**	CP Comunicacion, Madrid
Creative Director:	Chris Matyszczyk	**Creative Director:**	Ezequiel Triviño
Copywriter:	Monika Kaminska	**Copywriter:**	Antonio Pacheco
Art Director:	Aldona Mazur	**Art Director:**	Irma Escudero
Photographer:	Janusz Kobylinski	**Client:**	Canal+,
Client:	Ammirati Puris Lintas, Direct Marketing Department, "Pigeons"		Hotel Promotion

To launch the agency's new direct marketing department, cages were delivered by hand to potential clients. Inside each cage was a pigeon. All the prospect had to do was to release the bird if he wanted to talk to the agency. The pigeons, having been perfectly trained, returned directly to Ammirati Puris Lintas within hours of their release.

A four-part operation aimed at hotels, offering a month's free-trial subscription to Canal+, the leading pay-TV channel in Spain. First, a box of chocolates was delivered to the hotel manager, with a message reminding him that his clients appreciate this kind of special touch. The chocolates were followed by deliveries of champagne and a bowl of fruit, with similar messages. The fourth gift box, delivered in person by a sales representative, contained a decoding key and a reminder that Canal+ is another special service that clients appreciate.

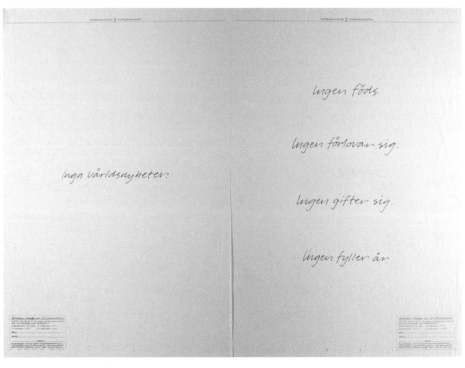

Agency:	Lonsdale Design, Paris	
Creative Director:	Gilles Riedberger	
Copywriter:	Sonia Chaine	
Art Director:	Hortense Sicardon	
Photographer:	Renaud Loisy	
Client:	Lonsdale Design, Self-Promotion	

A spoof mailing to demonstrate the agency's expertise in new product development and packaging design. The product is a VIP meal-substitute developed for Lambert & Garrat, Houston, using space-age technology. Each titanium and hardwood box contains two 3-course meals created by Bernard Loiseau, the renowned French chef (3 Michelin stars). The hors-d'oeuvre is a green pill, the main course is a beige one and dessert is brown. The product is designed for business travellers and the recommended price is $50.

Agency:	Forsman & Bodenfors, Gothenburg
Copywriter:	Björn Engström
Art Director:	Staffan Forsman
Illustrator:	Johan Eghammer
Client:	Göteborgs-Posten, Subscription Renewal Mailing

This empty edition of Göteborgs-Posten, Gothenburg's leading daily newspaper, was sent to all readers who failed to renew their subscriptions. The headline announces: "As if nothing has happened." Then inside, it states: "No international news. No births. No engagements. No marriages." etc. "Something's missing," concludes GP, "We miss you and hope that you're missing us."

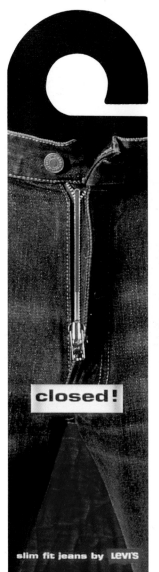

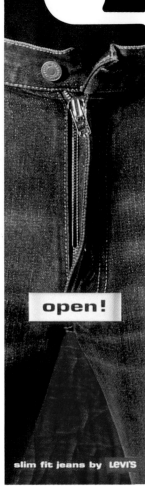

Agency:	Springer & Jacoby, Hamburg	A direct mail piece to introduce Levi's 505 zipfly jeans to the youth market.
Creative Directors:	Arndt Dallmann	
	Guido Heffels	
Copywriter:	Thomas Grabinger	
Art Director:	Rainer Kollender	
Illustrators:	Erik Hart	
	Stefan Leick	
Photographers:	Carli Hermes	
	Gary Owens	
Client:	Levi's 505 Doorhanger	

Agency:	Garbergs Annonsbyrå, Stockholm	Packages of 60 toilet paper rolls were sent to opinion leaders and clients so
Creative Director:	Martin Gumpert	that they could read about MTV in comfort
Copywriter:	Anna Qvennerstedt	and privacy. The target group included
Art Director:	John Mara	advertising agencies, media buyers,
Client:	MTV Music Channel	marketing departments, journalists, restaurants and bars.

Agency:	Leo Burnett Direkte, Oslo	This small filing cabinet introduced Scandinavian companies to Dun & Bradstreet's credit infomation services. It contains credit data on four well-known distilleries, one from each of the four Nordic countries, together with miniature samples of their products.	**Agency:**	Aanima Advertising Agency, Ljubljana	A new year's gift for the retail trade, promoting a new range of Paloma toilet tissues. In addition to product samples, the briefcase contained a radio and a comic book.
Copywriter:	Ole Kristian Ellingsen		**Creative Director:**	Mojca Hrusevar Rakuscek	
Art Director:	Rune Storkaas		**Copywriter:**	Mojca Hrusevar Rakuscek	
Client:	Dun & Bradstreet, "The Box File"		**Art Directors:**	Ignac Kofol Mojca Hrusevar Rakuscek	
			Client:	Paloma Toilet Tissue, "WC Set"	

Agency:	Kompas Design, Ljubljana	An exclusive calendar from Slovenia's leading manufacturer of picture frames.
Creative Director:	Zare Kerin	
Art Director:	Zare Kerin	
Photographer:	Janez Puksic	
Client:	Okvirji Vrhunc, "One Leaf" Calendar	

Agency:	Wunderman Cato Johnson, Eschborn	A direct mail promotion to rejuvenate the Hugo brand targeting "Generation X," the design-conscious and trend-oriented youth market. 2.6 million Hugo fragrance samples and sweepstake tickets were distributed by hand and by mail. The tickets were to be validated in the "Present Time" point-of-sale machines displayed in authorised Hugo perfumeries, in exchange for free digital button watches. The "Present Time" displays, recorded the time and date of the operation (information that determined the eventual sweepstake winners). The promotion was explained to the retail trade via Hugo cubes and "Present Time" button watches for the sales staff.
Creative Directors:	Ute Deyerling Timm Haenitsch	
Copywriter:	Stella Friedrichs	
Producer:	Michael Stickel	
Client:	Hugo Boss Fragrances, "Present Time" Promotion	

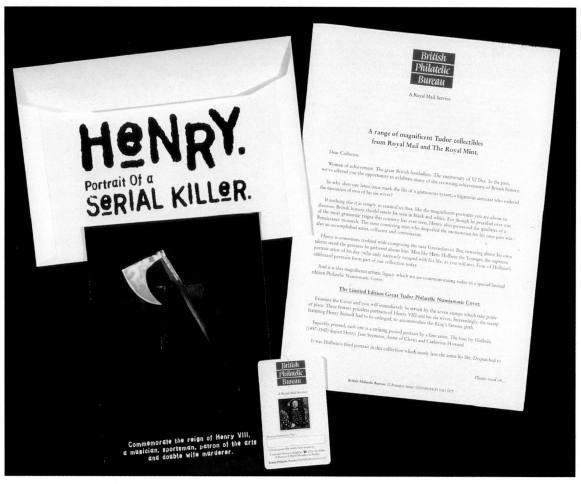

Agency:	IMP, London	To launch Southern Comfort's premium Street
Creative Director:	David Harris	Car drink to cynical and pessimistic pub trade
Copywriter:	Marcus Park	buyers, IMP designed a hollow alligator egg
Art Director:	Andy Regan	that contained a sample bottle of the product
Client:	Southern Comfort	and a sales leaflet. The egg was delivered by
	Street Car	hand in a straw-filled hessian sack, stamped

"Gator's Egg, Handle With Care." The operation stood out in a cluttered marketplace and created strong awareness in the trade, successfully exploiting and enhancing the image of the mother brand.

Agency:	OgilvyOne Worldwide, London	A mailing to stamp collectors using interesting and informative historical facts
Creative Directors:	Rory Sutherland	to promote the new Tudor first day covers.
	Mike Simm	
Copywriter:	Pete Wise	
Art Director:	Sue Lamb	
Client:	British Philatelic Bureau	

Agency:	Ardmore Advertising & Marketing, Belfast	A real can of sardines and the above card announced the agency's move to new offices beside the sea.
Copywriter:	Norma Nelson	
Art Director:	Michael Loughran	
Client:	Ardmore Advertising, Change of Address	

Agency:	Oslaj Design, Kranj	The petroleum lamp was distributed to the most important partners of Petrol, the Slovenian oil company, as a symbol of its mission to share energy, light and warmth. The lamp was produced in three versions, using natural Slovenian cherry wood, marble or clay, and came with two shades. The shades could be used separately or together to reflect or diffuse light according to one's mood and were made of brass, aluminium or copper, depending on the base material. The lamp was accompanied by a short message from Petrol, "Every single day we're giving you part of our energy. That's why we're here."
Creative Director:	Janja Oslaj	
Copywriter:	Irena Cebulj	
Art Director:	Janja Oslaj	
Photographer:	Domen Slana	
Client:	Petrol, Petroleum Lamp	

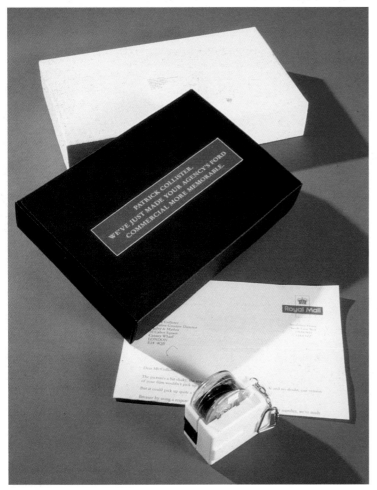

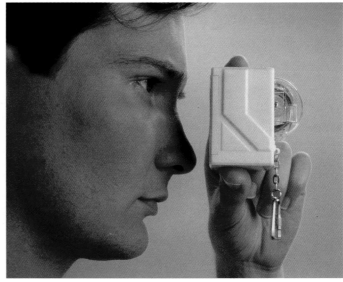

Agency:	Euro RSCG Direct, London	To launch the Iomega Zip Insider Drive
Creative Director:	Mick Mamuzelos	units to the retail trade, the agency
Copywriter:	Richard Stoney	designed a mailing that simulated PC and
Photographer:	Jem Grischotti	Mac hardware. When the box was opened
Client:	Iomega, Zip Atapi Insider Drive	a Zip disc popped out of the drive slot while the accompanying literature explained the scope of the sales opportunity involved.

Agency:	OgilvyOne Worldwide, London	Freepost Name is an easy postal response mechanism for television commercials
Creative Director:	Steve Harrison	whereby viewers can respond to a simple
Copywriter:	Xanthos Christodoulou	address such as "Freepost IBM." Senior
Art Directors:	Brian Storey	agency creative directors were sent a
	Robert Anderson	personalised mailing and a mini-projector
Client:	Royal Mail, Freepost Name	that featured one of their own commercials.

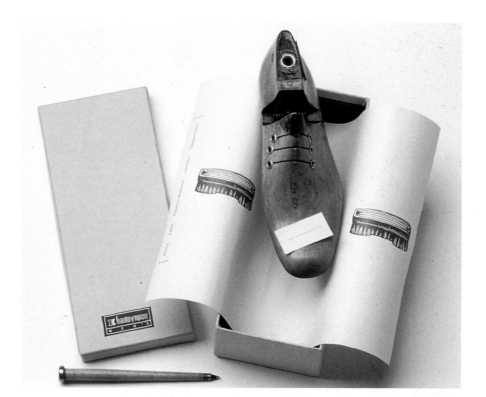

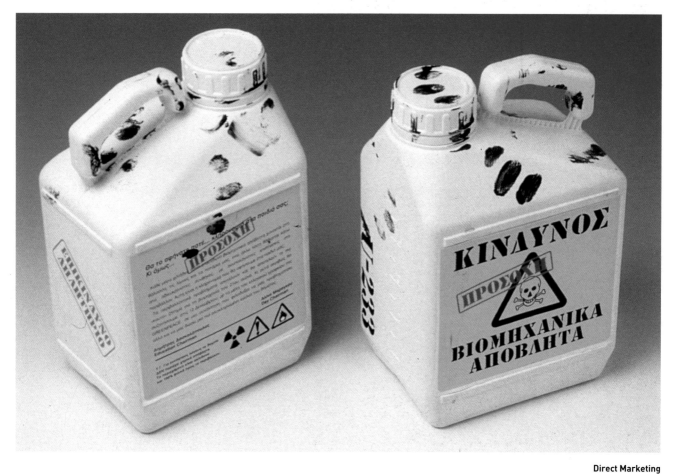

Agency:	McCann-Erickson, Athens	Kalogerou traditionally sold ladies' footwear only. This press kit announced the opening of a men's shoe department within their stores. The message reads, "Men have put their foot down at Kalogerou."
Creative Director:	Gerassimos Neofytos	
Copywriter:	Gerassimos Neofytos	
Art Director:	Grania Kelway	
Client:	Kalogerou Shoe Stores	

Agency:	Fortune/BDDP, Athens	"Danger. Industrial waste," warns this container that invited recipients to a meeting with Greenpeace on environmental issues. For obvious reasons, the receptacle and its contents were both quite safe from an environmental standpoint.
Creative Directors:	Vassilis Giannou Giorgos Giosis	
Copywriter:	Giorgos Giosis	
Art Director:	Vassilis Giannou	
Client:	Young President Organisation, Environmental Meeting	

Agency:	Grupo Barro-Testa, Madrid
Creative Directors:	Urs Frick
	Uschi Henkes
	Manolo Moreno Marquez
Copywriter:	Alberto Delgado
Art Directors:	David Villarrubia
	Pedro Conde
Client:	Polygram Films, " A Life Less Ordinary"

The press kit to launch the Danny Boyle film, "A Life Less Ordinary," takes the form of a top secret dossier from the archives of the Los Angeles Police Department. It contains the personal files of the two main actors, background documents on how the film was made, including paparazzi-style shots for publication, and an annonymous ransom demand. Coffee stains and hand-written notes give the impression of authentic police documents.

Agency:	Grupo Barro-Testa, Madrid	A press book for the "Mr. Bean" film, appropriately packed in cotton wool and boxed in a first aid kit, held together with a strip of plaster.
Creative Directors:	Urs Frick Uschi Henkes	
Art Director:	Urs Frick	
Client:	Polygram Films, "Mr. Bean"	

Agency:	Grupo Barro-Testa, Madrid	Fake fur, rubber bathmats and floral plastic wallpaper help make up the press book for "Twin Town," a publication that's as kitsch as the lifestyle of the principal characters in the film.
Creative Directors:	Urs Frick Uschi Henkes	
Copywriters:	Manolo Moreno Marquez Alberto Delgado	
Art Directors:	Judith Francisco Maria Nieto	
Client:	Polygram Films, "Twin Town"	

Agency:	Armando Testa, Turin	Each month a different fruit or vegetable is portrayed as something more exciting than just food to convey the superior freshness and quality of Esselunga produce. Thus, an onion becomes a scientist, a cucumber becomes a whale, bananas look like dolphins and so on. "Seal or aubergine?" is the question for March '97. "Our quality is something else," concludes Esselunga.
Creative Director:	Mauro Mortaroli	
Copywriter:	Erminio Perocco	
Art Director:	Mauro Cinquetti	
Photographer:	Mauro Cinquetti	
Client:	Esselunga Supermarkets, Calendar	

Agency:	Brader Perryman, London	Nine ads, all on the theme of passion, that ran in marketing and healthcare publications before being reproduced on cards for new business mailings, either individually or as a collection.
Creative Director:	Alex Perryman	
Copywriter:	Alex Perryman	
Art Directors:	Lucy Rainbow	
	Gerry Smith	
	Ellen Walton	
Photographers:	Sandra Lousada	
	Steve Hoskins	
	Richard Sharples	
Client:	Brader Perryman Self-Promotion	

Agency:	The Attik, Huddersfield	This self-promotion brochure, entitled "(noise)3," gave The Attik an opportunity to experiment	**Agency:**	Grupo Barro-Testa, Madrid

Agency: The Attik, Huddersfield

Creative Director: Simon Needham

Client: The Attik, Self-Promotion Brochure

This self-promotion brochure, entitled "(noise)3," gave The Attik an opportunity to experiment collectively with creative imagery and with applying as many processes to it as possible. The brochure is as much about touch and feel as it is about looks. It seeks both to demonstrate the company's capability to potiential clients and to inspire young designers to abandon their computers for a while, in order to learn about materials and the production process.

Agency: Grupo Barro-Testa, Madrid

Creative Directors: Urs Frick
Uschi Henkes
Manolo Moreno Marquez

Copywriter: Manolo Moreno Marquez

Art Directors: Urs Frick
Judith Francisco
Maria Nieto

Client: Polygram Films, "Photographing Fairies"

The small "Photographing Fairies" press book, in its velvet pouch, has the look and feel of an authentic publication from the early 1900's. The pages are yellow with age and personalised with annotations. It contains pressed flowers, newspaper clippings and other mementos in the style of a Victorian scrapbook.

Agency:	Ajans Ultra Reklam Hizmetleri, Istanbul	**Agency:**	The Chase Creative Consultants, Manchester
Creative Director:	Hakki Misirlioglu	**Creative Director:**	Ben Casey
Copywriter:	Leyla Üstel	**Copywriters:**	Ben Casey
Client:	Fol Magazine		Dave Walker
		Art Director:	Mark Ross
		Photographer:	Dave Walker
		Client:	The Chase, Self-Promotion Calendar

Fol is a quarterly human interest magazine that focuses on the artistic and literary scene. Each issue concentrates on a different subject. The human body was the theme of issue no. 6, while previous topics have included masks, tobacco, absurdity, births and deaths.

The calendar was produced as a self-promotion piece using the photography of Dave Walker. His work represents a personal view of the people and personalities of his home town, Leigh, in Lancashire.

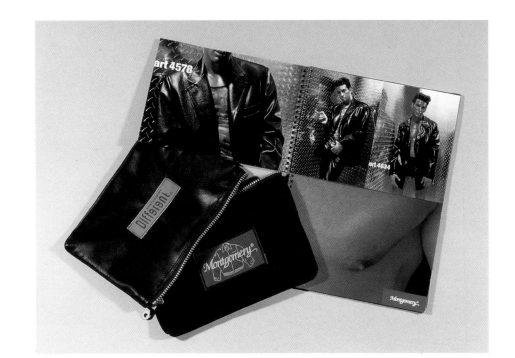

Agency:	Adoffice, Istanbul	Two brands, one for genuine and one for	**Agency:**	Hoehne Habann Elser,	A 142 page book describes the development

Agency: Adoffice, Istanbul
Creative Directors: Timucin Unan
Senay Isözen
Art Director: Timucin Unan
Photographer: Nazif Topcuoglu
Client: Montgomery
Tusa Leather

Two brands, one for genuine and one for artificial leather, are separated from each other in a horizontally-divided brochure. The brochure is contained in a pouch that's also divided into two parts by a zip fastener, enabling it to be separated into two smaller pouches, one for each of the two brands.

Agency: Hoehne Habann Elser, Ludwigsburg
Creative Directors: Armin Jochum
Kai Kittelberger
Copywriter: Kai Kittelberger
Art Directors: Armin Jochum
Katharina Keller
Client: Mercedes-Benz
Actros Trucks

A 142 page book describes the development of the Actros heavy-duty truck. The book is embedded in a presentation box that also contains some metal filings, a bolt and two Lego blocks. The text reads, "Why production was reorganised to prevent a handful of filings (page 20). Why it was necessary to re-invent the bolt (page 44). Why we used the latest CAD technology and a few Lego blocks (page 62)."

Agency:	Springer & Jacoby, Hamburg	A heavy brushed-metal cover and an	**Agency:**	Kompas Design,
Creative Directors:	Kurt Georg Dieckert	embossed title suggest elegance		Ljubljana
	Jan Ritter	and solidity, in line with the image	**Creative Director:**	Zare Kerin
	Robert Wohlgemuth	of the Mercedes SLK roadster.	**Copywriter:**	Zdravko Dusa
	Walter Schönauer		**Art Director:**	Zare Kerin
Art Directors:	Eric Urmetzer		**Photographer:**	Janez Puksic
	Walter Schönauer		**Client:**	Janez Puksic,
Photographers:	Peter Lindbergh			Photographer
	Michele Comte			
	Eberhard Sauer			
	Markus Bolsinger			
Client:	Mercedes-Benz			
	SLK Roadster			

Agency:	Image Now Consultants, Dublin	The rough cardboard cover and string binding of the small Filak catalogue (9cm x 13cm) reflect the traditional methods and natural ingredients that continue to characterise the company's products.
Creative Director:	Darrell Kavanagh	
Art Director:	Philip Rafferty	
Photographer:	Nigel Brand	
Client:	Irish Telecommunication Investments Annual Report	

Agency:	Kompas Design, Ljubjana
Creative Director:	Zare Kerin
Copywriter:	Janez Filak
Art Director:	Zare Kerin
Photographer:	Janez Puksic
Client:	Filak Fruits & Spirits

Agency:	Allan Burrows, Ingatestone		The overall design of the Ford Ka brochure reflects the character of a car that set itself apart in terms of automotive styling.
Creative Director:	Roydon Hearne		
Copywriter:	Stephen Hinchliffe		The agency even created a new font so that every element in the brochure remains consistent with the Ka's unique personality.
Art Directors:	Philip Sutton		
	Les Wetherell		
Photographers:	Taly Noy		
	Phil Price		
Client:	Ford Ka		

Agency:	Mainostoimisto Konsepti, Helsinki
Copywriter:	Pekka Nuikki
Art Director:	Pekka Nuikki
Photographer:	Pekka Nuikki
Client:	Mainostoimisto Konsepti Self-Promotion

"Travelling Without Moving" is the title of this metal-bound publication, sponsored by Konsepti, that describes the somewhat existential philosophy of Pekka Nuikki, a well-known Finnish photographer who is responsible for visual communications at the agency.

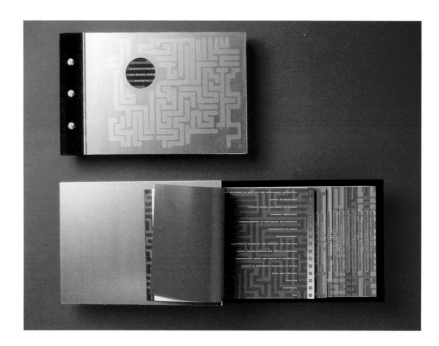

Agency:	Teviot, Edinburgh	The Risk & Safety manual is a metal,
Creative Director:	Kate Laing	rubber and reinforced paper emergency
Client:	Scottish Power,	procedures book designed to withstand the
	Risk & Safety Manual	rigours of the industrial workplace over

The Risk & Safety manual is a metal, rubber and reinforced paper emergency procedures book designed to withstand the rigours of the industrial workplace over a long period of time. It's heat, water and damage resistant and screw-bound to facilitate additions or deletions.

Agency: Cherlet & Clients, Aalst
Creative Director: Adri Cherlet
Copywriter: Adri Cherlet
Art Directors: Adri Cherlet
Chris Vantieghem
Photographer: Luc Gees
Client: Cherlet & Clients
Calendar

"Communication Planet '97" is the title of this self-promotion calendar that focuses on the agency's four partners and on their individual contributions to effective communication programmes for their clients.

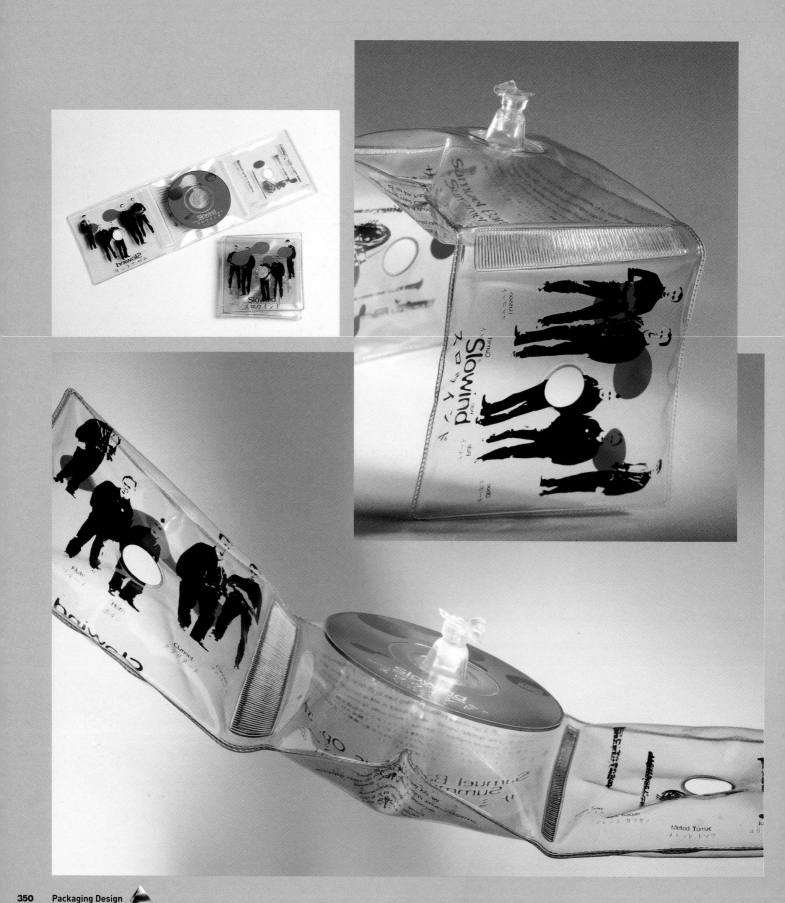

Agency: Futura, Ljubljana
Creative Director: Igor Arih
Art Director: Igor Arih
Photographers: Jane Straus
Dragan Arrigler
Client: Slowind CD Cover

An inflatable CD cover for the well-known Slovenian wind quintet, Slowind.

Agency:	Lewis Moberly, London	**Agency:**	Advertising Agency Särkka, Helsinki
Creative Director:	Mary Lewis	**Creative Director:**	Jari Särkka
Art Directors:	Mary Lewis	**Copywriter:**	Jari Särkka
	Paul Cilia la Corte	**Art Director:**	Jaakko Penttinen
	Shaun Bowen	**Illustrator:**	Saija Varis
	Bryan Clark	**Client:**	Tervakoski
Illustrator:	Peter Crowther		Office Paper
Client:	Starmaker, Tennis Racket Accessories		

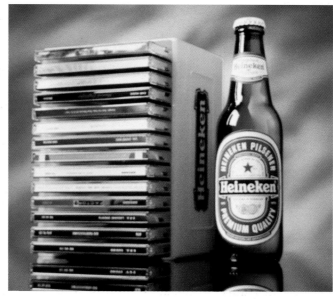

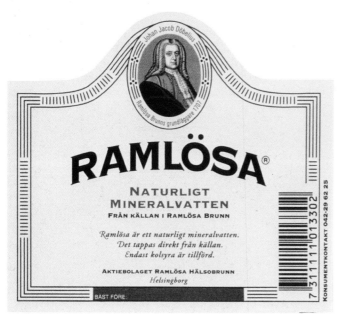

Agency:	Bartels Verdonk Impuls, Amstelveen	In the Netherlands, Heineken is normally sold in yellow plastic crates of 24 bottles. This successful promotion offered consumers a free CD, featuring music from the popular Heineken TV commercials, in a mini-crate that doubles as a CD rack.	**Agency:**	Cronert & Company, Helsingborg	The regular Ramlösa label, shown above, was replaced in December with a look-alike label that says, "Merry Christmas to the people of Sweden from everyone at Ramlösa, Hälsobrunn. Peace and goodwill this Christmas time, the joy of giving and the pleasure of receiving for young and old alike."
Creative Director:	Harry Bakker		**Copywriter:**	Christian Hultberg	
Copywriter:	Roland van Beveren		**Art Director:**	Per Ekros	
Art Director:	Fred Rosenkamp		**Photographer:**	Göran Örtegren	
Photographer:	Chris Hutter		**Client:**	Ramlösa Mineral Water, Christmas Packaging	
Client:	Heineken CD Promotion				

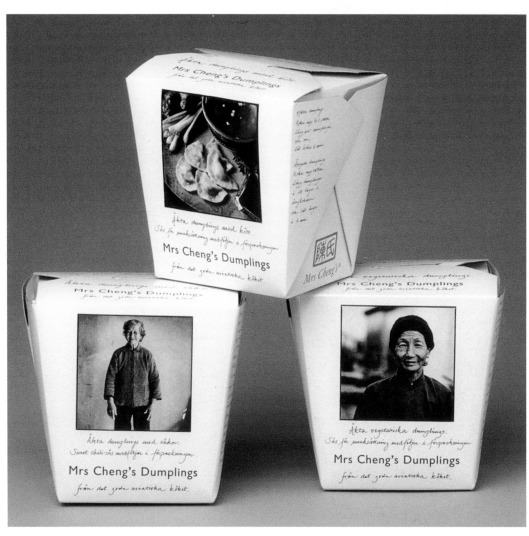

Agency:	Lewis Moberly, London		**Agency:**	Nord Åkestam Holst, Stockholm
Creative Director:	Mary Lewis		**Copywriter:**	Göran Åkestam
Art Directors:	Mary Lewis		**Art Director:**	Kerstin Mårtensson
	Julian Morey		**Photographer:**	Johan Carlsson
Illustrator:	Julian Morey		**Client:**	Mrs. Cheng, Fast Food
Client:	Boots Films			

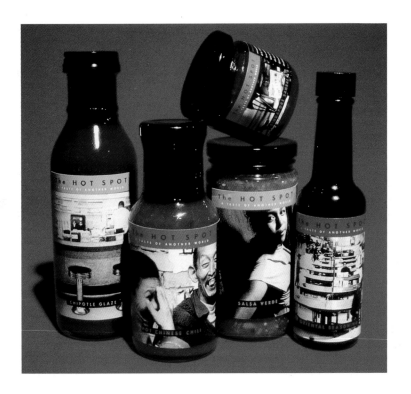

Agency:	Peppar & Co., Gothenburg	**Agency:**	Nucleus Design, Thames Ditton	
Creative Director:	Anders Wallin	**Creative Director:**	Peter Matthews	
Copywriter:	Daniel Röjnemark	**Art Designer:**	Simon Freer	
Art Director:	Fredrik Gauslandt	**Illustrator:**	Paul Chambers	
Client:	The Hot Spot, Mexican Sauces	**Client:**	Superdrug Stores, Woundcare Range	

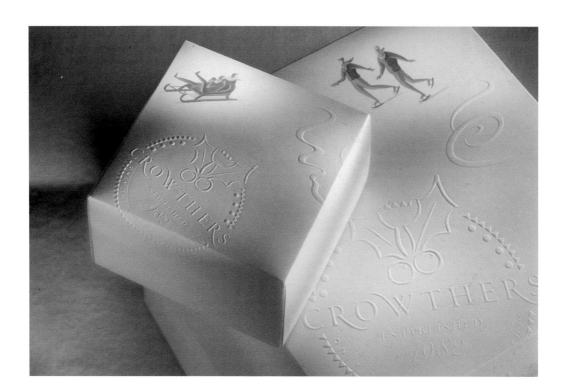

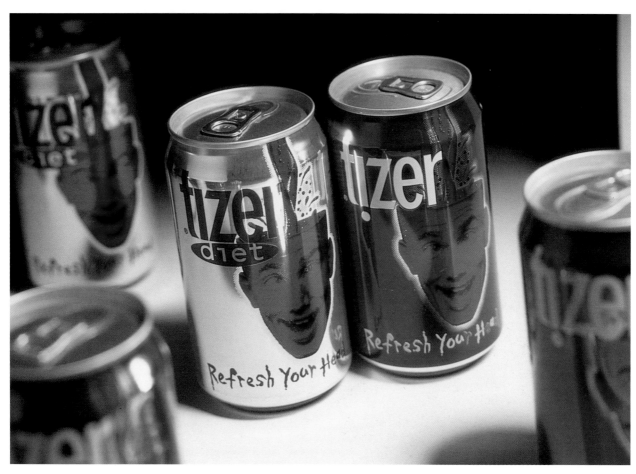

Agency:	Pearlfisher, London	Agency:	Pilot, Leeds
Creative Director:	Karen Welman	Creative Director:	Alan Rogan
Art Director:	Jonathan Ford	Copywriter:	Alan Rogan
Illustrator:	Richard Beards	Art Director:	Austin Marsden
Client:	Crowthers Restaurant, Christmas Range	Photographer:	Craig Oddy
		Client:	A G Barr, Tizer Soft Drink

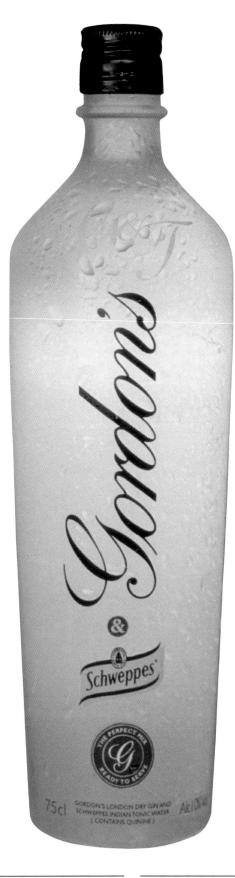

356 **Packaging Design**

Agency:	Sexton 87 Annonsbyrå, Stockholm	**Agency:**	The Branding Iron, Edinburgh	**Agency:**	Blackburn's, London
Design Director:	Gunnel Sahlin	**Creative Director:**	Nick Cadbury	**Creative Director:**	John Blackburn
Copywriter:	Magnus Bruforss	**Photographer:**	Paul Bock	**Illustrator:**	Fred van Deelen
Art Director:	Cecilia Strömgren	**Client:**	United Distillers,	**Client:**	Carl Reh Group,
Client:	Brännvin Vodka		Gordon's Gin & Tonic		Bend in the River German Wine

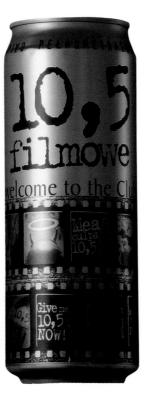

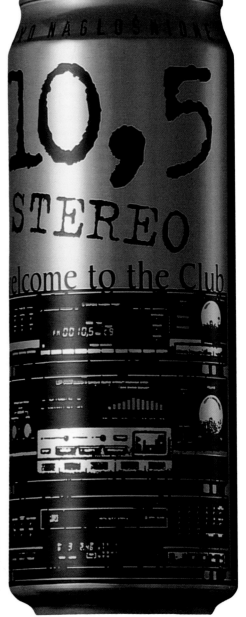

Agency:	3. Kusak, Istanbul
Creative Directors:	Mehmet Ali Turkmen
	Dogan Yarici
Copywriter:	Uygur Yilmaz
Art Director:	Mert Kunc
Photographer:	Jon Stigner
Client:	Dardanel,
	Fasuli Baked Beans

Agency:	Just Polska, Poznan
Creative Director:	Dominik Pijanski
Copywriter:	Piotr Kubiak
Art Director:	Tomasz Mikolajczak
Client:	Lech Brewery,
	10.5 Beer

The four 10.5 beer cans are called:
Seminarist, Overhaul, Stereo and Film.

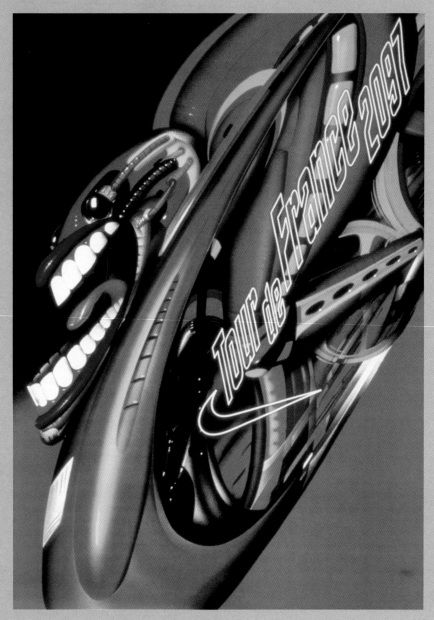

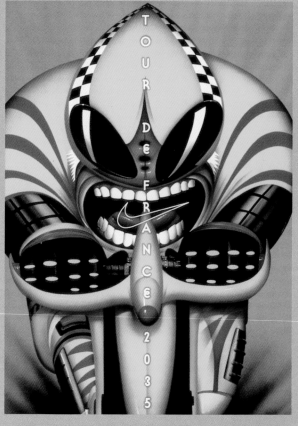

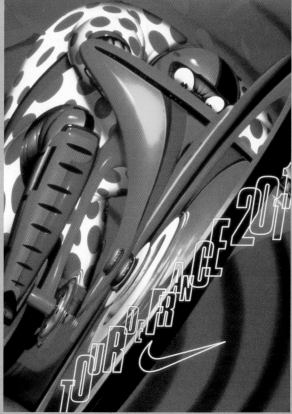

Agency:	KesselsKramer, Amsterdam	Nike has no history in the Tour de France, only a future. These posters are for the Tour de France in the next century, sponsored by Nike. In this way Nike brands the future of cycling.
Creative Directors:	Erik Kessels Johan Kramer	
Copywriters:	Johan Kramer Tyler Whisnand	
Art Director:	Erik Kessels	
Illustrator:	Bill Mayer	
Client:	Nike, Tour de France Sponsorship (Also a Finalist in the Recreation & Tourism Category)	

Agency:	Lodin Designbyrå, Stockholm	NB: The logo encourages consumers to reject genetically engineered food.
Creative Director:	Karin Lodin	
Art Director:	Karin Lodin	
Illustrator:	Karin Lodin	
Client:	Greenpeace	

Agency:	Newell & Sorrell, London	The new liveries position British Airways as a citizen of the world, accessible to everyone. Sixteen artists from around the globe participated in the launch phase of the re-design operation and others will contribute as the whole fleet eventually aquires new colours.
Creative Directors:	John Sorrell	
	Frances Newell	
	Rodney Mylus	
Client:	British Airways	

Agency:	Heye & Partner, Munich	Agency:	C-Pro Production, Moscow
Creative Director:	Norbert Herold	Creative Director:	Aleksey Fadeev
Copywriters:	Helmut Dietl Patrick Süskind	Copywriters:	Andrey Bychkov Dmitry Morozov
Art Director:	Karlheinz Müller	Art Director:	Aleksey Andreev
Photographer:	Jacques Schumacher	Illustrator:	Aleksey Fadeev
Client:	Classic Media, "Rossini" Poster	Client:	Lebedyansky Red Hot Sauce

Agency:	Grupo Barro-Testa, Madrid	Agency:	Lewis Moberly, London
Creative Directors:	Urs Frick Uschi Henkes	Creative Director:	Mary Lewis
		Copywriter:	Tony Hodges
Art Director:	Urs Frick	Art Directors:	Mary Lewis Nin Galister
Client:	Foco Comunicacion, Advertising Consultancy	Illustrator:	Nin Glaister
		Client:	Wineworld, Vinopolis

紫式部も今日はカタルーニャ人

Agency:	Tandem Campmany Guasch DDB, Barcelona	**Agency:**	Navy Blue Design Consultants, Edinburgh
Creative Director:	Fernando Macia	**Creative Director:**	Geoff Nicol
Copywriter:	Fidel del Castillo	**Illustrator:**	Jill Calder
Art Director:	Albert Giral	**Client:**	Health Education Board for Scotland, World Aids Day
Illustrator:	Albert Frenegal		
Client:	Generalitat de Catalunya, Worldwide Book & Copyright Day		

Agency:	Adoffice, Istanbul	Agency:	Werkstudio,
Creative Directors:	Timucin Unan		Rom & Freyler,
	Senay Isözen		Vienna
Copywriter:	Senay Isözen	Creative Director:	Toman Rom
Art Director:	Timucin Unan	Illustrator:	Mario Pirker
Client:	Underworld,	Client:	Hoechst Marion
	Men's Underwear		Rousell Antibiotics